Che furo allosso come dun can forti.
Hay pisa uituperio delle genti
Del bel paese la doue ilsi suona.
Poi che uiani ad te punir son lenti.
Mouissi la caurara & la gorgona.
Et faccian siepe adarno in sulla foce.
Si chegli aniegghi unte ogni persona.
Che sel conte ugolino haueua uoce.
Dhauer tradita te delle castella.
Non douia porre ifigliuoli ad tal croce.
Innocenti facea leta nouella.
Nouella thebe. uguiccion elbrigata.
Et gualteri due chel canto suso appella.
Noi passammo oltre doue lagelata
ruuidamente unaltra gente fascia
Non uolta ingiu ma tucta riuersata.
Lopianto stesso: li pianger non lascia.
Elduol che truoua in su gliocchi rintoppo.
Siuolge in esso ad far crescer lambascia
Che le lagrime prima fanno groppo.
Et si come uisiera di cristallo
Nempion socto ilciglio tucto ilcoppo.
Et aducgna che si come dun callo.
Per la freddura ciascun sentimento.
Cessato hauesse del mio uiso stallo.
Gia mi parea sentire alquanto uento.
Perchio maestro mio questo chimoue.
None quaggiuso ogni uapore spento
Ondegli adme auaccio sarai doue
Dicio ti fara locchio larisposta.
Veggendo la cagion chel fiato pioue.
Et un de tristi della fredda crosta.
Grido adnoi o anime crudeli.
Tanto che data ue lultima posta.
Leuatimi daluiso iduri ueli.
Si chi sfoghi ildolor chel cor mipregna.
Vn poco pria chel pianto siragieli.
Perchio allui se uuoi chio tisouegna.
Dimmi chise & siu nol disbrigo
...do della ghiaccia ir mi conuegna

Rispose adunque ison frate alberigo.
Io son quel delle fructe del male orto
Che qui riprendo dactero per figo.
O dissi lui hor settu anchor morto.
Et egli adme comel mio corpo stia.
Nel mondo su nulla scienza porto.
Cotal uantaggio ad questa tholomea.
Che spesse fiate lanima cade.
Anzi chantropos mossa ledia.
E te... u piu uolentier mirade.
...te lachryme daluolto
...to che lanima trade.
...ne ferio ilcorpo suo le tolto.
Da un demonio che poscia ilgouerna.
Mentre chel tempo suo tucto sia uolto.
Ella ruina in si facta cisterna.
Et forse pare anchora ilcorpo suso.
Dellombra che diqua dietro mi uerna.
Tu ildei saper se tu uien pur mo giuso.
Eglie ser branca doria & son piu anni
Poscia passati chel fu si rachiuso.
Io credo dissio lui che tu minganni.
Che brancadoria non mori unquanque.
Et mangia & bee & dorme & ueste panni.
Nel fosso su dissei di male branche.
La doue bolle la tenace pece.
Nonera giunto anchora inchel zanche.
Che questa lasciol dyauolo in sua uece.
Nel corpo suo & un suo proximano.
Chel tradimento insieme con lui fece.
Ma distendi oggimai in qua lamano.
Aprimi gliocchi & io non glielapersi.
Et cortesia fu lui esser uillano
Hay genouesi huomini diuersi.
Dogni costume & pien dogni magagna.
Per che nò siete uoi del mondo spersi.
Che col piggiore spiuto diromagna.
Trouai io un diuoi che per sua opra
In anima incocto gia si bagna.
Et in corpo par uiuo anchor di sopra.

THE DRAWINGS BY SANDRO BOTTICELLI FOR DANTE'S DIVINE COMEDY

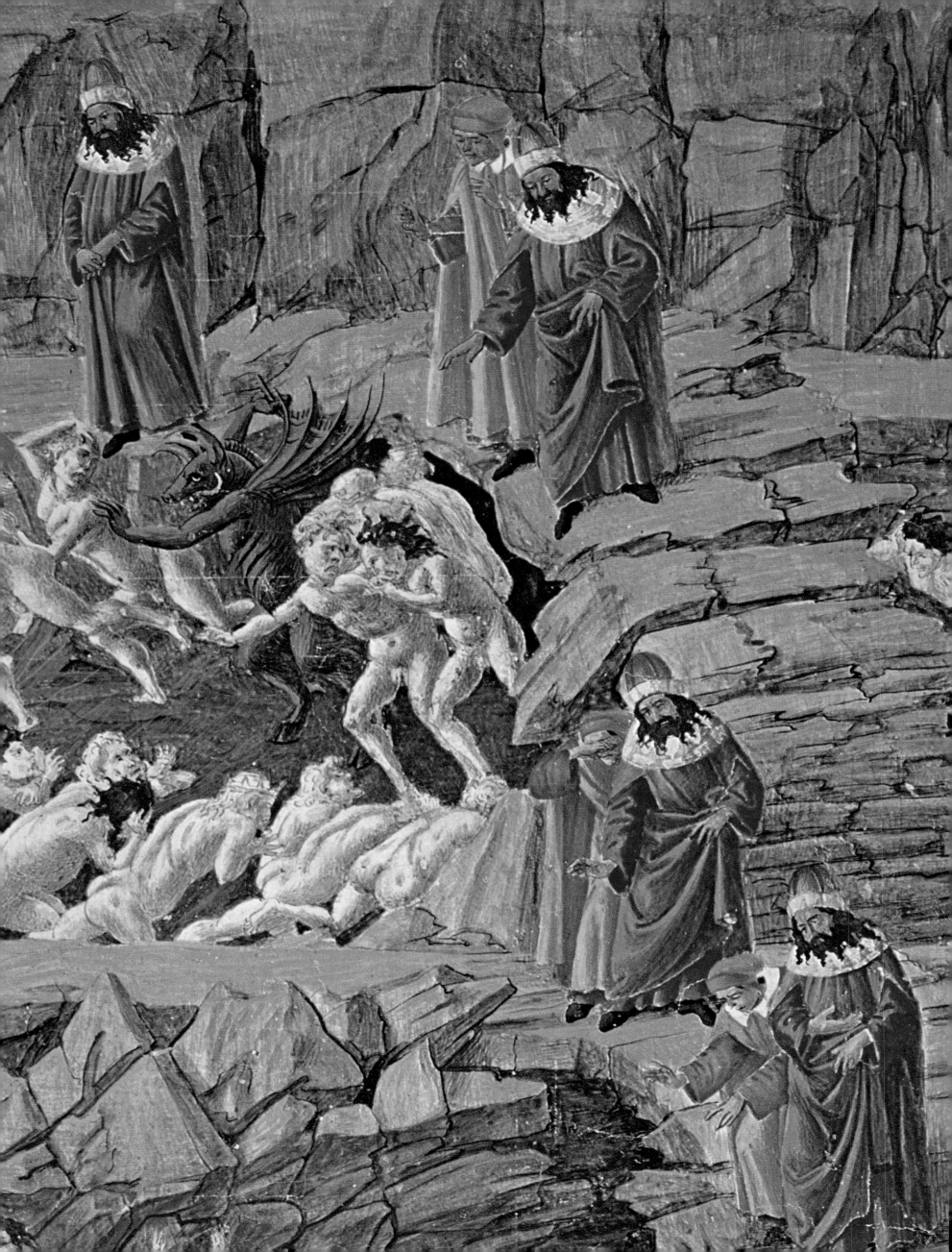

KENNETH CLARK

THE DRAWINGS BY SANDRO BOTTICELLI FOR DANTE'S DIVINE COMEDY

AFTER THE ORIGINALS IN THE BERLIN MUSEUMS AND THE VATICAN

HARPER & ROW, PUBLISHERS

New York, Hagerstown, San Francisco, London

To JANE
a devoted admirer
and earnest student of
DANTE

The endpapers are a reproduction of *Inferno* XXXIII in Botticelli's original text

Frontispiece: detail of the drawing for *Inferno* XVIII

Excerpts from Dante's *Divine Comedy*: *The Inferno*;
The Purgatorio; *The Paradiso* translated by John Ciardi.
Copyright 1954, © 1957, 1959, 1960, 1961, 1965, 1967, 1970 by John Ciardi.
Reprinted by permission of the translator.

THE DRAWINGS BY SANDRO BOTTICELLI FOR DANTE'S DIVINE COMEDY:
AFTER THE ORIGINALS IN THE BERLIN MUSEUMS AND THE VATICAN.
© 1976 Thames and Hudson Ltd, London
Introduction © 1976 Kenneth Clark

FIRST US EDITION

LIBRARY OF CONGRESS CATALOG CARD NUMBER: 76–5990

ISBN: 0–06–010777–4

CONTENTS

PREFATORY NOTE

The commentaries on Dante's allegory, the characters of his great poem and the events therein have been compiled and written by George Robinson, relying on the work of many generations of Dante scholars. Particularly helpful have been the published explications and scholarly contributions of Charles S. Singleton, G. Scartazzini, G. H. Grandgent, P. Toynbee.

Excerpts from the American poet John Ciardi's translation of the *Divina Commedia* have, in the main, been made to coincide with the actions and events Botticelli has illustrated; the few exceptions to that rule are those lines or *terzine* whose beauty and now centuries-old familiarity would make their omission a deprivation.

Because of their fragility and age, the original drawings by Botticelli present intricate difficulties in reproduction: some details are so faint as to be nearly invisible; the ageing of Botticelli's silver-point and inked lines has created a tonal contrast which was not part of his original purpose; the vellum itself has developed spots and areas of disfigurement. By using arduously painstaking printing methods, the most faithful possible reproductions have been achieved at approximately three-quarters of their original size (which ranges from 32cm × 47cm to 63cm × 47cm).

The reader may, in some instances, find it helpful, therefore, to examine some of the plates with a magnifying glass.

The original Botticelli drawings have been generously made available by the following institutions in whose collections various of them are: Biblioteca Apostolica Vaticana (*Inferno* 1, 9, 10, 12, 13, 15, 16); Staatliche Museen Preussischer Kulturbesitz, Kupferstichkabinett, Berlin. (*Inferno* 11, 14, 17–34; *Purgatorio* 1–8; Photography: Jörg P. Anders); Staatliche Museen zu Berlin, DDR, Kupferstichkabinett und Sammlung der Zeichnungen (*Inferno* 34–a; *Purgatorio* 9–33; *Paradiso* 1–32; Photography: Gerhard Kilian).

6

INTRODUCTION

'THE VALUE OF THESE DRAWINGS', said Bernard Berenson in writing about Botticelli's illustrations to Dante's *Divine Comedy*, 'consists in their being the handiwork of one of the greatest masters of the single line which our modern western world has ever had.'

Considering this judgment by the most influential critic of his time it is remarkable how few lovers of art have ever seen the great series of illustrations to which it refers, or are even aware of its existence. The reasons for this are partly accidental. Fifty-seven of the drawings are in the Kupferstichkabinett of the Staatliche Museen zu Berlin, Bodestrasse, and twenty-seven are in the Kupferstichkabinett of the Staatliche Museen Preussischer Kulturbesitz in Dahlem, Berlin; these are not normally exhibited. Eight more, in the Vatican Library, are not easily accessible. All except one, the double-sized second illustration to *Inferno* XXXIV, are done on large (approximately 32 × 47 cm) sheets of very white vellum, and are difficult both to handle and to reproduce. They were first published in 1887 by Dr F. Lippmann, in what must be one of the most cumbersome volumes ever put on the market, for the drawings are reproduced full size, and with ample margins: not so much a 'coffee-table' as a billiard-table book. Lippmann's collotype reproductions are, for their time, exceptionally good; but inevitably they have lost some of the delicacy of the originals and give no impression of the white vellum on which they are drawn. Although a few individual drawings have been re-photographed, all subsequent publications of the series as a whole have simply reproduced Lippmann's original plates, often so greatly reduced as to be meaningless.* The drawings are probably best known to English amateurs through the Nonesuch *Dante* (1928), which reproduces forty-eight of them. They have been reduced in scale, and re-engraved in the process, so that the background is often smudgy and the line spotty. Moreover, the drawings are reproduced double-spread, so that the spatial quality of the compositions is interrupted. They do not convey that feeling of absolute purity which is one of the chief beauties of the originals.

In the present edition the drawings have been reproduced from fresh photographs, and are only slightly reduced in the interests of a reader's convenience. We have also followed, or rather adapted, Botticelli's original practice, by which on the back of each illustration was written part of the canto to be illustrated on the next sheet; only since it was desirable to print a translation and short elucidation, the quotations from the cantos are shorter. In this way it is hoped that amateurs will at last become conscious of one of the most moving treasures of Italian art.

The earliest reference to the series of drawings is in the notes of one of those collectors of information about Florentine art who preceded Vasari, known as the Anonimo Gaddiano. It

* For example, Adolfo Venturi's *Botticelli and Dante*. A facsimile reprint of Lippmann's book was published by Julius Bard Verlag in 1921, but it is without any apparatus criticus, or even an index, so can be used only as a picture book.

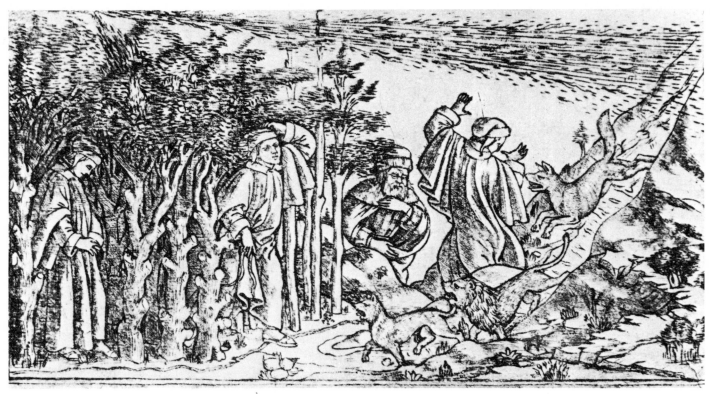

Baccio Bandini, *Dante and Virgil in the Dark Wood,* engraving. In *Inferno* I, Dante encounters the Leopard, the She-Wolf and the Lion.

reads: '*Dipinse et storio un Dante in carte pecora a Lorenzo di Pierfrancesco de' Medici cosa meravigliosa tenuta* – He painted and illustrated a Dante on sheepskin for Lorenzo di Pierfrancesco de' Medici, which was held to be something marvellous.' The mention of *carte pecora* leaves us in no doubt that this note refers to the series in Berlin and the Vatican, and it adds two important pieces of information: that the drawings were much admired in their own day, and that they were executed for Lorenzo di Pierfrancesco de' Medici. This member of the Medici family, usually known as Lorenzino, was a more enlightened patron of the visual arts than his cousin, the great Lorenzo. Lorenzo was chiefly interested in scholarship and literature, Lorenzino in painting. He had commissioned from Botticelli both the *Primavera* and the *Birth of Venus*, and was evidently a friend as well as a patron because in 1496 he used Botticelli as an intermediary in a correspondence with Michelangelo in Rome.

The next mention of Botticelli's involvement with Dante is to be found in Vasari. It appears in the edition of 1550 in almost the same form as in

the definitive edition of 1568, and reads: '*Dove per essere persona sofistica comento una parte di Dante: et figuro lo Inferno, et lo mise in stampa, dietro al quali consumo di molto tempo, perche non lavorando fu cagioni di infiniti disordini alla sua vita.* – So in order to show himself an intellectual he wrote a commentary on a part of Dante; and made illustrations to the Inferno, and had them printed. This took up much time, and the distraction from his work was the cause of infinite disorders in his life.' The 1568 edition of Vasari adds only one sentence, to the effect that the engravings were badly done. Vasari does not mention *carte pecora*, which suggests that he had not seen the original drawings, as the great white sheets of vellum are unforgettable.

As usual with Vasari, a kind of general truth transcends his errors of detail. There is no doubt that for at least twenty years Botticelli was obsessed by the study of Dante. It is unlikely that he wrote a commentary on the *Divine Comedy*, but at some time before 1480 he made a series of drawings to illustrate it. Nineteen of these were engraved by Baccio Bandini and were used as illustrations to the *Inferno* in a volume of the

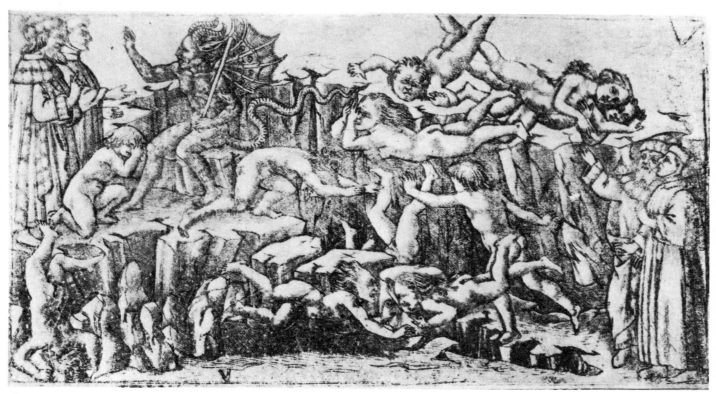

Baccio Bandini, *Minos and the Punishment of the Lustful*, engraving. Dante sees the souls of Paolo and Francesca da Rimini, in *Inferno* v, condemned to an eternal embrace of suffering.

Commedia with Cristoforo Landino's commentary, which was printed by Nicholas Alamanus in 1481.

As Vasari says, the engravings were poorly done. They seem to have been the work of several craftsmen. The first two may have been done by Bandini himself, but the third is by a very unskilled assistant, and a more naive hand is apparent in the later plates. Only the first two were actually printed on the page: the rest were 'tipped in' (sometimes upside down), and in the later cantos the spaces were left blank. Botticelli had been called to Rome to work in the Sistine Chapel, and so could not supervise the publication, and the whole edition was considered a failure. It is significant that the copy specially bound, and presented to the Signoria (now in the National Library of Florence), does not contain the engravings.

What sort of material did Botticelli leave behind for Bandini to engrave while he was in Rome? Allowing for the incompetence of the engravings, I would say that he left quite complete and careful drawings. Some motives appear with very little alteration in the Berlin–Vatican series, in particular the figures of Dante and Virgil (cf. the illustration to Canto XIX). One of the engravings is of particular interest, that depicting the carnal sinners (Canto V), which is one of the sheets missing from the later drawings, a deplorable loss because it contained, among other things, the episode of Virgil talking to Paolo and Francesca: one can imagine with what emotion Botticelli would have represented this encounter.

Incompetent as Bandini's engravings are, they suggest that some of the lost drawings on which they are based were more concentrated and dramatic than the ravishing, but diffuse, outlines that have come down to us. Botticelli, in 1480, was at the height of his powers, and one finds in the engravings echoes of the groups in the Sistine frescoes. But the restriction of scale did not allow that fantasy, that extension in space with which he could give his imagination full play. It is not surprising that he should have wanted to return to the subject twenty years later.

I say twenty years, because there can be very little doubt that the second series was begun about 1492. Mr Berenson says 'not before 1490'

9

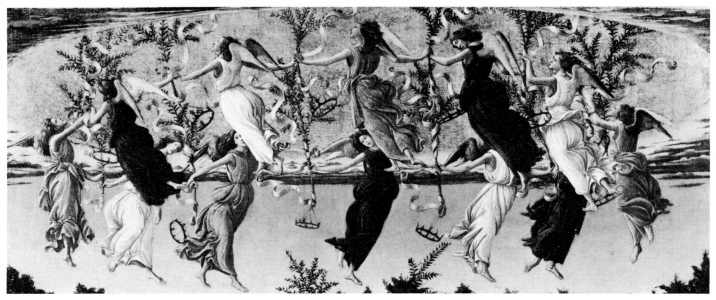

Sandro Botticelli, *The Mystic Nativity* (detail). Botticelli's angels here have little of the prosperous exuberance and joy he gives to those in *Paradiso* XXVIII.

and one may add, on stylistic grounds, not as late as 1500. The abrupt, angular movements of Botticelli's latest works, like the S. Zenobius panels, are at the furthest remove from the sweet, flowing movements of the Dante drawings. We have a legitimate standard of comparison, the angels in Botticelli's *Mystic Nativity* in the London National Gallery, dated the 20th day of March 1500 (which means, in our style, 1501). These thin, scrawny, unseductive creatures, spiritually beautiful as they are, bear no resemblance to the physically prosperous angels, with their billowing drapery, who surround Dante and Beatrice in *Paradiso* XXVIII, which one might suppose to be one of the latest of the illustrations. In his paintings the last time we find this kind of drapery, and this pleasure in physical beauty, is in the small *tondo* in the Ambrosiana. The picture most often spoken of in relation to the Dante drawings is the *Calumny of Apelles*, which in my opinion is usually dated too late. The draperies are just beginning to harden, but the heads of the girls have a round sweetness entirely different from the hysterical profiles of post-1500. On the other hand, the drawings reproduced here cannot be of the same date as the engravings. For one thing Botticelli was too fully occupied in the 1480s to have taken on such an exacting task. For another the drawings have a freedom and a fantasy which remove them

from the more academic character of the Sistine period. It seems reasonable to suppose that they date from after the death of Lorenzo (1492), who had kept Botticelli busy with odd jobs, after which he worked almost entirely for Lorenzino. They can hardly be later than 1497, when Lorenzino was forced to leave Florence, and Botticelli himself had thrown in his lot with Lorenzino's enemies, the followers of Savonarola.

From Vasari's time onwards we hear nothing of the drawings until seven of them were bought by Queen Christina of Sweden, who later sold them to the Vatican. The remaining eighty-five were in the hands of an Italian bookseller in Paris named Claudio Molini, and he probably sold them to that collector of genius, William Beckford, much of whose library passed to his daughter, who became Duchess of Hamilton. It is, however, possible that they were bought by the Duke of Hamilton, who was himself a collector. The indefatigable Dr Waagen, in his *Art Treasures of Great Britain*, published in 1854, noted a book of drawings, adding that the hand of Sandro Botticelli is very obvious. Milanesi does not mention Waagen's discovery in his edition of Vasari. But somebody had noticed it. This was Dr Lippmann, the creator of the Berlin Kupferstichkabinett. When the drawings were put up for sale in 1882, he came to London, stopped the sale, and bought

the eighty-five drawings for his department. Shortly afterwards Josef Strzygowski identified the seven drawings in the Vatican, that had belonged to Queen Christina, as being part of the same series.

It remains to be said that the drawings were originally done with a metal stylus, perhaps a silver point; but, as the vellum was not properly prepared, the stylus line has grown exceedingly faint, and must have done so almost immediately, so that Botticelli had to go over the original drawings with a pen outline. His inking-in follows no logical plan; areas that are important to the narrative and the design are left blank, and relatively unimportant details are carefully reinforced. For example, Michal mocking David as he dances before the Ark (*Purgatorio* x), which is the justification for including this curious example of humility, is only just perceptible; and the right-hand side of the River of Light (*Paradiso* xxx), which should be covered with flowers of wondrous spring, is almost invisible. A curious example is in *Purgatorio* xxix, where the chariot on the left, which plays so great a part in Dante's text, is left in stylus, almost invisible, whereas the three angels dancing above it are inked in with an enchanting grace. When the original stylus drawing is perceptible it sometimes seems more sensitive than the pen line, and this has led some critics to question whether the whole of the inking-in was done by Botticelli's own hand. In most cases the beauty of the line leaves us in no doubt, but there are points at which the quality deteriorates. If the reader will compare *Paradiso* v with *Paradiso* ix he will find an unquestionable falling-off in the penmanship. Nevertheless, I do not believe that Botticelli employed an assistant in this great enterprise. It was too near his heart. I believe simply that on some days his hand grew tired. Three of the sheets are coloured. Most critics have rejected the idea that they were coloured by Botticelli himself, but I am inclined to agree with Mr Berenson that they were. For example, the draperies in *Inferno* xxiv are characteristic of Botticelli's colour. But even he, in

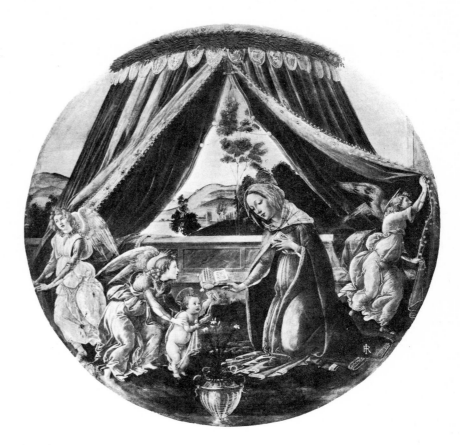

Sandro Botticelli, *Madonna and Child*. The air of spiritual bounty of these angels recalls the angels who accompany Dante and Beatrice towards the end of the *Paradiso*.

his state of obsession, must have realized that to colour the whole series would have been an impossible task. And, thank God, he abandoned it.

In order to realize the revolutionary character of Botticelli's drawings one must look briefly at the illustrations to Dante that preceded him. They began to appear soon after the *Divine Comedy* was in circulation. This was inevitable: apart from its greatness and authority, which was never in doubt, the *Comedy* was full of descriptions so vivid, concrete and convincing that readers longed to have them made visible. Various critics, beginning with Vernon Lee, indefatigably curious and intelligent, have written of Dante's visual images. Those that occur in the similes, which are perhaps the parts of the *Commedia* that give us most pleasure today, those beautiful descriptions of dawn over the sea, or the many snapshots of birds, are short masterpieces of direct observation. I am sure that Dante never conceived that they could be reproduced visually, and they were not until the Dante illustrations of Blake. But the narrative contains visual images as strong, which are also the result

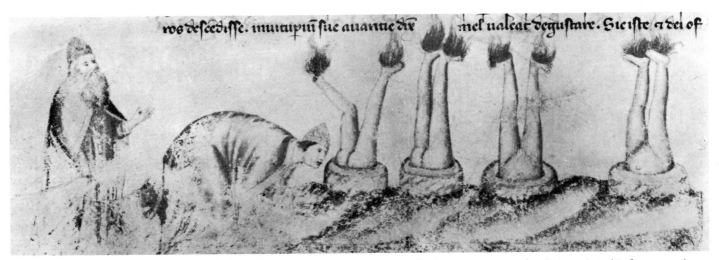

Virgil stands by as Dante bends to speak to the spirit of Pope Nicholas III among the Simonists (*Inferno* XIX). An illumination to Guido da Pisa's commentary in the *Inferno*, written about 1345.

of direct experience. One of these is so vivid that it appears in almost every illustrated *Inferno*. It occurs in Canto XXIII, where Virgil and Dante have descended to the realm of the Hypocrites. I cannot resist quoting the original passage:

> *Lià giù trovammo una gente dipinta,*
> *che giva intorno assai con lenti passi*
> *piangendo, e nel sembiante stanca e vinta.*
>
> *Elli avean cappe con cappucci bassi*
> *dinanzi a li occhi, fatte de la taglia*
> *che per li monaci in Cologna fassi.*
>
> *Di fuor dorate son sì ch'elli abbaglia,*
> *ma dentro tutte piombo, . . .*

Below we found a painted people, who wandered round with slow steps, weeping and seeming exhausted and overcome. They wore cloaks with deep hoods before their eyes, such as are made for the monks of Cologne. Outwardly they were gilded so that they dazzled, but within all lead.

They pass the wretched figures nailed to the ground, without raising their heads. No wonder that this marvellous image inspired one of Botticelli's most memorable drawings, and perhaps the most profoundly Dantesque of all Blake's illustrations. I will quote one other visual image which no illustrator could resist,* the Simonists,

* There are about twenty examples in Peter Brieger, Millard Meiss and Charles S. Singleton, *Illuminated Manuscripts of the Divine Comedy*, 2 vols, Princeton University Press/Routledge & Kegan Paul, London, 1969. The best is in a manuscript in Chantilly.

head downwards, with upturned soles of their feet on fire, in *Inferno* XIX. This is introduced by an example of Dantesque precision which is unforgettable. The holes in which the Simonists were placed head downwards in flames were similar in size to the round holes in the Florentine baptistry in which adults were baptized, and one of which Dante himself had broken to save someone from drowning:

> *. . . ciascun era tondo.*
>
> *Non mi parean men ampi né maggiori*
> *che que' che son nel mio bel San Giovanni*
> *fatti per loco d'i battezzatori; . . .*

What an astonishing example of Dante's use of personal experience to add vividness to a poetical concept. The Simoniacs in holes of fire, similar to the holes of water in which they had been baptized, is a wonderful stroke of the imagination. The lover of Dante will immediately recall many other examples of compulsive images, and it is interesting to find that from the first these are the passages that have inspired illustrators.

For the visual images in the *Inferno* Dante had a certain number of models in the mosaics and paintings of the *Last Judgment*, which had long been an obligatory subject in medieval art. It was necessary to remind people of the potential horrors of the future life in order that they should not make a hell on earth. Giotto's *Last Judgment* in the Scrovegni Chapel in Padua must

be of about the same date as the *Inferno*, and may have been known to Dante; and he certainly knew the *Last Judgment* in the Bargello, in which, traditionally, his portrait appears. However, the episodes in Dante's poems are far more varied than anything in the more or less conventionalized *Last Judgments* of the thirteenth and early fourteenth centuries, and this forced the early illustrators of the *Inferno* to strain their powers of invention. They were limited by the fact that almost all these images involved violent bodily movement, deployed over a large area; and the fourteenth-century illustrators still had difficulty in depicting both movement and space.

They were further restricted by the convention, which seems to go back to a manuscript now in Florence (Laur. Strozzi 152, dateable about 1335), that illustrations to the *Commedia* should take the form of a strip along the bottom

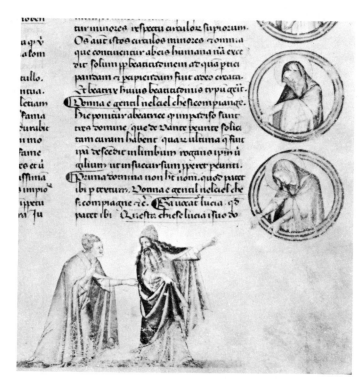

Virgil shows Dante the 'diritta via', while Beatrice encourages him to set out on his pilgrimage (*Inferno* II). From Giovanni de Pisa's commentary, now in the library of the Musée Condé, Chantilly.

of the page. Two beautiful examples of this form are worth citing. The first is in the library at Chantilly (Condé 597) and is probably by a Pisan follower of Traini. He is a scrupulous artist, and when the subject suits him, as in Beatrice's message to Virgil (*Inferno* II), where, incidentally, he has ventured into the margin, he can come close to poetry. He is also one of the few fourteenth-century illustrators successfully to depict a crowd of naked figures (*Inferno* XV). But in general his delicate drawings give no idea of the turmoil in which Virgil and Dante are involved. The other example is in a manuscript in the British Museum (Add. 19587), which seems to be Neapolitan although based on Strozzi 152. This illustrator makes a serious effort to convey some of the horror of the *Inferno*. His devils look terrifyingly evil. Dante and Virgil remain dignified and static figures and do not reveal those emotions of pity and fear that are so delicately suggested by Botticelli; but in two instances he seems to me to give rather more of Dante's feeling than Botticelli. One of these is *Inferno* XIII, the Wood of the Harpies, which in Botticelli's drawing is a ravishing confusion of

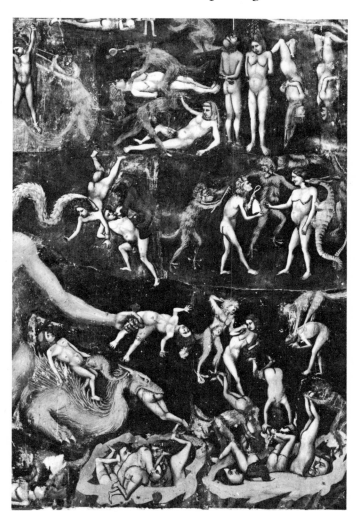

Giotto, *The Last Judgment* (detail). Medieval artists left very little to the imagination when it came to depicting the horror of eternal damnation.

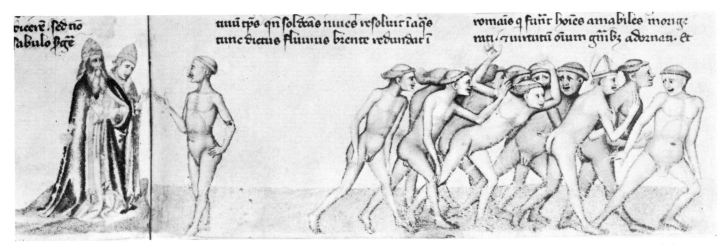

An almost jaunty Brunetto Latini, Dante's old teacher, talks with the two pilgrim-poets in the circle of the Sodomites (*Inferno* xv). The Chantilly artist has captured the eternal restlessness which Dante believes to be the essence of the Sodomites' punishment.

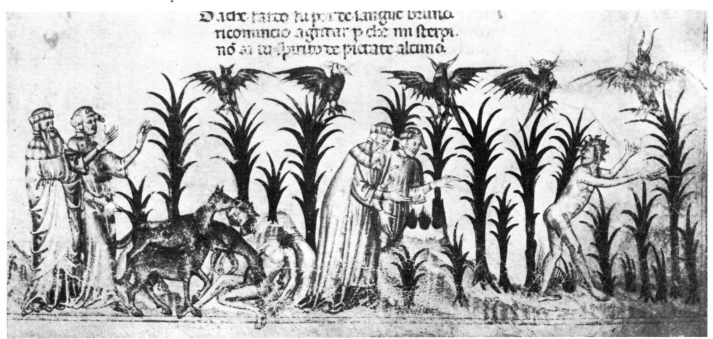

The 14th-century illuminator of the *Commedia* illustrates the stark aridity of the Wood of the Suicides (*Inferno* xiii) and its guardians, the foul and rapacious Harpies, in a less decorative manner than Botticelli.

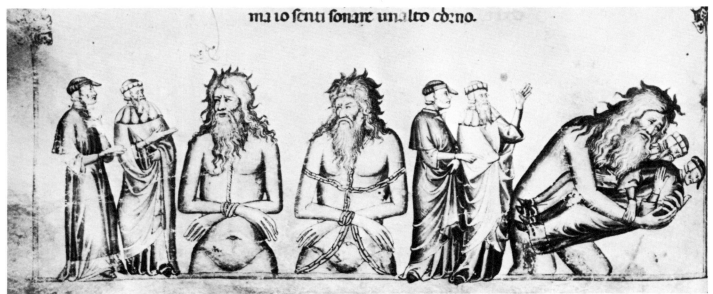

Directness is, perhaps, the outstanding quality of the Neapolitan illuminator of *Inferno* xxxi, in which Dante and Virgil come upon the Titans, one of whom, Antaeus, carries them down to the next level of Hell.

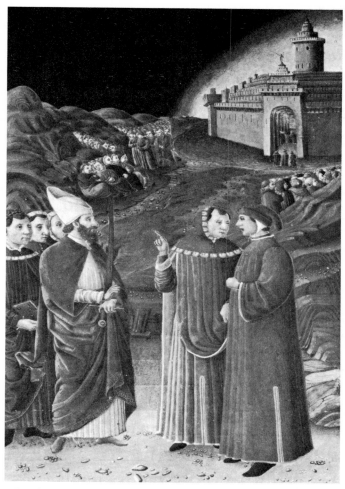

Chief among the Virtuous Pagans (*Inferno* IV) is
Homer, who with high formality in this 15th-
century manuscript carries a sword as a symbol that
he was the first poet to write about war.

decorative boscage, but in BM Add. 19587 is
alarming. The other is the famous scene of the
Giants (*Inferno* XXXI), which no illustrator of the
Inferno could resist. Botticelli's drawing, excep-
tional in the series by its scale and its Pollaiuo-
lesque figures, is admirable in itself. But when
one comes to the end of the canto, where the
giant Antaeus gently lifts up the two pilgrims to
take them down to Cocytus – *come albero in nave
si levo* ('as a mast is lifted into a ship') – the
fourteenth-century illustrator has drawn closer
to Dante's idea. Taken as a whole, BM Add.
19587 contains the most impressive illustrations
of Dante done within living memory of the poet.

Towards the end of the century the con-
vention of strip illustrations was relaxed, and
there are one or two manuscripts which show a
real Dantesque feeling, notably Vatican 4776.
In the early fifteenth century illustrations to the
Divina Commedia grew ridiculously undramatic.

A famous manuscript in the Biblioteca Marciana
in Venice (it. IX 276) contains scenes that look
like a kind of genre painting, serene and peace-
ful. The climax of this 'underplaying' of the
Inferno is in the most finished and elaborate of all
illustrated Dantes, the manuscript (MS Urb. lat.
365, in the Vatican Biblioteca Apostolica) illus-
trated by Guglielmo Giraldi for the Library of
Urbino. The encounter with the virtuous
Pagans (*Inferno* IV) is the formal record of some
official occasion; Virgil and Dante approach the
entrance of Dis (*Inferno* IX) like a sacristan and a
pew-opener walking through an over-crowded
cemetery.

To this general decline in the intensity of
Dante illustrations there is one shining exception
– literally shining, for its colours, touched with
gold, are of unequalled brilliance – the Codex of
the *Divina Commedia* bequeathed to the British
Museum by Mrs Yates-Thompson in 1941. It
was illustrated, about the year 1440, by two
Sienese painters. The illustrations in the *Inferno*

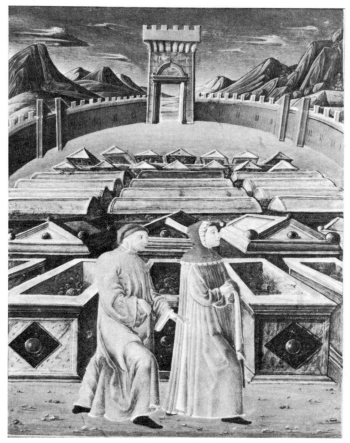

Dante and Virgil, in another illumination in the Vati-
can manuscript, seem almost in formal procession as
they walk through the cemetery where the souls of
Heretics are confined in burning tombs (*Inferno* IX).

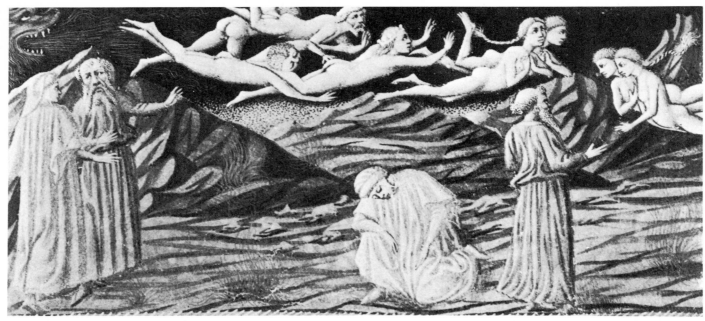

The Yates-Thompson *Inferno* illuminator centres attention on Dante's overwhelming grief at the eternal tragedy of Paolo and Francesca in *Inferno* v.

and the *Purgatorio* are by either Lorenzo Vecchietta or Priamo della Quercia; those in the *Paradiso* are certainly the work of Giovanni di Paolo. The unidentified Sienese illustrator of the first two *cantiche* is not a very refined or skilful artist, but he is dauntless. The naked bodies of the damned are shown in every sort of attitude. He is also remarkably ingenious in the way that he follows Dante's text. Giovanni di Paolo's illustrations are no less inventive, and considerably more poetical. The figures glide over the most enchanting backgrounds that even this great landscape painter ever depicted. The colour throughout is of a jewel-like radiance. It is unquestionably the most beautiful illustrated Dante in existence.

We must naturally speculate as to whether this marvellous book★ was known to Botticelli. It is so different in scale and space-filling from the Berlin–Vatican drawings that scholars seem to have dismissed the idea without examination.

★ The MS was reproduced in full, but unfortunately without colour, by John Pope-Hennessy, A *Sienese Codex of the Divine Comedy,* 1947. Pope-Hennessy's attribution of the *Inferno* and *Purgatorio* miniatures to Vecchietta has been questioned by Brieger, Meiss and Singleton, *op. cit.,* I, 270, who argue that they are by Priamo della Quercia. At first sight the miniatures seem superior to the documented work of Priamo, but there are certain stylistic resemblances, and it may be that Priamo's basic mediocrity is less apparent on a small scale.

When, however, we compare the Sienese miniatures to Bandini's engravings, we see many points of correspondence, for example in the Wood of Suicides (*Inferno* XIII); and one of these parallels seems to me conclusive. This is the scene already referred to in which Virgil addresses Paolo and Francesca. There can be no reasonable doubt that this is connected with the miniature on f.10 *recto* of the Yates-Thompson manuscript, and with this in mind we can find other points in which Botticelli's drawings of 1480 seem to have been influenced by the unknown Sienese.

After this short summary of Botticelli's visual antecedents, let me now give some indication of the spirit in which he approached his task. We cannot doubt that he took it seriously. His obsession with the subject is recorded convincingly by Vasari; his friend Manetti was a famous Dante scholar. He was an earnest student of the king of Dante commentators, Landino, and probably many details in the drawings were inspired by Landino's commentaries. In face of all this evidence we must reject the judgments of critics who treat Botticelli's imagery as unimportant. 'What then is the value of his illustrations?' asks Mr Berenson. 'The answer is simple enough. Their value consists in their

being drawings by Botticelli, not at all in their being illustrations to Dante.' That this statement is mistaken will, I hope, be apparent to anyone who reads this introduction and looks carefully at the plates. Adolfo Venturi made the obvious judgment that Botticelli's delicate, fluttering line is not appropriate to the stern punishments of the *Inferno*. Feminine grace, he says, as opposed to masculine severity. It is true that Signorelli's roundels in Orvieto, illustrating scenes from the *Purgatorio*, done in the same decade as Botticelli's drawings, have a virile harshness that is outside Botticelli's range: also a certain coarseness of execution that mars so much of Signorelli's great fresco. To form a just idea of how Signorelli could have treated scenes of diabolical violence one must turn to his magnificent drawings. But critics who give preference to Signorelli are thinking only of the punishments in the *Purgatorio*, and not of the great processions of angels and church fathers with which it concludes; still less of the *Paradiso*, which was altogether outside Signorelli's scope, and which of course he never attempted.

The fact remains that at the first glance Botticelli's illustrations to the horrors of the *Inferno* seem to show conflict between style and

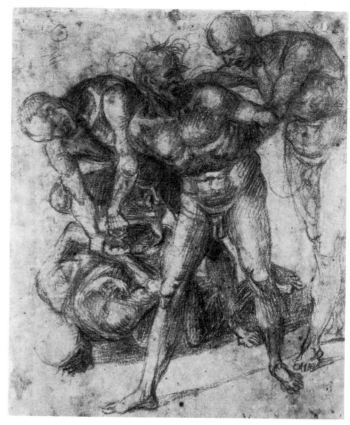

Luca Signorelli, study for the martyrdom of a saint.

content. This is partly due to our stylistic preconceptions. Since Caravaggio we have come to expect scenes of violence to be depicted in strong light and shade, and there is enough darkness, Heaven knows, in Dante's words to justify our prejudice. We do not expect horrors to be rendered in pure and unemphatic outline, and

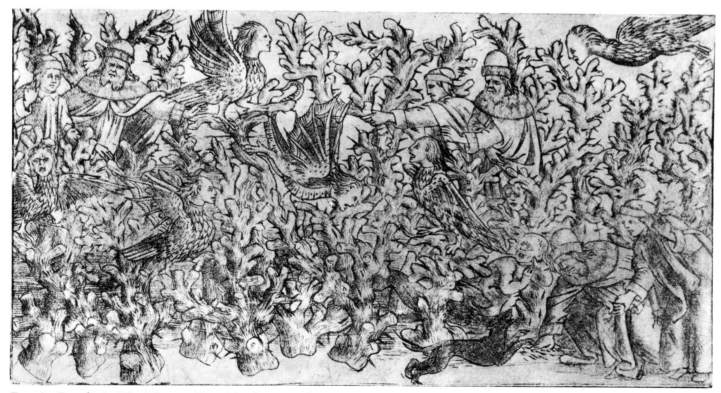

Baccio Bandini, *The Thorny Wood* (*Inferno* XIII), engraving.

17

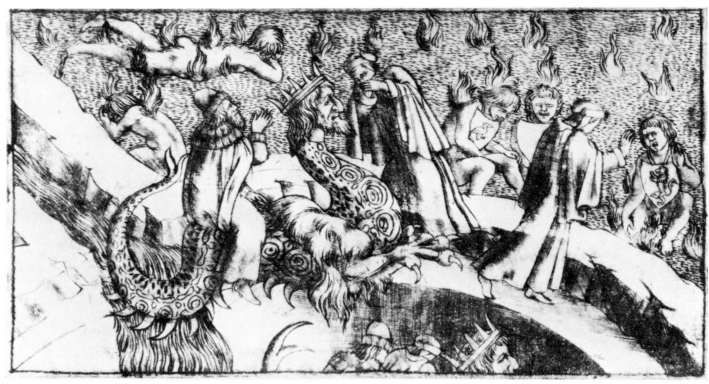

Baccio Bandini, *Geryon* (*Inferno* XVII), engraving.

looking hastily at Botticelli's drawings for the *Inferno* we do not realize how many painful and dramatic episodes they contain. The fourteenth-century illustrators tended to omit the more bloodcurdling episodes, or put them in an uncomfortable heap in the corner of their strip. Botticelli is far too serious a student of Dante to practise such an evasion. In sheet after sheet of the *Inferno* images of the most horrible sufferings fill the whole page. It is true that two of the most painful are the sheets that he has coloured, *Inferno* XV, the Violent against Nature, and *Inferno* XVIII, the Swindlers, Panders and Seducers. But turning over the sheets of the *Inferno*, one comes on the most heartbreaking episodes. Look for example at the group to the right of Canto XXIX, the Falsifiers, whose pitiful cries make Dante cover his ears with his hands. The air was so foul *che gli animali, infino al picciol vermo, cascaron tutti* – 'that all animals, even the little worm, dropped down.' In their maddening irritation the spirits scratch each other, as a stable-boy curry-combs a horse. Even more miserable are the Traitors (Canto XXXII), who lie in their frozen circle, almost incapable of movement.

One of the most beautiful drawings in the *Inferno* is less full of horrors, the illustration to Canto XVII, showing the monster Geryon. 'His face', says Dante, 'was the face of a just man, so benign did it seem to the outer view: and the rest was a reptile's body.' What a marvellously subtle observation! It is followed by a description of the gaudy painting on Geryon's body: 'Never did Tartar nor Turk make cloth with more colour and broidery.' Dante and Virgil have to ride on the back of the monster to reach the circle of the Usurers, lying in burning sand, and Botticelli realizes to perfection Dante's conception of the perilous ride. Botticelli had already represented Geryon in one of his drawings for the Bandini engravings; but the restricted scale did not allow the sense of aerial movement and adventure that distinguishes the drawing in Berlin.

There are equally moving images in the *Purgatorio*, like the Late Repenters in Canto V, who sit brooding, and then rush forward to tell their stories, or the Slothful, Canto XVII, whose penitence is to be in continual activity. In face of such drawings as these it is hard to believe that anyone could say that Botticelli fails as an illustrator, even in those parts of the *Divine Comedy* that would seem to be least suited to his genius. His outlines describe the tortures of the damned,

and the slightly less severe pains of Purgatory, with a clarity that is more disturbing than the obviously dramatic style of Zuccaro and Gustave Doré, precisely because they are presented with such serious simplicity. Perhaps the reason why so great a critic as Berenson should have made this mistake is that in his time aesthetes looked at works of art synthetically, and lost the faculty of reading them like a book, which was clearly one way in which they were regarded in the sixteenth century.

But much as I admire Botticelli as an illustrator I must admit that I cannot completely accept one important element in his *Inferno*, the devils. They are grotesque, absurd, and frightening only in their ugliness. They are really terrifying in *Inferno* XXIII, where a flight of devils swoops down on Virgil and Dante who narrowly escape into the realm of the Hypocrites; and they are shockingly cruel in *Inferno* XXII, the Barrators,* for they are armed with gigantic hooks on lances. The wretched Barrators try to hide beneath the boiling pitch, but the devils hook them up like otters – *Mi parve una lontra* – and one lies screaming at Virgil's feet.

Where Botticelli derived his image of a devil has a certain art-historical interest, because it occurs, with all its attributes, in a drawing in Windsor (12371), formerly attributed to Leonardo da Vinci, but certainly a copy by Melzi. Personally I am convinced that several of Leonardo's drawings were intended as illustrations to Dante, and that the famous drawing of a pointing lady (12581) actually represents Matilda. It is remarkably Botticellian; is, indeed, almost a free version of the Matilda in *Purgatorio* XXVIII. Botticelli is the only living painter mentioned in the *Trattato della Pittura*, and I think there is a strong probability that the Dante drawings were known to Leonardo.

* Some people may not know the meaning of the word 'barrators' (*barratieri*). The dictionary meaning is 'a vexatious raiser of discord', but barratry is 'fraud or gross negligence of master or crew to the prejudice of owners', and even in Dante's time *barratieri* seems to have had some connection with crimes committed at sea.

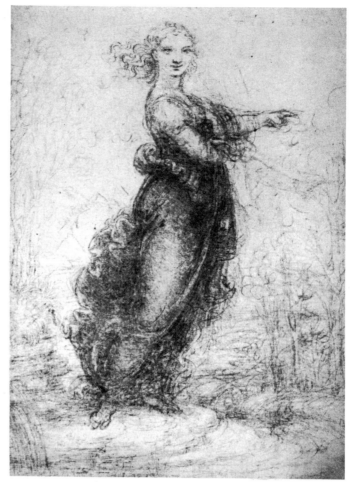

Leonardo da Vinci, *Young Woman Pointing*, drawing.

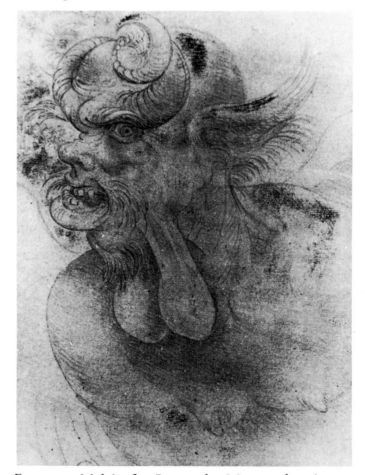

Francesco Melzi, after Leonardo, *Monster*, drawing.

Although there are many moving and power-ful drawings for the *Inferno*, I think it must be allowed that Botticelli breathes more freely when he reaches the *Purgatorio*. We feel in the very first sheet a sense of liberation:

> *Dolce color d'oriental zaffiro,*
> *che s'accoglieva nel sereno aspetto*
> *dell' aer puro infino al primo giro,*
>
> *a li occhi miei ricominciò diletto,*
> *tosto ch' io uscii fuor de l'aura morta,*
> *che m'avea contristati li occhi e 'l petto.*

The sweet colour of an orient sapphire which was gathering on the calm forehead of the sky, pure even in the first circle, restored to my eyes delight, as soon as I came forth from the dead air which had saddened my eyes and my heart.

In the *Purgatorio* Dante and Virgil move in a less painfully enclosed world. They still are to wit-ness much suffering, but it seems to be depicted with greater sympathy, like the seated figures of the Envious in Canto XIII.

One of the aesthetic advantages of the *Purga-torio* for Botticelli was that it allowed for the appearance of angels. We all know that angels are sexless, and to refer to them as women is heresy. However, the fact remains that in almost the whole of Christian art they are represented in an unquestionably, and sometimes very em-phatically, female form. Botticelli loved paint-ing women. Femininity, as his first rediscoverers recognized, was the inspiration of his finest work. Since the drawing for Canto V is missing, there are practically no women in the *Inferno*: a man's world (although there are a few resolute angels in *Inferno* IX). But in the *Purgatorio* angels appear almost from the first, and in Canto XII, the Proud, an angel welcomes Dante and Virgil with feminine sweetness after they have passed the scene of the fall of a diminutive tower of Babel.

Before coming to the six marvellous draw-ings with which the *Purgatorio* closes, I must notice two exceptional sheets which break up the sequence of misfortunes that occupy the cantos of the book only a little less painfully than do the episodes of the *Inferno*. The first of these is the illustration to Canto X, where Virgil and Dante, after mounting a twisting path, which moves from one side to another like a wave – *che si moveva e d'una e d'altra parte, sì come l'onda che fugge e s'appressa* – find them-selves in front of carvings which represent alle-gories of humility. First, and understandably, the Annunciation; then, more unexpectedly, David dancing before the Ark. Alas, the metal point line of the Ark and of David's palace has almost vanished, but one can still make out the figure of David's wife, Michal, mocking him. Finally, Virgil points out to Dante a huge representation of the Justice of Trajan (Trajan plays a promi-nent role in the *Divine Comedy*), which is so full and elaborate that it is worth examining in detail. It is, in effect, a battle scene. We think of Leonardo's *Battle of Anghiari*, and even more of Raphael's *Attila* in the Stanze; but when we come to look closely at the widow and her dead son, she is a moving figure, as Dante says, *per-sona in cui dolor s'affretta*. Beneath this allegory of humility are two figures of the Proud, crawling on all fours under their heavy burdens. These unhappy penitents occupy the next canto, XI, and Dante recognizes one of them, the Bolog-nese artist Oderiso, whom he calls *buon penello azzuro*. This is one of several references to artists, of which that to Cimabue and Giotto in the same canto is the most famous, which prove Dante's interest in the visual arts. The other ex-ceptional drawing, to Canto XXVI, illustrates the punishment of the Lustful. In Dante's mind they are evidently the most forgiveable of sinners, as they are the last sufferers in the *Purgatorio*, and appear immediately before the sequence of cantos which lead to the vision of bliss. The Lustful move among the flames of their own desires, and this has allowed Botticelli to release with complete freedom his passion for linear movement. The flames twist and swirl and mount with a rhythmic life unsurpassed in European art, and seldom equalled in the East. They are alive, and compared to them the famous panel of flames in the Japanese scroll of

Hell of Flames (twelfth-century Tokyo) is decorative, almost Lalique. Only the flames that surround the *Blue Fudo* in a tenth-century hanging scroll in Kyoto seem to me to equal, or even to surpass, Botticelli in their intensity and rhythmic determination. The flames dominate the design, so that at first we do not look at the sheet as an illustration of Dante's poem. But when we do so we find that around the central figure of the poet, the Lustful, flying through the flames, are exquisitely drawn, heads, hands and arms all expressive. They turn to each other as they pass, and illustrate perfectly Dante's lines:

> *Li veggio d'ogni parte farsi presta*
> *ciascun' ombra, e baciarsi una con una*
> *senza restar, contente a breve festa.*

There saw I on either side each shade making haste, and one kisses the other without staying, content with this short pleasure.

Immediately after the turbulence of the flames comes a drawing of heavenly calm and simplicity, in which the poets (accompanied by Statius) enter the divine forest – 'thick and living', says Dante, but Botticelli makes it sparse and exquisite – of the Earthly Paradise (*Purgatorio* XXVIII). They find a lady, Matilda, bending down to pick the flowers, whom Dante addresses in lines that are amongst the most familiar in the *Commedia*:

> *Tu mi fai remembrar dove e qual era*
> *Proserpina nel tempo che perdette*
> *la madre lei, ed ella primavera.*

Matthew Arnold, in a famous essay, advised us to keep in our minds certain lines of poetry which would be reminders of true greatness, and he includes among his 'touchstone' lines a passage from Milton:

Not that fair field of Enna, where Proserpin gathering flowers, Herself a fairer flower, by gloomy Dis was gathered.

Surely these lines were inspired by the even more beautiful *terzetto* of Dante, which to my mind is the perfect touchstone of pure poetry. It has inspired Botticelli to do one of the three or four most economically beautiful drawings of the series.

After the limpid clarity of the meeting with Matilda come four of the most elaborate drawings of the series, the processions that accompany Beatrice as she goes to meet Dante. In their profusion of ornament they are like the Triumphs that are so often the subject of mid-fifteenth century *cassoni*, but, instead of extending parallel with the picture plane, they move forward out of depth, and are compositions of surprising ingenuity. Pageants, beloved in the Renaissance, have become slightly wearisome to us, and these drawings, which follow Dante's descriptions very closely, are at first sight so crowded with Elders, Evangelists and Church Fathers that we would look at them with more interest than delight were it not for the ravishing beauty of the angels. They dance round the holy men and scatter flowers on Beatrice's chariot; and finally when Beatrice, with a severe expression, has reproved Dante and ordered him to wash away his sins and his memories in the river Lethe, they help Matilda to pull him out. Later they surround and encourage the poet and cry out to Beatrice to forgive him: *Per grazia fa noi grazia.* These groups of dancing girls – there is really no pretence that they are angels, for most of them lack even wings – are pure Botticelli, and if we can isolate them from their entourage they give us that delight in delicate grace which only he can give.

The last drawing in the *Purgatorio* is one of the most beautiful. The mood has changed from pageantry to one of withdrawal. We are back in the sacred wood, but full of fears and forebodings. Beatrice sits on the ground, surrounded by the Seven Virtues, who weep at the wickedness of the world. Then they all move across the wood, with heads mysteriously bent, and Beatrice gives Dante a lecture so obscure that even he protests. Finally the long-suffering poet is ordered a second immersion, this time in the river of Eunoë, which will secure in his mind all good impressions.

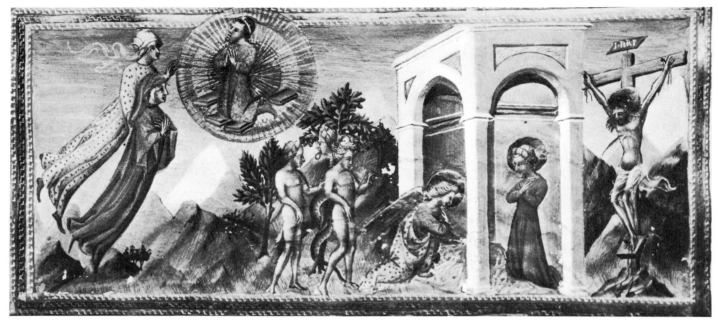

In *Paradiso* VIII, as Dante contemplates Justinian, within the Sphere of Mercury, Beatrice has a vision of the Mystery of the Redemption, from the Incarnation to the Crucifixion.

And, as Dante says:

> *Io ritornai dalla santissim' onda*
> *rifatto sì, come piante novelle*
> *rinnovellate di novella fronda,*
>
> *puro e disposto a salire alle stelle.*

Pure, and ready to mount to the stars. This is the subject of the first illustration to the *Paradiso*, and, like the encounter with Matilda at the end of the *Purgatorio*, it is one of the two or three drawings in the series that is familiar to all lovers of the Renaissance. The floating movement of the two figures, Dante and Beatrice, as they rise out of the divine forest, is of a delicate and economical beauty unequalled in Western art. Seldom has the sense of spiritual yearning been so exquisitely portrayed.

And now a very curious, and in some ways disappointing, development takes place. From Canto II to Canto XXII Botticelli concentrates almost entirely on the figures of Dante and Beatrice, isolated in a circle. To the medieval and Renaissance mind the circle was the perfect form, and as such plays a great part in the imagery of the *Divine Comedy*; but nowhere more than in the *Paradiso*, where every canto makes reference to it. So it is not surprising that Botticelli should make it the setting of Dante's long course of spiritual instruction. But visually it is a rather restricting ambience. Occasionally a few small attendants are added as auditors, as in the beautiful illustration to Canto III, where Beatrice addresses certain spirits who, through no fault of their own, have failed to keep their vows; and occasionally they are surrounded by flames. But Beatrice and Dante are always the dominant figures, and had clearly become an obsession to Botticelli. The variations of their poses are a marvel of linear interplay, and their gestures communicate a sense of spiritual relationship. Consider Canto V, in which Beatrice expounds to Dante the doctrine of the freedom of the will. With her beautiful feet pressed close together she floats in front of the poet, who raises his hand in admiration and astonishment. What could be finer than the contrast between her billowing draperies and Dante's severe outline?★

★ This is a striking use of the traditional Dante image. How this unforgettable profile came into existence is not a question for a footnote. The explanation, once generally accepted, that it was derived from a fresco by Taddeo Gaddi in Sta Maria Novella, has been questioned, but no alternative answer has been accepted. The so-called portrait of Dante in the Bargello fresco is entirely the work of an English amateur who painted it in the nineteenth century while doing a supposed copy for the Arundel Society. But I may notice that frequently Botticelli makes him much younger and less hatchet-faced.

Almost equally moving, in an entirely different mood, is the illustration to Canto XI, where Beatrice no longer admonishes severely, but points the way, and Dante looks at her with touching affection.

Throughout the whole series the relationship of the two figures is subtly varied, and each drawing by itself is of exquisite beauty. But I must confess that, when the theme has been repeated twenty times, I find my attention beginning to flag, and so, as I have ventured to suggest on an earlier page, did that of Botticelli. We know from Giovanni di Paolo's illustrations that the *Paradiso* contains plenty of images and similes which can be rendered visually. If only Botticelli had undertaken some of these subjects – for example, the story of Justinian from Canto VI – or had even illustrated certain theological concepts, as in Giovanni di Paolo's beautiful miniature of the Mystery of the Redemption, how much richer we should be. Why didn't he? Herbert Horne believed that the *Paradiso* drawings were unfinished, but I am sure that this is a mistake. Botticelli felt, I believe, that the true subject of all these cantos was the spiritual and theological instruction imparted by Beatrice to Dante, and this could be conveyed only by concentrating on the two figures. To have included any other illustrative material would have been to deviate from the high purpose of the book.

At last, in the illustration to Canto XXI, there comes fresh action, where Beatrice shows Dante the ladder that leads to heaven, while the souls of those who have lived contemplative lives fly round them 'like daws at daybreak, warming their feathers'. On this sheet the figure of Beatrice on the ladder is perhaps the most clearly visible of all the stylus drawings. On the next page we see Dante fainting at the thought of the ascent, but Beatrice supports him and encourages him on his way, so that we also see him climbing the ladder, with hopeful gaze. They find themselves in the starry heavens (Canto XXIII), and Dante concentrates his mind on the Virgin. The whole canto is full of heavenly images, and one cannot help regretting Botticelli's self-imposed

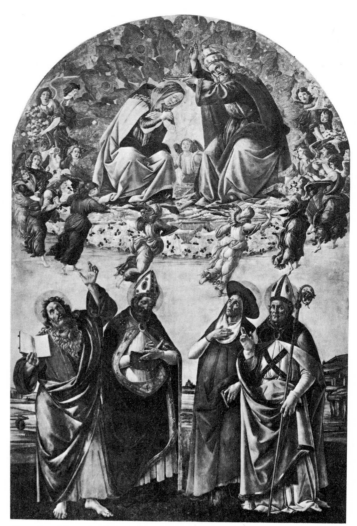

Sandro Botticelli, *The Coronation of the Virgin.*

discipline that confined him to the two figures.

The same instruction, and the same repudiation of imagery, continue for three cantos. Then in Canto XXVI Dante averts his head and covers his eyes in shame. In the following canto, XXVII, Beatrice tells him to raise his head, the clouds begin to clear, and she leads him upwards. This is one of the most moving of the illustrations, because it shows both Beatrice and Dante in a mood of humility, prior to their flight. Then comes the wonderful sheet where they are surrounded by a heavenly host – playing, says Dante, angelic games. One may spend a long time looking at these ravishing little figures before discovering that one of them bears a tiny plaque on which are inscribed the words *Sandro dima rian o.* These flying figures remind us of the angels who surround and celebrate the *Coronation of the Virgin* in the Uffizi, a picture that gave Ruskin such transports of delight that he felt like falling on the floor, and if scholars are

23

right in dating it 1491 then we cannot be far from the date of the Dante drawings. Another flight of angels, and then the last of the finished, or rather of the half-finished drawings (Canto XXX), for only a faint indication of the stylus stroke is visible on the right side. Dante and Beatrice fly upwards over a River of Light, and on either side were originally two banks, *due rive dipinti di mirabil primavera* ('painted with miraculous Spring'), with flowers of such beauty that Dante, 'clothed in light', feels faint at their brilliance and their perfume. Alas, on only one bank have the flowers been inked in, and that incompletely.

This is effectively the last drawing of the series, and we have no right to ask for more. Even Botticelli's imagination must have been exhausted by the effort to make such high spirituality visible. But we may selfishly grieve that he did not try to realize St Bernard's wonderful hymn to the Virgin, which opens the last canto:

Virgine madre, figlia del tuo figlio,
umile e alta più che creatura.

That vision of the Madonna which Botticelli, more than any other artist, perhaps, has fixed in our imaginations, would have made a most moving close to the series. Was he exhausted; or did he shrink from so great a responsibility? Or is the sheet simply lost?

There are many reasons why Botticelli's illustrations to Dante have a value to us greater than any others that have survived: they are the work of a serious student of the poet, instructed by the second generation of expositors of the great poem. They represent what the commentators of the fifteenth century believed to be Dante's meaning. When I used the words 'have survived' I was thinking of the tradition that

Michelangelo, who was also a profound student of Dante, did a series of illustrations to the *Purgatorio* in the margins of a large folio of the *Divine Comedy*. The earliest reference to this tradition occurs in a letter dated 1747 from Bottari, editor of the first collection of artists' letters, to his friend Gori. It is repeated, without any references, in a footnote to Vasari's life of Michelangelo in the Milanesi edition of 1881. 'This precious volume', he says, 'passed into the possession of Antonio Montauti, who sent it with the rest of his goods from Livorno to Civitavecchia, but the ship was wrecked, and the volume lost.' Michelangelo is known to have studied Dante throughout his life, and there are undoubtedly echoes of the Inferno in the *Last Judgment* of the Sistine Chapel. What an inestimable treasure his marginal illustrations to the *Purgatorio* would have been! But I fear that the whole story has the character of a legend.

But even if Michelangelo's drawings had existed they might, I believe, have lacked something that we find in Botticelli. The character of Michelangelo's style is so strong that it might have overshadowed Dante's meaning, whereas Botticelli's self-denial seems to come nearer to Dante's style than would have been possible for a more assertive genius. His drawings have two qualities that are essentially Dantesque: purity and economy. The way in which Dante, both in his descriptions and in his moral judgments, combines vividness and economy is one of the first things to impress every reader of his sublime poem. And Botticelli, by the controlled simplicity of his style, arrives at something of Dante's purity of diction, so that each time we return to his drawings we feel ourselves closer to that vast, elusive work, so complex, so incomprehensible, and yet so clear.

KENNETH CLARK

24

THE PLATES

INFERNO

The Chart of Hell

ACCORDING TO DANTE'S CONCEPTION, Hell is a vast funnel-shaped cavity, extending to the centre of our world and vaulted over by the crust of the earth's surface. Immediately above it is Jerusalem, the centre of the medieval world. The vast, dim, circular cavern gradually grows smaller, as it descends in a series of precipitous, cliff-like ledges of rock, which form a number of horizontal and circular stages constituting the nine circles of Hell. In Botticelli's drawing, which shows this cone-shaped cavity in a vertical section, not only do these circles appear with the eighteen subdivisions of the last three, but the various punishments which are executed in each of them are represented by the minute figures of the souls in torment. Above, in the left-hand corner, Virgil and Dante are seen passing through the gate of Hell into 'the twilight country', which forms a kind of ante-region to the great river Acheron, and the circles of the cavern.

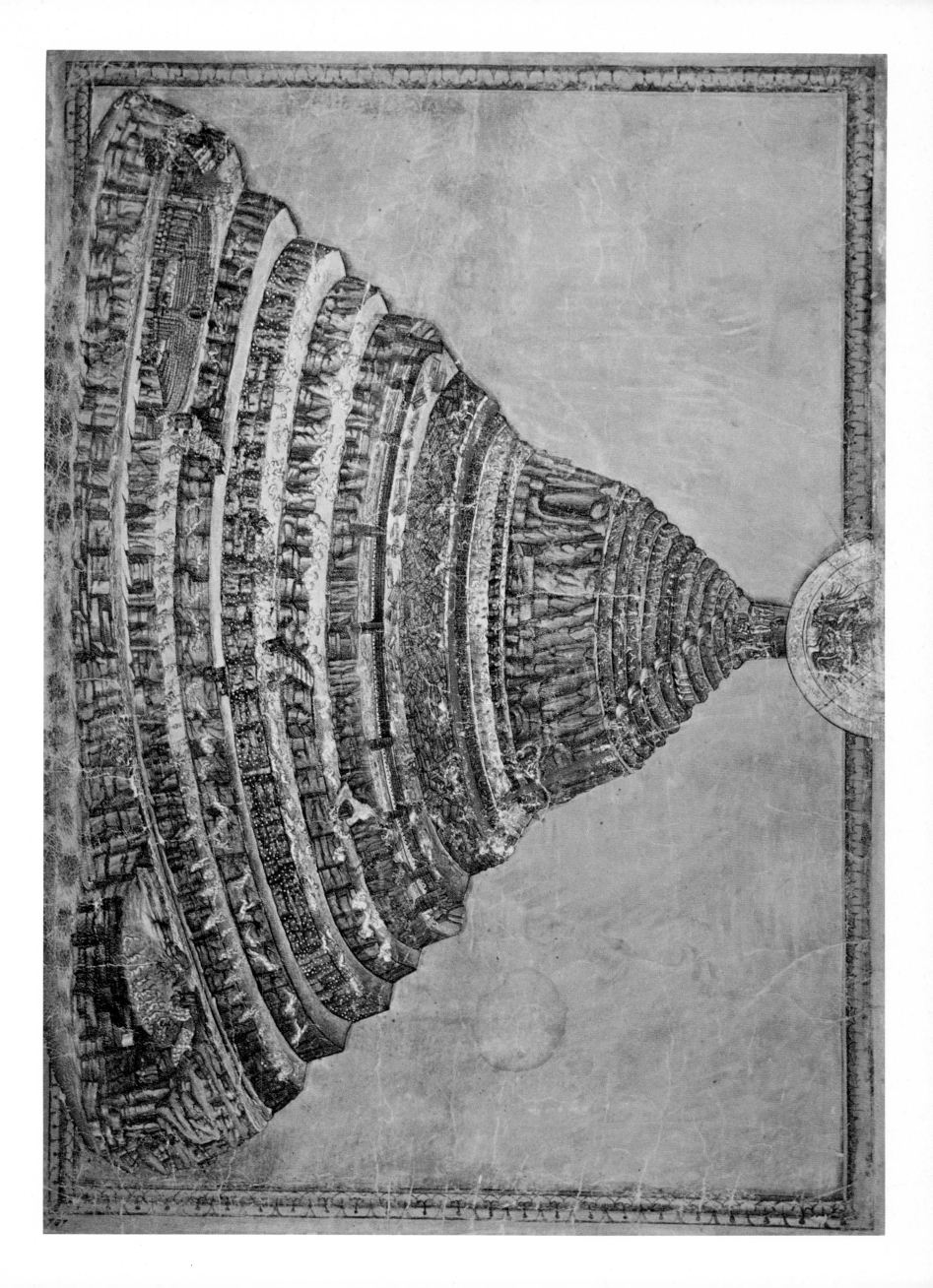

Midway in our life's journey, I went astray
from the straight road and woke to find myself
alone in a dark wood. How shall I say

what wood that was! I never saw so drear,
so rank, so arduous a wilderness!
Its very memory gives a shape to fear.

Death could scarce be more bitter than that place!
But since it came to good, I will recount
all that I found revealed there by God's grace.

How I came to it I cannot rightly say,
so drugged and loose with sleep had I become
when I first wandered there from the True Way.

 * * *
 And lo!

almost at the beginning of the rise
I faced a spotted Leopard, all tremor and flow

and gaudy pelt. And it would not pass, but stood
so blocking my every turn that time and again
I was on the verge of turning back to the wood.

 * * *
 I shook with dread

at sight of a great Lion that broke upon me
raging with hunger, its enormous head

held high as if to strike a mortal terror
into the very air. And down his track,
a She-Wolf drove upon me, a starved horror

ravening and wasted beyond all belief.
She seemed a rack for avarice, gaunt and carving.
Oh many the souls she has brought to endless grief!

 * * *

And as I fell to my soul's ruin, a presence
gathered before me on the discolored air,
the figure of one who seemed hoarse from long silence.

At sight of him in that friendless waste I cried:
'Have pity on me, whatever thing you are,
whether shade or living man.' And it replied:

'Not man, though man I once was, and my blood
was Lombard, both my parents Mantuan.
I was born, though late, sub Julio, and bred

in Rome under Augustus in the noon
of the false and lying gods. I was a poet
and sang of old Anchises' noble son

who came to Rome after the burning of Troy.
But you – why do you return to these distresses
instead of climbing that shining Mount of Joy

which is the seat and first cause of man's bliss?'
'And are you then that Virgil and that fountain
of purest speech?'

The Dark Wood

ON THE LEFT of the drawing Dante, lost in contempla-
tion with his hands clasped before him, wanders through
the 'dark wood', represented by oaks and pine trees.
On his right, two other figures appear to have been
erased. The upper one may have represented the poet
emerging from the wood at the foot of the hill, which rose
up where the valley ended. The lower figure, of which
only the outline of the head and one of the feet can be made
out, appears to have represented the poet seated on the
ground, his face covered with his cloak, 'loose with sleep'
after he had left the True Way. In the centre of Botticelli's
drawing, the Leopard with the 'gaudy pelt' impedes
Dante's way up the hill. Again, on the right, he starts in
terror at the Lion, who comes upon him raging with
hunger. Finally, on the extreme right of the drawing, the
She-Wolf springs out upon the poet who, as he turns to
rush down the hill in terror, is stopped by Virgil, who
throughout the drawings is dressed as a medieval magus.
The animals are the semi-heraldic creatures of the gothic
bestiaries and may, in Dante's allegory, respectively
represent fraud, violence and incontinence.

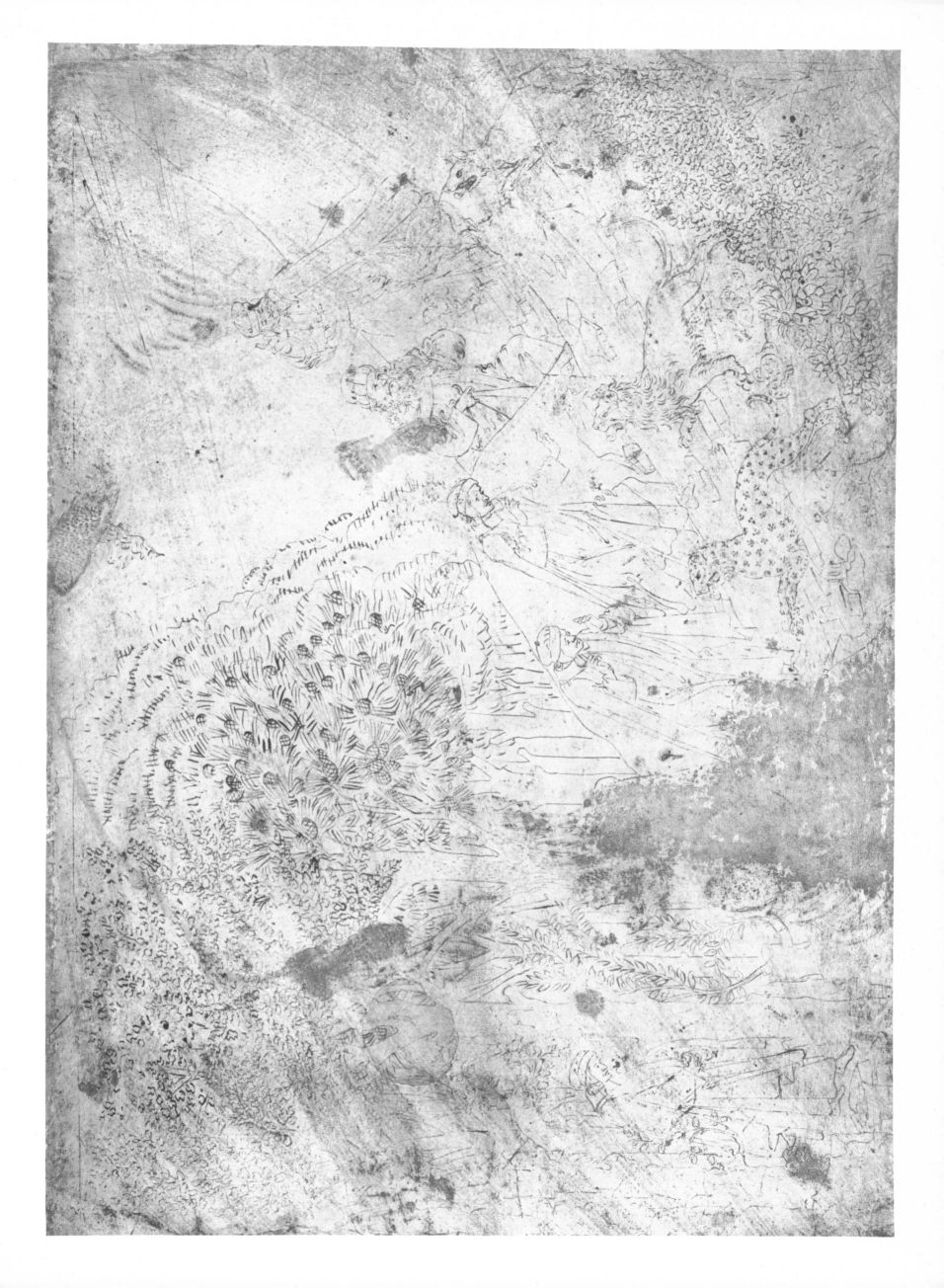

The Wrathful
The Fallen Angels

ON THE RIGHT Dante and Virgil descend through a rocky gorge, on the far bank of the Styx, the marsh of filth, into the Fifth Circle. Here are punished the Wrathful, whose unchecked anger in life has condemned them to be punished by an eternity of unrelenting anger frustrated by the repulsive sludge of the Styx. A devil holds two lighted torches from the window of a tower, perhaps as a summoning signal to Phlegyas, the boatman of the Styx who collects newly arrived souls, ferries them into the swamp, and then forces them overboard. Virgil, followed by Dante, steps into the boat of Phlegyas. As they cross the Styx, the soul of Filippo Argenti, a Florentine who in life had a reputation for unbridled irascibility, cries out to Dante. The poet rebukes and rejects him, and Virgil embraces Dante in approbation of his repudiating the damned soul. In the lower left-hand corner, the two wayfarers have left Phlegyas' boat, and Virgil moves to parley with the Fallen Angels, guardians of Dis, the Inner City of Hell. Creatures of consummate and essential evil, the damned angels stand within the Gate of Iron refusing entrance to Dante and Virgil. Dante is cast down, but Virgil reassures him that God, who alone can deal with essential evil, will send a Messenger to throw open the Iron Gate of Dis. Within the infernal city, on the right, Botticelli has drawn an anticipatory glimpse of the next canto and the Heretics in their eternal chastizing cemetery.

'Phlegyas, Phlegyas,' said my Lord and Guide,
'this time you waste your breath: you have us only
for the time it takes to cross to the other side.'

Phlegyas, the madman, blew his rage among
those muddy marshes like a cheat deceived,
or like a fool at some imagined wrong.

My Guide, whom all the fiend's noise could not nettle,
boarded the skiff, motioning me to follow
and not till I stepped aboard did it seem to settle

* * *

into the water. At once we left the shore,
that ancient hull riding more heavily
than it had ridden in all of time before.

'My son,' the Master said, 'the City called Dis
lies just ahead, the heavy citizens,
the swarming crowds of Hell's metropolis.'

And I then: 'Master, I already see
the glow of its red mosques, as if they came
hot from the forge to smolder in this valley.'

And my all-knowing Guide: 'They are eternal
flues to eternal fire that rages in them
and makes them glow across this lower Hell.'

* * *

I could not hear my Lord's words, but the pack
that gathered round him suddenly broke away
howling and jostling and went pouring back,

slamming the towering gate hard in his face.

* * *

His eyes were fixed upon the ground, his brow
had sagged from its assurance. He sighed aloud:
'Who has forbidden me the halls of sorrow?

. . . You need not be cast down
by my vexation, for whatever plot
these fiends may lay against us, we will go on.

This insolence of theirs is nothing new:
they showed it once at a less secret gate
that still stands open for all that they could do –

the same gate where you read the dead inscription;
and through it at this moment a Great One comes.
Already he has passed it and moves down

ledge by dark ledge. He is one who needs no guide,
and at his touch all gates must spring aside.'

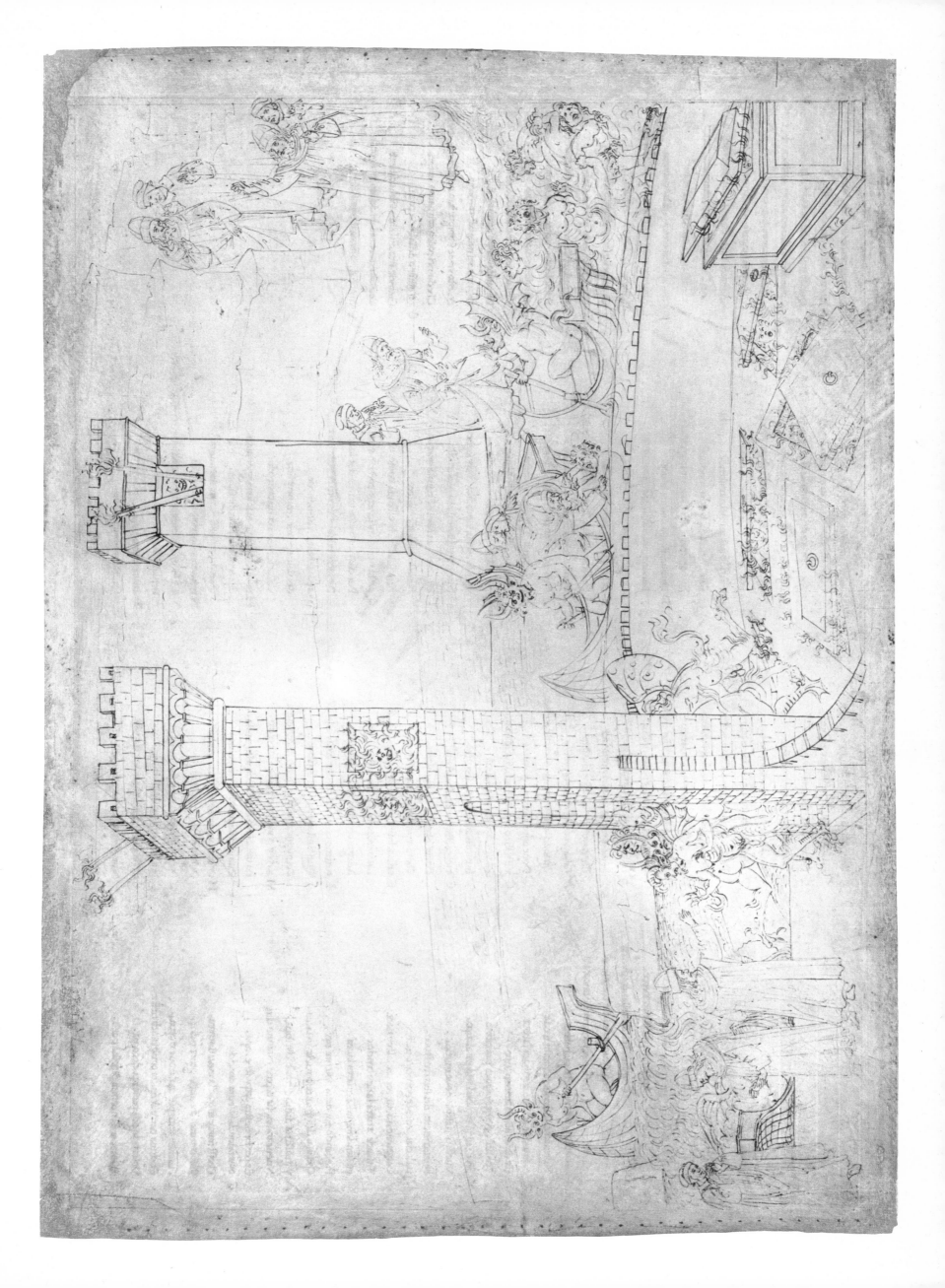

The City of Dis
The Heretics

DANTE AND VIRGIL stand at the Iron Gate, waiting for the Divine Messenger. Dante has begun to lose heart, and even Virgil becomes aware of his own hesitation. At that moment, the three Furies standing at the top of the tower begin to jeer at them. In a frenzy of evil, Megaera, Alecto and Tisiphone call out for Medusa to come and turn Dante to stone, transmuting his cowardice to the immobility of faithlessness. As a demon behind the Furies holds up the Gorgon's head, Virgil quickly covers Dante's eyes and turns him from the sight of her. Once hesitation has been overcome, a sound 'as if two continents of air ... clashed head on' is heard, and God's Messenger is seen crossing the Styx above, scattering the souls like frogs before a hunting snake. Arrived at the doorway of the Iron Gate, the Messenger waves his wand, the rod of God's power, and the Fallen Angels withdraw before it. Their path now clear, Dante and Virgil enter Dis. Here is a cemetery, 'except that here the tombs were chests of pain'. In each tomb, surrounded by fire hotter than any forge, lie the souls of 'arch-heretics of all cults, with all their followers'. As the fires of uncontrolled theological zeal urged the heretics to overstep the boundaries and limits of orthodoxy, so they are condemned to an eternity of suffering by flame within the cribbed confinement of a tomb.

And I: 'Master, what shades are these who lie
buried in these chests and fill the air
with such a painful and unending cry?'

'These are the arch-heretics of all cults,
with all their followers,' he replied. 'Far more
than you would think lie stuffed into these vaults.

Like lies with like in every heresy,
and the monuments are fired, some more, some less;
to each depravity its own degree.'

* * *

. . . Suddenly my attention

was drawn to the turret with the fiery crest

where all at once three hellish and inhuman
Furies sprang to view, bloodstained and wild.
Their limbs and gestures hinted they were women.

* * *

With their palms they beat their brows, with their nails they
* clawed*
their bleeding breasts. And such mad wails broke from them
that I drew close to the Poet, overawed.

And all together screamed, looking down at me:
'Call Medusa that we may change him to stone!
Too lightly we let Theseus go free.'

'Turn your back and keep your eyes shut tight;
for should the Gorgon come and you look at her,
never again would you return to the light.'

This was my Guide's command. And he turned me about
himself, and would not trust my hands alone,
but, with his placed on mine, held my eyes shut.

* * *

As frogs before the snake that hunts them down
churn up their pond in flight, until the last
squats on the bottom as if turned to stone –

so I saw more than a thousand ruined souls
scatter away from one who crossed dry-shod
the Stygian marsh into Hell's burning bowels.

* * *

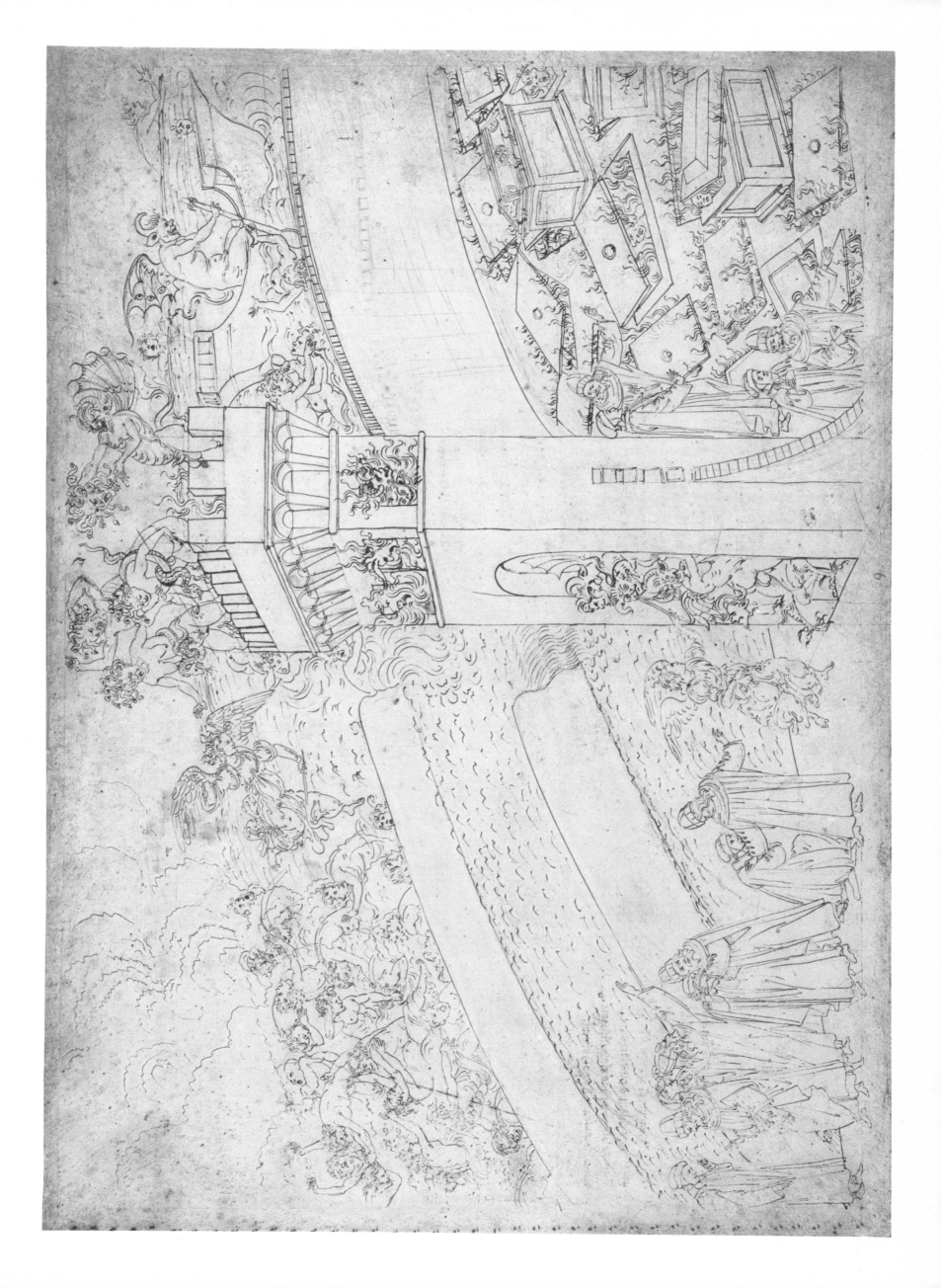

We go by a secret path along the rim
of the dark city, between the wall and the torments.
My Master leads me and I follow him.

* * *

And he: 'Turn around. What are you doing? Look there:
it is Farinata rising from the flames.
From the waist up his shade will be made clear.'

My eyes were fixed on him already. Erect,
he rose above the flame, great chest, great brow;
he seemed to hold all Hell in disrespect.

* * *

And when I stood alone at the foot of the tomb,
the great soul stared almost contemptuously,
before he asked: 'Of what line do you come?'

Because I wished to obey, I did not hide
anything from him: whereupon, as he listened,
he raised his brows a little, then replied:

'Bitter enemies were they to me,
to my fathers, and to my party, so that twice
I sent them scattering from high Italy.'

* * *

At this another shade rose gradually,
visible to the chin.

* * *

'. . . the face of her who reigns in Hell shall not
be fifty times rekindled in its course
before you learn what griefs attend that art.'

* * *

And he disappeared without more said, and I
turned back and made my way to the ancient Poet,
pondering the words of the dark prophecy.

He moved along, and then, when we had started,
he turned and said to me, 'What troubles you?
Why do you look so vacant and downhearted?'

And I told him. And he replied: 'Well may you bear
those words in mind.' Then, pausing, raised a finger:
'Now pay attention to what I tell you here:

when finally you stand before the ray
of that Sweet Lady whose bright eye sees all,
from her you will learn the turnings of your way.'

So saying, he bore left, turning his back
on the flaming walls, and we passed deeper yet
into the city of pain, along a track

that plunged down like a scar into a sink
which sickened us already with its stink.

The Heretics

THE SCENE IS THE PLAIN of burning sepulchres, which the two poets have entered by the open portal in the upper right-hand corner. They walk through the infernal cemetery between its outer wall and the tombs along a path across the background of Botticelli's drawing. Virgil lays his right hand on Dante's shoulder, to encourage the fearful pilgrim, pointing out with his left a tomb from which rises the spirit of Farinata degli Uberti. Head of his family, which was itself the leading Ghibelline house, Farinata, who is here because of his heretical Epicureanism, had been responsible for expelling the Guelphs from Florence in 1248. Farinata prophesies Dante's banishment from Florence. Visible in Farinata's tomb is the face of Cavalcante dei Cavalcanti, infamous in life as an Epicurean and father of Guido Cavalcanti, a rival poet of Dante and son-in-law of Farinata. As the poets continue on their way, Dante covers his mouth and nose against the stink rising from the tombs. In the lower left-hand corner of the drawing Botticelli anticipates Canto xi (the drawing for which is lost) by showing the lid of the tomb of Pope Anastasius, who in medieval tradition was confused with his contemporary Emperor Anastasius, a heretic.

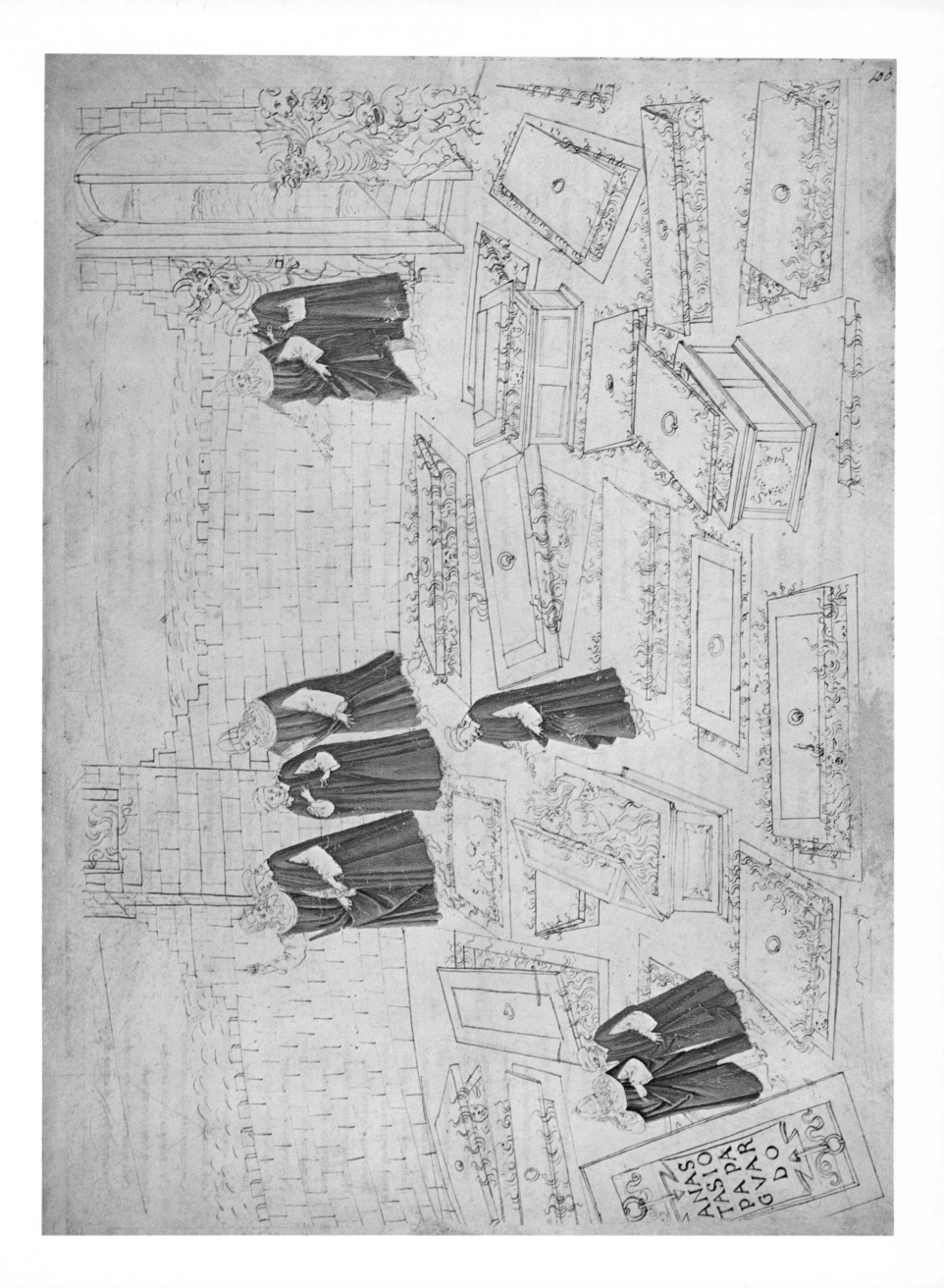

ANAS
TASIO
PAPA
GUAR
DO

The Violent against their Neighbour

BELOW THE CIRCLE of burning sepulchres and the background of Botticelli's drawing is the 'circle of great broken boulders' identified in Canto XI as the boundary between the Sixth Circle of Hell and the Seventh, which Dante and Virgil now enter. Descending the fallen rock wall, shattered by the earthquake that shook Earth and Hell at Christ's death, the wayfarers first encounter the Minotaur, 'the Infamy of Crete'. Virgil evades the threats of the monster (which, according to Dante and, here, Botticelli, has a human head on a bull's body, in distinction to another tradition), and he and Dante proceed to the River of Boiling Blood, where those souls are punished who had wallowed in the blood of others. Centaurs are the keepers of the damned here, and three of them – Nessus, Chiron and Pholus – are pointed out by Virgil and named to Dante. Chiron, their leader, assigns Nessus to guide the wayfarers across the hideous stream, at a point where it is only ankle deep. Once across, Virgil and Dante continue their journey, into the thorny wood, along the lower margin of Botticelli's drawing, where suicides are damned. Nessus crosses back over the bloody ford.

The scene that opened from the edge of the pit
was mountainous, and such a desolation
that every eye would shun the sight of it:

* * *

a ruin like the Slides of Mark near Trent
on the bank of the Adige, the result of an earthquake
or of some massive fault in the escarpment.

* * *

Such was the passage down the steep, and there
at the very top, at the edge of the broken cleft,
lay spread the Infamy of Crete, the heir

* * *

of bestiality and the lecherous queen
who hid in a wooden cow. And when he saw us,
he gnawed his own flesh in a fit of spleen.

* * *

As a bull that breaks its chains just when the knife
has struck its death-blow, cannot stand nor run
but leaps from side to side with its last life –

* * *

so danced the Minotaur, and my shrewd Guide
cried out : 'Run now! While he is blind with rage!
Into the pass, quick, and get over the side!'

* * *

I saw an arching fosse that was the bed
of a winding river circling through the plain
exactly as my Guide and Lord had said.

* * *

A file of Centaurs galloped in the space
between the bank and the cliff, well armed with arrows,
riding as once on earth they rode to the chase.

* * *

And seeing us descend, that straggling band
halted, and three of them moved out toward us,
their long bows and their shafts already in hand.

* * *

Along the stream of blood, its level fell
until it cooked no more than the feet of the damned.
And here we crossed the ford to deeper Hell.

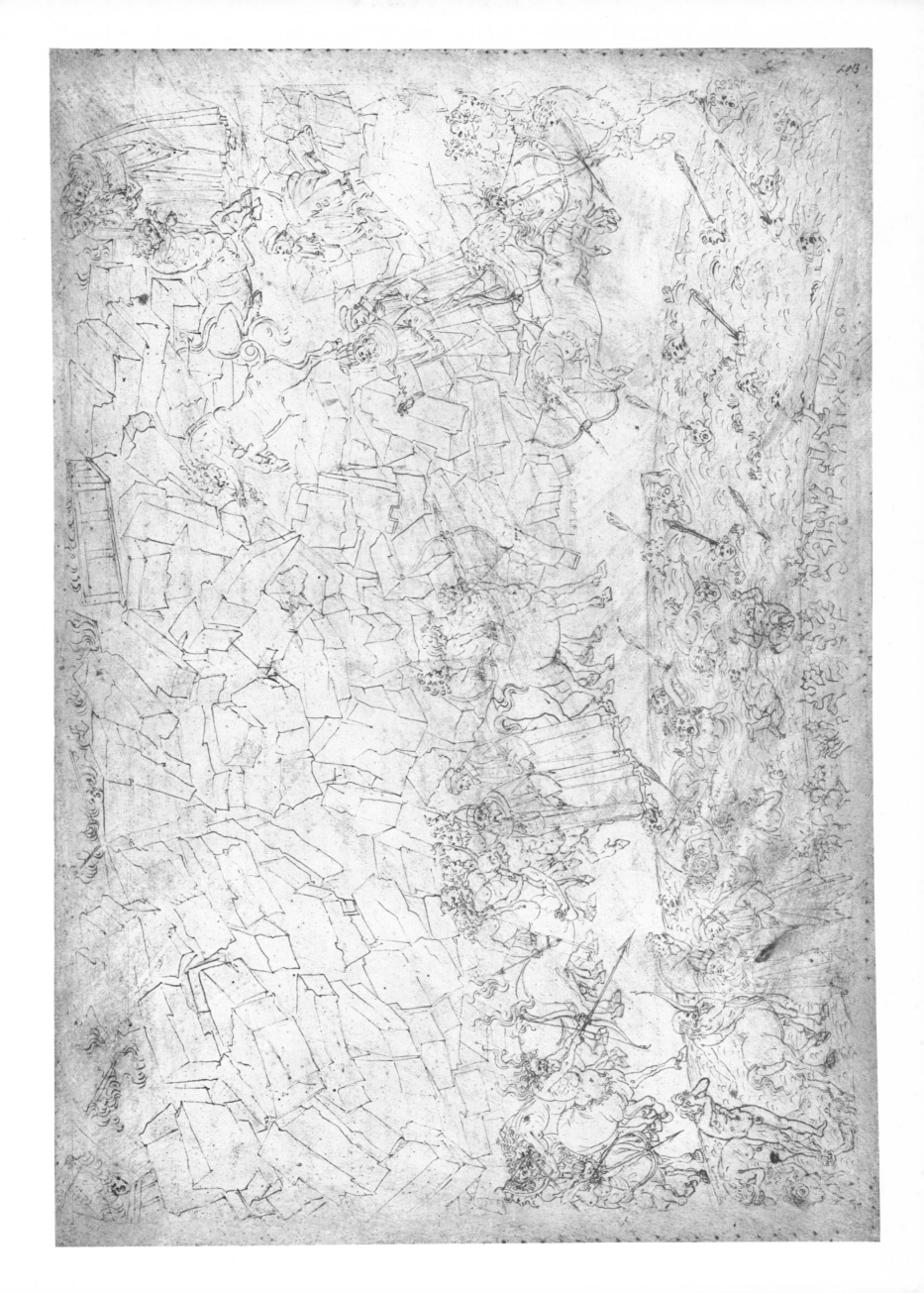

The Violent against Themselves

ONCE ACROSS the River of Boiling Blood, along the top of Botticelli's drawing, Virgil and Dante enter the dismal wood in which are kept the spirits of Suicides and Spendthrifts. Meanwhile, in the upper right-hand corner, Nessus the Centaur recrosses the river. Careless of their bodies or their wealth while alive, the sinners here are condemned to spend eternity sensible to pain, and capable of bleeding, but as thorny stunted trees, bereft of the bodies which they so disdained 'for it is not just that a man be given what he throws away'. The guardians of the damned are Harpies, part woman and part scavenging bird, who pick and nibble unceasingly at the thorn trees; the damaged trees bleed from their wounds and only while bleeding have they voices. On Virgil's suggestion, Dante, in the upper left, snaps a branch from one of the trees, which cries out in pain and bleeds. The thorn bush holds the spirit of Piero della Vigna, minister of Frederick II, who committed suicide after falling into disgrace; his face is visible among the branches at Dante's fingertips. In the middle of the drawing, Lano da Siena and Jacopo da Sant'Andrea, the first a notorious Sienese prodigal and his companion a Paduan spendthrift, are pursued by a pack of savage hounds, which tear apart their bodies in a violent wasting parallel to the violence of their prodigality in life. Finally, at the bottom of the drawing, Virgil has led Dante to a bush which had cried out in pain. Beyond saying that he was born in Florence and 'I made myself a gibbet of my own lintel', the soul reveals nothing of his identity.

Nessus had not yet reached the other shore
when we moved on into a pathless wood
that twisted upward from Hell's broken floor.

Its foliage was not verdant, but nearly black.
The unhealthy branches, gnarled and warped and tangled,
bore poison thorns instead of fruit.

* * *

Here nest the odious Harpies of whom my Master
wrote how they drove Aeneas and his companions
from the Strophades with prophecies of disaster.

Their wings are wide, their feet clawed, their huge bellies
covered with feathers, their necks and faces human.

* * *

Puzzled, I raised my hand a bit and slowly
broke off a branchlet from an enormous thorn:
and the great trunk of it cried: 'Why do you break me?'

And after blood had darkened all the bowl
of the wound, it cried again: 'Why do you tear me?
Is there no pity left in any soul?

* * *

And there on the left, running so violently
they broke off every twig in the dark wood,
two torn and naked wraiths went plunging by me.

* * *

Then at his back,
the wood leaped with black bitches, swift as greyhounds
escaping from their leash, and all the pack

sprang on him; with their fangs they opened him
and tore him savagely, and then withdrew,
carrying his body with them, limb by limb.

* * *

'I was born
in the city that tore down Mars and raised the Baptist.
On that account the God of War has sworn

her sorrow shall not end. And were it not
that something of his image still survives
on the bridge across the Arno, some have thought

those citizens who of their love and pain
afterwards rebuilt it from the ashes
left by Attila, would have worked in vain.

I am one who has no tale to tell:
I made myself a gibbet of my own lintel.'

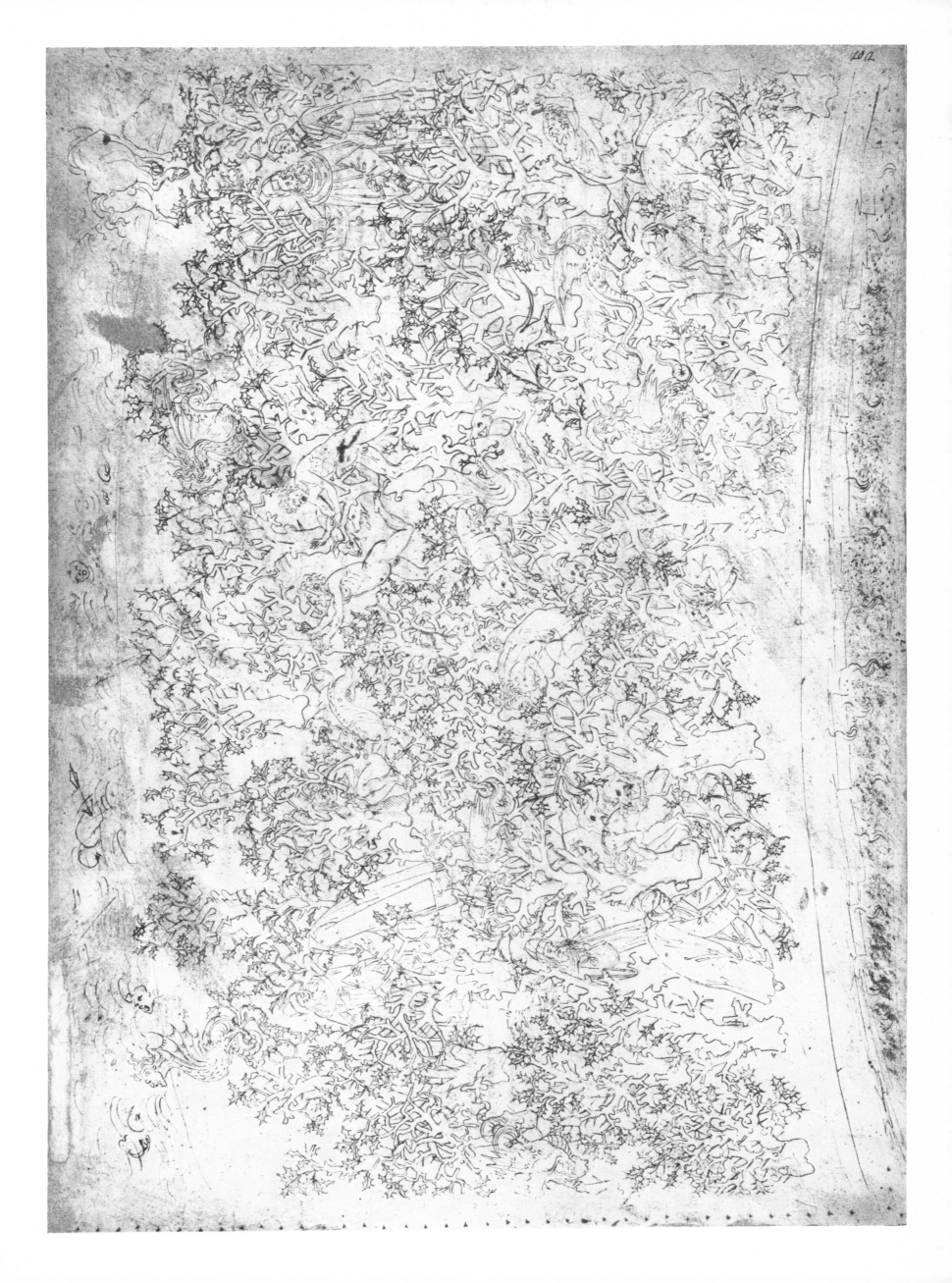

The Violent against Nature

HAVING LEFT THE WOOD of the Suicides and moved into the Seventh Circle, in which are punished the Violent against God, Nature and Art, Dante and Virgil proceed alongside the River of Boiling Blood. Here, on this burning, desert plain, suffer those guilty of blasphemy, sodomy and usury. Because of the sterility of their sins' unnaturalness, they undergo unending torments stretched supine on the burning waste (the Blasphemers), moving in endless circles (the Sodomites) or huddled upon themselves in a despairing crouch (the Usurers). All the while, 'great flames of smoke fell slowly as snow falls in the Alps', increasing their agony and, in Dante's allegory, heightening by its contrast to the cool relief they crave the irony of their punishment. As Virgil and Dante pass along the steep banks of the River of Boiling Blood, one of the souls on the burning plain grabs hold of Dante's garment and calls out to him. This is Brunetto Latini, Florentine author of the *Livre du Tresor*, poet, philosopher and public servant. Because the Sodomites here, of whom Brunetto is one, may not stand still for even an instant under pain of lying 'a hundred years forbidden to brush off the burning rain', Brunetto walks along with Dante, who bends down from the high bank the better to converse. Botticelli repeats the figures of the walking Dante and Brunetto down along the drawing until, at last, Brunetto bids farewell to run and rejoin his band of fellow sufferers.

Already we were so far from the wood
that even had I turned to look at it,
I could not have made it out from where I stood,

when a company of shades came into sight
walking beside the bank. They stared at us
as men at evening by the new moon's light

stare at one another when they pass by
on a dark road, pointing their eyebrows toward us
as an old tailor squints at his needle's eye.

* * *

Stared at so closely by that ghostly crew,
I was recognized by one who seized the hem
of my skirt and said: 'Wonder of wonders! You?'

and bending near
to put my face closer to his, at last
I answered: 'Ser Brunetto, are you here?'

'O my son! may it not displease you,' he cried,
'if Brunetto Latino leave his company
and turn and walk a little by your side.'

* * *

'Ah, had I all my wish,' I answered then,
'you would not yet be banished from the world
in which you were a radiance among men . . .'

* * *

'I would say more, but there across the sand
a new smoke rises and new people come,
and I must run to be with my own band.

Remember my Treasure, in which I still live on:
I ask no more.'

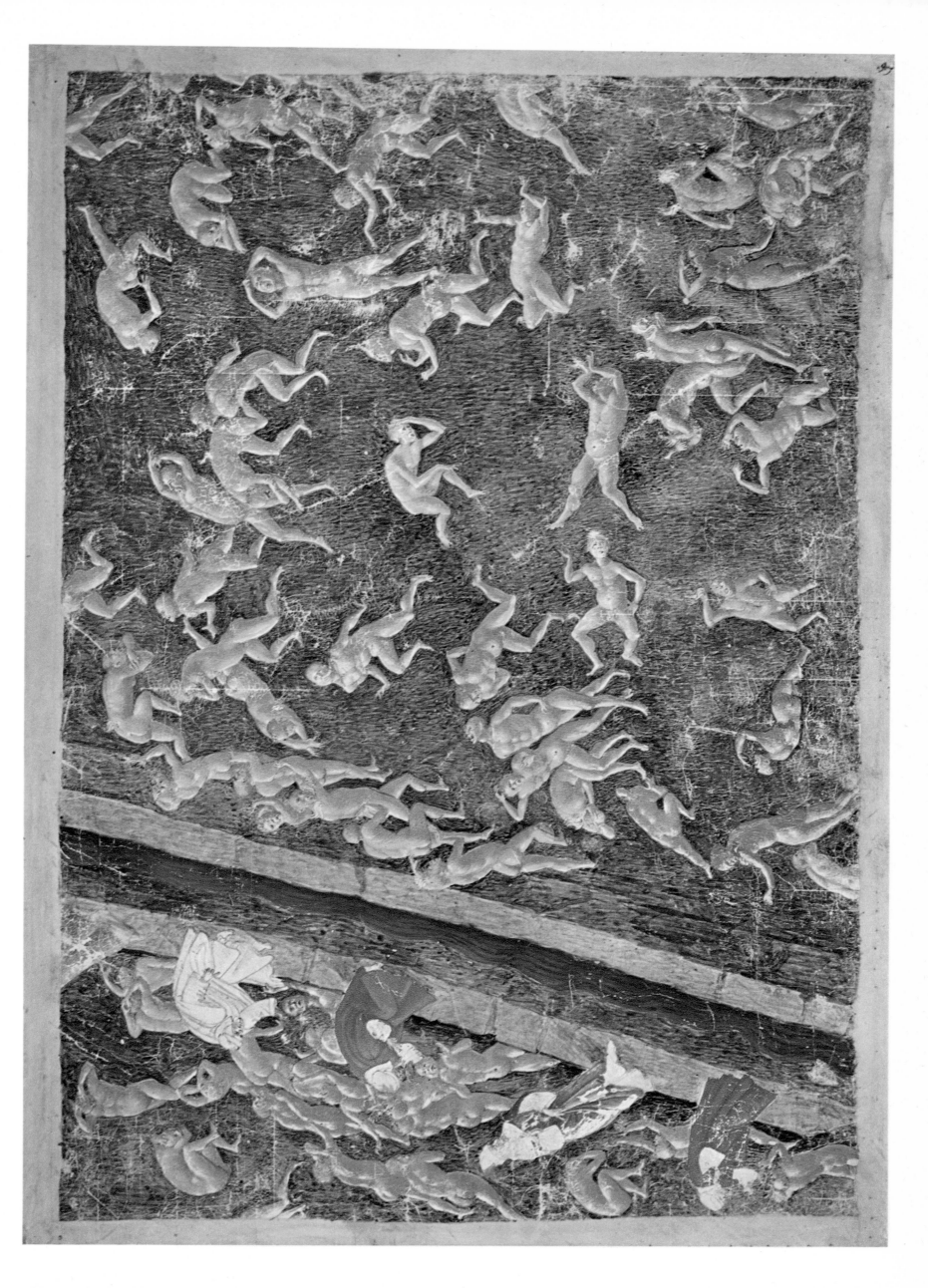

The Violent against Nature and Art

CONTINUING ALONG THE STEEP BANK of the River of Boiling Blood, Dante and Virgil encounter the spirits of the three Florentine Guelph leaders, Guido Guerra, Tegghiaio Aldobrandi and Jacopo Rusticucci, holding one another's hands and 'formed into a moving wheel', in the unceasing motion Brunetto Latini pointed out as the essence of the Sodomites' punishment. Across the bank, tormented by fire, more Sodomites are depicted by Botticelli, who below them anticipates the next canto by including in this drawing the crouching Usurers and the purses hanging from their necks. Soon the wayfarers hear the roar of the waterfall the river makes as it hurtles into the next circle. As they walk along the high bank, Dante complies with Virgil's request that he remove the belt round his garment. Botticelli shows Dante in the process of taking off the belt just before putting it into Virgil's hands. The girdle was, Dante says, what he had planned to use 'to snare the Leopard with the gaudy pelt' of the first canto, thus recalling that the Leopard is used allegorically to represent fraud. At the bottom of the drawing, Virgil takes the cord and twists his body to cast it down and into Malebolge, the Eighth Circle. At this, Geryon, the Monster of Fraud, rises from the abyss; Botticelli includes his head at the lower left-hand corner of the drawing. It is on Geryon's back that the two poets will ride across the chasm and down into the Eighth Circle.

We paused, and they began their ancient wail
over again, and when they stood below us
they formed themselves into a moving wheel.

* * *

So circling, each one stared up at my height,
and as their feet moved left around the circle,
their necks kept turning backward to the right.

* * *

A little way beyond we felt the quiver
and roar of the cascade, so close that speech
would have been drowned in thunder.

I had a cord bound round me like a belt
which I had once thought I might put to use
to snare the Leopard with the gaudy pelt.

When at my Guide's command I had unbound
its loops from about my habit, I gathered it
and held it out to him all coiled and wound.

He bent far back to his right, and throwing it
out from the edge, sent it in a long arc
into the bottomless darkness of the pit.

* * *

He said to me: 'You will soon see arise
what I await, and what you wonder at;
soon you will see the thing before your eyes.'

* * *

Reader, I swear
by the lines of my Comedy – so may it live –
that I saw swimming up through that foul air

a shape to astonish the most doughty soul,
a shape like one returning through the sea
from working loose an anchor run afoul

of something on the bottom – so it rose,
its arms spread upward and its feet drawn close.

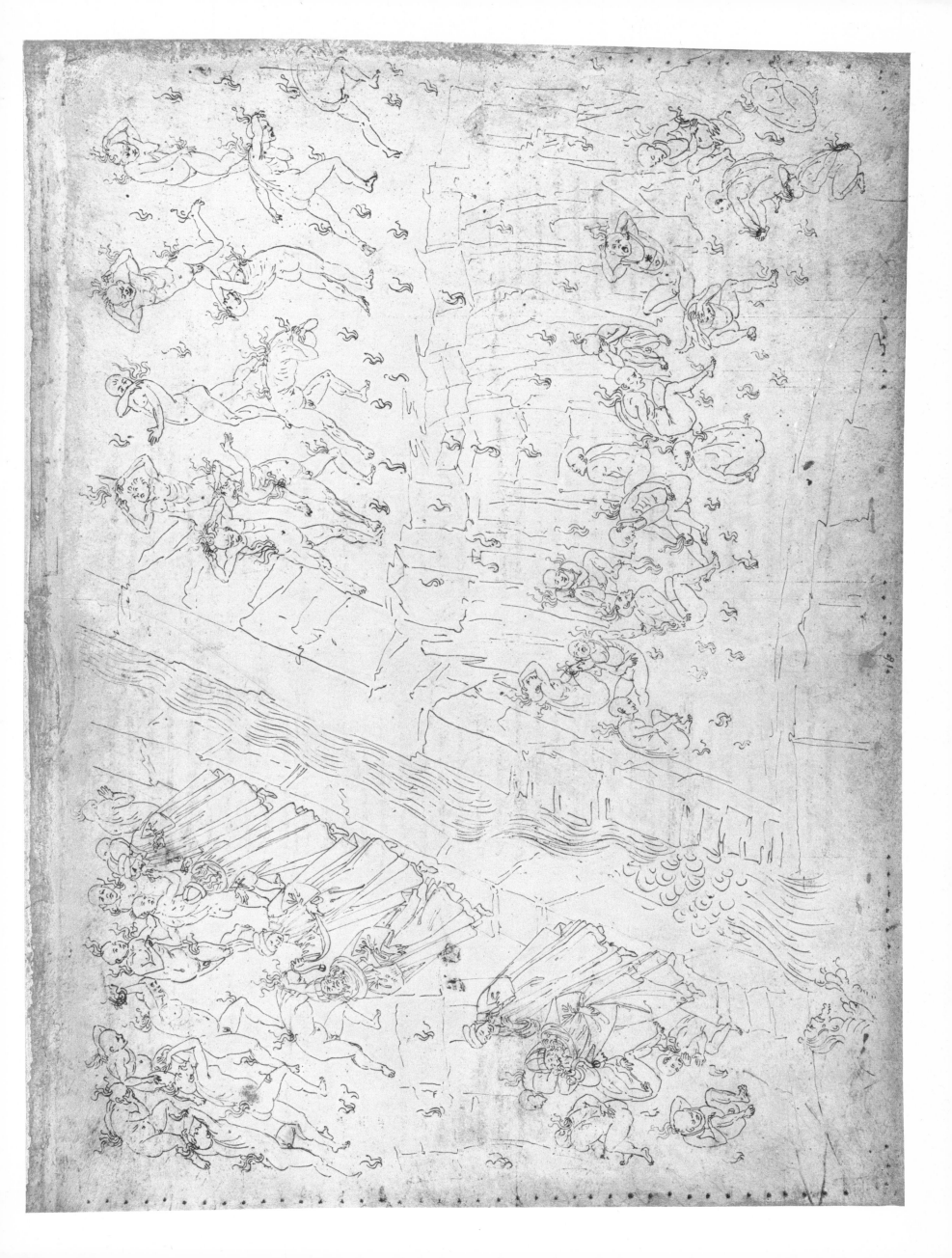

The Violent against Art

ON THE RIGHT the poets are seen about to descend from the dam to the level brink of the abyss 'which closes the great sand with stone'. Virgil, with outstretched hand, bids Dante behold the savage beast 'that makes the whole world stink'. The figure of Geryon is depicted in accordance with Dante's description, with a human head, a body half reptile and half hairy beast, and an enormous scorpion tail. The poets are again seen in the centre of the composition, on the brink of the abyss, with Geryon before them, who at Virgil's bidding has come ashore, resting his fore-quarters on the rocky ledge. Dante now proceeds alone, along the margin of the burning sand, at the 'outer edge of the seventh circle' where among the falling flames crouch the souls of the Usurers. From the neck of each hangs a pouch, an eternally tormenting reminder of his sins, left unblazoned by Botticelli though Dante says that each purse was marked like a coat of arms. Dante is twice represented, the second time talking with two spirits. Dante now returns to Virgil and finds his guide already mounted upon Geryon. Having placed himself on the huge haunches, Virgil clasps Dante with his arms. Geryon is now thrice represented with the poets on his back, as he swings out from his station backwards, like a barque, and wheeling round, slowly descends the abyss in great circles.

The filthy prototype of Fraud drew near
and settled his head and breast upon the edge
of the dark cliff, but let his tail hang clear.

His face was innocent of every guile,
benign and just in feature and expression;
and under it his body was half reptile.

His two great paws were hairy to the armpits;
all his back and breast and both his flanks
were figured with bright knots and subtle circlets.

* * *

So further yet along the outer edge
of the seventh circle I moved on alone
And came to the sad people of the ledge.

I examined several faces there among
that sooty throng, and I saw none I knew;
but I observed that from each neck there hung

an enormous purse, each marked with its own beast
and its own colors like a coat of arms.
On these their streaming eyes appeared to feast.

* * *

Returned, I found my Guide already mounted
upon the rump of that monstrosity.
He said to me: 'Now must you be undaunted:

this beast must be our stairway to the pit:
mount it in front, and I will ride between
you and the tail, lest you be poisoned by it.'

* * *

I think there was no greater fear the day
Phaeton let loose the reins and burned the sky
along the great scar of the Milky Way,

nor when Icarus, too close to the sun's track
felt the wax melt, unfeathering his loins,
and heard his father cry 'Turn back! Turn back!'

than I felt when I found myself in air
afloat in space with nothing visible
but the enormous beast that bore me there.

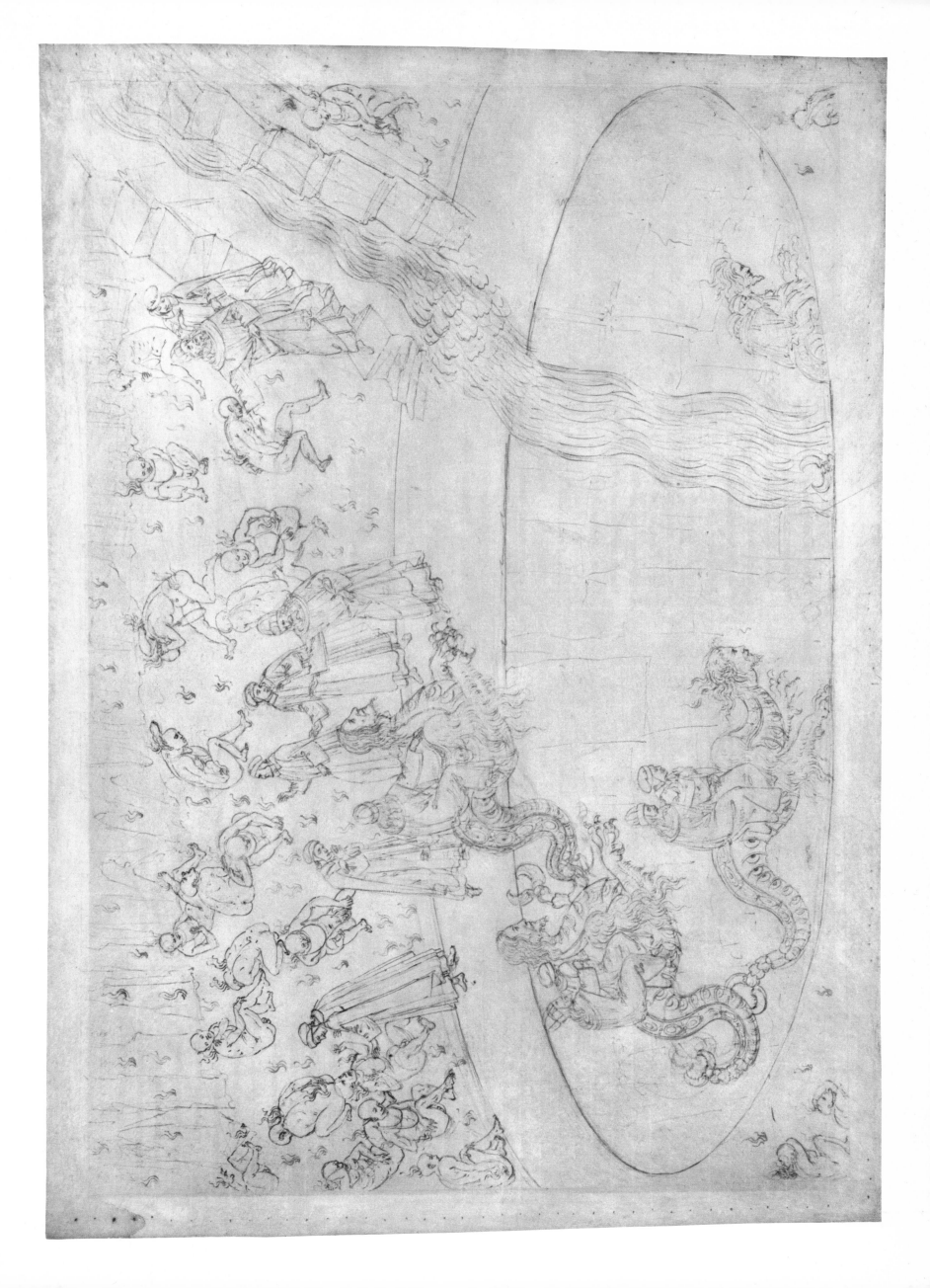

The Panderers and Seducers
The Flatterers

THE POETS NOW ENTER the Eighth Circle, Malebolge, with its successive ditches or pits. Like a steep amphitheatre, Malebolge's concentric sunken ditches are bridged from its outer rim to its centre by reefs running like spokes of a wheel. In Botticelli's drawing, Dante and Virgil have alighted from Geryon, who flies away at the upper left hand, and walk along the circular rim of the first ditch to the reef, down which they proceed. In this ditch, the Panderers and Seducers are driven in two opposing rings by the lashes of tormenting devils. In life they goaded others on for their own sinful purposes, and so for eternity are similarly driven on in their turn. Dante and Virgil pause on entering the bridge over the first ditch as Virgil points out to Dante the soul of Jason, whose ambitions drove him to seduce the Lemnian women, Hypsipele, Creusa and, with ultimate tragedy, Medea. As the pilgrims come to the second ditch, Dante covers his face at the stench arising from it which 'sickened my eyes and hammered at my nose'. Here, for eternity wallowing in a pit of excrement, are the Flatterers, whose words and actions in life were worth as much as the material of their punishment. Dante is called to by the spirit of Alessio Interminei, a notorious Luccan flatterer of whom a contemporary wrote that he 'dripped with flattery and stank of it'. In the middle of this ditch, Botticelli has depicted Thaïs, a notorious courtesan cited by Cicero as an example of an outrageous flatterer, in her case for the purpose of seduction.

There is in Hell a vast and sloping ground
called Malebolge, a lost place of stone
as black as the great cliff that seals it round.

* * *

The border that remains between the well-pit
and the great cliff forms an enormous circle,
and ten descending troughs are cut in it,

offering a general prospect like the ground
that lies around one of those ancient castles
whose walls are girded many times around

* * *

by concentric moats.

* * *

Here, shaken from the back of Geryon,
we found ourselves. My Guide kept to the left
and I walked after him. So we moved on.

Below, on my right, and filling the first ditch
along both banks, new souls in pain appeared,
new torments, and new devils black as pitch.

All of these sinners were naked; on our side
of the middle they walked toward us; on the other,
in our direction, but with swifter stride.

* * *

And everywhere along that hideous track
I saw horned demons with enormous lashes
move through these souls, scourging them on the back.

* * *

And the good Master, studying that train,
said: 'Look there, at that great soul that approaches
and seems to shed no tears for all his pain —

what kingliness moves with him even in Hell!
It is Jason, who by courage and good advice
made off with the Colchian Ram. Later it fell

that he passed Lemnos, where the women of wrath,
enraged by Venus' curse that drove their lovers
out of their arms, put all their males to death.'

* * *

Here we heard people whine in the next chasm,
and knock and thump themselves with open palms,
and blubber through their snouts as if in a spasm.

* * *

That chasm sinks so deep we could not sight
its bottom anywhere until we climbed
along the rock arch to its greatest height.

Once there, I peered down; and I saw long lines
of people in a river of excrement
that seemed the overflow of the world's latrines.

* * *

And my Guide prompted then: 'Lean forward a bit
and look beyond him, there — do you see that one
scratching herself with dungy nails, the strumpet

who fidgets to her feet, then to a crouch?
It is the whore Thaïs.'

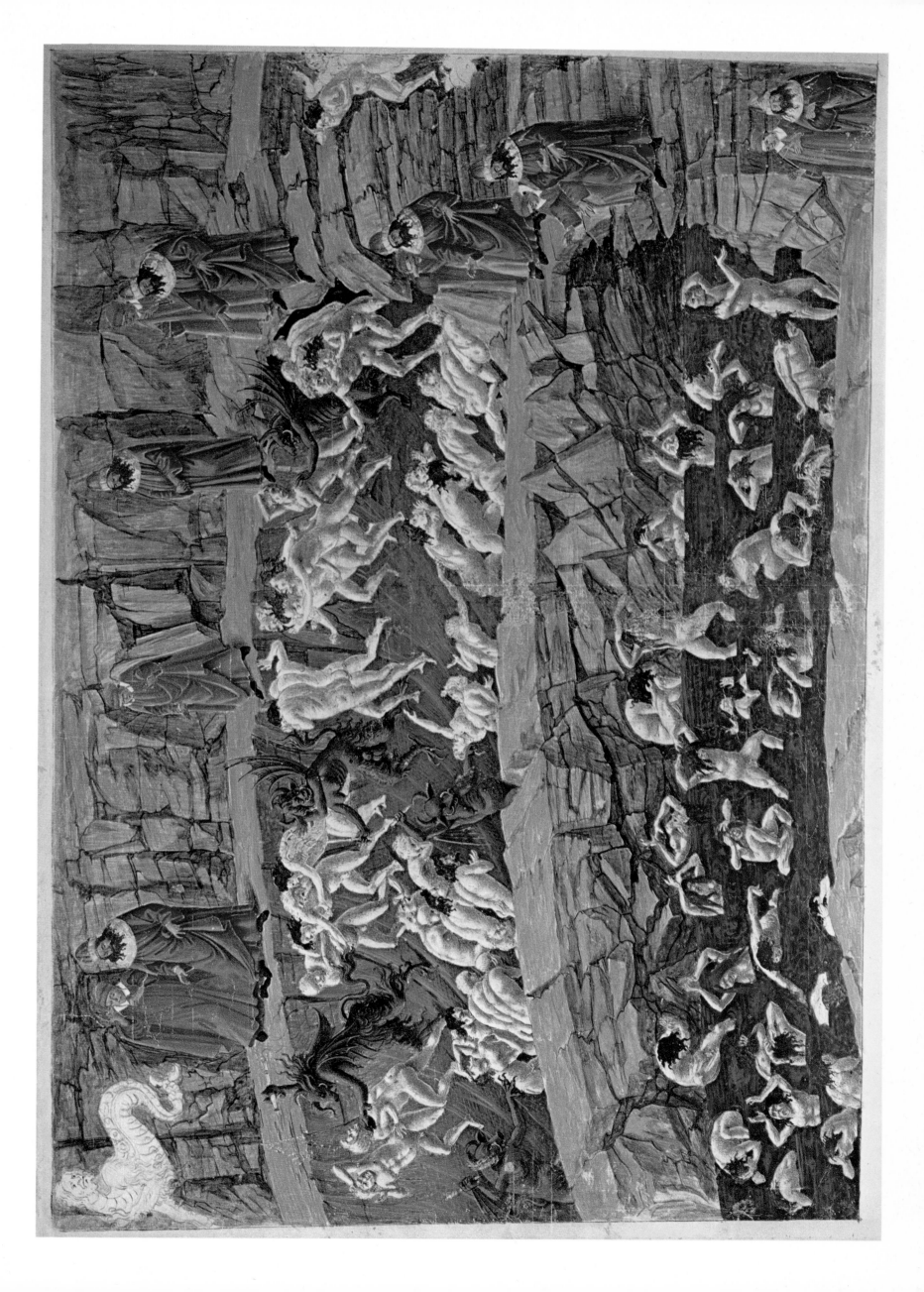

INFERNO XIX

The Simoniacs

LEAVING BEHIND THE PIT of the Flatterers, at the top of Botticelli's drawing, Dante and Virgil come to the bridge over the third chasm, where the Simoniacs are punished. In an allegorical irony, Dante the poet has these buyers and sellers of sacred offices and favours buried upside down to the calf in holes covering the floor and walls of this chasm: as their sinful lives made mock of their religion and therefore ultimately their baptism, their punishment is itself a tormenting mockery of that baptism, the pits reminiscent of baptismal fonts common in the Northern Italy of Dante's time, the fire a ridiculing antithesis to baptismal water. Dante asks Virgil who the sinner is who writhes and quivers more than the others, and his guide takes him over the arch and down into the pit itself, as Botticelli indicates by drawing the pair several times. This is the soul of Pope Boniface III, and Dante raises his arms in shocked rebuke to find here one who has worn the 'great mantle' of papacy. Boniface, who was infamously simoniacal during his papacy, is reported by contemporary writers to have said that everything that belonged to the Church was lawfully his. At the lower edge of the drawing, Virgil and Dante are seen climbing up out of the pit: '... with both arms he lifted me and, when he had gathered me against his breast, remounted the rocky path out of the valley'.

I saw along the walls and on the ground
 long rows of holes cut in the livid stone;
 all were cut to a size, and all were round.

From every mouth a sinner's legs stuck out
 as far as the calf. The soles were all ablaze
 and the joints of the legs quivered and writhed about.

* * *

'Master,' I said, 'who is that one in the fire
 who writhes and quivers more than all the others?
 From him the ruddy flames seem to leap higher.'

And he to me: 'If you wish me to carry you down
 along that lower bank, you may learn from him
 who he is, and the evil he has done.'

* * *

'Were it not that I am still constrained
 by the reverence I owe to the Great Keys
 you held in life, I should not have refrained

from using other words and sharper still;
 for this avarice of yours grieves all the world,
 tramples the virtuous, and exalts the evil.'

* * *

He approached, and with both arms he lifted me
 and, when he had gathered me against his breast,
 remounted the rocky path out of the valley,

nor did he tire of holding me clasped to him,
 until we reached the topmost point of the arch
 which crosses from the fourth to the fifth rim

of the pits of woe. Arrived upon the bridge,
 he tenderly set down the heavy burden
 he had been pleased to carry up that ledge

which would have been hard climbing for a goat.
 Here I looked down on still another moat.

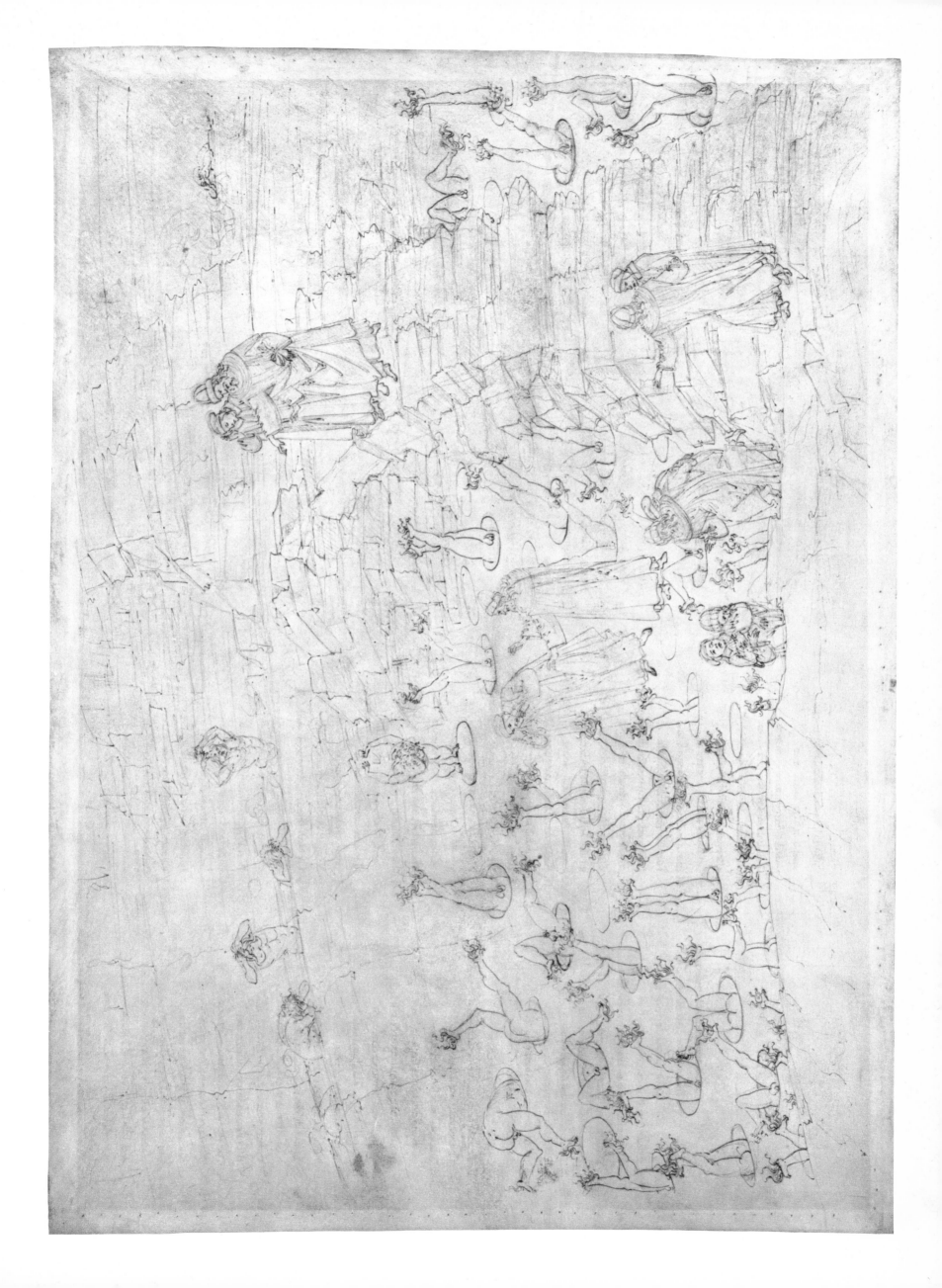

The Fortune Tellers and Diviners

ON THE ARCH over the fourth pit, Dante and Virgil look down at the spirits of Fortune Tellers and Diviners. 'Silent and weeping', they go round and round the chasm at a slow and measured pace, as though walking in a litany procession of penitence or intercession. Their heads are reversed on their bodies so that they must eternally walk forward while looking behind them, an ironic allegorical punishment to souls who in life claimed the power to see the future before their fellow men. Dante is overcome with pity at the 'image of our distorted humanity'; Virgil rebukes him, pointing out among the spirits Amphiareus, one of the Seven against Thebes who foresaw his own death and attempted to run away from it; Tiresias, the Theban seer; Eurypylus, 'whose beard spreads like a flame over his shoulders' and who divined the propitious moment for the Greek fleet to sail for Troy; and Michael Scot, thirteenth-century Scottish necromancer and scholar. Finally, Virgil directs Dante's attention to the souls of women who 'left their spinning and sewing for soothsaying' and urges Dante on to the next chasm. At the lower right-hand corner of his drawing, Botticelli has the two poets already across the bridge, moving on.

Silent and weeping they wound round and round it.

* * *

And when I looked down from their faces, I saw
that each of them was hideously distorted
between the top of the chest and the lines of the jaw;

for the face was reversed on the neck, and they came on
backwards, staring backwards at their loins,
for to look before them was forbidden.

* * *

I wept. I leaned against the jagged face
of a rock and wept so that my Guide said: 'Still?
Still like the other fools? There is no place

for pity here. Who is more arrogant
within his soul, who is more impious
than one who dares to sorrow at God's judgment?

* * *

But come: Cain with his bush of thorns appears
already on the wave below Seville,
above the boundary of the hemispheres;

and the moon was full already yesternight,
as you must well remember from the wood,
for it certainly did not harm you when its light

shone down upon your way before the dawn.'
And as he spoke to me, we traveled on.

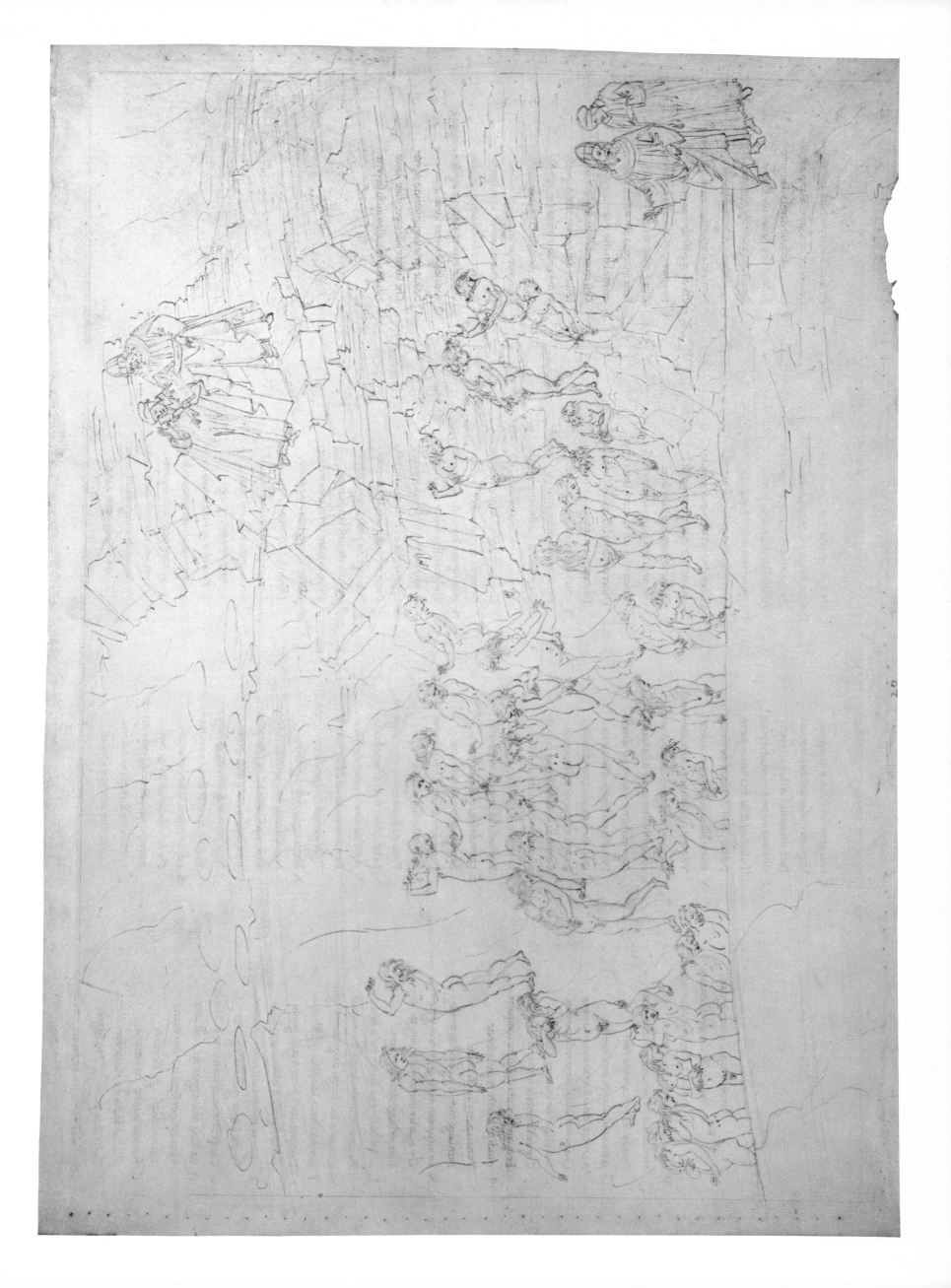

The Grafters

DANTE AND VIRGIL, in the upper left-hand corner of Botticelli's drawing, come to the fifth chasm, where the souls of Grafters are tormented by being submerged in ever-boiling pitch. Demons with pikes and hooks push them below the pitch when they return to its surface. As in life their fingers were unceasingly sticky for illegitimate profit, so now they are condemned to an eternity of being hidden – like their sinful acts – in clinging pitch. An arriving demon, carrying down his back the spirit of an elder of Lucca, which was known for the corruption of its city officials, flings him forward over his shoulders into the chasm. Botticelli draws the senator's spirit hurtling head-long down, and then being pushed beneath the surface of the boiling mass by two demons. Virgil instructs Dante, who had unjustly been charged with graft when exiled from Florence, to hide himself behind a rock while he goes to parley with Malacoda, the demons' spokesman. Malacoda tells Virgil that the bridge to the next chasm has been destroyed but that he will depute ten of his fellows to guide the two poets. Dante rejoins Virgil and, in the bottom right-hand corner of the drawing, the two pilgrims proceed with their infernal guides.

I saw the pitch; but I saw nothing in it
except the enormous bubbles of its boiling,
which swelled and sank, like breathing, through all the pit.

And as I stood and stared into that sink,
my Master cried, 'Take care!' and drew me back
from my exposed position on the brink.

* * *

I saw a figure that came running toward us
across the ridge, a Demon huge and black.

* * *

Across each high-hunched shoulder he had thrown
one haunch of a sinner, whom he held in place
with a great talon round each ankle bone.

* * *

Down the sinner plunged, and at once the Demon
spun from the cliff; no mastiff ever sprang
more eager from the leash to chase a felon.

Down plunged the sinner and sank to reappear
with his backside arched and his face and both his feet
glued to the pitch, almost as if in prayer.

* * *

And the Master said: 'You had best not be seen
by these Fiends till I am ready. Crouch down here.
One of these rocks will serve you as a screen.'

* * *

With that, he walked on past the end of the bridge;
and it wanted all his courage to look calm
from the moment he arrived on the sixth ridge.

* * *

'Do you think, Malacoda,' my good Master said,
'you would see me here, having arrived this far
already, safe from you and every dread,

without Divine Will and propitious Fate?
Let me pass on, for it is willed in Heaven
that I must show another this dread state.'

The Demon stood there on the flinty brim,
so taken aback he let his pitchfork drop;
then said to the others: 'Take care not to harm him!'

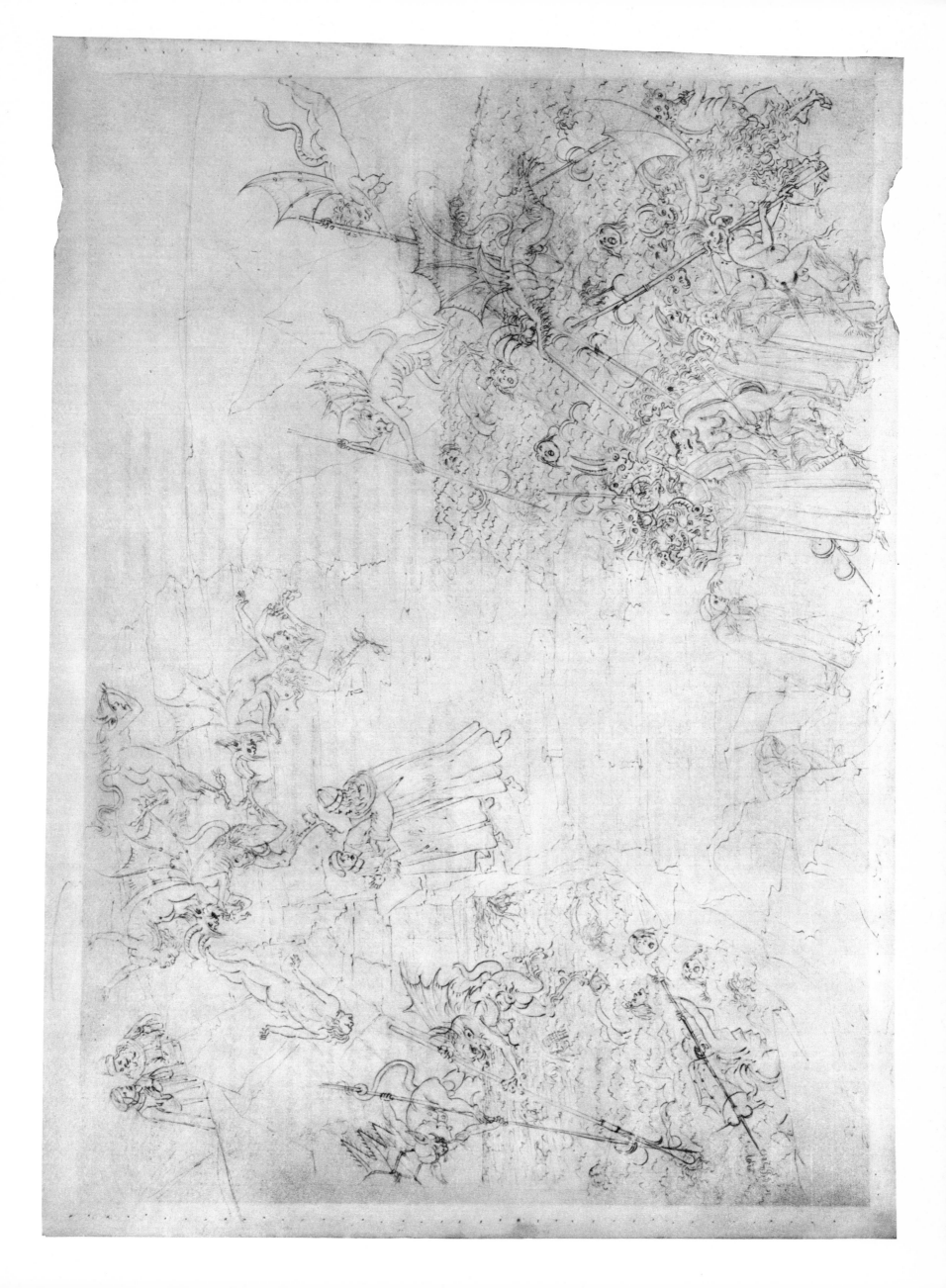

INFERNO XXII

We went with the ten Fiends – ah, savage crew! –
but 'In church with saints; with stewpots in the tavern,'
as the old proverb wisely bids us do.

All my attention was fixed upon the pitch:
to observe the people who were boiling in it,
and the customs and the punishments of that ditch.

As dolphins surface and begin to flip
their arched backs from the sea, warning the sailors
to fall-to and begin to secure ship –

So now and then, some soul, to ease his pain,
showed us a glimpse of his back above the pitch
and quick as lightning disappeared again.

* * *

And I then: 'Master, can you find out, please,
the name and history of that luckless one
who has fallen into the hands of his enemies?'

My Guide approached that wraith from the hot tar
and asked him whence he came. The wretch replied:
'I was born and raised in the Kingdom of Navarre.

My mother placed me in service to a knight;
for she had borne me to a squanderer
who killed himself when he ran through his birthright.

Then I became a domestic in the service
of good King Thibault. There I began to graft,
and I account for it in this hot crevice.'

The Grafters

WITH THE DIVINERS of the previous chasm visible at the top of Botticelli's drawing, Dante and Virgil proceed along the lower edge, escorted by ten demons. One of the damned spirits is too slow in diving down beneath the pitch to escape the demons' forks, and is hauled out on to the bank at the feet of the two poets. Dripping with the hot tar like 'an otter dripping from the brook', the spirit tells Dante that he was in life a servant in the household of the Navarrese King Thibault; he there took up the crime of graft and has ended here. The Navarrese tricks the demons to divert their attention from himself and is drawn by Botticelli diving back into the chasm of molten pitch. At the finish of this canto, the demons fall to fighting among themselves, and Botticelli draws the beginning of this skirmish at the middle right.

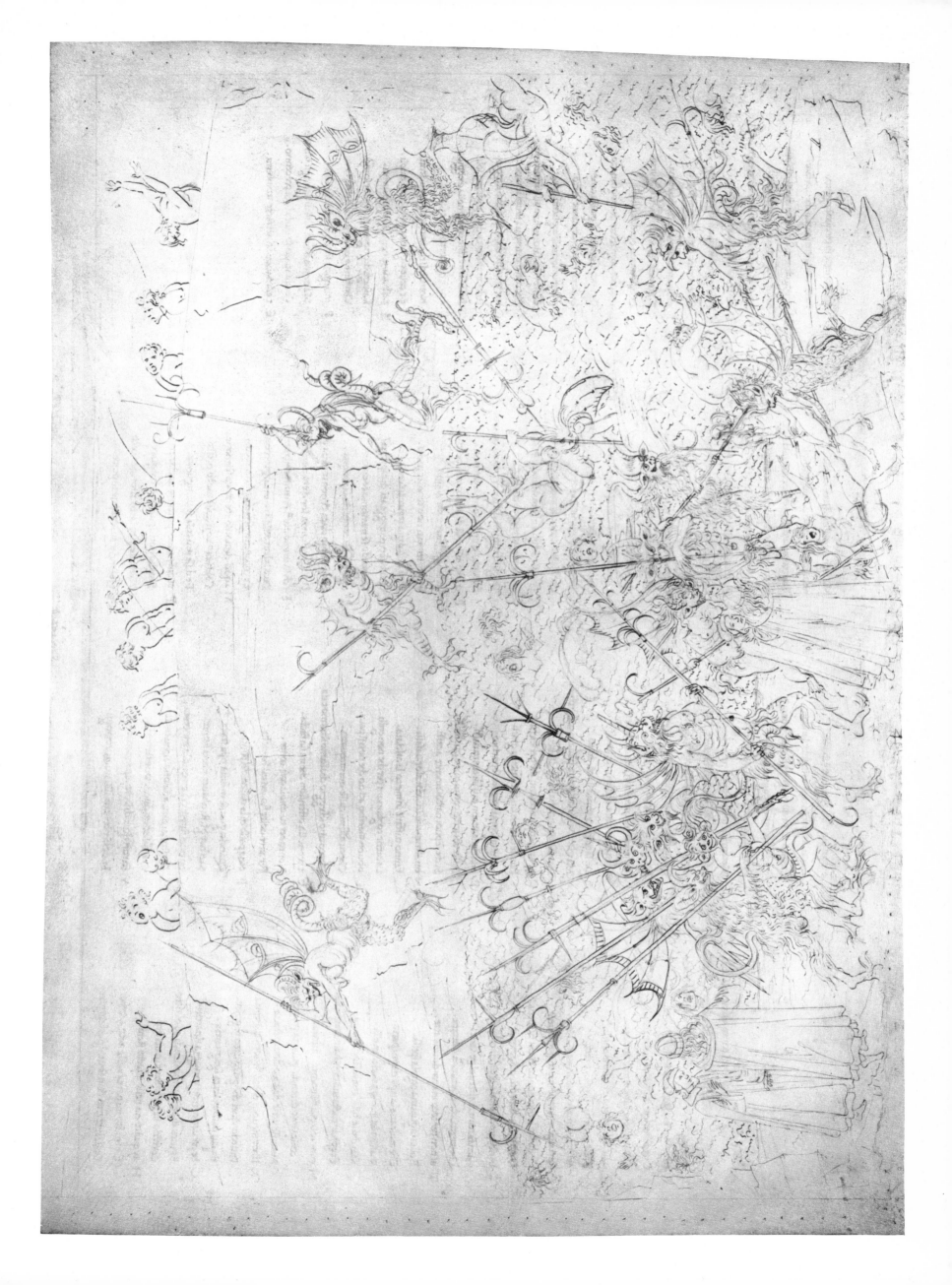

The Hypocrites

As THE DEMONS of the chasm of the Grafters fight among themselves, Dante and Virgil slip away, thoughtful about what they have seen and silent. Suddenly, they are aware that the demons are pursuing them; Virgil lifts Dante in his arms, at the upper right of the drawing, and they slide down the wall of the next pit. Here are punished the Hypocrites, dressed as monks except that their habits – as were their lives and actions – are on the outside 'all dazzle, golden and fair', while the inside is leaden, heavy, tormenting. Dante is approached by two of the spirits: they are Catalano dei Malavolti and Loderingo degli Andolo, members of a military religious order known popularly as the 'Jovial Friars' because the laxity of their lives was not congruent with their apparent serious purpose. Turning from the two hypocritical clerics in disgust, Dante sees a figure crucified to the floor of the abyss. This is Caiaphas, whose hypocritical collusion in the crucifixion of Christ has condemned him to this punishment, along with his father-in-law Annas and others of the Sanhedrin. Botticelli shows them so at the bottom of the drawing, with Dante and Virgil, and some of the friar-like Hypocrites, treading on them so that they may feel 'the weight of all through all eternity'.

Already I felt my scalp grow tight with fear.
I was staring back in terror as I said :
'Master, unless we find concealment here

and soon, I dread the rage of the Fiends : already
they are yelping on our trail : I imagine them
so vividly I can hear them now.'

* * *

Seizing me instantly in his arms, my Guide –
like a mother wakened by a midnight noise
to find a wall of flame at her bedside

(who takes her child and runs, and more concerned
for him than for herself, does not pause even
to throw a wrap about her) raised me, turned,

and down the rugged bank from the high summit
flung himself supine onto the slope
which walls the upper side of the next pit.

* * *

All wore great cloaks cut to as ample a size
as those worn by the Benedictines of Cluny.
The enormous hoods were drawn over their eyes.

* * *

I waited there, and saw along that track
two souls who seemed in haste to be with me ;
but the narrow way and their burden held them back.

When they had reached me down that narrow way
they stared at me in silence and amazement,
then turned to one another.

* * *

'This one seems, by the motion of his throat,
to be alive ; and if they are dead, how is it
they are allowed to shed the leaden coat?'

And then to me 'O Tuscan, come so far
to the college of the sorry hypocrites,
do not disdain to tell us who you are.'

* * *

'Jovial Friars and Bolognese were we.
We were chosen jointly by your Florentines
to keep the peace, an office usually

held by a single man ; near the Gardingo
one still may see the sort of peace we kept.
I was called Catalano, he, Loderingo.'

* * *

'That one nailed across the road
counselled the Pharisees that it was fitting
one man be tortured for the public good.

Naked he lies fixed there, as you see,
in the path of all who pass ; there he must feel
the weight of all through all eternity'.

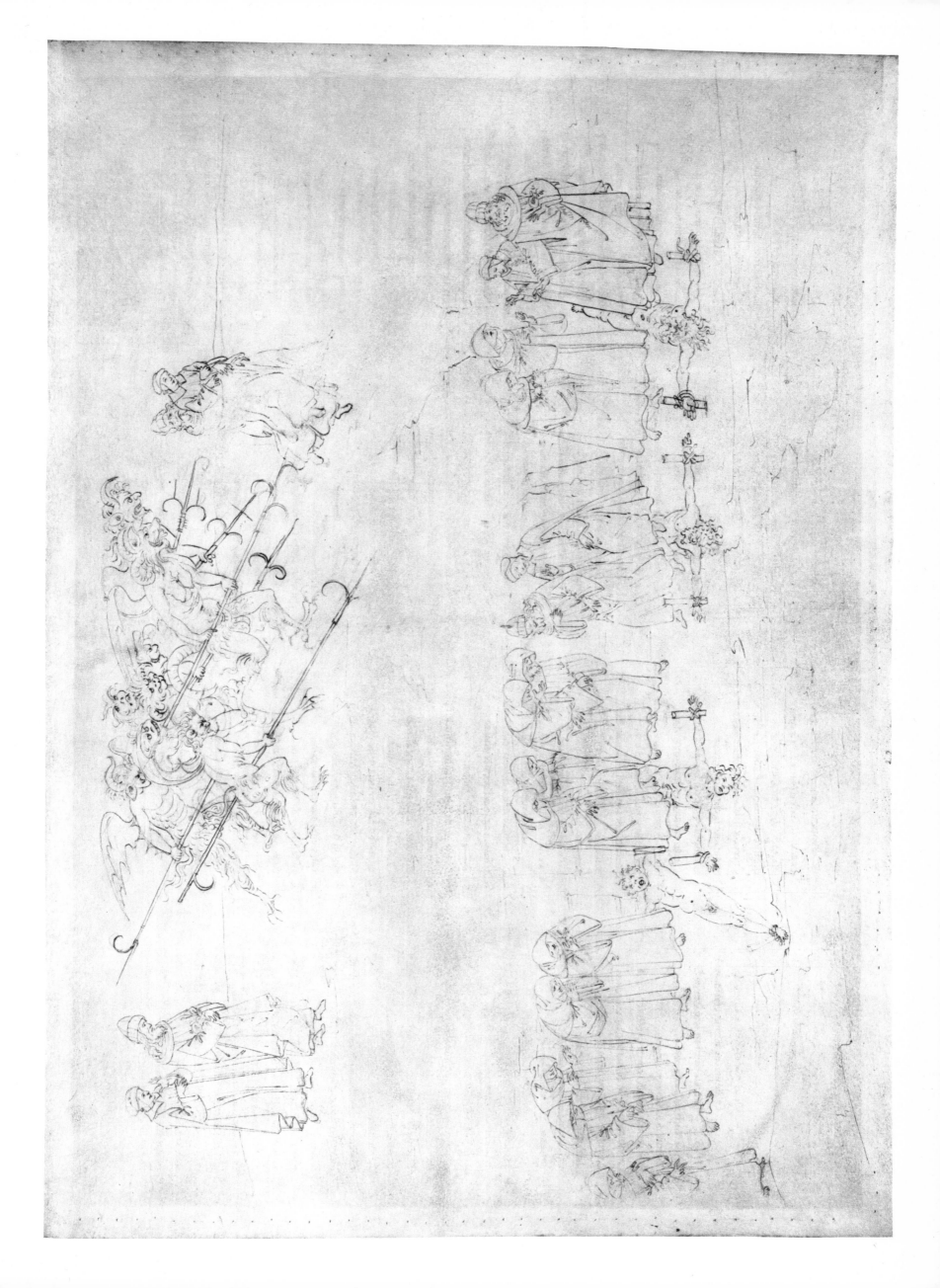

The Thieves

LEAVING THE CHASM of the Hypocrites, Dante and Virgil reach the shattered bridge over the abyss of the Thieves. Botticelli conveys the difficulty of their climbing up and over the bridge, and down into the pit – they could scarcely 'crawl handhold by handhold' – by drawing the pair at five successive stages. In this chasm the poets find the Thieves, each one twined about by a serpent, their hands bound behind their backs in the coils. Other reptiles swarm about, biting each of the spirits 'where the neck joins the shoulder'; instantly the tormented wretch burns and falls to ashes, whereupon the ashes rise up and resume their former shape. As thieving is reptilian in its stealth, so these sinners are unceasingly tortured by infernal reptiles which bind their hands, the instruments of their sin, and consume their substance with flame, as they deprived others of their wealth and property. At the lower edge of Botticelli's drawing Dante and Virgil are listening to Vanni Fucci, a Pistoian who, he confesses to Dante, plundered the treasury in the church of San Jacopo at Pistoia, a theft for which others were blamed.

When he had paused and studied carefully
the heap of stones, he seemed to reach some plan,
for he turned and opened his arms and lifted me.

Like one who works and calculates ahead,
and is always ready for what happens next –
so, raising me above that dismal bed

to the top of one great slab of the fallen slate,
he chose another saying : 'Climb here, but first
test it to see if it will hold your weight.'

* * *

My lungs were pumping as if they could not stop ;
I thought I could not go on, and I sat exhausted
the instant I had clambered to the top.

'Up on your feet ! This is no time to tire !'
my Master cried. 'The man who lies asleep
will never waken fame, and his desire

and all his life drift past him like a dream,
and the traces of his memory fade from time
like smoke in air, or ripples on a stream.

Now, therefore, rise. Control your breath, and call
upon the strength of soul that wins all battles
unless it sink in the gross body's fall.'

* * *

So we moved down the bridge to the stone pier
that shores the end of the arch on the eighth bank,
and there I saw the chasm's depths made clear ;

and there great coils of serpents met my sight,
so hideous a mass that even now
the memory makes my blood run cold with fright.

* * *

'I am Vanni Fucci, the beast. A mule among men,
I chose the bestial life above the human.
Savage Pistoia was my fitting den.'

And to my Guide : 'Detain him a bit longer
and ask what crime it was that sent him here ;
I knew him as a man of blood and anger.'

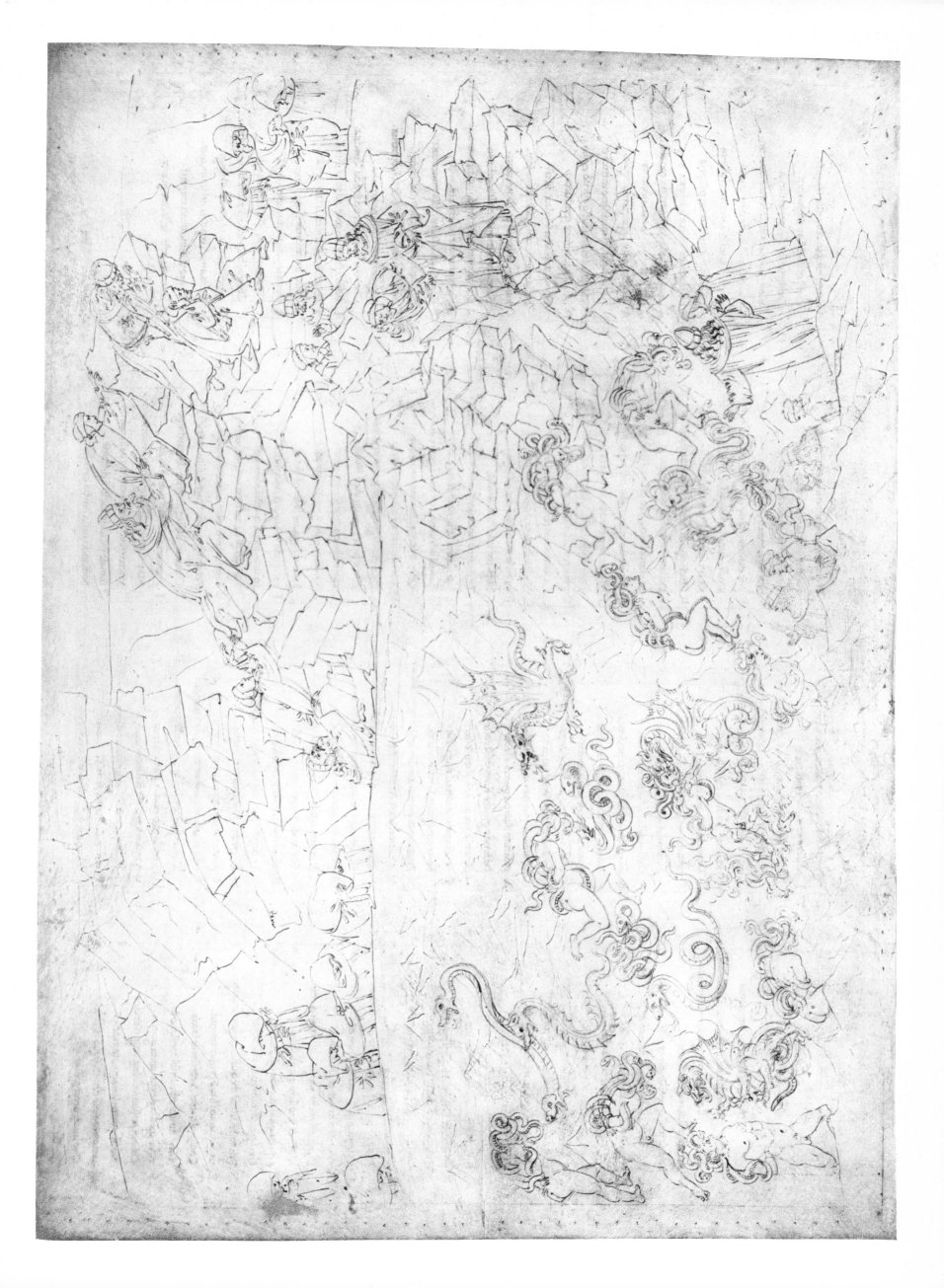

The Thieves

STILL IN THE CHASM of the Thieves, Dante and Virgil stand listening to Vanni Fucci as his rage at his sin mounts, culminating in blasphemy. At this, serpents swarm over him, driving him away shrieking. But his way is blocked by a centaur eager to avenge Fucci's blasphemy, even in Hell. His back and lower body swarming with serpents, the Centaur, who is Cacus, the thief of Hercules' cattle, bears on his head, like an elaborate jousting helm, a dragon. Dante now sees five spirits – Agnello Brunelleschi, Cianfa de' Donati, Buoso degli Abati, Francesco dei Cavalcanti and Puccio Sciancato – all infamous Florentine noble thieves. Because by their sins of theft they appropriated to themselves other men's substance and identity, four of these – Puccio alone escapes this horror – are changed into serpentine beasts which attack and cling to their partners, absorbing as it were their identity. At the left of the lower edge of his drawing Botticelli has Virgil and Dante looking towards Agnello, who is merging with Cianfa, already transformed into a six-legged lizard. Behind this pair, Buoso is attacked by the serpent into which Francesco has been changed.

Reader, should you doubt what next I tell,
it will be no wonder, for though I saw it happen,
I can scarce believe it possible, even in Hell.

For suddenly, as I watched, I saw a lizard
come darting forward on six great taloned feet
and fasten itself to a sinner from crotch to gizzard.

Its middle feet sank in the sweat and grime
of the wretch's paunch, its forefeet clamped his arms,
its teeth bit through both cheeks. At the same time

its hind feet fastened on the sinner's thighs:
its tail thrust through his legs and closed its coil
over his loins. I saw it with my own eyes!

* * *

No ivy ever grew about a tree
as tightly as that monster wove itself
limb by limb about the sinner's body;

they fused like hot wax, and their colors ran
together until neither wretch nor monster
appeared what he had been when he began:

just so, before the running edge of the heat
on a burning page, a brown discoloration
changes to black as the white dies from the sheet.

As lizards at high noon of a hot day
dart out from hedge to hedge, from shade to shade,
and flash like lightning when they cross the way,

so toward the bowels of the other two,
shot a small monster; livid, furious,
and black as a pepper corn. Its lunge bit through

that part of one of them from which man receives
his earliest nourishment; then it fell back
and lay sprawled out in front of the two thieves.

Its victim stared at it but did not speak:
indeed, he stood there like a post, and yawned
as if lack of sleep, or a fever, had left him weak.

The reptile stared at him, he at the reptile;
from the wound of one and from the other's mouth
two smokes poured out and mingled, dark and vile.

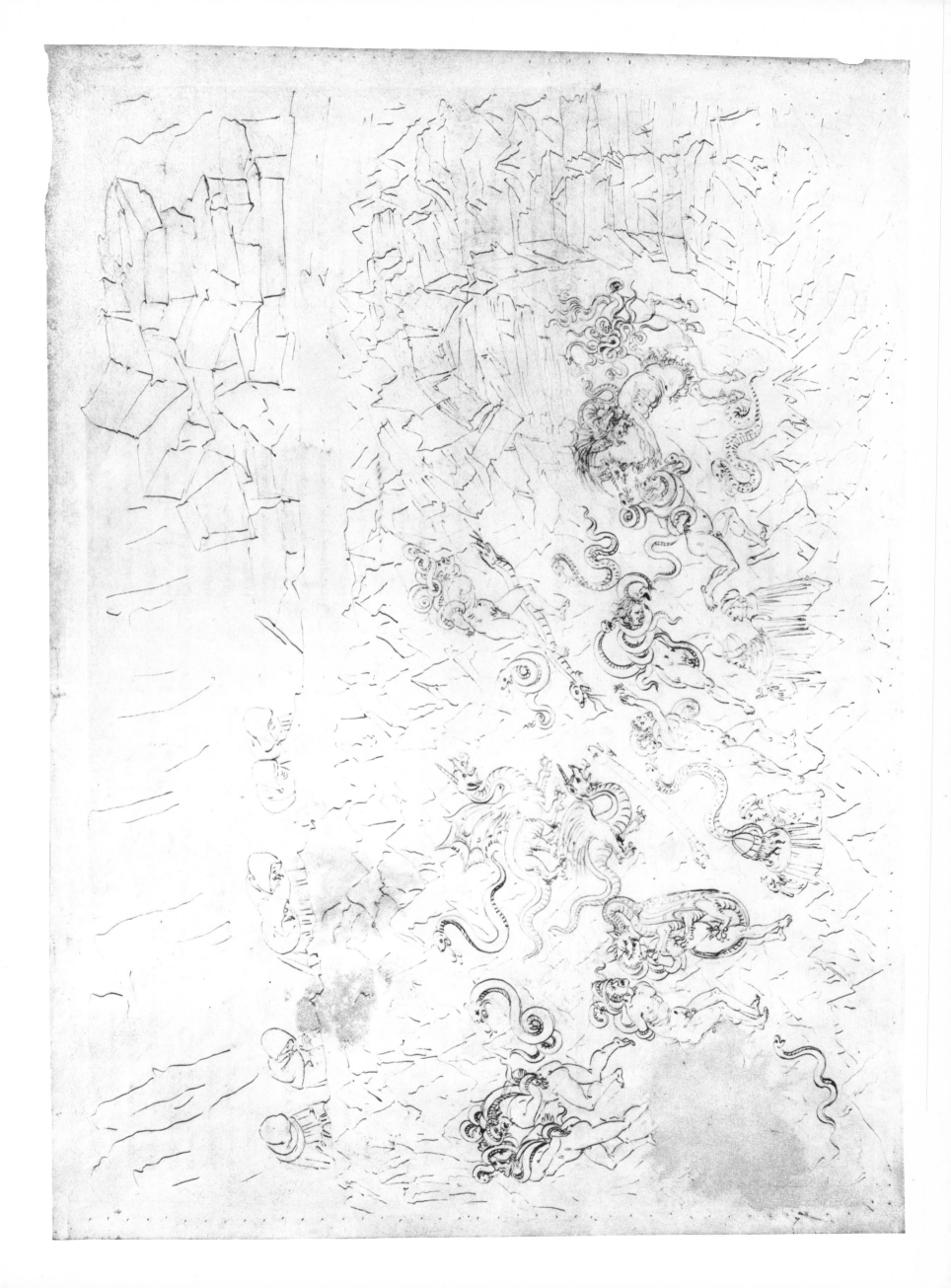

The Evil Counsellors

DANTE AND VIRGIL, at the top of the Botticelli drawing, climb up out of the seventh chasm, walk along the craggy rim of the eighth and come to the bridge over it. The floor of this pit is crossed and recrossed by the souls of Evil Counsellors hidden within great flames. Because they worked their evil in hiding and with glibness of tongue, they are punished by being themselves eternally hidden in tongues of flame, darting about like fireflies on a moonless summer night. Standing at the crown of the arch over the chasm, the two poets see a double-headed flame. Virgil explains that Ulysses and Diomede are here and thus punished for their crimes in life: the ruse of the wooden horse at Troy, persuading Achilles to join the siege of that city, and the theft of the Palladium, the sacred image of Pallas Athene on which the Trojans believed depended the safety and prosperity of their city.

As many fireflies as the peasant sees
when he rests on a hill and looks into the valley
(where he tills or gathers grapes or prunes his trees)

in that sweet season when the face of him
who lights the world rides north, and at the hour
when the fly yields to the gnat and the air grows dim —

such myriads of flames I saw shine through
the gloom of the eighth abyss when I arrived
at the rim from which its bed comes into view.

* * *

I stood on the bridge, and leaned out from the edge ;
so far, that but for a jut of rock I held to
I should have been sent hurtling from the ledge

without being pushed. And seeing me so intent,
my Guide said: 'There are souls within those flames ;
each sinner swathes himself in his own torment.'

* * *

'Forever round this path
Ulysses and Diomede move in such dress,
united in pain as once they were in wrath ;

there they lament the ambush of the Horse
which was the door through which the noble seed
of the Romans issued from its holy source ;

there they mourn that for Achilles slain
sweet Deidamia weeps even in death ;
there they recall the Palladium in their pain.'

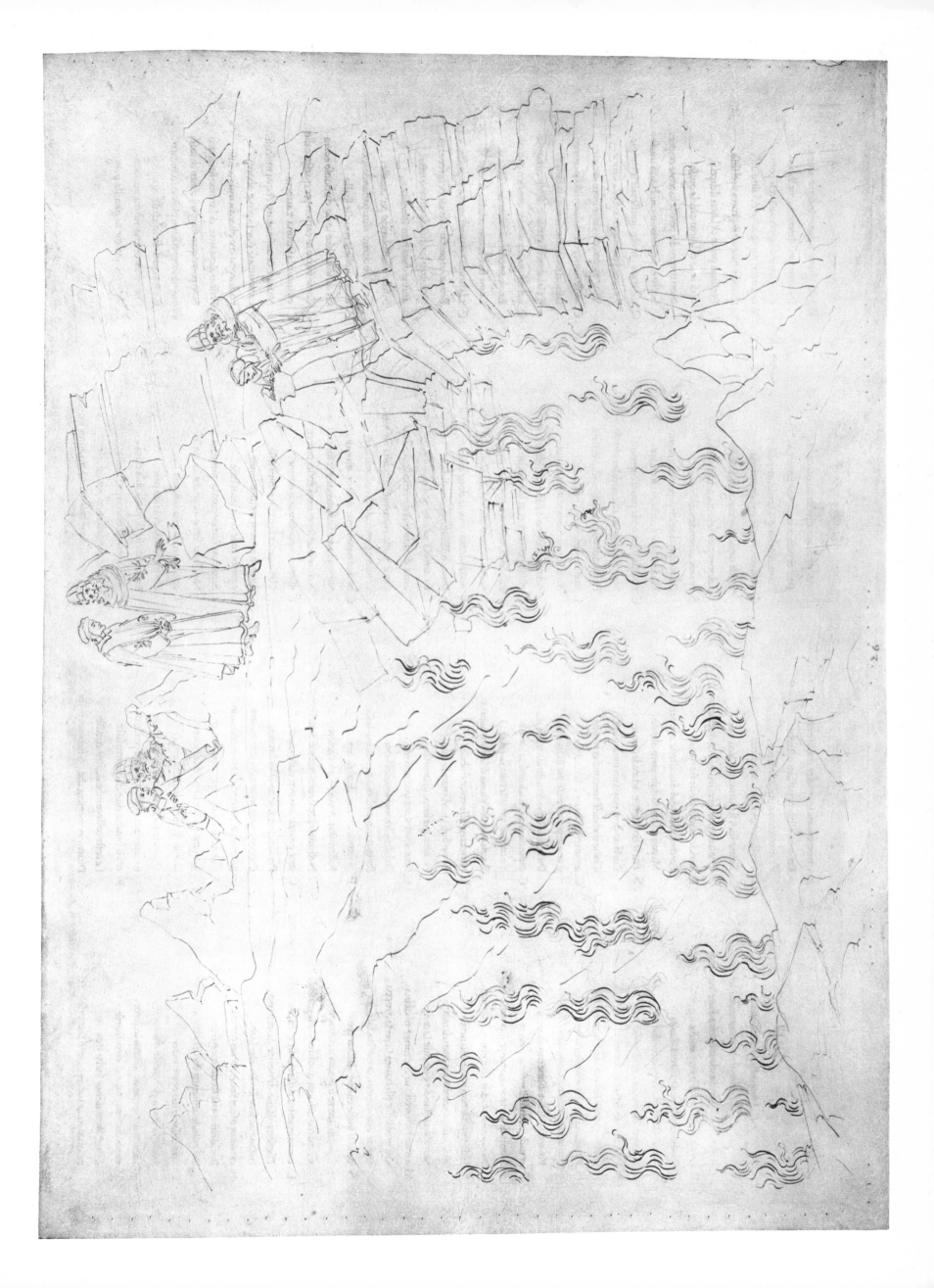

The Evil Counsellors

WHEN THE FACES of Ulysses and Diomede have disappeared from the two-headed flame, another face appears in a new flame. This is Count Guido da Montefeltro. Guido had heard Dante speaking Italian and called out to him to ask, as a fellow countryman, how things fared in the cities of Romagna. Guido had been a leader of the Ghibellines, described as 'the shrewdest and finest soldier in Italy'. He is here, being punished as with the Evil Counsellors, because it was he, apparently, who advised Pope Boniface VIII how to reduce Palestrina, the stronghold of the Colonna family.

When it had finished speaking, the great flame
stood tall and shook no more. Now, as it left us
with the sweet Poet's license, another came

along that track and our attention turned
to the new flame : a strange and muffled roar
rose from the single tip to which it burned.

 * * *

 'O you at whom I aim
my voice, and who were speaking Lombard, saying :
"Go now, I ask no more," just as I came –

though I may come a bit late to my turn,
may it not annoy you to pause and speak a while :
you see it does not annoy me – and I burn.

If you have fallen only recently
to this blind world from that sweet Italy
where I acquired my guilt, I pray you, tell me :

is there peace or war in Romagna? for on earth
I too was of those hills between Urbino
and the fold from which the Tiber springs to birth.'

I was still staring at it from the dim
edge of the pit when my Guide nudged me, saying :
'This one is Italian ; you speak to him.'

My answer was framed already : without pause
I spoke these words to it : 'O hidden soul,
your sad Romagna is not and never was

without war in her tyrants' raging blood ;
but none flared openly when I left just now.
Ravenna's fortunes stand as they have stood

these many years : Polenta's eagles brood
over her walls, and their pinions cover Cervia.
The city that so valiantly withstood

the French, and raised a mountain of their dead,
feels the Green Claws again. Still in Verrucchio
the Aged Mastiff and his Pup, who shed

Montagna's blood, raven in their old ranges.
The cities of Lamone and Santerno
are led by the white den's Lion, he who changes

his politics with the compass. And as the city
the Savio washes lies between plain and mountain,
so it lives between freedom and tyranny.

Now, I beg you, let us know your name ;
do not be harder than one has been to you ;
so, too, you will preserve your earthly fame.'

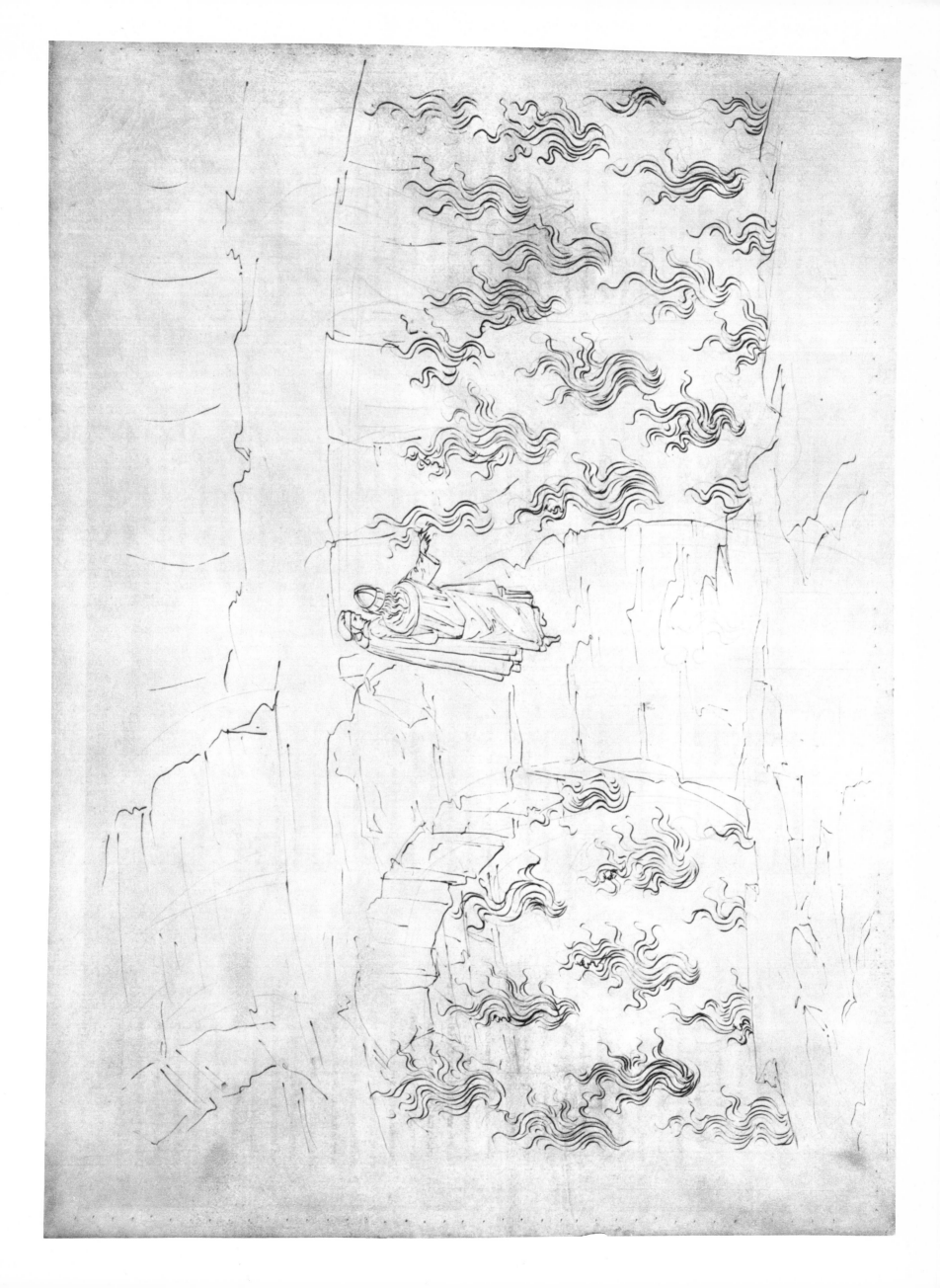

The Sowers of Discord

VIRGIL AND DANTE stand on the archway over the ninth pit, where are punished those spirits who in life sowed division and discord, religious, social or political; Botticelli's awestruck Dante echoes the poet's words opening this canto. On the left stands the pit's guardian demon, hacking at their bodies and eternally renewing the wounds that heal in their circuit round the pit. His sword makes in them the distorting splits and dismemberments that their sins caused in the lives and fortunes of others. Dante sees Mahomet, cleft from chin to groin and with his entrails dragging on the ground between his feet. Beside the Prophet stands his son-in-law Ali, his head split in two: as Mahomet rent the body of religious unity in life, so his own body is punished by everlasting division in Hell; after the death of Mahomet, the dispute in Islam over his successor led to Ali's rise to power. In Dante's allegory, just as Mahomet caused schism in the body of the world's religious belief, so Ali extended that rift and, indeed, was responsible for division within Islam itself. To the left of the arch, the three souls at whom Botticelli has Dante and Virgil looking down are Pier de Medicina and the Roman Curius, and Bertran de Born. Pier's reputation in life had been for gossip and mischievous scandal; Curius urged the hesitating Caesar to cross the Rubicon, an action that unleashed Rome's Civil War. For his reckless speech, Curius has had his tongue torn out by the tormentor; Pier's probing nose has been slashed away, one of his curious ears is gone and his throat slit. Below this trio, waving his handless stumps, is Mosca dei Lamberti, whose irresponsible dabbling in Florentine affairs ended in the Guelph and Ghibelline feuds in that city. Finally, Dante looks back at Bertran, 'a body without a head . . . it held the severed head by its own hair . . . and wept in its despair.' A soldier and famous Provençal troubadour, Bertran set Prince Henry of England against his father, Henry II, 'as Achitophel set Absalom and David'. Because he came between 'those who should be one', Bertran is condemned to an eternity of separation between his head and his body.

Who could describe, even in words set free
of metric and rhyme and a thousand times retold,
the blood and wounds that now were shown to me!

At grief so deep the tongue must wag in vain;
the language of our sense and memory
lacks the vocabulary of such pain.

* * *

Between his legs all of his red guts hung
with the heart, the lungs, the liver, the gall bladder,
and the shrivelled sac that passes shit to the bung.

I stood and stared at him from the stone shelf;
he noticed me and opening his own breast
with both hands cried: 'See how I rip myself!

See how Mahomet's mangled and split open!
Ahead of me walks Ali in his tears,
his head cleft from the top-knot to the chin.

And all the other souls that bleed and mourn
along this ditch were sowers of scandal and schism:
as they tore others apart, so are they torn.'

* *

This outcast settled Caesar's doubts that day
beside the Rubicon by telling him:
'A man prepared is a man hurt by delay'.

Ah, how wretched Curio seemed to me
with a bloody stump in his throat in place of the tongue
which once had dared to speak so recklessly!

* *

I saw it there; I seem to see it still —
a body without a head, that moved along
like all the others in that spew and spill.

It held the severed head by its own hair
swinging it like a lantern in its hand;
and the head looked at us and wept in its despair.

It made itself a lamp of its own head,
and they were two in one and one in two;
how this can be, He knows who so commanded.

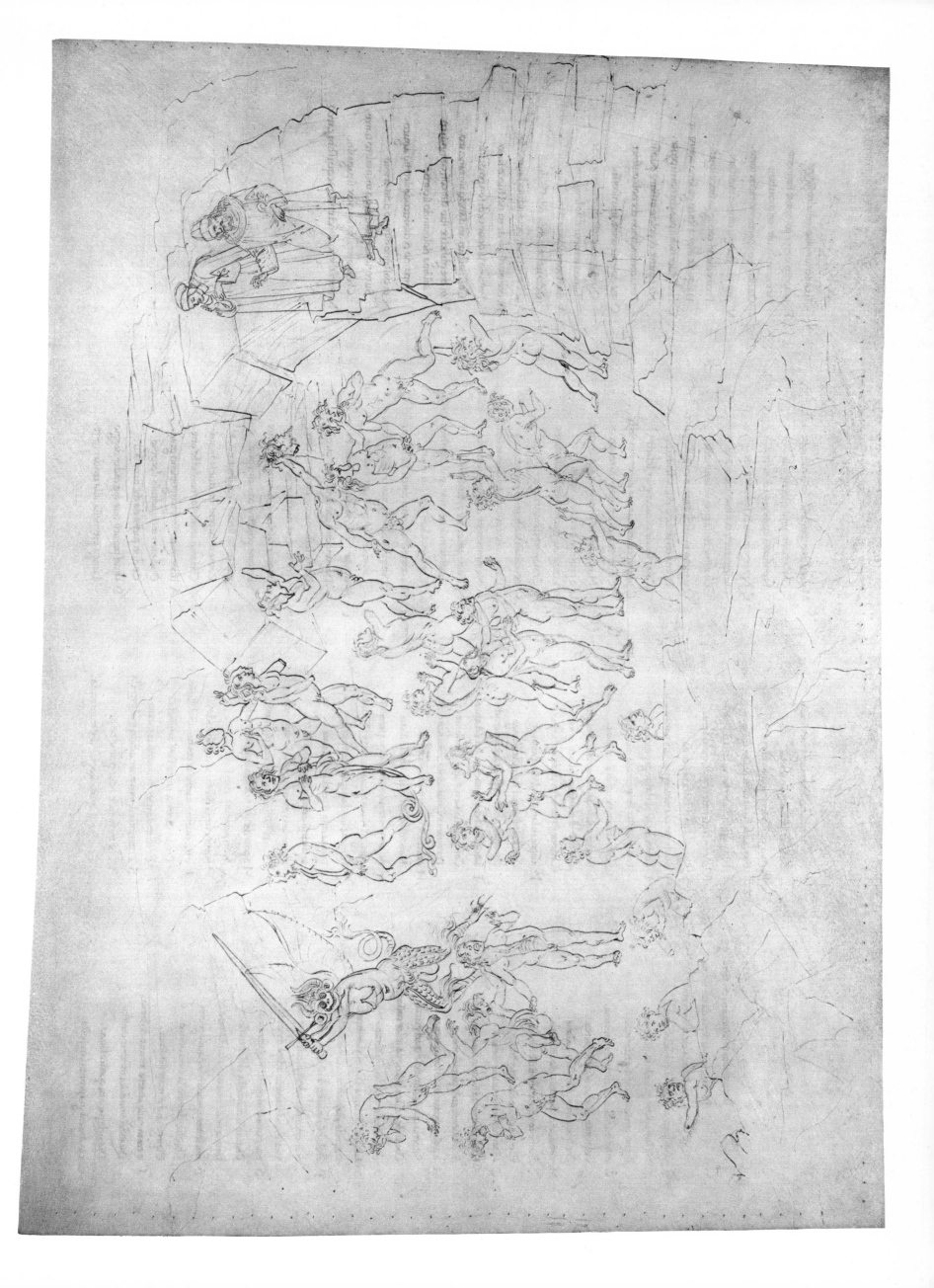

The Falsifiers: Alchemists

STILL ON THE BRIDGE over the ninth chasm, Dante hesitates to proceed, explaining that he expected to see his kinsman, Geri del Bello, among the Sowers of Discord. Virgil urges him to proceed, as time is short, explaining further that he had seen one of the spirits standing near to Bertran de Born shaking his fist at Dante. This was Geri, a distant cousin to Dante, who had a reputation for being likable and easy to talk to, but for enjoying making trouble among people, so skilfully that few could guard themselves against it. He was, finally, murdered by a member of one of the families among whom he had created dissension. Proceeding on to the bridge over the tenth, and last, chasm of the Eighth Circle, the poets see the Alchemists, falsifiers of things. The Falsifiers, who in life had corrupted society by distortions of whatever natural order, are punished themselves by darkness, stench, thirst, filth and unending din; some of them run about the pit, ravening on their fellows. In their eternity, not even the body has honesty. Here Dante, who has covered his ears against the horrid noise, encounters Griffolino, an alchemist of Arezzo, who was burnt to death as a magician for duping Albero of Siena into thinking he could be taught by Griffolino to fly, and Capocchio, a Florentine alchemist who was also burnt as a magician and who was notorious as a counterfeiter. Dante and Virgil have gone down into this chasm to speak with the two alchemists.

The sight of that parade of broken dead
had left my eyes so sotted with their tears
I longed to stay and weep, but Virgil said:

'What are you waiting for? Why do you stare
as if you could not tear your eyes away
from the mutilated shadows passing there?

You did not act so in the other pits.
Consider – if you mean perhaps to count them –
this valley and its train of dismal spirits

 Out from that ledge

winds twenty-two miles round. The moon already
is under our feet; the time we have is short,
and there is much that you have yet to see.'

* * *

Malebolge's final cloister lay outspread,
and all of its lay brethren might have been
in sight but for the murk; and from those dead

such shrieks and strangled agonies shrilled through me
like shafts, but barbed with pity, that my hands
flew to my ears. If all the misery

that crams the hospitals of pestilence
in Maremma, Valdichiano, and Sardinia
in the summer months when death sits like a presence

on the marsh air, were dumped into one trench –
that might suggest their pain.

* * *

One lay gasping on another's shoulder,
one on another's belly; and some were crawling
on hands and knees among the broken boulders.

* * *

I saw two there like two pans that are put
one against the other to hold their warmth.
They were covered with great scabs from head to foot.

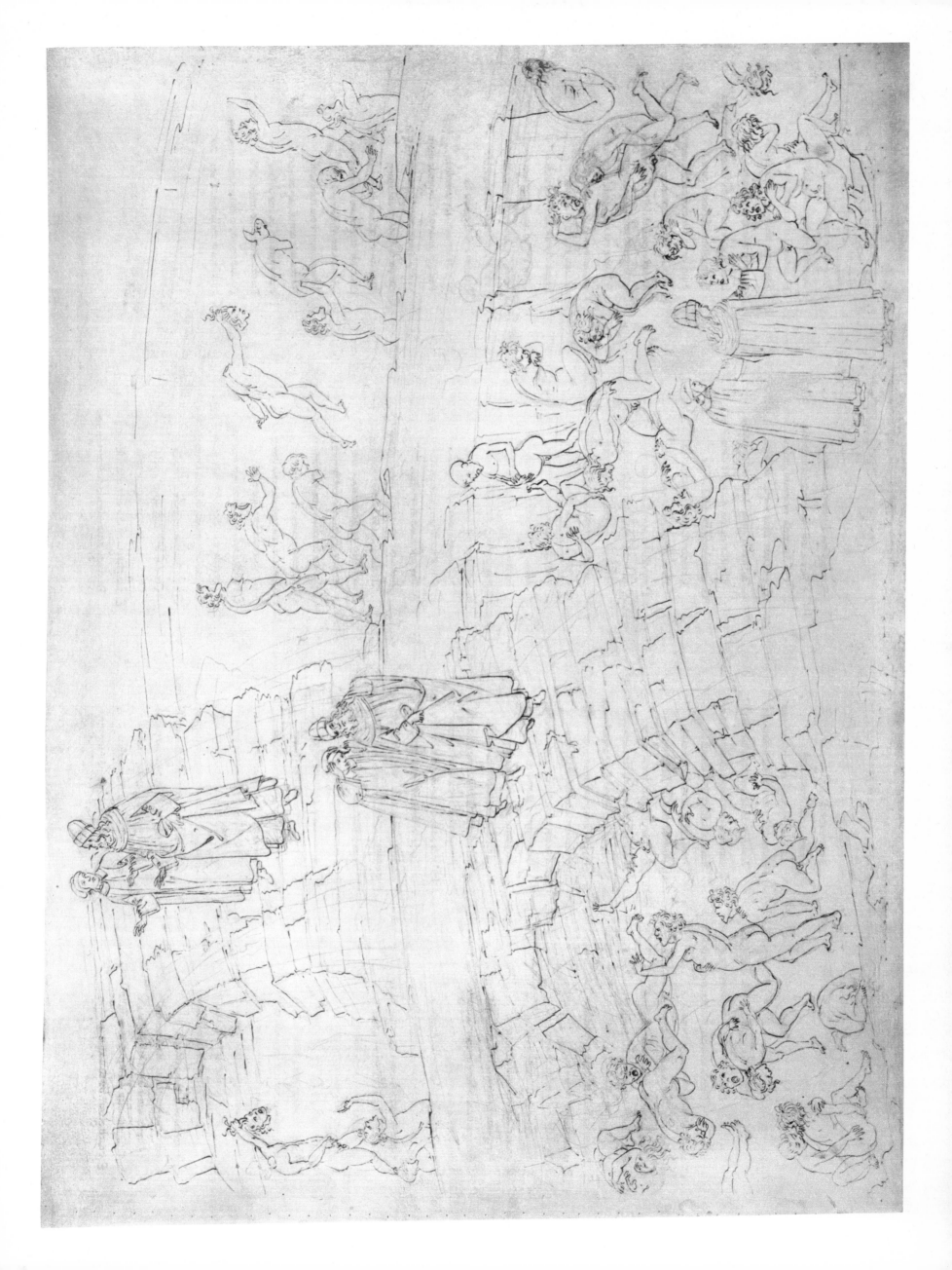

The Falsifiers: Evil Impersonators, Counterfeiters, False Witnesses

As Capocchio finishes speaking, two raving spirits run up to him; one of them drags him away. In the middle of Botticelli's sketch here, Dante and Virgil watch this horror, and Griffolino identifies the two as Gianni Schicchi and Myrrha, who spend their eternity running through this chasm snatching at other damned souls. Gianni Schicchi took the place of the already dead Buoso Donati in order to dictate a false will. Myrrha, the daughter of King Cinyras of Cyprus, impersonated her mother in order to insinuate herself into her father's bed.

As they seized upon the identity of others in life, for their sins they are condemned to run forever through Hell, literally falling upon the appearances (for, excepting Dante as narrator–pilgrim, all of the Divine Comedy's characters are spirits only) of their fellows. In almost the exact centre of the sketch is Adam of Brescia, a counterfeiter of Florence who was burnt at the stake for his crime of deception. For his debasing of coinage, Adam is himself eternally tortured by incompleteness: his body swells from thirst and his legs have bloated to uselessness. Virgil scolds Dante for delaying their progress by staring.

But never in Thebes nor Troy were Furies seen
to strike at man or beast in such mad rage
as two I saw, pale, naked, and unclean,

who suddenly came running toward us then,
snapping their teeth as they ran, like hungry swine
let out to feed after a night in the pen.

* * *

And when the rabid pair had passed from sight,
I turned to observe the other misbegotten
spirits that lay about to left and right.

And there I saw another husk of sin,
who, had his legs been trimmed away at the groin,
would have looked for all the world like a mandolin.

The dropsy's heavy humors, which so bunch
and spread the limbs, had disproportioned him
till his face seemed much too small for his swollen paunch.

* *

I was still standing, fixed upon those two
when the Master said to me: 'Now keep on looking
a little longer and I quarrel with you.'

When I heard my Master raise his voice to me,
I wheeled about with such a start of shame
that I grow pale yet at the memory.

As one trapped in a nightmare that has caught
his sleeping mind, wishes within the dream
that it were all a dream, as if it were not —

such I became: my voice could not win through
my shame to ask his pardon; while my shame
already won more pardon than I knew.

The Giants

DANTE IS CAST DOWN by Virgil's reproach, and shamefaced, but his Guide assures him that he will not leave him, and they cross the stone arch into the central chasm of Malebolge. Through the darkness Dante sees what he mistakes for a ring of towers encircling a city, but Virgil tells him the shapes are not towers but Giants, the Titans, those embodiments of elemental forces untempered by love, restrained desire, or moral and theological law. The six stand in a ring within the pit, so immense that only the upper halves of their naked bodies rise above its rim. As the poets approach, one of the Giants shouts unintelligible words at them and then raises to his lips a hunting-horn that hangs from a chain round his neck. This, Virgil explains, is Nimrod the Hunter, who built the tower of Babel, as a result of which 'mankind no longer speaks a common tongue'. To the right along the curve of the pit stands Ephialtes, the son of Neptune, who warred against the gods of Olympus by striving to pile Mount Ossa on Mount Olympus, and Mount Pelion on Mount Ossa. Ephialtes was killed by Apollo, and spends his eternity in Hell with one arm chained across his chest, the other behind his back: 'the arms he raised then, now are bound forever'. In the foreground of Botticelli's drawing is Briareus, whom Dante wanted especially to see and who was another of the Titans who tried to overthrow the Olympian gods. Briareus is forever bound, impotent, in constricting chains. Finally, Virgil takes Dante in his arms as Antaeus, the only of the Giants who is not chained, lifts them and places them down 'into the final hole whose ice holds Lucifer and Judas in its grip'. Antaeus is not bound, because he was born after the war of the other Giants (including Tityos and Typhon, here standing at the lower left of the pit's rim) with the gods.

Then taking my hand in his, my Master said:
'The better to prepare you for strange truth,
let me explain those shapes you see ahead:

they are not towers but giants. They stand in the well
from the navel down; and stationed round its bank
they mount guard on the final pit of Hell.'

* * *

I had drawn close enough to one already
to make out the great arms along his sides,
the face, the shoulders, the breast, and most of the belly.

Nature, when she destroyed the last exemplars
on which she formed those breasts, surely did well
to take such executioners from Mars.

* * *

His very babbling testifies the wrong
he did on earth: he is Nimrod, through whose evil
mankind no longer speaks a common tongue.

Waste no words on him: it would be foolish.
To him all speech is meaningless; as his own,
which no one understands, is simply gibberish.'

* * *

He is Ephialtes, who made the great endeavour
with the other giants who alarmed the Gods:
the arms he raised then, now are bound forever.'

* * *

Virgil, when he felt himself so grasped,
called to me: 'Come, and I will hold you safe.'
And he took me in his arms and held me clasped.

* * *

So

Antaeus seemed to me in the fraught moment
when I stood clinging, watching from below

as he bent down; while I with heart and soul
wished we had gone some other way, but gently
he set us down inside the final hole

whose ice holds Judas and Lucifer in its grip,
Then straightened like a mast above a ship.

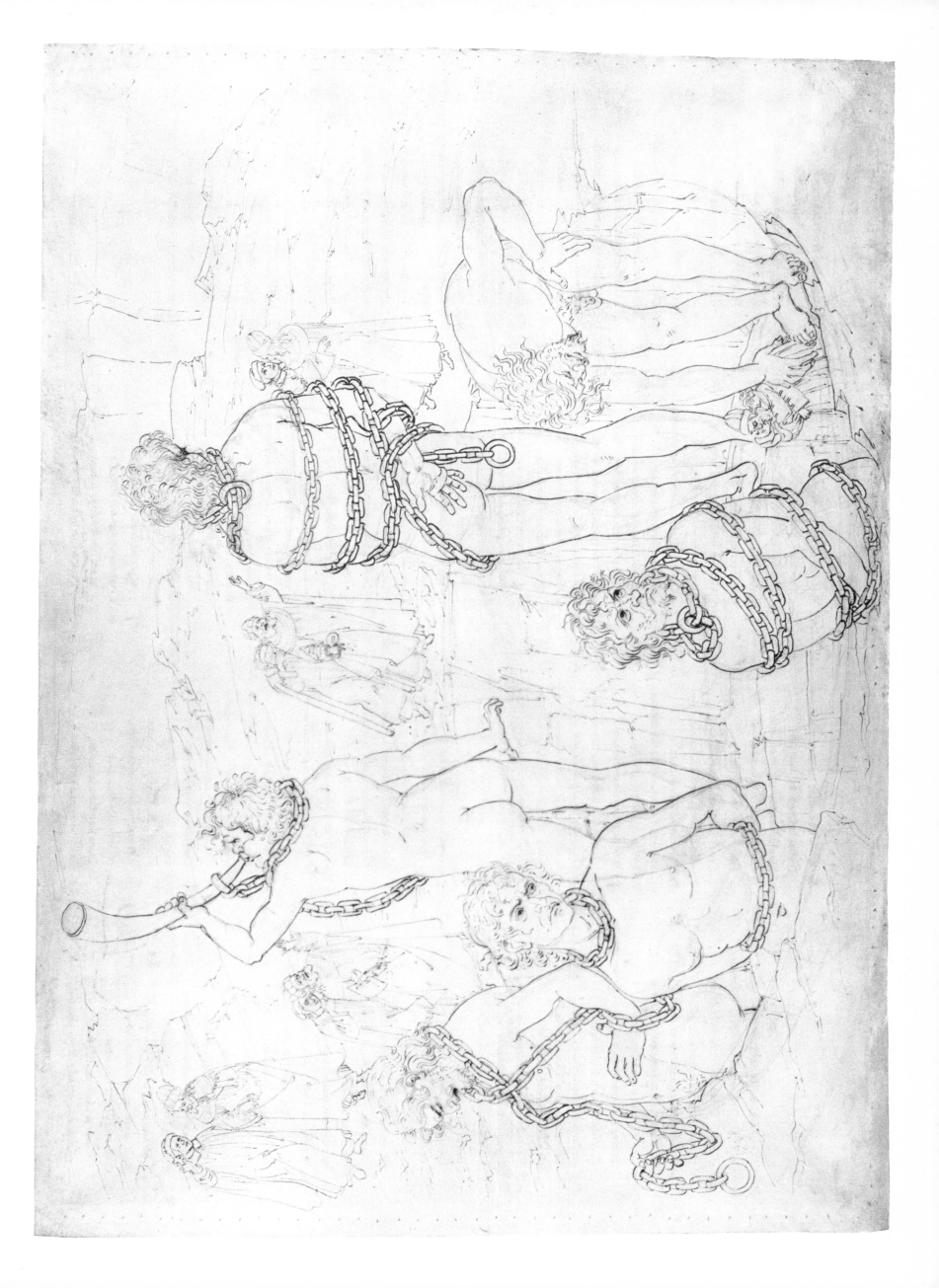

The Treacherous to Kin
The Treacherous to Country

DEEP AT THE BOTTOM of this final pit of Hell, Cocytus, the great lake of ice, Dante and Virgil stand looking down at the first two of the pit's four concentric rings, while the lower legs and feet of the Giants are visible above them. Here in ultimate desolation lie forever immobile those who denied by their lives human love, the warmth of life. The outermost ring is marked CHAINA, for Cain the Fratricide. The figure of Dante is drawn as though he were first looking up at the Giants and then, in a swift movement, down at the souls he sees here. These souls have only their necks and heads out of the ice – so that their tears of remorse may ever flow without freezing. In this ring lie Alessandro and Napoleone degli Alberti, brothers who killed each other in a dispute over their inheritance. They lie at Dante's feet frozen together in a mockery of the fraternal bond they denied. The next ring, ANTENORA, named for Antenor, the Trojan who betrayed his city to the Greeks, holds political traitors. Dante unwittingly but violently kicks the face of one of these traitors, who shouts abuse at him. The poet snatches at his hair to make him identify himself: this is Bocca degli Alberti, who at the battle of Montaperti cut off the hand of the standard-bearer of the Guelphs, his own party, and brought on their disastrous defeat. Finally, at the centre of the foreground, Dante sees two sinners frozen together, with one sinking his gnawing teeth into the nape of the other. These spirits are identified in the next canto.

We stood now in the dark pit of the well,
far down the slope below the Giants' feet,
and while I still stared up at the great wall,

I heard a voice cry: 'Watch which way you turn:
take care you do not trample on the heads
of the forsworn and miserable brethren.'

* * *

Whereat I turned and saw beneath my feet
and stretching out ahead, a lake so frozen
it seemed to be made of glass. So thick a sheet

never yet hid the Danube's winter course,
nor, far away beneath the frigid sky,
locked the Don up in its frozen source:

* * *

When I had stared about me, I looked down
and at my feet I saw two clamped together
so tightly that the hair of their heads had grown

together. 'Who are you,' I said, 'who lie
so tightly breast to breast?'

* * *

As we approached the center of all weight,
where I went shivering in eternal shade,
whether it was my will, or chance, or fate,

I cannot say; but as I trailed my Guide
among those heads, my foot struck violently
against the face of one. Weeping, it cried:

'Why do you kick me? If you were not sent
to wreak a further vengeance for Montaperti,
why do you add this to my other torment?'

* * *

Leaving him then, I saw two souls together
in a single hole, and so pinched in by the ice
that one head made a helmet for the other.

As a famished man chews crusts – so the one sinner
sank his teeth into the other's nape
at the base of the skull, gnawing his loathsome dinner.

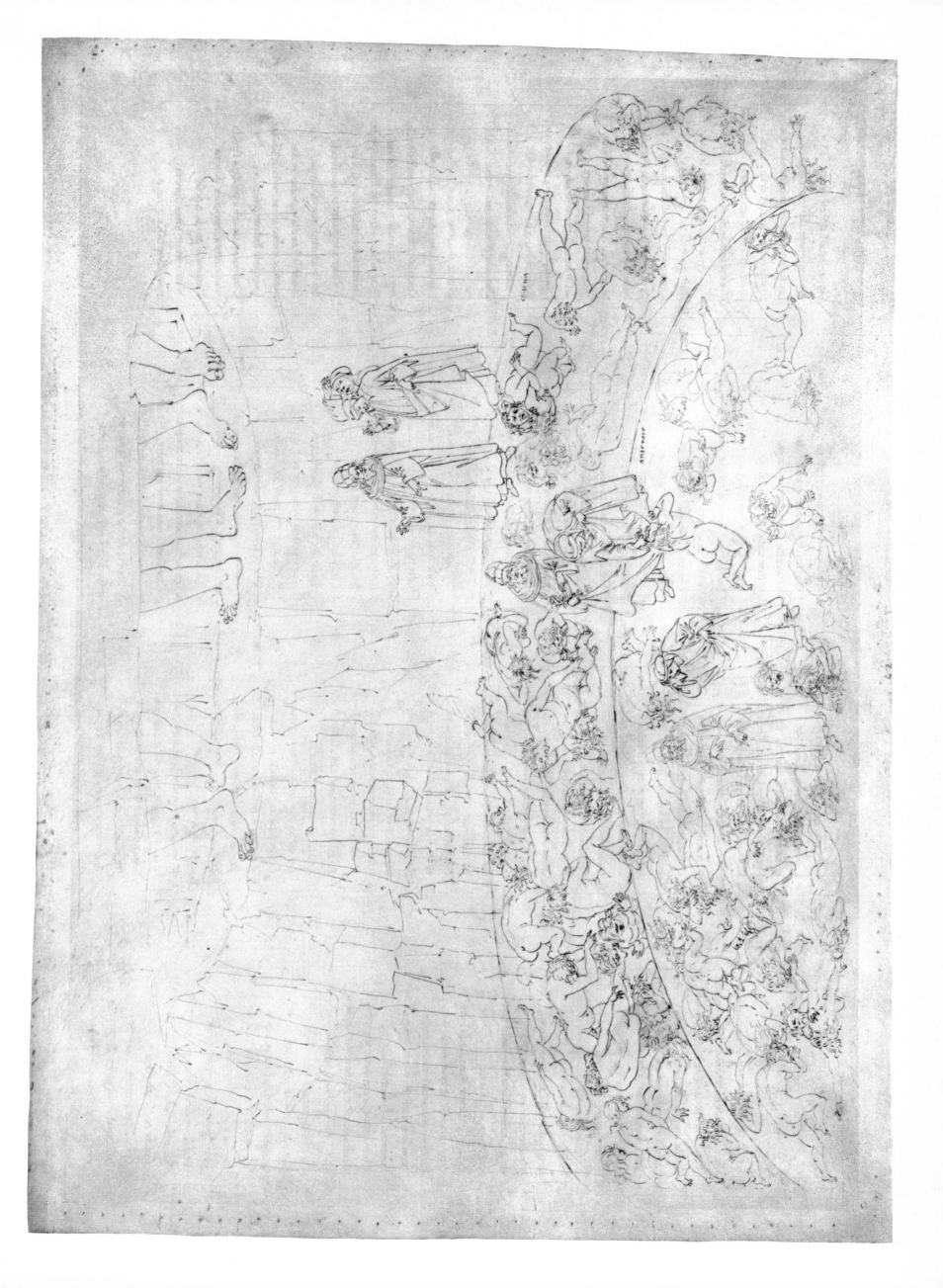

The Treacherous to Country
The Treacherous to Guests and Hosts

The four rings of Cocytus – CHAINA GIUDECHA, ANTENORA, TOLOMEA and GIUDECHA – are clearly inscribed. Still in Antenora, Dante hears the two sinners who ended the last canto identify themselves: the wretch gnawing his companion's head is Ugolino della Gherardesca, his victim Archbishop Ruggieri degli Ubaldini of Pisa. Together they had conspired for political power in Pisa, but the Archbishop betrayed Ugolino and caused his death by starvation; Ugolino here wreaks eternal vengeance on his betrayer by feeding on him. The two poets move on into the third ring, Tolomea, so called after Ptolemy of Jericho, who betrayed his duties as a host by murdering Simon the Maccabee and two of his sons at a banquet he gave for them. In this ring are punished traitors against the bonds of hospitality, who lie here with only half their faces above the ice and their tears freezing in their eyes, thus depriving them of even the relief of tears. Dante and Virgil, at the bottom of this ring in Botticelli's drawing, encounter Fra Alberigo de' Manfredi, another of the 'Jovial Friars', who assassinated an enemy invited to his table as guest of honour, and Branca Doria, who murdered his father-in-law in similar circumstances. Alberigo tells Dante that the damned of this ring are often brought in spirit to Tolomea before their bodies have in fact died, so that they feel the torment of their guilt before death.

The sinner raised his mouth from his grim repast
and wiped it on the hair of the bloody head
whose nape he had all but eaten away. At last

he began to speak: 'You ask me to renew
a grief so desperate that the very thought
of speaking of it tears my heart in two.

But if my words may be a seed that bears
the fruit of infamy for him I gnaw,
I shall weep, but tell my story through my tears.

I was Count Ugolino, I must explain;
this reverend grace is the Archbishop Ruggieri:
now I will tell you why I gnaw his brain.

That I, who trusted him, had to undergo
imprisonment and death through his treachery,
you will know already. What you cannot know –

that is, the lingering inhumanity
of the death I suffered – you shall hear in full:
then judge for yourself if he has injured me.'

* * *

We passed on further, where the frozen mine
entombs another crew in greater pain;
these wraiths are not bent over, but lie supine.

Their very weeping closes up their eyes;
and the grief that finds no outlet for its tears
turns inward to increase their agonies:

for the first tears that they shed knot instantly
in their eye-sockets, and as they freeze they form
a crystal visor above the cavity.

* * *

'I am Friar Alberigo,' he answered therefore,
'the same who called for the fruits from the bad garden.
Here I am given dates for figs full store.'

'What! Are you dead already?' I said to him.
And he then: 'How my body stands in the world
I do not know. So privileged is this rim

of Ptolomea, that often souls fall to it
before dark Atropos has cut their thread.'

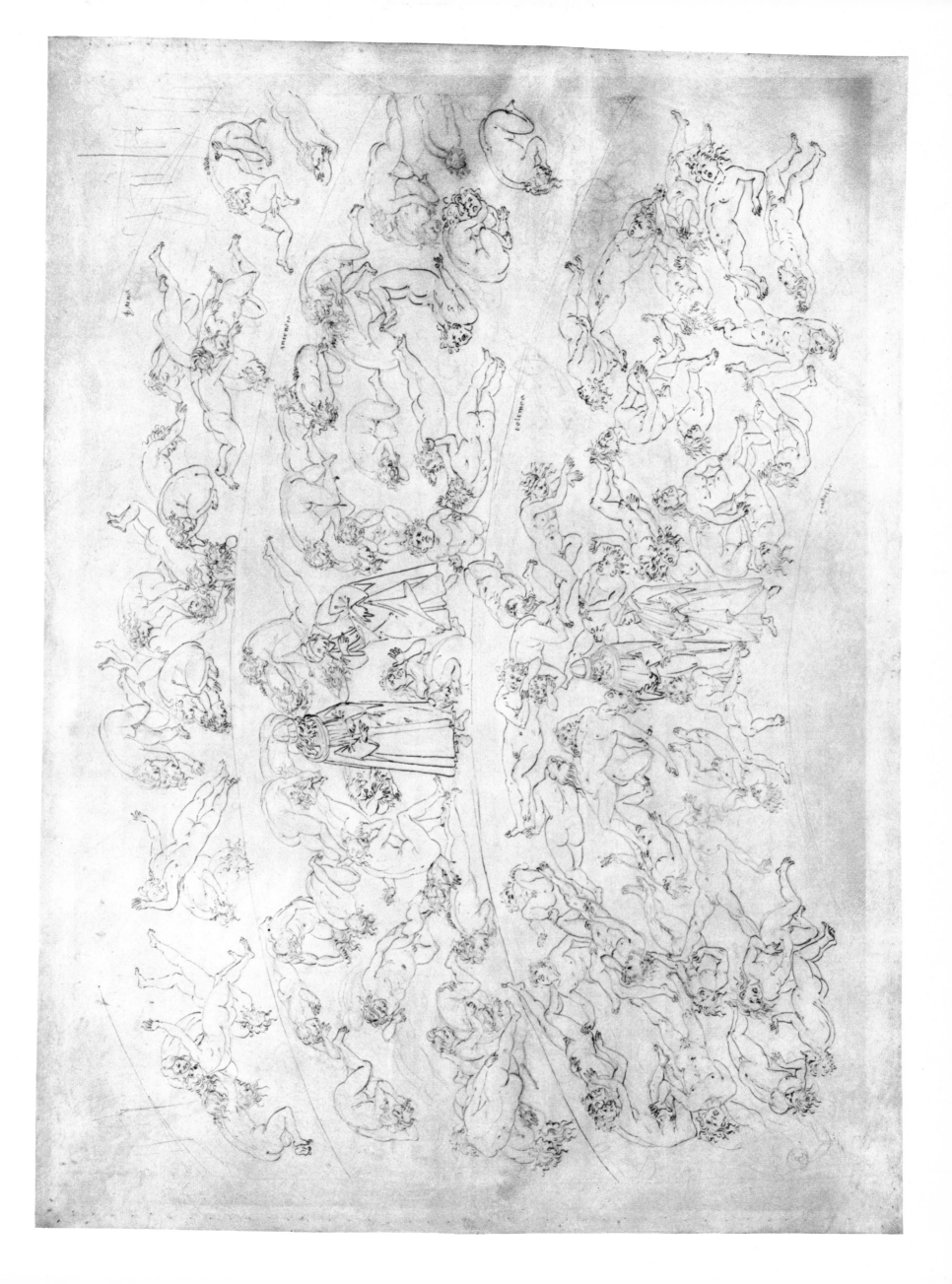

The Treacherous to their Master
Satan

HERE, THE FIRST of his two illustrations to this last ring of Cocytus, Botticelli draws the three-headed Satan described by Dante. This last circle is named after Judas Iscariot, prime analogue of a traitor against his master; in Judas' case (and in Dante's belief), of course, the betrayed master was God Incarnate. Dante sees that the souls of this circle are completely entombed in ice, 'like straws in glass'. Virgil points out to him Satan, Dis, whose six wings and eyes are a fearful parody of the six-winged, many-eyed Seraph he once was, as his triune head is a revolting mockery of the Trinity, whose eternal antithesis he is. Satan weeps from his six eyes and the tears run down his chin mixed with blood and pus. From the mouth of the head in front protrude the trunk and legs of Judas Iscariot; Brutus, who murdered Caesar, hangs head down from the jaws of the left face, and Cassius, who formed the conspiracy against Caesar, hangs in the same position from the face on the right. The poets begin to descend the body of Dis, to emerge from Hell.

'On march the banners of the King of Hell,'
my Master said. 'Toward us. Look straight ahead:
can you make him out at the core of the frozen shell?'

Like a whirling windmill seen afar at twilight,
or when a mist has risen from the ground –
just such an engine rose upon my sight

stirring up such a wild and bitter wind
I cowered for shelter at my Master's back,
there being no other windbreak I could find.

I stood now where the souls of the last class
(with fear my verses tell it) were covered wholly;
they shone below the ice like straws in glass.

Some lie stretched out; others are fixed in place
upright, some on their heads, some on their soles;
another, like a bow, bends foot to face.

* * *

When we had gone so far across the ice
that it pleased my Guide to show me the foul creature
which once had worn the grace of Paradise,

he made me stop, and, stepping aside, he said:
'Now see the face of Dis! This is the place
where you must arm your soul against all dread.'

Do not ask, Reader, how my blood ran cold
and my voice choked up with fear. I cannot write it:
this is a terror that cannot be told.

In every mouth he worked a broken sinner
between his rake-like teeth. Thus he kept three
in eternal pain at his eternal dinner.

* * *

'That soul that suffers most,' explained my Guide,
'is Judas Iscariot, he who kicks his legs
on the fiery chin and has his head inside.

Of the other two, who have their heads thrust forward,
the one who dangles down from the black face
is Brutus: note how he writhes without a word.

And there, with the huge and sinewy arms, is the soul
of Cassius. – But the night is coming on
and we must go, for we have seen the whole.'

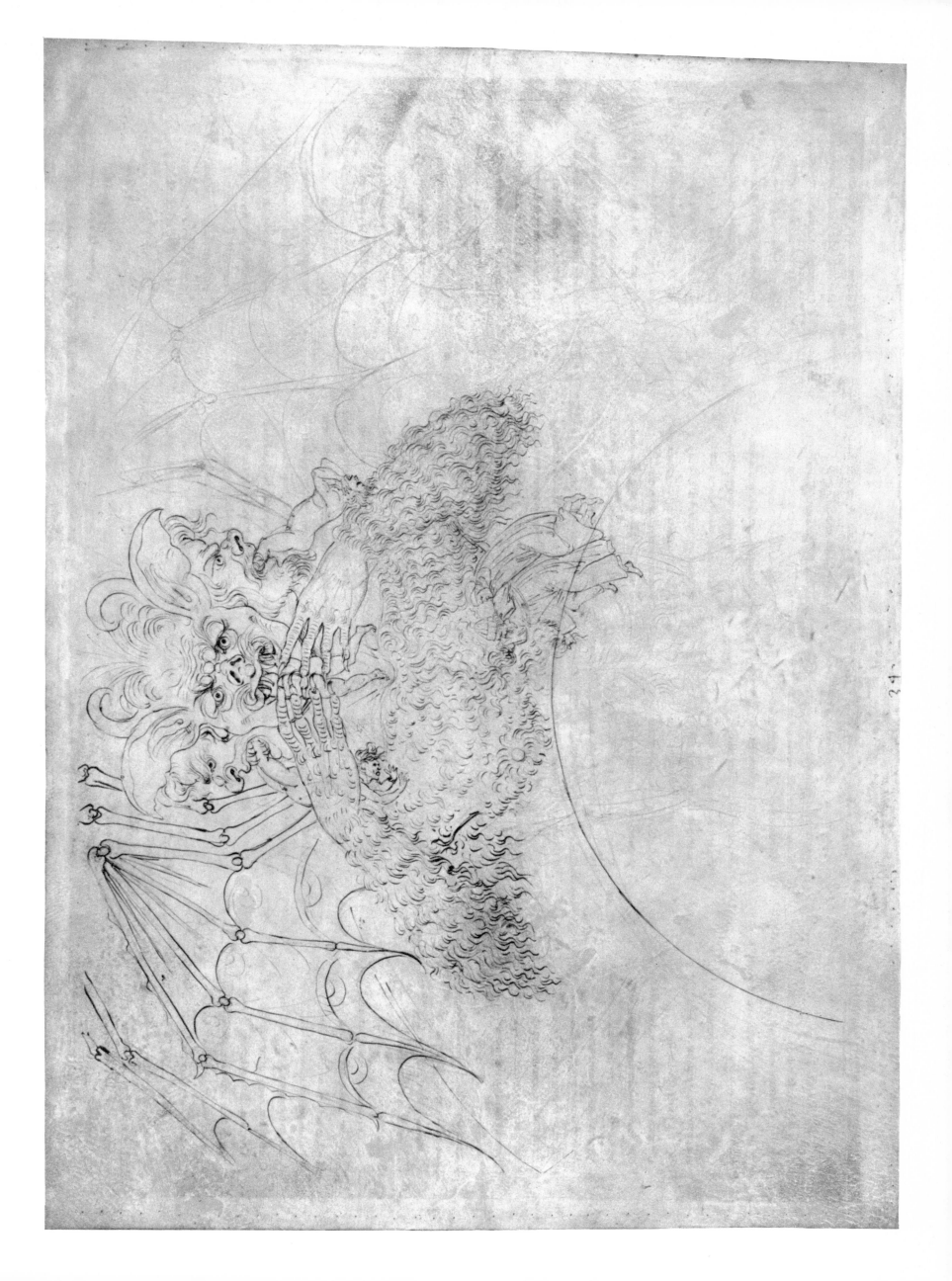

Satan

IN THIS LAST of his drawings, twice the size of the others and done on two sheets of vellum fastened together, for the first *cantica* of the Divine Comedy, Botticelli confronts us with the horror of Satan, 'Emperor of the Universe of Pain', revolting in his perverted majesty. The two poets, prepared now to leave Hell and ascend the mountain of Purgatory, approach him. Virgil encourages Dante, who hides his face at the horror. Dante clasps Virgil round the neck as they use the hideous gigantic body for their way out of Hell. When they come to 'the joint where the great thigh merges into the swelling of the haunch', Virgil turns his head to where his feet had been and begins to strain with climbing. Here, at this turning-point, the wayfarers have reached the centre of the earth and of gravity. Thus the centre of Dis is the very heart and nucleus of everything that is not God or divine. Now, therefore, they begin to climb up through the earth to a spot antipodal to Jerusalem, which as we know from Canto I of *Inferno* lies above the outer rim of Hell: Satan, in his fall, came as far as possible from that holy city. Finally, the poets emerge from a cleft in the rock. Dante, who has been confused by their passage through the centre of gravity, looks up expecting to see Lucifer standing above him; instead, he sees him with 'his legs projecting high into the air'. Virgil explains to him the course of their journey and clarifies the poet's understanding of where they now are. At the lower right-hand corner of the drawing, Botticelli has sketched in the pair as they prepare to 'ascend into the shining world', following the sound of a little stream they hear but cannot see.

The Emperor of the Universe of Pain
jutted his upper chest above the ice;
and I am closer in size to the great mountain

the Titans make around the central pit,
than they to his arms. Now, starting from this part,
imagine the whole that corresponds to it!

* * *

If he was once as beautiful as now
he is hideous, and still turned on his Maker,
well may he be the source of every woe!

* * *

When we had reached the joint where the great thigh
merges into the swelling of the haunch,
my Guide and Master, straining terribly,

turned his head to where his feet had been
and began to grip the hair as if he were climbing;
so that I thought we moved toward Hell again.

* * *

'Get up. Up on your feet,' my Master said.
'The sun already mounts to middle tierce,
and a long road and hard climbing lie ahead.'

* * *

He to me: 'You imagine you are still
on the other side of the center where I grasped
the shaggy flank of the Great Worm of Evil

which bores through the world – you were while I climbed down,
but when I turned myself about, you passed
the point to which all gravities are drawn.

You are under the other hemisphere where you stand;
the sky above us is the half opposed
to that which canopies the great dry land.

Under the mid-point of that other sky
the Man who was born sinless and who lived
beyond all blemish, came to suffer and die.'

* * *

My Guide and I crossed over and began
to mount that little known and lightless road
to ascend into the shining world again.

He first, I second, without thought of rest
we climbed the dark until we reached the point
where a round opening brought in sight the blest

and beauteous shining of the Heavenly cars.
And we walked out once more beneath the Stars.

Satan, Emperor of the Universe of Pain

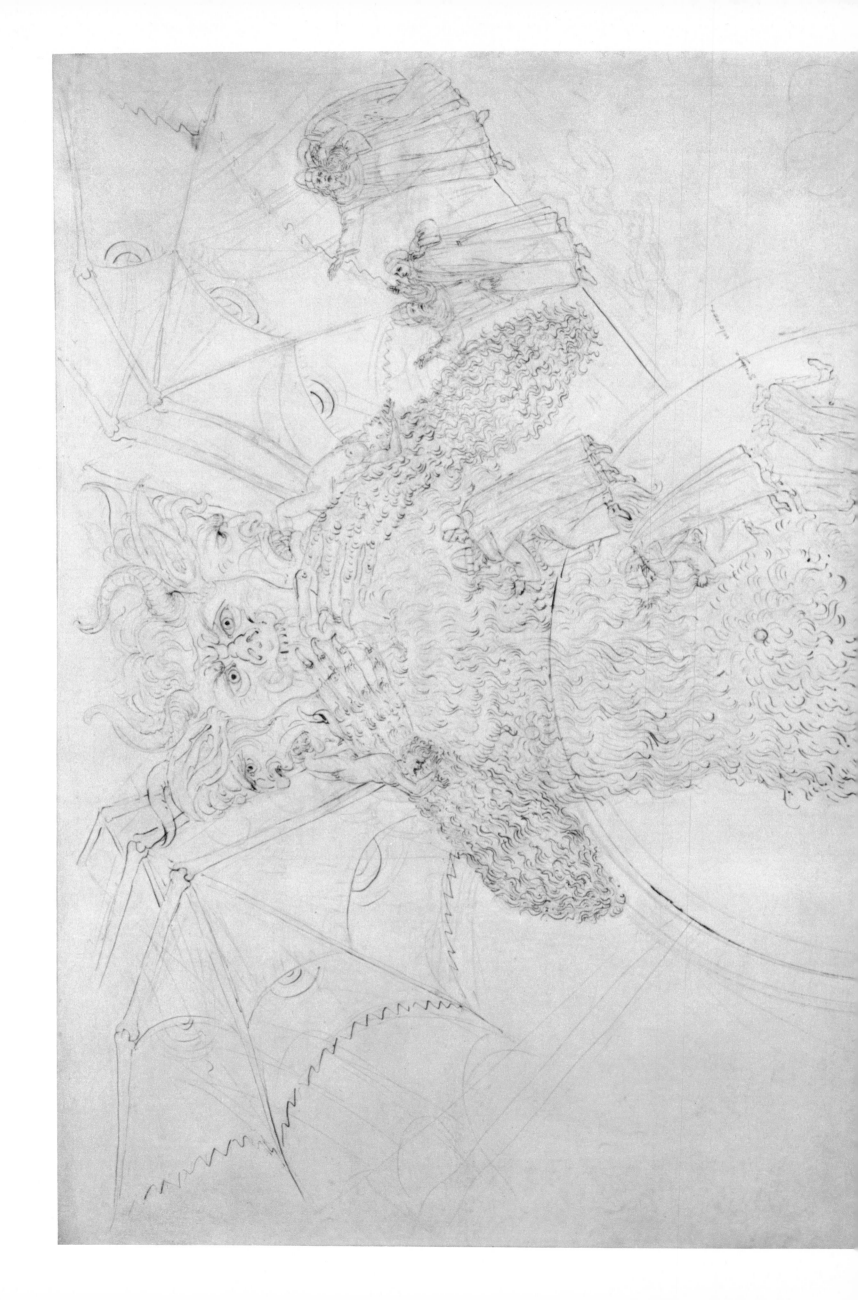

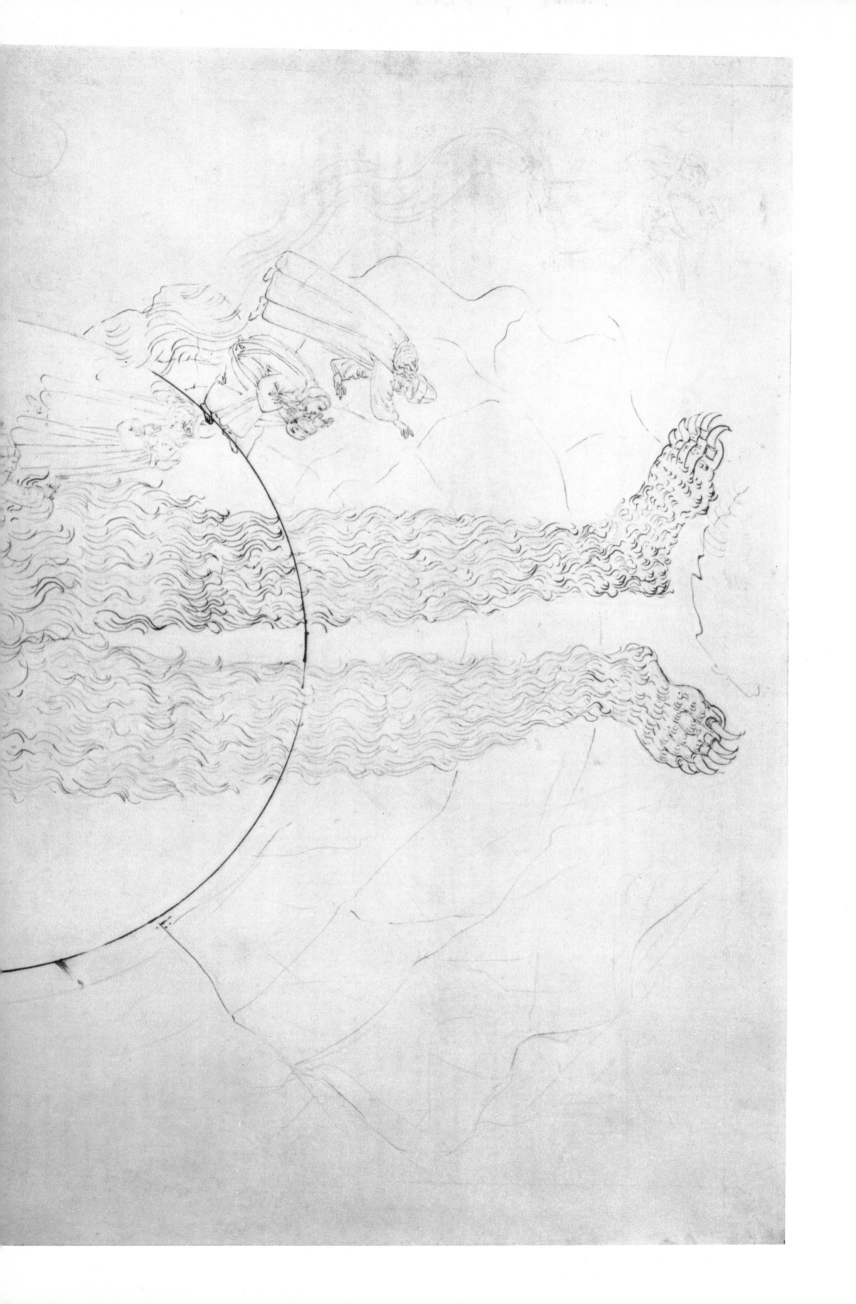

PURGATORIO

Cato of Utica

As HE DID at the beginning of the *Inferno*, Botticelli begins this *cantica's* drawings with a schematic diagram of the mount of Purgatory, seven-tiered and resting on a gently sloping hill in the centre of an island. Dante and Virgil emerge through the doorway at the hill's base, and they are challenged as fugitives from Hell by Cato of Utica, on the right of the drawing. Cato the Younger had been brought up as a Stoic and during his lifetime (95–46 BC) was conspicuous for his rigid morality. Though by his suicide for political reasons he might be considered more suitably a character in Dante's *Inferno* than here, where all the inhabitants are destined eventually to a place in Paradise, Cato's love of liberty and high moral code moved Dante the poet to represent him as custodian of the souls in Purgatory. Barely visible in Botticelli's drawing, the two poets come to Cato and Dante kneels. They must, Cato says, go to the shore, where Virgil will wash Dante's face and hands with the dew of morning – for this is shortly before dawn on Easter Sunday, 1300 – and bind round his waist in token of humility a reed from those growing in the mud there. Cato then disappears, and Botticelli shows the bending Virgil collecting dew and, to the left, girding Dante with a reed whose stalk, when broken, regenerated a new reed, restoring itself to what it had been. At the left of his drawing, Botticelli anticipates the next canto with the arrival of new souls in Purgatory.

Now shall I sing that second kingdom given
the soul of man wherein to purge its guilt
and so grow worthy to ascend to Heaven.

* * *

Sweet azure of the sapphire of the east
was gathering on the serene horizon
its pure and perfect radiance – a feast

to my glad eyes, reborn to their delight,
as soon as I had passed from the dead air
which had oppressed my soul and dimmed my sight.

* * *

I saw, nearby, an ancient man, alone.
His bearing filled me with such reverence,
no father could ask more from his best son.

His beard was long and touched with strands of white,
as was his hair, of which two tresses fell
over his breast.

* * *

'Go then, and lead this man, but first see to it
you bind a smooth green reed about his waist
and clean his face of all trace of the pit.

For it would not be right that one with eyes
still filmed by mist should go before the angel
who guards the gate: he is from Paradise.'

* * *

We strode across that lonely plain like men
who seek the road they strayed from and who count
the time lost till they find it once again.

* * *

With gentle graces my Sweet Master bent
and laid both outspread palms upon the grass.
Then I, being well aware of his intent,

lifted my tear-stained cheeks to him, and there
he made me clean, revealing my true color
under the residues of Hell's black air.

* * *

There, as it pleased another, he girded me.
Wonder of wonders! when he plucked a reed
another took its place there instantly,

arising from the humble stalk he tore.
so that it grew exactly as before.

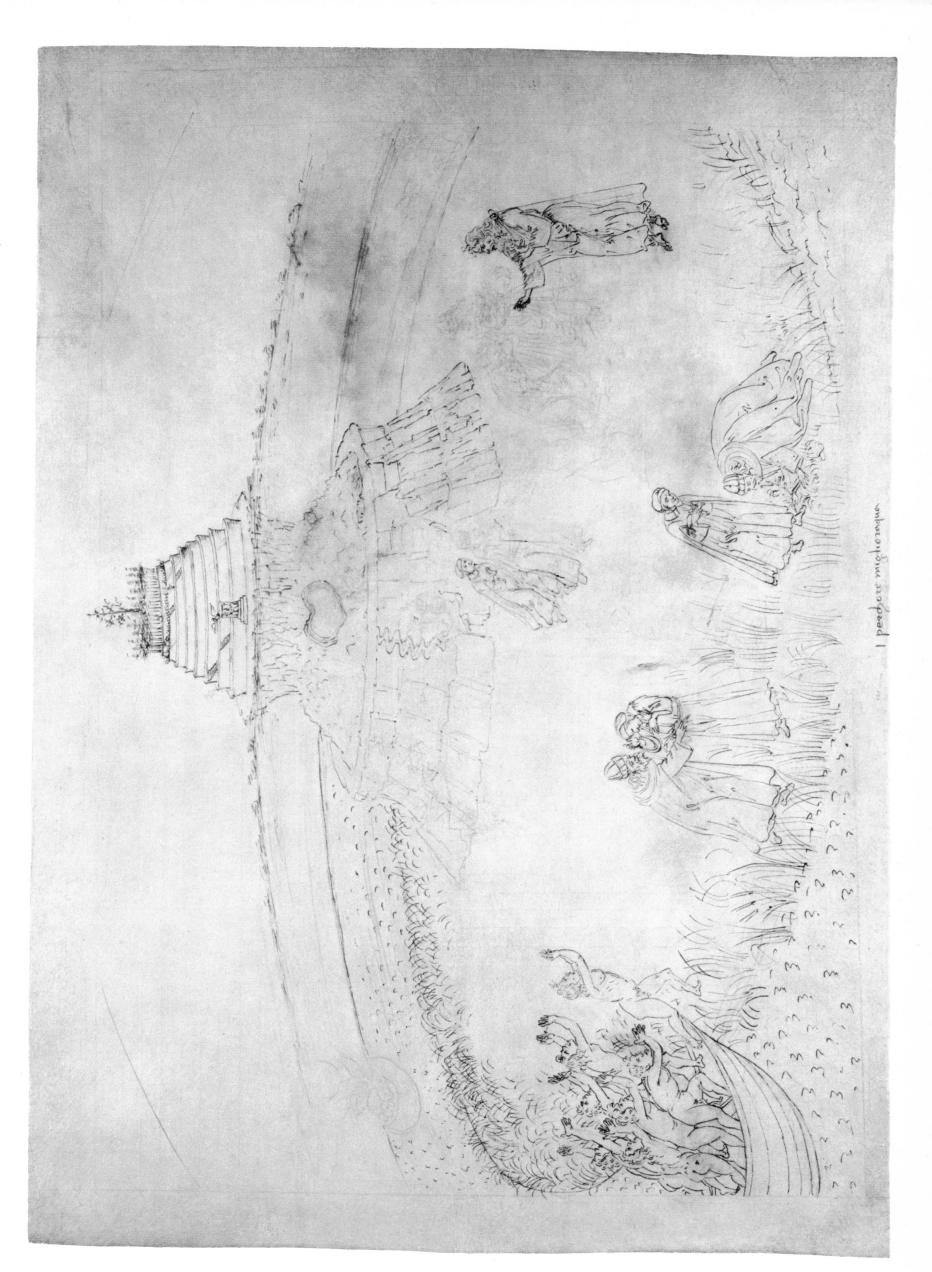

Ante-Purgatory

As THE LITTLE BOAT with its passengers (and because they are spirits it draws no water but, as Botticelli has shown it here and in the previous illustration, seems to skim across the water's surface) reaches the shore, Virgil commands Dante to kneel and fold his hands prayerfully before God's messenger, the Angel Boatman. The souls debark as the Angel, seated at the boat's stern, makes the Sign of the Cross with his upraised arm and hand. With the boat and its helmsman then departing, the spirits ask Dante and Virgil the way to the mount of Purgatory but, seeing Dante's breathing, they realize he is still alive and in his physical body, and rush towards him. One of them, in the centre of the drawing, comes forward to greet and be embraced by Dante but: 'Three times I clasped my hands behind him, and three times I drew them to my breast through empty air.' The spirit identifies himself to Dante as Casella, a friend of Dante and musician of Pistoia. At the poet's request, Casella begins to sing one of Dante's own *canzone*, but Cato, ever the disciplinarian, scolds the laggard souls and, on the right of the drawing, hurries them along to the mount of Purgatory. This is Ante-Purgatory, the mound on which Purgatory actually rests and where are purged by delay and waiting those whose sin in life was delay, stubbornness, carelessness or negligence.

'*Down on your knees! It is God's angel comes!*
Down! Fold your hands! From now on you shall see
many such ministers in the high kingdoms.'

* * *

See how his pinions tower upon the air,
pointing to Heaven: they are eternal plumes
and do not moult like feathers or human hair.'

Then as that bird of heaven closed the distance
between us, he grew brighter and yet brighter
until I could no longer bear the radiance,

* * *

and bowed my head. He steered straight for the shore,
his ship so light and swift it drew no water;
it did not seem to sail so much as soar.

* * *

The angel made the Sign of the Cross, and they
cast themselves, at his signal, to the shore.
Then, swiftly as he had come, he went away.

The throng he left seemed not to understand
what place it was, but stood and stared about
like men who see the first of a new land.

* * *

One came forward to embrace me, and his face
shone with such joyous love that, seeing it,
I moved to greet him with a like embrace.

* * *

In a voice as gentle as a melody
he bade me pause; and by his voice I knew him,
and begged him stay a while and speak to me.

He answered: 'As I loved you in the clay
of my mortal body, so do I love you freed:
therefore I pause. But what brings you this way?'

* * *

'*Casella mine, I go the way I do*
in the hope I may return here,' I replied.

* * *

I said to him, 'Oh sound a verse once more
to soothe my soul which, with its weight of flesh
and the long journey, sinks distressed and sore.'

'*Love that speaks its reasons in my heart,'*
he sang then, and such grace flowed on the air
that even now I hear that music start.

* * *

My Guide and I and all those souls of bliss
stood tranced in song; when suddenly we heard
the Noble Elder cry: 'What's this! What's this!

Negligence! Loitering! O laggard crew
run to the mountain and strip off the scurf
that lets not God be manifest in you!'

* * *

So that new band, all thought of pleasure gone,
broke from the feast of music with a start
and scattered for the mountainside.

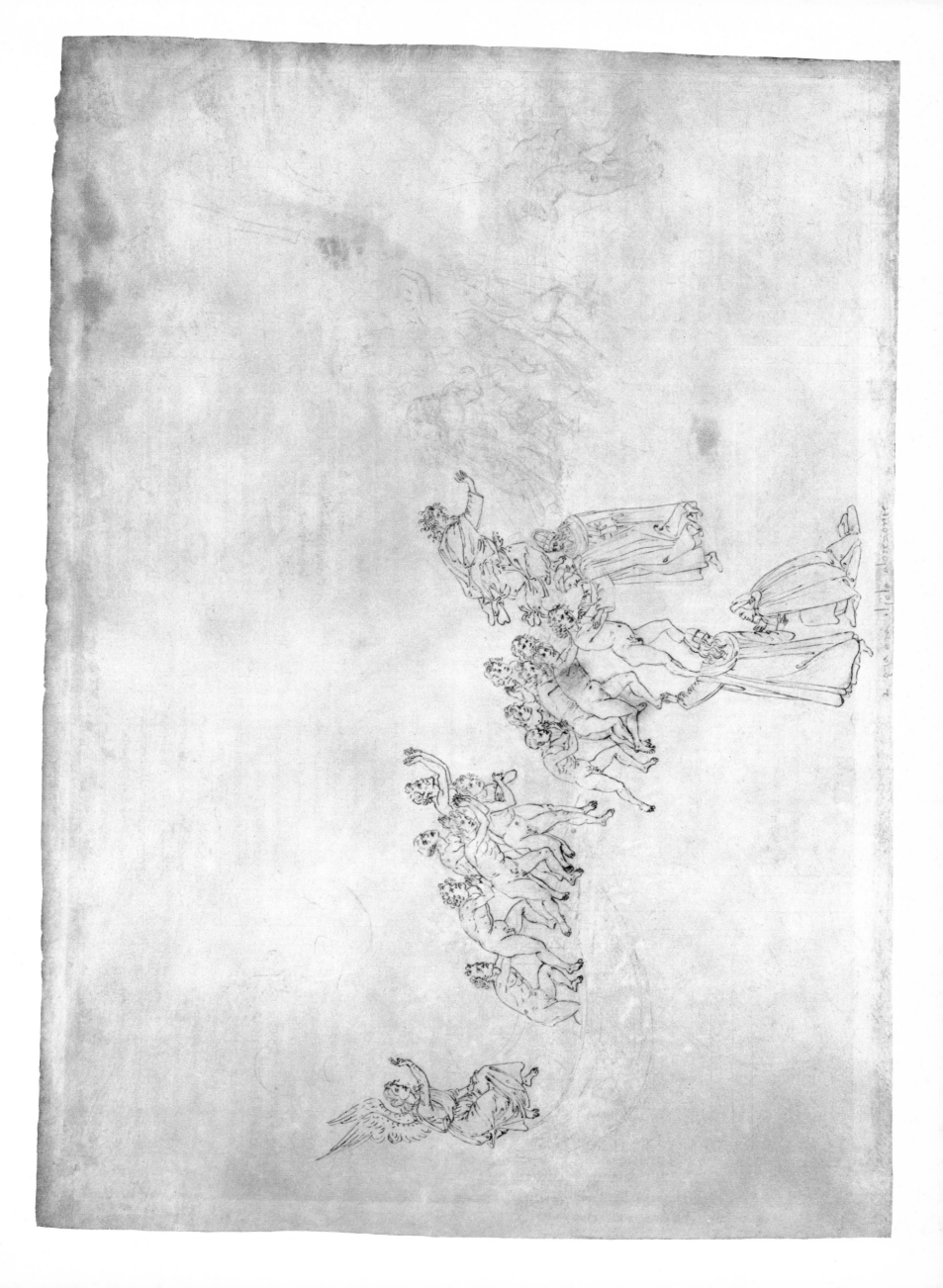

The Contumacious

As Dante and Virgil make their way, from the left of the drawing, across the plain at the foot of the mount of Purgatory, the sun has risen, and the Angel Boatman is seen in the background sailing away. Dante turns abruptly when he sees his own shadow only, and not his guide's as well; Virgil reminds him that he has long been dead and therefore without a body to cast a shadow. When they reach the foot of the mountain but cannot find a way to climb it, Virgil asks the spirits there how they may go up. These souls move exceedingly slowly and imitate one another's motions and gestures, like sheep coming through a gate. As Dante approaches them, his shadow falls on the rock-face and they shrink in fear. These are the Contumacious, who remained stubbornly disobedient to God until the moment of death. Before they may ascend even to the mount of Purgatory, they must wait here at its foot, in Ante-Purgatory, with no pain but that of their own frustrated desire for God. Among them is the spirit of Manfred of Sicily, who though he died excommunicate nevertheless at the end surrendered to God. The Contumacious, Manfred explains to Dante, must wait in Ante-Purgatory for thirty times the length of their delayed repentance.

Those routed souls scattered across the scene,
their faces once again turned toward the mountain
where Reason spurs and Justice picks us clean;

but I drew ever closer to my Guide:
and how could I have run my course without him?
Who would have led me up the mountainside?

* * *

Low at my back, the sun was a red blaze;
its light fell on the ground before me broken
in the form in which my body blocked its rays.

I gave a start of fear and whirled around
seized by the thought that I had been abandoned,
for I saw one shadow only on the ground.

And my Comfort turned full to me then to say:
'Why are you still uncertain? Why do you doubt
that I am here and guide you on your way?

Vespers have rung already on the tomb
of the body in which I used to cast a shadow.
It was taken to Naples from Brindisium.

If now I cast no shadow, should that fact
amaze you more than the heavens which pass the light
undimmed from one to another?'

* * *

My Guide exclaimed: 'Now who is there to say
in which direction we may find some slope
up which one without wings may pick his way!'

While he was standing, head bowed to his shoulders,
and pondering which direction we might take,
I stood there looking up among the boulders,

and saw upon my left beside that cliff-face
a throng that moved its feet in our direction,
and yet seemed not to, so slow was its pace.

* * *

As sheep come through a gate – by ones, by twos,
by threes, and all the others trail behind,
timidly, nose to ground, and what the first does

the others do, and if the first one pauses,
the others huddle up against his back,
silly and mute, not knowing their own causes –

just so, I stood there watching with my Guide,
the first row of that happy flock come on,
their look meek and their movements dignified.

And when the souls that came first in that flock
saw the light broken on the ground to my right
so that my shadow fell upon the rock,

they halted and inched back as if to shy,
and all the others who came after them
did as the first did without knowing why.

* * *

'Those who die contumacious, it is true,
though they repent their feud with Holy Church,
must wait outside here on the bank, as we do,

for thirty times as long as they refused
to be obedient, though by good prayers
in their behalf, that time may be reduced.'

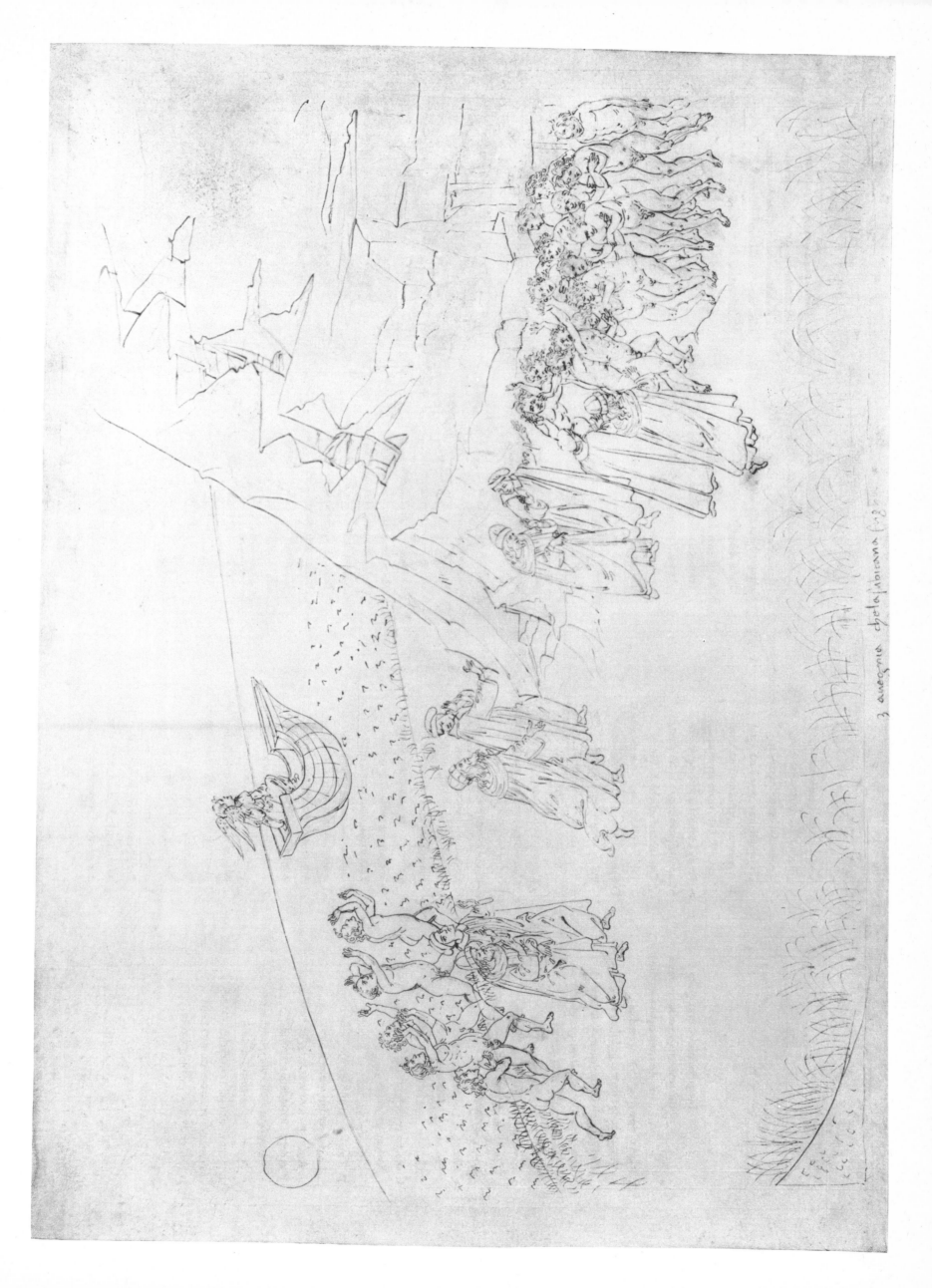

3 auesigma chetalabicorna (13)

The Indolent

AT THE DIRECTION of the Contumacious spirits, along the lower edge of the drawing, Dante and Virgil move to the cleft in the rock leading to the passage up to the first level of Ante-Purgatory. The high-walled passageway is very steep. Dante – like the Indolent souls whose place in Purgatory this is – complains to Virgil that the climb is too hard and taxing; his guide spurs him on. At last, they reach the first rock-shelf and sit resting, as Virgil explains to Dante that the first step upwards to repentance is always the most difficult and trying. From behind a massive boulder, at the upper right of the drawing, one of the spirits calls out to them, and the two poets make their way over to him. He is Belacqua, a Florentine maker of musical instruments who was noted among his contemporaries for his indolence. Belacqua had been a friend of Dante, who is well aware of his laziness and habits of procrastination. Because he put off turning back to God until just before his death, Belacqua must, he explains, wait here in Ante-Purgatory for exactly the length of his postponed repentance.

Often when grapes hang full on slope and ledge
the peasant, with one forkful of his thorns,
seals up a wider opening in his hedge

* * *

than the gap we found there in that wall of stone;
up which – leaving that band of souls behind –
my Guide led and I followed: we two alone.

Squeezed in between two walls that almost meet
we labor upward through the riven rock:
a climb that calls for both our hands and feet.

* * *

The climb had sapped my last strength when I cried:
'Sweet Father, turn to me: unless you pause
I shall be left here on the mountainside!'

He pointed to a ledge a little ahead
that wound around the whole face of the slope.
'Pull yourself that much higher, my son,' he said.

His words so spurred me that I forced myself
to push on after him on hands and knees
until at last my feet were on that shelf.

There we sat, facing eastward, to survey
the trail we had just climbed; for oftentimes
a backward look comforts one on the way.

* * *

We turned together at the sound, and there,
close on our left, we saw a massive boulder
of which, till then, we had not been aware.

To it we dragged ourselves, and there we found
stretched in the shade, the way a slovenly man
lies down to rest, some people on the ground.

* *

His short words and his shorter acts, combined,
made me half smile as I replied: 'Belacqua,
your fate need never again trouble my mind.

Praise be for that. But why do you remain
crouched here? Are you waiting for a guide, perhaps?
Or are you up to your old tricks again?'

'Old friend,' he said, 'what good is it to climb? –
God's Bird above the Gate would never let me
pass through to start my trials before my time.

I must wait here until the heavens wheel past
as many times as they passed me in my life,
for I delayed the good sighs till the last.'

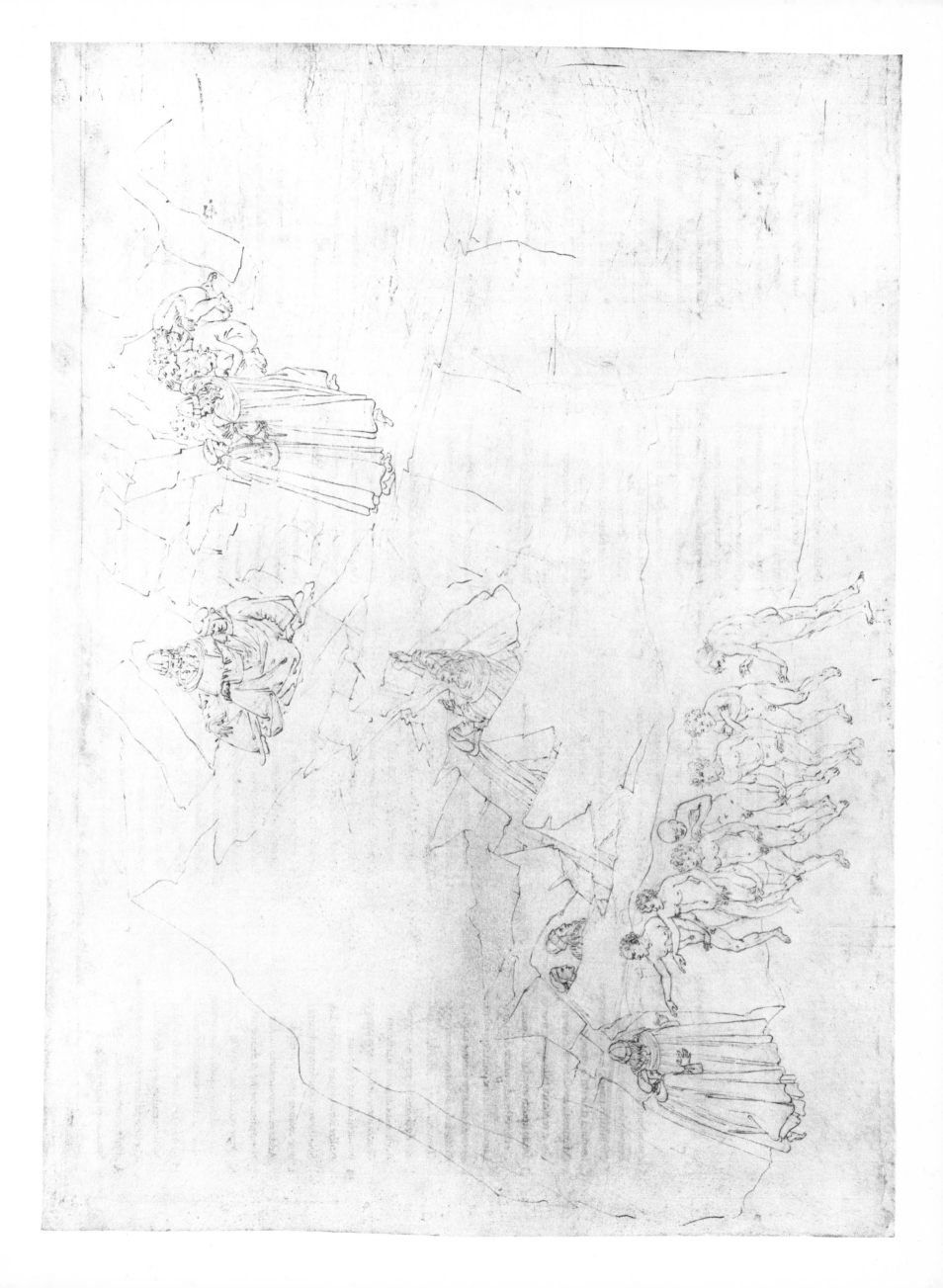

Those who died by Violence without the Last Rites

CONTINUING ALONG THEIR WAY up through Ante-Purgatory, Dante and Virgil pass a group of spirits, on the left in the drawing, who sit crouched beneath a rock; one of them points at Dante and exclaims that he has a shadow, and must therefore still be alive. In Hell, where the sun never shines, Dante cast no shadow; but here in Purgatory, on the surface of the earth, Dante and Virgil are travelling with the sun overhead, and Dante the poet uses the reiterated surprise at the shadow to remind the reader of that. As they proceed, the two poets come to a group of souls chanting the *Miserere*, Psalm 50 in the version of the Bible known to Dante and his contemporaries, and one of the seven 'Penitential Psalms', beginning: 'Have mercy on me, O God, in your goodness.' Two of the spirits break from the group and run up to Dante, again to ask if he is still living, and return, as Botticelli shows them, to their companions. At their return, all these souls approach the wayfarers. They are, they explain, the spirits of men and women who died by others' violence; they repented in their last moments, but died without the Church's last rites. As their lives were cut off and repentance was in a sense out of their hands, they are placed a step higher here than the Indolent and procrastinating. One of the two souls identifies himself as Jacopo del Cassero, of Fano in the kingdom of Naples, who was assassinated by a political rival; the other is Bonconte, a son of that Guido da Montefeltro whom Dante encountered among the Evil Counsellors in Hell (*Inferno* XXVII), who was a Ghibelline killed in a battle against the Guelphs.

I was following the footsteps of my Guide,
having already parted from those shades,
when someone at my back pointed and cried:

'Look there! see how the sun's shafts do not drive
through to the left of that one lower down,
and how he walks as if he were alive!'

I looked behind me to see who had spoken,
and I saw them gazing up at me alone,
at me, and at the light, that it was broken.

* *

'...when a man lets his attention range
toward every wisp, he loses true direction,
sapping his mind's force with continual change.'

* * *

Meanwhile across the slope a little before us
people approached chanting the Miserere
verse by verse in alternating chorus.

But when they noticed that I blocked the course
of the Sun's arrows when they struck my body,
their song changed to an 'Oh!...' prolonged and hoarse.

Out of that silenced choir two spirits ran
like messengers and, reaching us, they said:
'We beg to know – are you a living man?'

* * *

'Pure spirit,' they came crying, 'you who thus
while still inside the body you were born to
climb to your bliss – oh pause and speak to us.

* * *

We all are souls who died by violence,
all sinners to our final hour, in which
the lamp of Heaven shed its radiance

into our hearts. Thus from the brink of death,
repenting all our sins, forgiving those
who sinned against us, with our final breath

we offered up our souls at peace with Him
who saddens us with longing to behold
His glory on the throne of Seraphim.'

* * *

'I was of Fano, but the wounds that spilled
my life's blood and my soul at once, were dealt me
among the Antenori. I was killed

where I believed I had the least to fear.
Azzo of Este, being incensed against me
beyond all reason, had me waylaid there.'

* * *

'I am Bonconte, once of Montefeltro.
Because Giovanna and the rest forget me,
I go among these souls with head bowed low.'

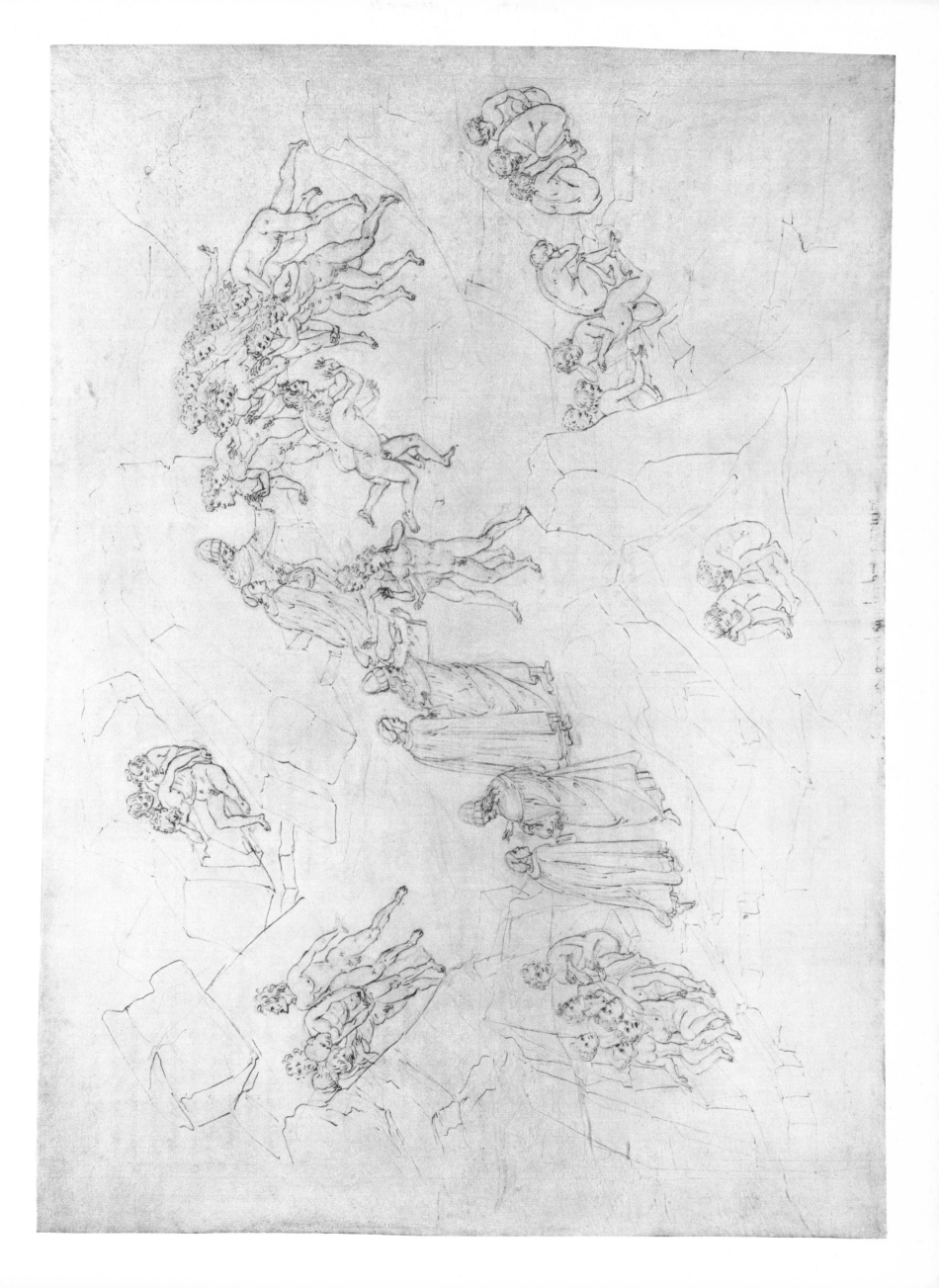

Those who died by Violence

THE CROWD OF SPIRITS remain around Dante, telling him (who is still alive) that the prayers of the living can shorten their time in Purgatory. Dante does not stop in his climb, but assures the souls he will bear word of them back to the world. As he and Virgil proceed, they discuss how prayer can seem to influence God's will, and Dante reminds Virgil that he himself had written in the sixth book of his Aeneid that it is bootless to think that 'heaven's decrees may be turned aside by prayer'. Virgil replies that Dante must wait to pose the question to Beatrice when he meets her, later in this *cantica*. Farther up the slope, at the upper centre of the drawing, the poets encounter the soul of Sordello, like Virgil a native of Mantua, and a troubadour of the early thirteenth century. Because perhaps the most renowned of Sordello's songs exhorted rulers to realize and fulfil their responsibilities, Dante the poet has placed him here as the two wayfarers' guide to the Negligent Rulers on the next level of Ante-Purgatory in the following canto.

When I had won my way free of that press
of shades whose one prayer was that others pray,
and so advance them toward their blessedness,

I said: 'O my Soul's Light, it seems to me
one of your verses most expressly states
prayer may not alter Heaven's fixed decree:

yet all these souls pray only for a prayer.
Can all their hope be vain? Or have I missed
your true intent and read some other there?'

And he: 'The sense of what I wrote is plain,
if you bring all your wits to bear upon it.
Nor is the hope of all these spirits vain.

* *

But save all questions of such consequence
till you meet her who will become your lamp
between the truth and mere intelligence.

Do you understand me? I mean Beatrice.
She will appear above here, at the summit
of this same mountain, smiling in her bliss.

* *

But see that spirit stationed all alone
and looking down at us: he will point out
the best road for us as we travel on.'

* *

Virgil . . . climbed to his side
and begged him to point out the best ascent.
The shade ignored the question and replied

by asking in what country we were born
and who we were. My gentle Guide began:
'Mantua . . .' And that shade, till then withdrawn,

leaped to his feet like one in sudden haste
crying: 'O Mantuan, I am Sordello
of your own country!' And the two embraced.

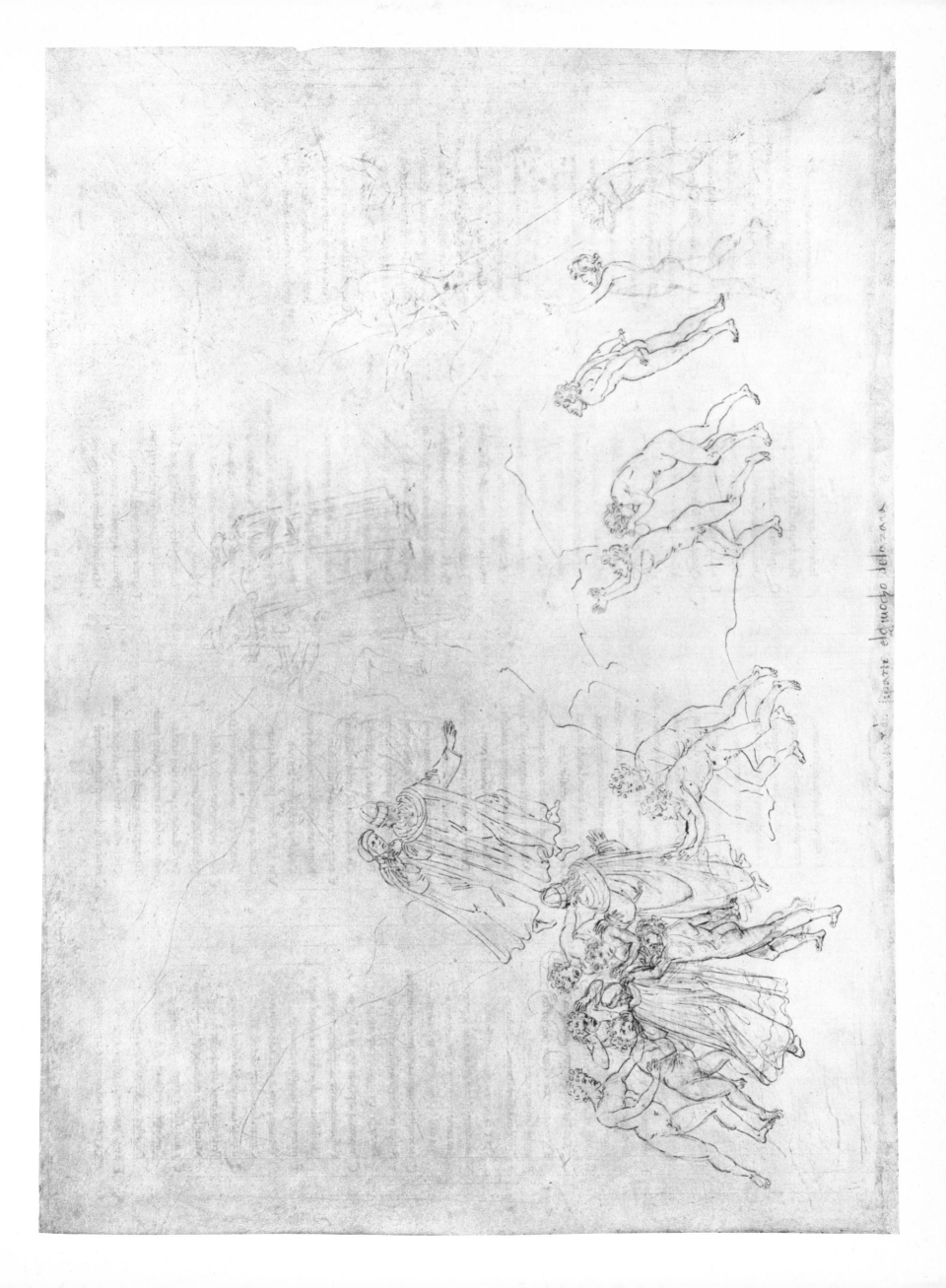

The Late Repentant
The Flowering Valley: Negligent Rulers

As Virgil identifies himself to his fellow Mantuan Sordello, the latter kneels and embraces him as 'Eternal glory of the Latin race'. Then Sordello crouches to draw on the ground a line beyond which the wayfarers may not proceed once the sun sets, according to the law of ascent. Thus, in his allegory, Dante the poet reinforces the understanding of Purgatory as a place of purgation in the sense of approach to God; when the sun, allegorically Divine Illumination, is absent, no progress is possible. The three proceed and Sordello points out to the pilgrims a hollow in the hillside, the Flowering Valley, where rest and wait the Negligent Rulers, whose responsibilities to others distracted them from their own spiritual welfare. At the top of the drawing Sordello is pointing out these kings and princes, only three of whom are finished here in ink: Rudolf I of Habsburg, Ottokar of Bohemia and his son Wenceslaus of Bohemia, Philip the Bold and his son Philip the Fair, Charles I of Naples and Sicily, Henry III of England, William of Monferrato and others. All except Henry were in some manner connected with the Holy Roman Empire and thus, in the mind of Dante the poet, sanctified by the divine right of kings. Hence their waiting in the Flowering Valley, a place of unearthly beauty and fragrance greater in its excellence than the other levels of Ante-Purgatory.

Three or four times in brotherhood the two
embraced and re-embraced, and then Sordello
drew back and said: 'Countryman, who are you?'

'Before those spirits worthy to be blessed
had yet been given leave to climb this mountain,
Octavian had laid my bones to rest.

I am Virgil, and I am lost to Heaven
for no sin, but because I lacked the faith.'
In these words was my Master's answer given.

* *

'We are not fixed in one place,' he replied,
'but roam at will up and around this slope
far as the Gate, and I will be your guide.

But the day is fading fast, and in no case
may one ascend at night: we will do well
to give some thought to a good resting place.

Some souls are camped apart here on the right.
If you permit, I will conduct you to them:
I think you will find pleasure in the sight.'

'What is it you say?' my Guide asked. 'If one sought
to climb at night, would others block his way?
Or would he simply find that he could not?'

'Once the sun sets,' that noble soul replied,
'you would not cross this line' – and ran his finger
across the ground between him and my Guide.

* * *

'There,' said that spirit, 'where the mountain makes
a lap among its folds: that is the place
where we may wait until the new day breaks.'

* * *

Salve Regina! – from that green the hymn
was raised to Heaven by a choir of souls
hidden from outer view by the glade's rim.

'Sirs,' said that Mantuan, 'do not request
that I conduct you there while any light
remains before the Sun sinks to its nest.

You can observe them from this rise and follow
their actions better, singly and en masse,
than if you moved among them in the hollow.'

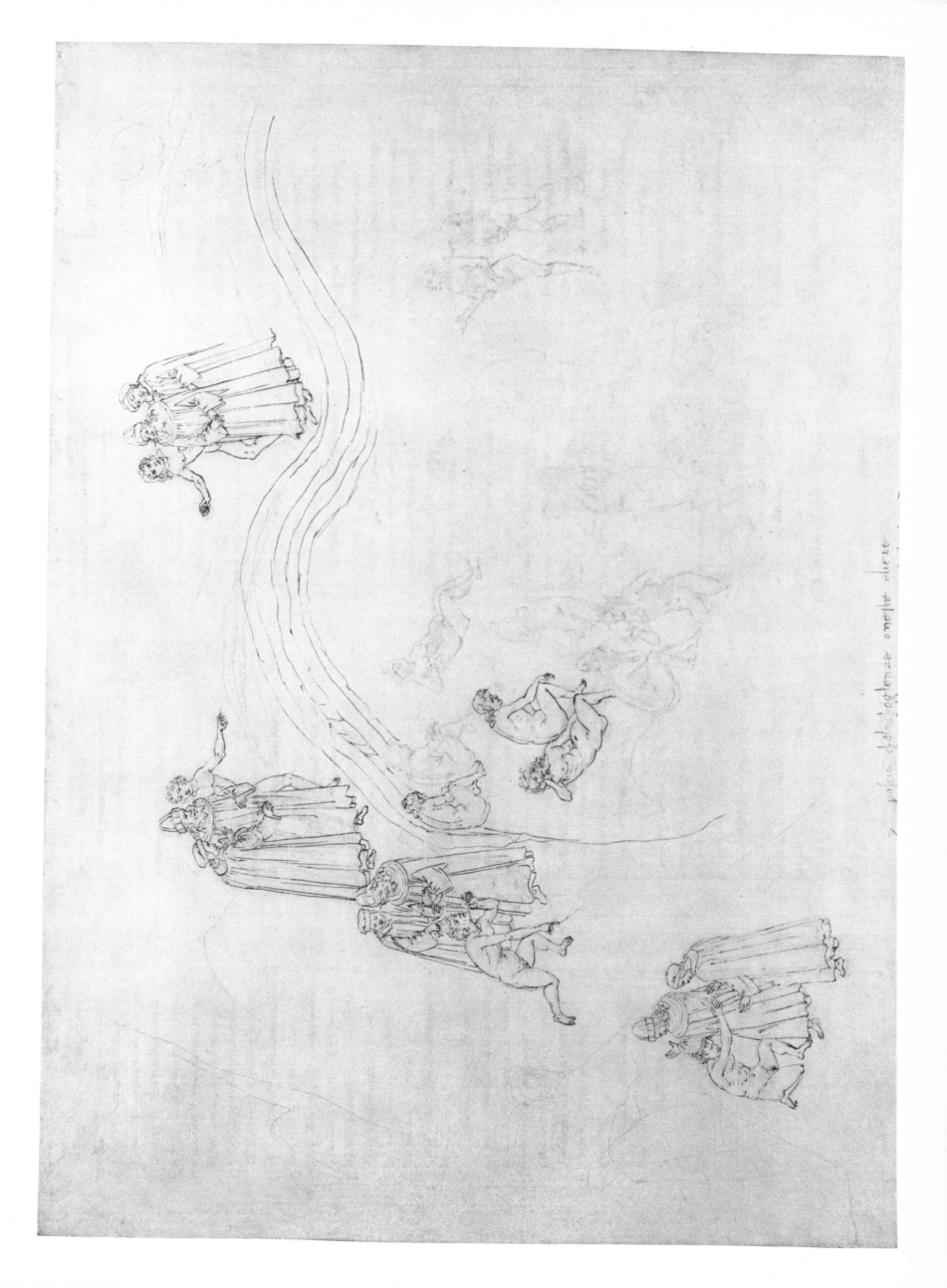

The Late Repentant
The Flowering Valley: the Angels and
the Serpent

THE FOUR WAYFARING poets and Sordello stand looking down at the souls in the Flowering Valley: it is dusk now, and the souls sing the Compline hymn, 'Te lucis ante terminum . . . Before the ending of the day', asking God's protection through the night against 'our ghostly foe'. Instantly two Angels appear, wearing green robes and with green wings. Angels of hope, whose colour they wear, they carry flaming but blunted swords. As in Botticelli's sketch here, one Angel stands on either side of the Flowering Valley to guard it from the Serpent, which appears in the lower right of the drawing and to which Sordello is gesturing. The Angels swoop down to chase away the Serpent which, hearing the beating of their wings, flees. The flaming swords of the Angels recall that of the Angel placed by God at the entrance to Paradise – an earlier green and flowering garden – to protect it from evil; Dante's Angels' blunted swords indicate that in Purgatory God's justice is tempered by His mercy.

Straight through the valley's unprotected side
a serpent came, perhaps the very one
that gave the bitter food for which Eve cried.

Through the sweet grass and flowers the long sneak drew,
turning its head around from time to time
to lick itself as preening beasts will do.

I did not see and cannot tell you here
how the celestial falcons took to flight;
but I did see that both were in the air.

Hearing their green wings beating through the night,
the serpent fled. The angels wheeled and climbed
back to their posts again in equal flight.

* *

Raising his hands, he joined his palms in prayer
and turned his rapt eyes east, as if to say:
'I have no thought except that Thou art there.'

'Te lucis ante' swelled from him so sweetly,
with such devotion and so pure a tone
my senses lost the sense of self completely.

Then all the others with a golden peal
joined in the hymn and sang it to the end,
their eyes devoutly raised to Heaven's wheel.

* * *

I saw two angels issue and descend
from Heaven's height, bearing two flaming swords
without a point, snapped off to a stub end.

Green as a leaf is at its first unfurling,
their robes; and green the wings that beat and blew
the flowing folds back, fluttering and whirling.

One landed just above me, and one flew
to the other bank. Thus, in the silent valley,
the people were contained between the two.

* *

'They are from Mary's bosom,' Sordello said,
'and come to guard the valley from the Serpent
that in a moment now will show its head.'

And I, not knowing where it would appear,
turned so I stood behind those trusted shoulders
and pressed against them icy-cold with fear.

* *

The Gate of Purgatory
The Angel Guardian

NIGHT HAS FALLEN, and Dante lies down to sleep. He dreams that a Golden Eagle takes him up to the 'sphere of fire' which in Dante's day was thought to exist above the sphere of air and below the sphere of the moon. When he wakes, he sees that he and Virgil, at the top of Botticelli's drawing, have left the Flowering Valley and are on the rampart around Purgatory itself. At its gate, to which the poets hasten, sits wordless and unmoving an Angel Guardian. The Angel challenges them, and at last calls them forward. Virgil tells Dante to prostrate himself and beg entrance from the Angel. With the tip of his sword, the Angel cuts into Dante's brow seven P's, for each of the seven capital sins, in Latin *peccata*. In his left hand, the Angel holds two keys, one of gold, the other of silver; these are the Keys of Peter, who has bade the Angel to be 'more eager to let in than to keep out'. With the keys he opens the gates behind him in the drawing, warning Dante not to look back, a reiteration of the fact that in Dante's Purgatory one must go always forward and upward. Lightly sketched in behind the Angel in Botticelli's drawing are Dante and Virgil entering into Purgatory's first level.

In a dream I saw a soaring eagle hold
the shining height of heaven, poised to strike,
yet motionless on widespread wings of gold.

* * *

I thought to myself: 'Perhaps his habit is
to strike at this one spot; perhaps he scorns
to take his prey from any place but this.'

Then from his easy wheel in Heaven's spire,
terrible as a lightning bolt, he struck
and snatched me up high as the Sphere of Fire.

It seemed that we were swept in a great blaze,
and the imaginary fire so scorched me
my sleep broke and I wakened in a daze.

* * *

I sat up with a start; and as sleep fled
out of my face, I turned the deathly white
of one whose blood is turned to ice by dread.

There at my side my comfort sat – alone.
The sun stood two hours high, and more. I sat
facing the sea. The flowering glen was gone.

'Don't be afraid,' he said. 'From here our course
leads us to joy, you may be sure. Now, therefore,
hold nothing back, but strive with all your force.'

* * *

As we drew near the height, we reached a place
from which – inside what I had first believed
to be an open breach in the rock face –

I saw a great gate fixed in place above
three steps, each its own color; and a guard
who did not say a word and did not move.

Slow bit by bit, raising my lids with care,
I made him out seated on the top step,
his face more radiant than my eyes could bear.

He held a drawn sword, and the eye of day
beat such a fire back from it, that each time
I tried to look, I had to look away.

* * *

Seven P's, the seven scars of sin,
his sword point cut into my brow. He said:
'Scrub off these wounds when you have passed within.'

* * *

He drew out two keys.

One was of gold, one silver. He applied
the white one to the gate first, then the yellow,
and did with them what left me satisfied.

* * *

Then opening the sacred portals wide:
'Enter. But first be warned: do not look back
or you will find yourself once more outside.'

The Proud

With the Gates of Purgatory, at the bottom centre of the drawing, behind them, Dante and Virgil proceed to the First Terrace of Purgatory, where the Proud are cleansed of the remnants of sin, through a narrow zigzag passage. Hell's gate is wide, but Purgatory's 'strait and close' as the eye of a needle. The inner face of the cliff is of marble, into which are carved scenes exemplifying incidents of great humility, to urge on the souls of the Proud to final purgation. Dante first sees, on the left of the drawing, a representation of the Annunciation, when Mary, to whom Gabriel has just declared that she is to be the mother of the Incarnate Word, humbly referred to herself as the handmaiden of the Lord. Virgil then directs Dante's attention to the second scene, and Botticelli draws the upper part of his body a second time as he turns abruptly to a sculpture of David the King dancing before the cart, drawn by two oxen, which brought the Ark of the Covenant into Jerusalem. David has put aside all the trappings of his high office to surrender in humility to his joy in the Lord, though his wife Michal, lightly sketched in as looking from a window of the palace in the background, ridiculed him for what she considered his loss of dignity. Finally, the last panel depicts a legendary incident from the life of the Roman Emperor Trajan who interrupted a cavalry march to redress the injustice done to a poor widow by the murder of her son. Beneath this last panel are two figures of the Prideful, crawling on all fours beneath enormous slabs of rock: the higher they tried to raise themselves in life by pride, the heavier their burden here and the deeper their abasement.

When we had crossed the threshold of that gate
so seldom used because man's perverse love
so often makes the crooked path seem straight,

I knew by the sound that it had closed again;
and had I looked back, to what water ever
could I have gone to wash away that stain?

We climbed the rock along a narrow crack
through which a zigzag pathway pitched and slid
just as a wave swells full and then falls back.

* *

Our feet had not yet moved a step up there,
when I made out that all the inner cliff
which rose without a foothold anywhere

was white and flawless marble and adorned
with sculptured scenes beside which Polyclitus',
and even Nature's, best works would be scorned.

The Angel who came down from God to man
with the decree of peace the centuries wept for,
which opened Heaven, ending the long ban,

stood carved before us with such force and love,
with such a living grace in his whole pose,
the image seemed about to speak and move.

* *

'Do not give all your thoughts to this one part,'
my gentle Master said. (I was then standing
on that side of him where man has his heart.)

I turned my eyes a little to the right
(the side on which he stood who had thus urged me)
and there, at Mary's back, carved in that white

and flawless wall, I saw another scene,
and I crossed in front of Virgil and drew near it
the better to make out what it might mean.

Emerging from the marble were portrayed
the cart, the oxen, and the Ark from which
the sacrilegious learned to be afraid.

* * *

Here was portrayed from glorious history
that Roman Prince whose passion to do justice
moved Gregory to his great victory.

I speak of Trajan, blessed Emperor.
And at his bridle was portrayed a widow
in tears wept from the long grief of the poor.

* * *

'Master,' I said, 'those do not seem to me
people approaching us; nor do I know –
they so confuse my sight – what they may be.'

* * *

True, those who crawled along that painful track
were more or less distorted, each one bent
according to the burden on his back;

yet even the most patient, wracked and sore,
seemed to be groaning: 'I can bear no more!'

The Proud

THE POET-WAYFARERS watch the souls of the Proud creep near, and Virgil asks one of them, hidden from view beneath his burden, the way of ascent up Purgatory. In Botticelli's drawing, Dante bends to one knee to look at the spirit and hear him. He was in life Omberto Aldobrandescho he says without turning his head, for the stone he carries is so huge that he cannot, scion of a powerful and proud Ghibelline family. Omberto explains that his pride of birth was his principal sin. Another soul, whose burden is lighter, twists about and calls out to Dante: he is Oderisi da Gubbio, a renowned Bolognese miniature painter who was known to his contemporaries as vain and boastful of his talents. Though he draws Dante and Virgil as if entering the scene from the right, Botticelli appears to have then interpreted the action of this canto from the left, with the desperately laden Omberto the first at that side, being listened to by the crouching Dante, followed by Oderisi.

'I am Omberto, and my haughty ways
were not my ruin alone, but brought my house
and all my followers to evil days.

Here until God be pleased to raise my head
I bear this weight. Because I did not do so
among the living, I must among the dead.'

I had bowed low, better to know his state,
when one among them – not he who was speaking –
twisted around beneath his crushing weight,

saw me, knew me, and cried out. And so
he kept his eyes upon me with great effort
as I moved with those souls, my head bowed low.

'Aren't you Od'risi?' I said. 'He who was known
as the honor of Agobbio, and of that art
Parisians call illumination?'

'Brother,' he said, 'what pages truly shine
are Franco Bolognese's. The real honor
is all his now, and only partly mine.

While I was living, I know very well,
I never would have granted him first place,
so great was my heart's yearning to excel.

Here pride is paid for. Nor would I have been
among these souls, had I not turned to God
while I still had in me the power to sin.

* * *

The fame of man is like the green of grass:
it comes, it goes; and He by whom it springs
bright from earth's plenty makes it fade and pass.'

The Proud

VIRGIL URGES DANTE to move along through this terrace, and points out to him scenes of destruction and tragedy wrought by pride, counterbalancing the carvings at the entrance to this terrace which had glorified the triumph of humility. First is Satan, transformed by pride from the most excellent of the angels into a monster; to the left of him the dismembered body of the Titan Briareus, who was felled by a thunderbolt as he tried to overthrow the gods of Olympus (*Inferno* XXXI); surrounding the giant's scattered limbs are Jupiter, Apollo and Mars, with Pallas Athene holding her shield with the gorgon's head on it. In the centre of the drawing is the fall of the tower of Babel with Nimrod at its foot, and to the left Niobe, weeping over three of her fourteen children, all of whom were killed by Apollo for their mother's boasting love of them. Lightly sketched in is the figure of Saul fallen upon his own sword after his defeat by the Philistines. In the lower left is the besieged Troy. When they have examined all these scenes, Virgil urges Dante forward to meet the Angel approaching them with arms and wings outspread. The Angel and Dante embrace and then, at the foot of the staircase, the Angel beats the tips of his wings about Dante's forehead. As, finally, the wayfarers ascend to the next terrace, and Dante touches his forehead to discover that one P – this one for the sin of pride – has been removed from it, they hear the Angel singing 'Beati pauperes spiritu – Blessed are the poor in spirit.'

'*Look down. You will find solace on the way*
in studying what pavement your feet tread.

* * *

Mark there, on one side, him who had been given
a nobler form than any other creature.
He plunged like lightning from the peak of Heaven.

Mark, on the other, lying on the earth,
stricken by the celestial thunderbolt,
Briareus, heavy with the chill of death.

Mark there, still armed, ranged at their father's side,
Thymbraeus, Mars, and Pallas looking down
at the Giants' severed limbs strewn far and wide.

Mark Nimrod at the foot of his great tower,
bemused, confounded, staring at his people
who shared at Shinar his mad dream of power.

Ah, Niobe! with what eyes wrung with pain
I saw your likeness sculptured on that road
between your seven and seven children slain!

Ah, Saul! how still you seemed to me, run through
with your own sword, dead upon Mount Gilboa,
which never after that felt rain nor dew.'

* * *

We had, I found, gone round more of the mount,
and the sun had run more of its daily course,
than my bound soul had taken into account;

when Virgil, ever watchful, ever leading,
commanded: 'Lift your head. This is no time
to be shut up in your own thoughts, unheeding.

Look there and see an Angel on his way
to welcome us; and see – the sixth handmaiden
returns now from her service to the day.

That he may gladly send us up the mountain,
let reverence grace your gestures and your look.
Remember, this day will not dawn again.'

* * *

'Master,' I said, 'tell me what heaviness
has been removed from me that I can climb
yet seem to feel almost no weariness.'

He answered: 'When the P's that still remain,
though fading, on your brow, are wiped away
as the first was, without a trace of stain –

then will your feet be filled with good desire:
not only will they feel no more fatigue
but all their joy will be in mounting higher.'

* * *

I put my right hand to my brow,
fingers outspread, and found six letters only
of those that had been carved there down below

by the Angel with the keys to every grace;
at which a smile shone on my Master's face.

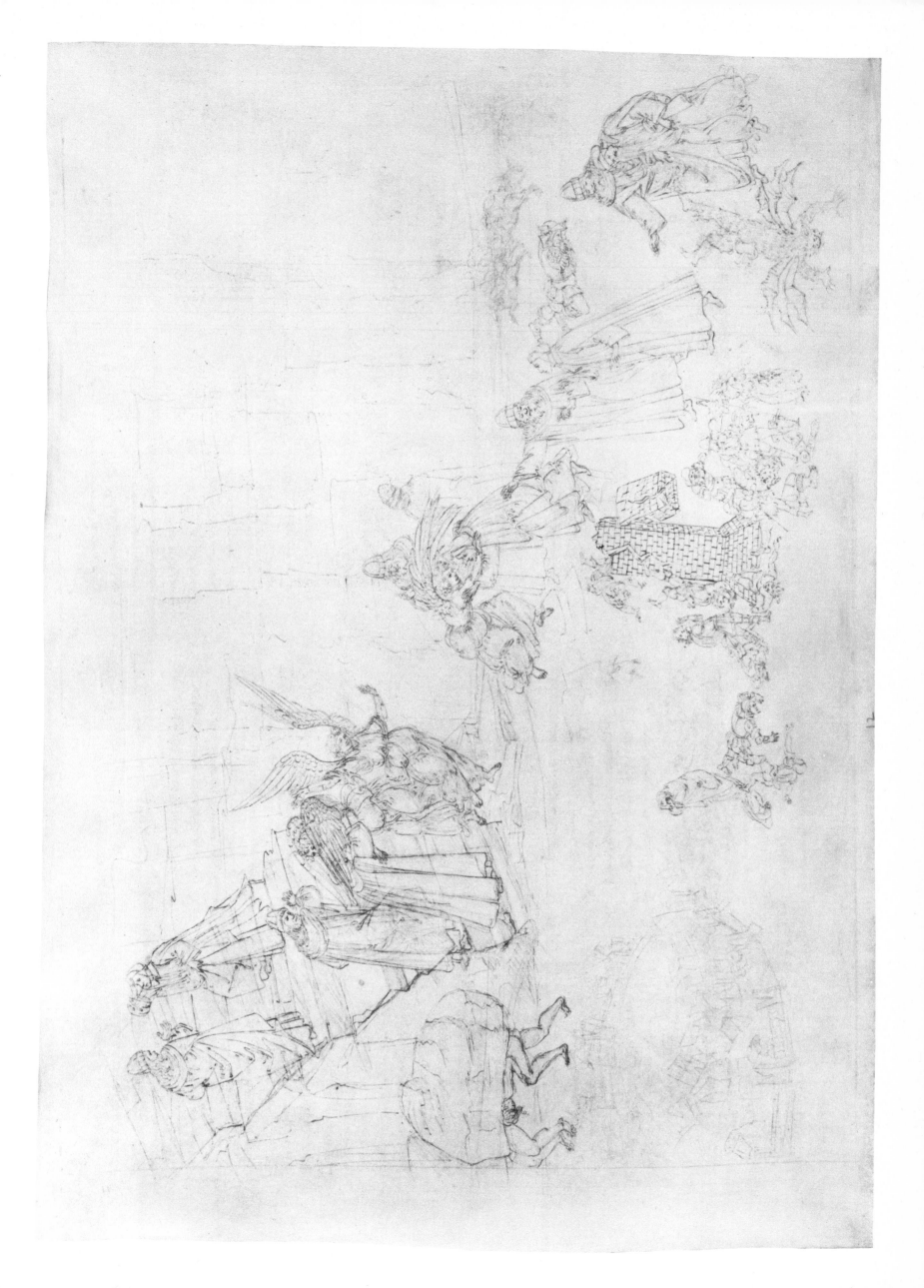

We climbed the stairs and stood, now, on the track
where, for a second time, the mount that heals
all who ascend it, had been terraced back.

* *

'Were we to wait till someone came this way
who might direct us,' Virgil said to me,
'I fear that would involve a long delay.'

Then he looked up and stared straight at the sun;
and then, using his right side as a pivot,
he swung his left around; then he moved on.

* *

We moved on with a will, and in a while
we had already gone so far up there
as would be reckoned, here on earth, a mile;

when we began to hear in the air above
invisible spirits who flew toward us speaking
sweet invitations to the feast of love.

The first voice that flew past rang to the sky
'Vinum non habent.' And from far behind us
we heard it fade repeating the same cry.

Even before we heard it cry its last
around the slope, another voice rang out:
'I am Orestes!' — and it, too, sped past.

'Sweet Father,' I began, 'what are these cries?' —
and even as I asked, I heard a third
bodiless voice say: 'Love your enemies.'

* *

The Envious

DANTE AND VIRGIL ascend to the Second Terrace of Purgatory and, because there is no spirit in sight to guide them, Virgil turns towards the sun to get his bearings. As they walk on, spirit voices cry out examples of great love for others – the Virgin Mary, Orestes and Pylades, and Jesus – unending reminders to the souls here of their great failure, and Dante looks up in astonishment, both hands raised, at hearing them. Here, against stone walls of a livid colour – the colour of envy in Dante's time – and wrapped in cloaks of the same colour, sit the spirits of the envious. Because in life the very sight of their neighbour's prosperity caused them to sin, in Purgatory their eyes are stitched closed with wires, while they weep endlessly; further, though in their lives they widened the breach between themselves and others, here they sit huddled against and supporting one another. Among the spirits – on the left in this drawing – Dante encounters Sapia Saracini, a Sienese lady who, as she tells Dante, 'found more joy in the bad luck of others than in the good that fell to my lot'.

The impoverished blind who sit all in a row
during Indulgences to beg their bread
lean with their heads together exactly so,

the better to win the pity they beseech,
not only with their cries, but with their look
of fainting grief, which pleads as loud as speech.

* * *

'If this confession rings false to your ears,
hear my tale out; then see if I was mad.
— In the descending arc of my own years,

the blood of my own land was being spilled
in battle outside Colle's walls, and I
prayed God to do what He already willed.

So were they turned – their forces overthrown –
to the bitter paths of flight; and as I watched
I felt such joy as I had never known.'

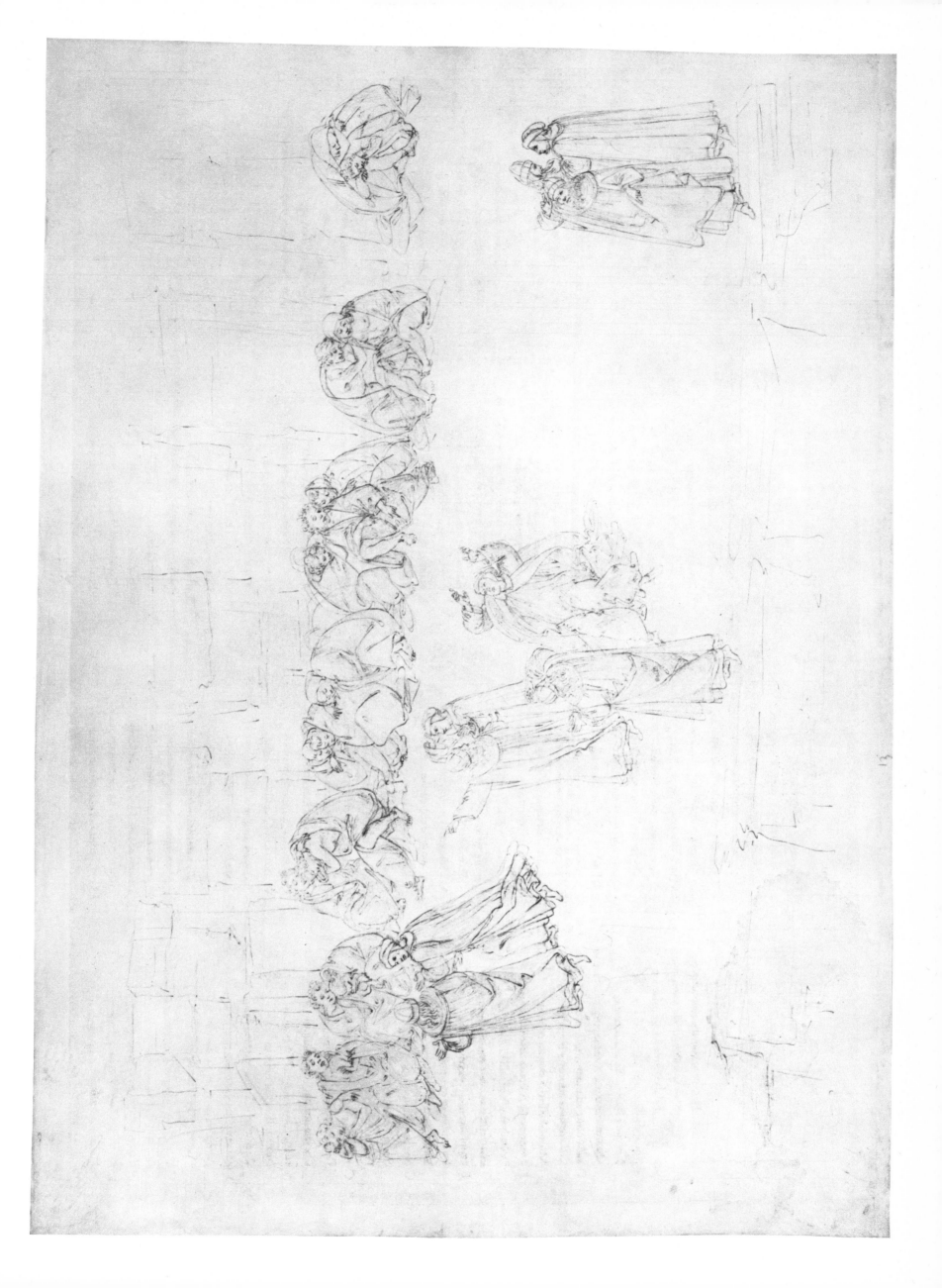

Thus, on my right, and leaning head to head,
two of those spirits were discussing me.
Then they turned up their faces, and one said:

'O soul that though locked fast within the flesh
still makes its way toward Heaven's blessedness,
in charity, give comfort to our wish:

tell us your name and city, for your climb
fills us with awe at such a gift of grace
as never has been seen up to this time.'

* * *

'The fires of envy raged so in my blood
that I turned livid if I chanced to see
another man rejoice in his own good.

This seed I sowed; this sad straw I reap here.
O humankind, why do you set your hearts
on what it is forbidden you to share?'

* * *

We had scarce left those spirits to their prayer,
when suddenly a voice that ripped like lightning
struck at us with a cry that split the air:

'All men are my destroyers!' It rolled past
as thunder rolls away into the sky
if the cloud bursts to rain in the first blast.

* * *

'I am Aglauros who was turned to stone!'
Whereat, to cower in Virgil's arms, I took
a step to my right instead of going on.

The Envious

LEAVING THE SPIRIT of Sapia, Dante and Virgil, on the right of the drawing, proceed along this terrace. Dante hears two of the spirits discussing who he may be – though they cannot see him, they know that he is a living man and is not alone – and stops to talk with them. They are Guido del Duca and Rinieri de' Paolucci da Calboli. Guido's confession of an envious life is the only testament to his sin that has come down to us, nor is there any documentary evidence of Rinieri's envious life; Dante the poet clearly includes them here as known to his contemporaries for being, respectively, Ghibelline and Guelph leaders, but without indicating precisely why they figure so importantly in this canto. The poet-wayfarers hurry along, in the centre of the drawing, and have hardly made progress when two voices are heard: Cain's, lamenting (as in Genesis 4, 14: 'Everyone that findeth me shall slay me') the punishment he suffers as the first man guilty of the sin of envy, and Aglauros', who was turned to stone because out of envy she tried to prevent the god Mercury from visiting her sister Herse, whom he loved. Thus the sinners in this terrace are reminded of the destructiveness of their sin, which in these two cases put brother against brother and sister against sister. Both Dante and Virgil are amazed and terror-struck at the regret and violence of the voices.

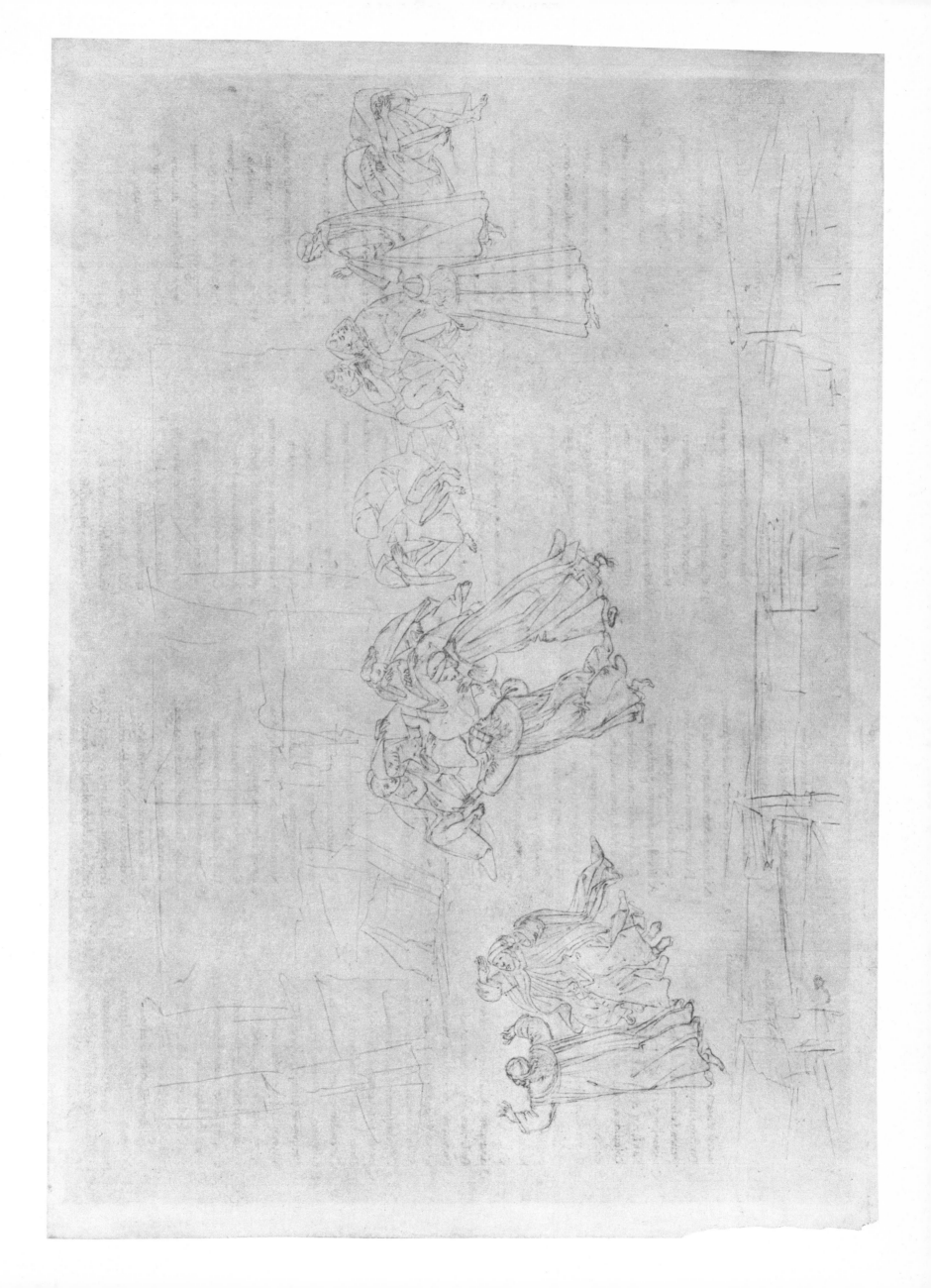

PURGATORIO XV

The Envious
The Wrathful

WALKING TOWARDS THE SUN with Virgil, Dante is dazzled by an even greater light, and raises his hands to shield his eyes. At the foot of the stairs leading up to the next terrace stands the Angel of Charity, pointing out the way. As he and Virgil begin to climb the stone stairway, Dante hears two choirs singing, one 'Blessed are the merciful', the other 'Rejoice thou who hast overcome'. The singing of the fifth beatitude of the Sermon on the Mount counterbalances by extolling compassion the egocentricity of envy; the second hymn is a personal encouragement to Dante, who is on the point of having erased from his forehead the second of the seven P's, this time the one standing for envy. At the head of the stairway, and now on the terrace of the Wrathful, Dante falls into a trance and has three dreams – of the Virgin Mary, of Pisistratos and of St Stephen – each an example of the gentleness antithetical to wrath. Lightly sketched in at the upper left of the drawing are Dante and Virgil about to make their circuit of this terrace in the black smoke in which the Wrathful work out their penitence.

The Sun's late rays struck us full in the face,
for in our circling course around the mountain
we now were heading toward his resting place.

Suddenly, then, I felt my brow weighed down
by a much greater splendor than the first.
I was left dazzled by some cause unknown

and raised my hands and joined them in the air
above my brows, making a sunshade of them
which, so to speak, blunted the piercing glare.

 * * *

'Dear Father, what is that great blaze ahead
from which I cannot shade my eyes enough,
and which is still approaching us?' I said.

'Do not be astonished,' answered my sweet Friend
'if those of the Heavenly Family still blind you.
He has been sent to bid us to ascend.'

 * * *

We stand before the Blessed Angel now.
With joyous voice he cries: 'Enter. The stair
is far less steep than were the two below.'

 * * *

Here suddenly, in an ecstatic trance,
I find myself caught up into a vision.

 * * *

And there ahead of us against the light
we saw come billowing in our direction
by slow degrees, a smoke as black as night.

Nor was there refuge from it anywhere.
It took our sight from us, and the pure air.

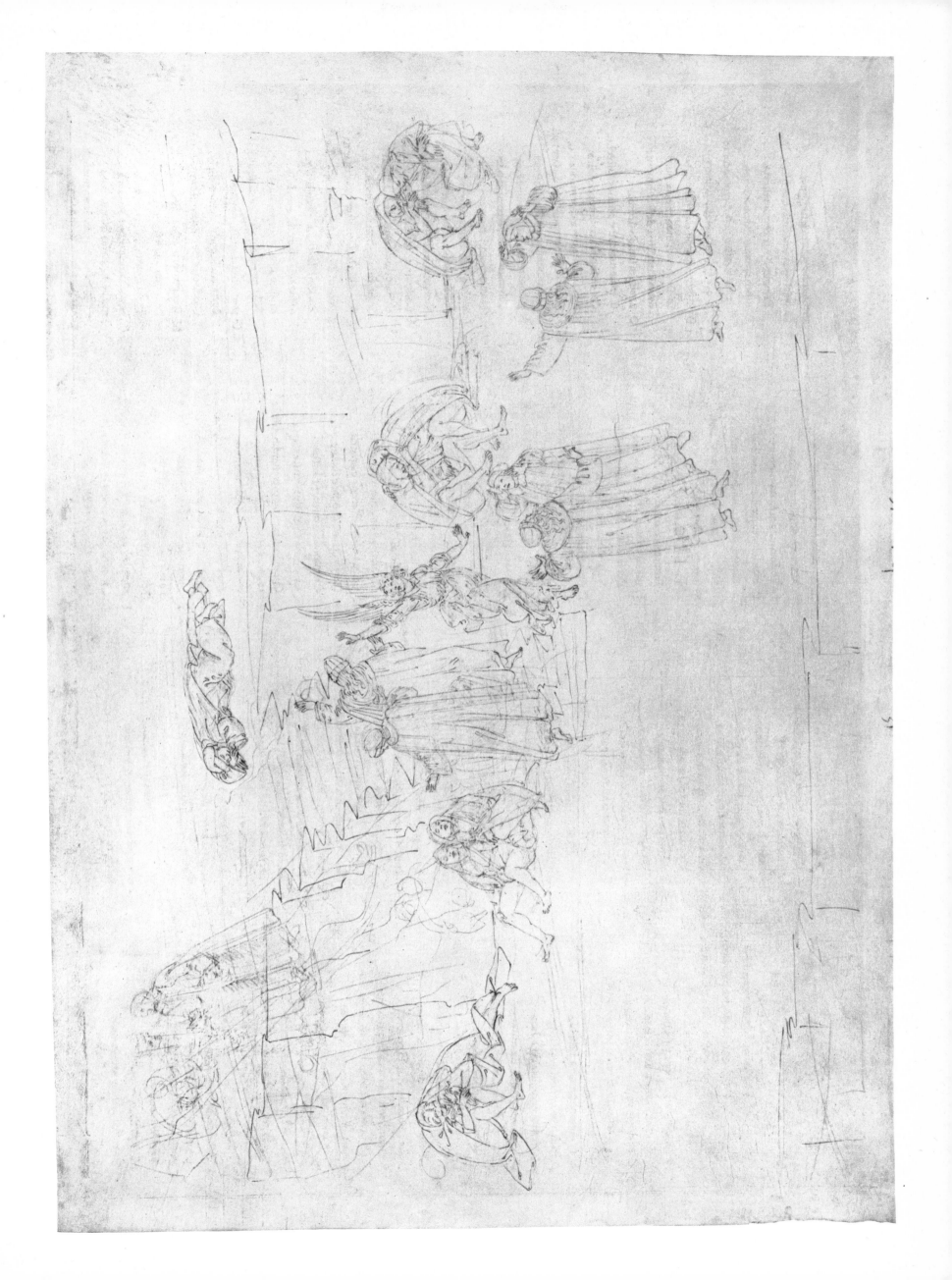

The Wrathful

THROUGH SMOKE AS CORROSIVE as wrath to the soul and obscuring the light as anger does love, the pilgrim poets begin their journey on this third terrace. Dante holds on to Virgil's garment, following him like a blind man. The spirits here chant unceasingly a prayer for mercy to the gentle Lamb of God, 'loosening the knot of Wrath', as they walk about with hands folded in supplication. In the centre of the drawing Dante and Virgil turn to listen to one of the spirits who calls out to them. Marco Lombardo is his name, he tells Dante, and he walks along with the two wayfarers, conversing with Dante on a number of subjects, particularly the Church's loss of spirituality and growing corruption because of its increasing wealth and temporal power. At last, as the light of the Angel of Meekness breaks through the black and stinging smoke, Dante and Virgil, on the left of the drawing, leave Marco behind to ascend to the next terrace.

Just as a blindman – lest he lose his road
or tumble headlong and be hurt or killed –
walks at his guide's back when he goes abroad ;

so moved I through that foul and acrid air,
led by my sweet Friend's voice, which kept repeating :
'Take care. Do not let go of me. Take care.'

And I heard other voices. They seemed to pray
for peace and pardon to the Lamb of God
which, of Its mercy, takes our sins away.

They offered up three prayers, and every one
began with Agnus Dei, and each word
and measure rose in perfect unison.

* *

'I was a Lombard. Marco was my name.
I knew the ways of the world, and loved that good
at which the bows of men no longer aim.

You are headed the right way to reach the stair
that leads above,' he added. And : 'I pray you
to pray for me when you have mounted there.'

* *

'O Marco mine,' I said, 'you reason well!
And now I know why Levi's sons alone
could not inherit wealth in Israel.'

* *

'See there across the smoke, like dawn's first rays,
the light swell like a glory and a guide.
The Angel of this place gives forth that blaze,

and it is not fit he see me.' Thus he spoke,
and said no more, but turned back through the smoke.

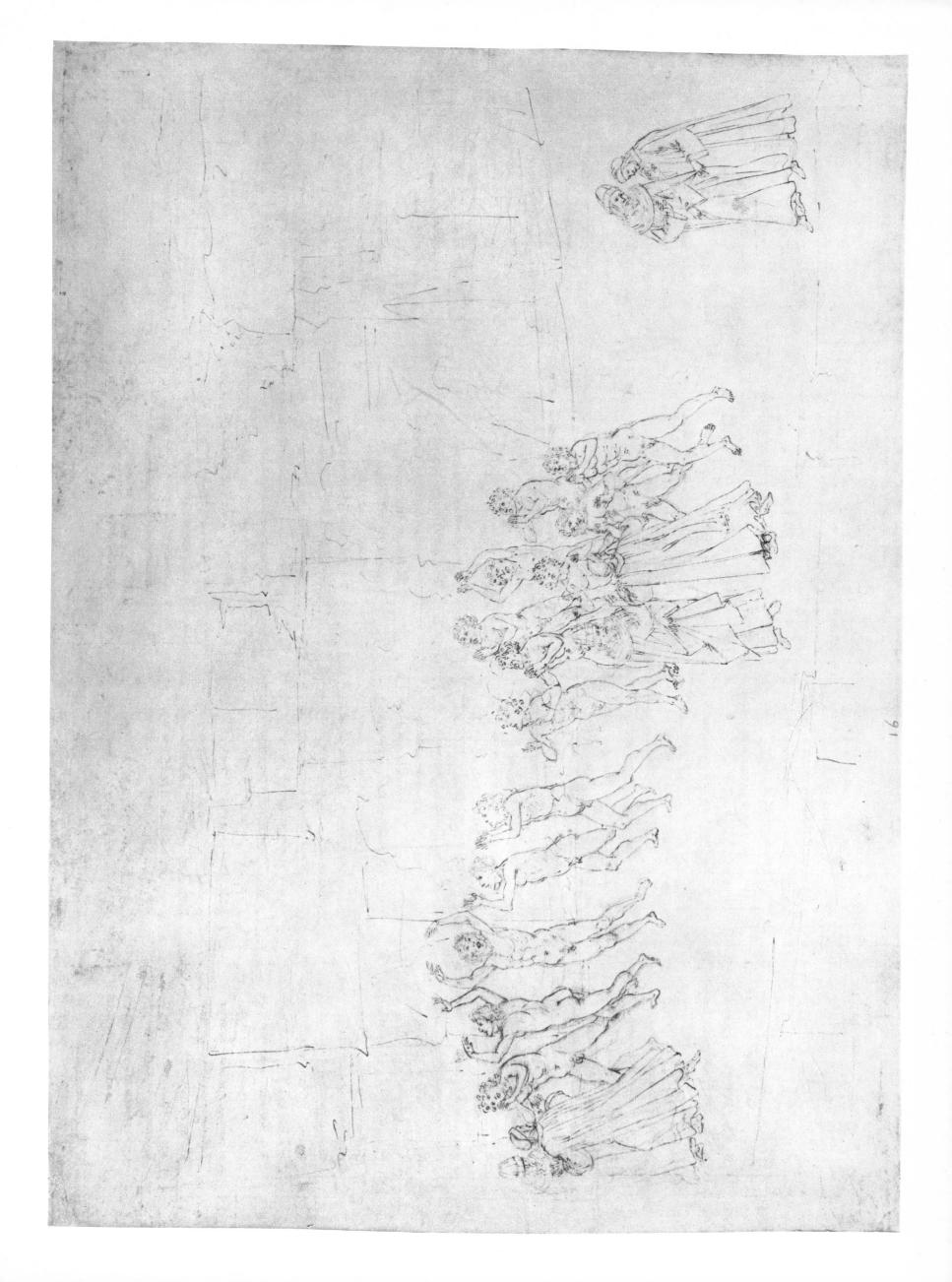

The Wrathful
The Angel of Meekness

WALKING TOWARDS THE ANGEL of Meekness, in the centre of Botticelli's drawing, who points out to them the ascent to the next terrace, Virgil and Dante gradually emerge into the light. Dante is lost in thoughtful fantasy, revealing instances – the legendary Procne, Haman of Persia and Queen Amata of Latium – of the destructiveness of wrath. They arrive at the Angel who in an open gesture of encouragement leads them up the stone stairway. As they ascend, Dante feels the Angel's wing brush his face, erasing yet another of the seven P's, and hears the sixth beatitude, 'Blessed are the peacemakers', being sung, juxtaposing to the confusion and destructiveness of anger the serenity and self-possession of equanimity. At the top of the drawing the poet-pilgrims have reached the next terrace, where the Slothful make their repentance.

Thus, matching steps with my true Guide once more,
I passed beyond the cloud into those rays
which lay already dead on the low shore.

O Fantasy, which can entrance us so
that we at times stand and are not aware
though in our ears a thousand trumpets blow ! –

what moves you since our senses lie dead then ?
– A light that forms in Heaven of itself,
or of His will who sends its rays to men.

* * *

I was looking all about, as if to find
where I might be, when a new voice that cried,
'Here is the ascent' drove all else from my mind ;

and kindled in my spirit such a fire
to see who spoke, as cannot ever rest
till it stand face to face with its desire.

* *

But, as in looking at the sun, whose rays
keep his form hidden from our stricken eyes –
so I lacked power to look into that blaze.

'A spirit of Heaven guides us toward the height :
he shows us the ascent before we ask,
and hides himself in his own holy light.'

* *

I felt what seemed to be a great wing fan
my face and heard : 'Blessed are the peacemakers,
who feel no evil wrath toward any man.'

* *

I said : 'Dear Father, what impurity
is washed in pain here ? Though our feet must stay,
I beg you not to stay your speech.' And he :

'That love of good which in the life before
lay idle in the soul is paid for now.
Here Sloth strains at the once-neglected oar.'

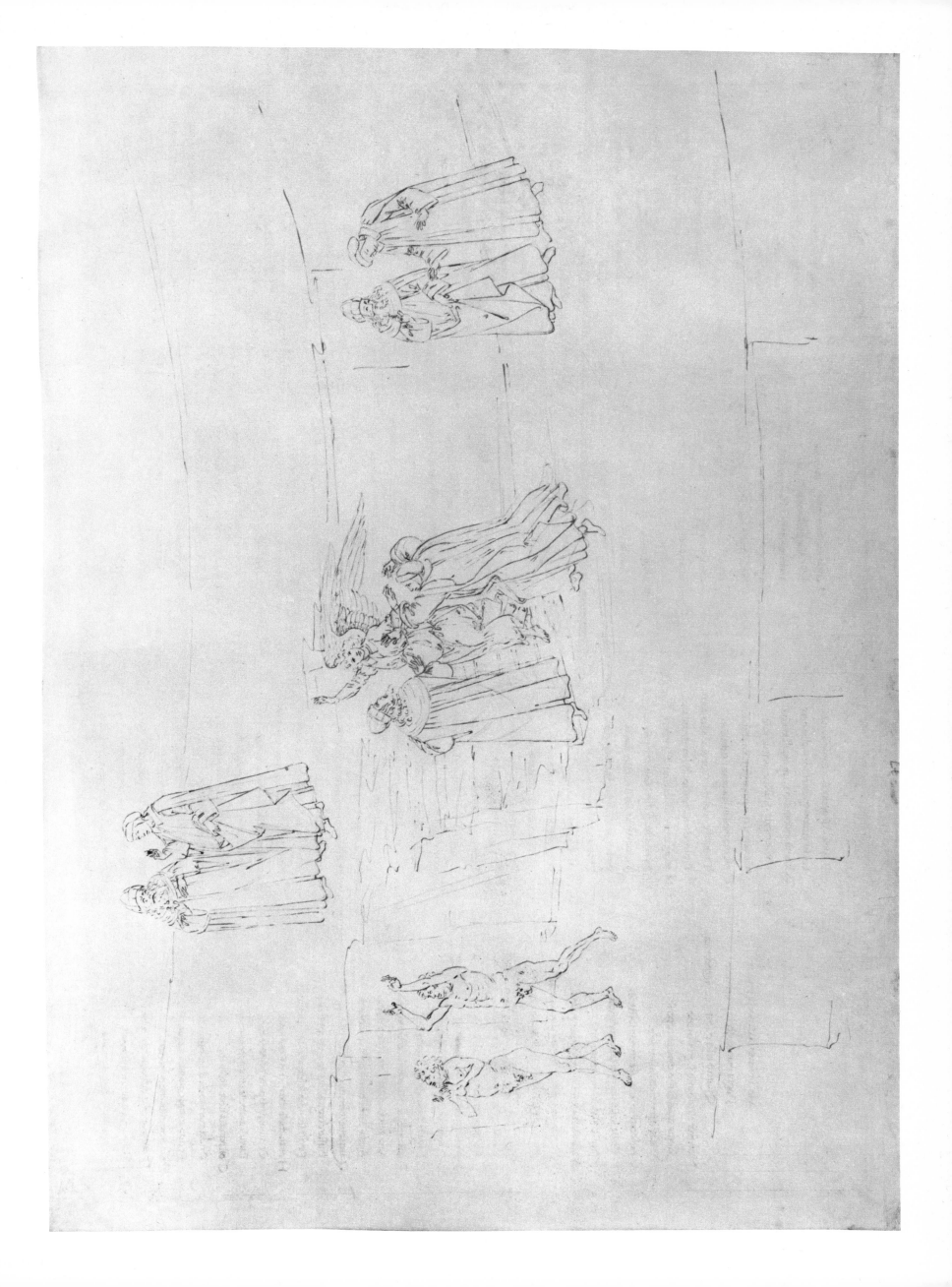

PURGATORIO XVIII

The Slothful

CARELESS IN THEIR PURSUIT of the Good during life, the Slothful on the Fourth Terrace of Purgatory purge their guilt in unflagging activity and zeal. Dante and Virgil approach, from the right-hand corner of the drawing, a group of them, two of whom run ahead of the others shouting out examples of the fruitfulness of zeal, Sloth's spiritual antonym: the Virgin Mary's haste, after the Annunciation, to go to her cousin Elizabeth, already long pregnant with John the Baptist, and Caesar's diligence in conquering Ilerda (the modern Lerida). Dante is again lost in meditation on what he is witnessing. On the left of Botticelli's drawing two souls have run up to the wayfarers, declaring examples of the evil influence of Sloth: some of the Israelites were laggard in following Moses in his pursuit of the Good and so perished in the wilderness; many of Aeneas' companions and followers chose to remain behind in Sicily rather than to proceed with him on his journey, and so missed the opportunity to share in the glory of founding Rome. Dante thereupon falls into a dream.

It was near midnight. The late-risen moon,
like a brass bucket polished bright as fire,
thinned out the lesser stars, which seemed to drown.

* * *

I wakened in an instant to a pack
of people running toward us, a great mob
that broke around the mountain at my back:

* * *

in such a frenzy, far as I could see,
those who were spurred by good will and high love
ran bent like scythes along that Cornice toward me.

* * *

'Mary ran to the hills' — so one refrain;
and the other: 'Caesar, to subdue Ilerda
struck at Marseilles, and then swooped down on Spain.'

* * *

My aid on all occasion, the prompt Master,
said: 'Look, for here come two who cry aloud
the Scourge of Sloth, that souls may flee it faster.'

At the tail end one runner cried: 'They died
before the Jordan saw its heirs, those people
for whom the Red Sea's waters stood aside.'

The other: 'Those who found it too laborious
to go the whole way with Anchises' son
cut from their own lives all that was most glorious.'

Then when those shades had drawn so far ahead
that I could not make out a trace of them,
a new thought seized upon me, and it bred

so many more, so various, and so scrambled,
that turning round and round inside itself
so many ways at once, my reason rambled;

I closed my eyes and all that tangled theme
was instantly transformed into a dream.

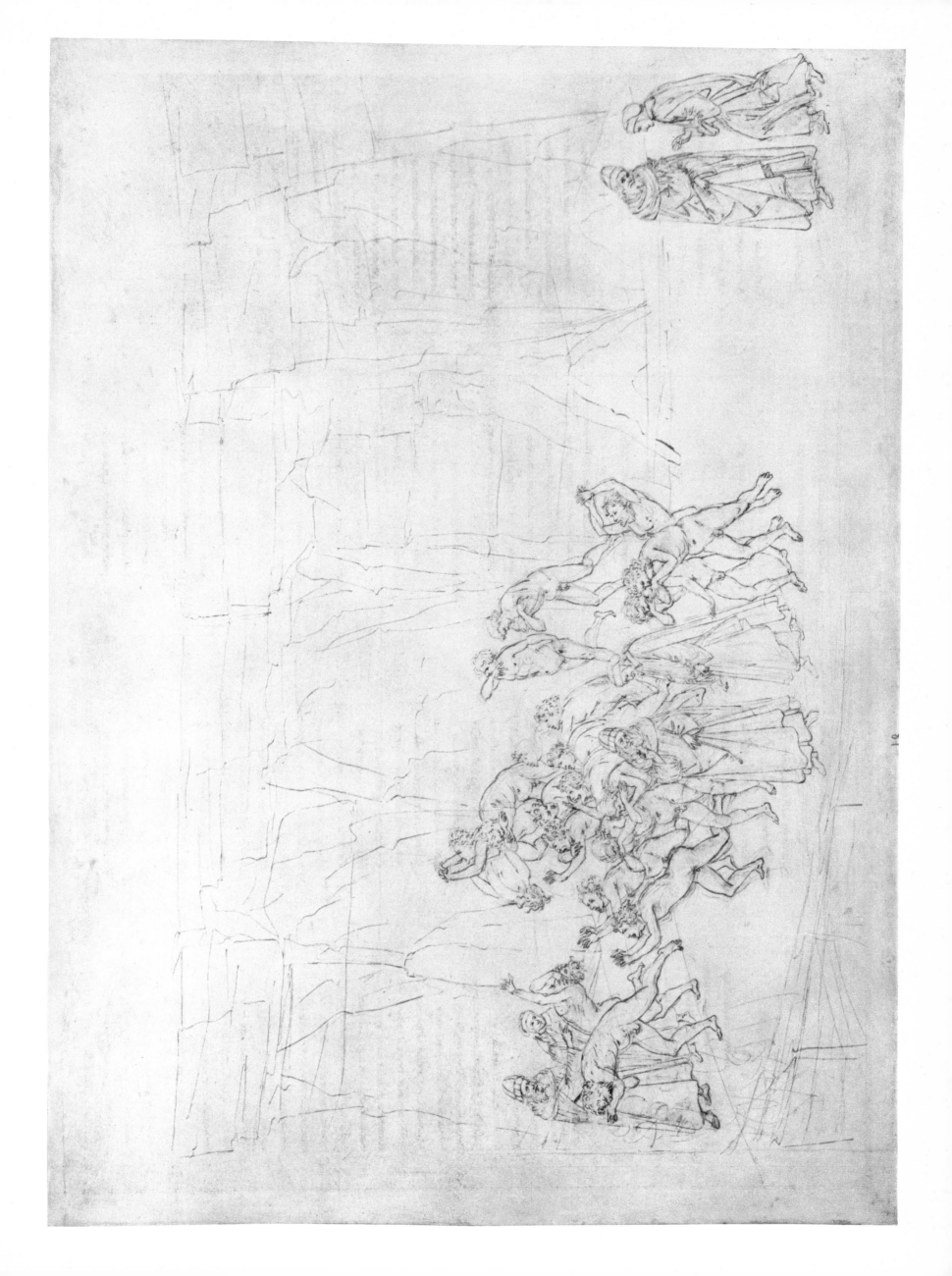

The Angel of Zeal
The Avaricious

DANTE, in the lower right-hand corner of the drawing, wakes from his dream, rises, and follows Virgil. The Angel of Zeal is pointing up to the Fifth Terrace, of the Avaricious, and a thoughtful Dante, bending 'like half an arch of a bridge', accompanies Virgil. Once again the Angel's wings brush Dante's forehead to remove one of the P's and he hears the next beatitude, 'Blessed are they that mourn', being sung as they leave behind the terrace of the Slothful, who in life had not the fortitude or zealous energy to endure pain. The souls of the Avaricious, bound hand and foot, lie prone, cleaving in their expiation to the dust of the pavement which reminds them of the barrenness of the material things they so avidly desired in life. Among these spirits, and wearing a mitre in Botticelli's drawing, is the spirit of Pope Adrian V, whom for an unknown reason Dante the poet places here among the Avaricious. As the pilgrim Dante learns the high spiritual office of this soul, Botticelli has him kneel in respectful reverence. After a brief exchange with Dante, Adrian dismisses him, and he and Virgil are seen, on the right in the upper part of the drawing, walking farther along this terrace.

*I turned then, and my Virgil said to me:
'I have called at least three times now. Rise and come
and let us find your entrance.' Willingly*

*I rose to my feet. Already the high day
lit all the circles of the holy mountain.
The sun was at our backs as we took our way.*

*I followed in his steps, my brow as drawn
as is a man's so bowed with thought he bends
like half an arch of a bridge. And moving on,*

*I heard the words: 'Come. This is where you climb.'
pronounced in such a soft and loving voice
as is not heard here in our mortal time.*

 ✳ ✳

*With swanlike wings outspread, he who had spoken
summoned us up between the walls of rock.
He fanned us with his shining pinions then.*

*When I stood on the fifth ledge and looked around,
I saw a weeping people everywhere
lying outstretched and face-down on the ground.*

 ✳ ✳

*I had knelt to him. Now I spoke once more.
That spirit sensed at once my voice was nearer
and guessed my reverence. 'Why do you lower*

*your knees into the dust?' he said to me.
And I: 'My conscience troubled me for standing
in the presence of your rank and dignity.'*

*'Straighten your legs, my brother! Rise from error!'
he said. 'I am, like you and all the others,
a fellow servant of one Emperor.'*

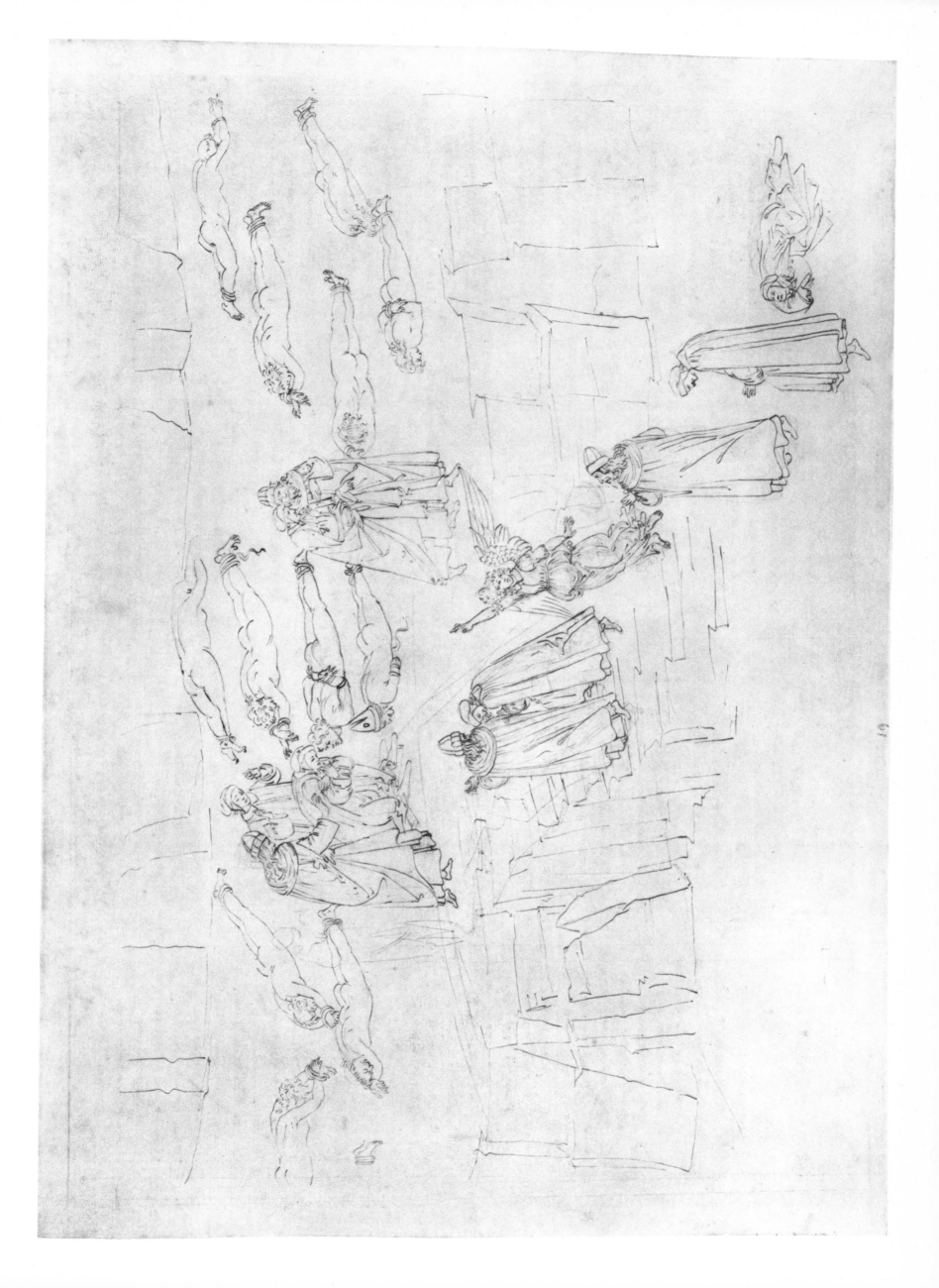

The Avaricious

SO CROWDED WITH THE SOULS of the Avaricious is this terrace that Dante and Virgil, at the left of the drawing, find open to them only a very narrow space at the inner cliff-face along which to proceed. They hear the spirits crying out a litany of lives of exemplary poverty and generosity: the Virgin Mary; Fabricius, the Roman consul whose integrity forbade his dealing in bribes and gifts while in office and who died a pauper; and St Nicholas of Myra, who gave all his riches to the poor (including the secret gift of dowries to a poor man's three daughters who would otherwise have had to lead lives of whoredom) and is known to the modern world as Santa Claus. Dante bends to speak and listen to the spirit of Hugh Capet, first of the Capetian dynasty of French kings. Suddenly, there is an earthquake: Botticelli draws the two poets, on the right, motionless in surprised suspense, Dante with his hands folded across his breast. When the tremor has subsided, through the entire terrace goes out a shout of 'Glory to God in the highest!' Dante is puzzled and confused about the meaning and purpose of the earthquake and clamour, but he and Virgil continue on their way, at the right edge of the drawing, with their questions unanswered.

I was Hugh Capet in my mortal state.
From me stem all the Philips and the Louis'
who have occupied the throne of France of late.

I was born in Paris as a butcher's son.
When the old line of kings had petered out
to one last heir, who wore a monk's gray gown,

I found that I held tight in my own hand
the reins of state, and that my new wealth gave me
such power, and such allies at my command,

that my son's head, with pomp and sacrament
rose to the widowed crown of France. From him
those consecrated bones took their descent.

* * *

Till the great dowry of Provence increased
my race so that it lost its sense of shame,
it came to little, but did no harm at least.

That was the birth of its rapacity,
its power, its lies. Later – to make amends –
it took Normandy, Ponthieu, and Gascony.'

We had already left him to his prayers
and were expending every ounce of strength
on the remaining distance to the stairs,

when suddenly I felt the mountain shake
as if it tottered. Such a numb dread seized me
as a man feels when marching to the stake.

Not even Delos, in that long ago
before Latona went there to give birth
to Heaven's eyes, was ever shaken so.

Then there went up a cry on every side,
so loud that the sweet Master, bending close
said: 'Do not fear, for I am still your Guide.'

'Glory to God in the Highest!' rang a shout
from every throat – as I could understand
from those nearby, whose words I could make out.

We stood there motionless, our souls suspended –
as had the shepherds who first heard that hymn –
until the ground grew still and the hymn ended.

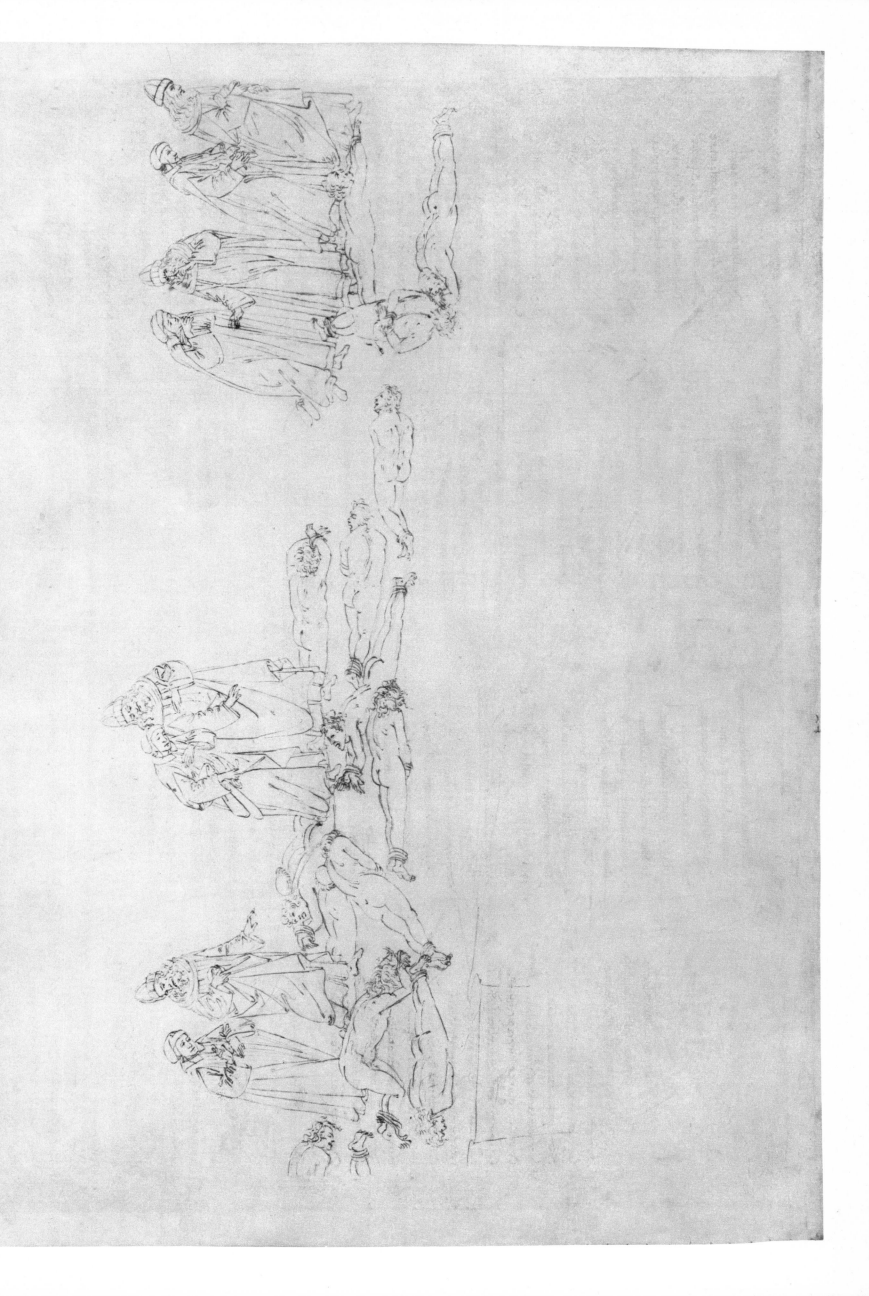

The Avaricious

Status

EAGER TO KNOW THE CAUSE of the earthquake and clamour of the previous canto, Dante and Virgil hurry along this terrace by the narrow way. From behind them, at the left of Botticelli's drawing, comes a soul calling out in greeting. Once he has courteously returned this spirit's salutation, Virgil asks him the meaning and cause of the 'shock and shout'. When a soul has finished his time on one terrace of Purgatory, he explains, and moves to the next higher or begins its final ascent to Heaven, the tremor is felt and the exultant cry heard. Declaring that he has himself been on this terrace of Purgatory for 'five hundred years and more' and has only now felt 'free to seek a better sphere', he identifies himself as Statius, an epic Latin poet who died in AD 96. Thus, as he has been here with the Avaricious for five hundred years and (as he will point out in the next canto) was on the Fourth Terrace, purging Sloth, for four hundred years, Statius has already been in Purgatory for nine hundred years and must therefore be assumed to have spent the first three hundred years (for we are, in Dante's poem, in AD 1300) after his death in Ante-Purgatory or a lower circle. Statius describes his career as poet and gives all credit to Virgil (who has not yet revealed his identity) and his Aeneid. Virgil warns Dante with a glance not to declare who he is, but Dante, because 'man's will is not supreme in every circumstance', gives a little smile, which Statius remarks. At last, Virgil allows Dante to identify him to Statius, who in the central group of the drawing throws up his hands in wonder and admiration at the encounter. At the right-hand side of the drawing, Statius has knelt to embrace Virgil, who has himself stooped to raise him: 'Shade you are, and shade am I. You must not kneel to me.' Dante looks on, his hands raised in emotion.

'Brothers, God give you peace.' My Guide and I
turned quickly toward his voice, and with a sign
my master gave the words their due reply.

Then he began: 'May the True Court's behest,
which relegates me to eternal exile,
establish you in peace among the blest.'

'But how, if you are souls denied God's bliss,'
he said – and we forged onward as he spoke –
'have you climbed up the stairs as far as this?'

My Teacher then: 'You cannot fail to see,
if you observe the Angel's mark upon him,
that he will reign among the just. But she

whose wheel turns day and night has not yet spun
the full length of the thread that Clotho winds
into a hank for him and everyone.

Therefore, his soul, sister to yours and mine,
since it cannot see as we do, could not
climb by itself. And, therefore, Will Divine

has drawn me out of the great Throat of Woe
to guide him on his way, and I shall lead him
far as my knowledge gives me power to go.'

'Statius my name, and it still lives back there.
I sang of Thebes, then of the great Achilles,
but found the second weight too great to bear.'

✳ ✳ ✳

I did no more than half smile, but that shade
fell still and looked me in the eye – for there
the secrets of the soul are most betrayed.

✳ ✳ ✳

'This one who guides my eyes aloft is he,
Virgil, from whom you drew the strength to sing
the deeds of men and gods in poetry.'

✳ ✳ ✳

He was bending to embrace my Teacher's knee,
but Virgil said: 'No, brother. Shade you are,
and shade am I. You must not kneel to me.'

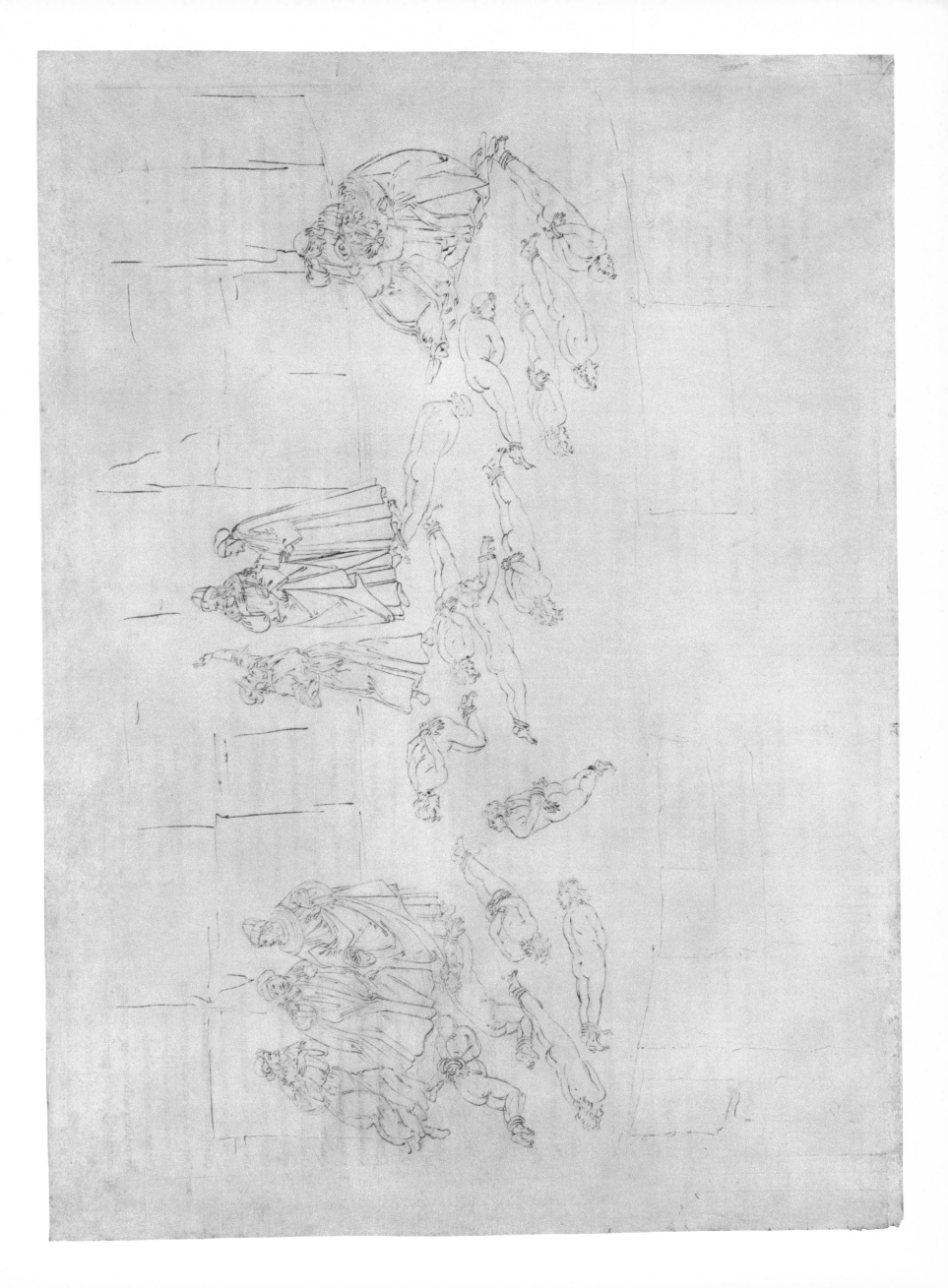

The Gluttons

CLIMBING THE STAIRWAY to the Sixth Terrace, where the Gluttons expiate their sin, the three poets (for Statius remains with Dante and Virgil) have passed the Angel guarding the staircase, who erases the P of Avarice from Dante's forehead while reciting 'Blessed are they who . . . thirst after justice', opposing the thirst for virtue to the wicked craving of the Avaricious. Botticelli does not illustrate, in the drawing to this canto, either the staircase, the Angel, or the Angel's cleansing of Dante's forehead. Here, the focus of his imagination and of the viewer's attention is the great tree which grows upside down and on to which a fall of water sprays from a ledge of rock above it. This is the Tree of Grace, and as Statius, Virgil and Dante, at the top of the drawing, notice and draw near to it, a voice from within its branches forbids the picking of its fruit. In Purgatory, the waiting, purging souls must patiently collaborate with Divine Grace and work out their cleansing, before moving, as Statius has done, on to a higher terrace or out of Purgatory altogether. There can be no 'gluttonous' grasping of grace here, and the tree's voice calls out three exemplary instances of moderation and temperance: the Virgin Mary at the marriage at Cana, when she thought only of the comfort of others and not her own appetite (John 2, 1–7); the matrons of Republican Rome, whose custom it was not to drink wine; and Daniel, who resolved not to defile himself with King Nebuchadnezzar's meat and drink (Daniel 1, 8).

We had, by now, already left behind
the Angel who directs to the Sixth Round.
He had erased a stigma from my brow,

and said that they who thirst for rectitude
are blessèd, but he did not say 'who hunger'
when he recited that Beatitude.

* * *

I, lighter than on any earlier stairs,
followed those rapid spirits, and I found it
no strain at all to match my pace to theirs.

They walked ahead and I came on behind
treasuring their talk, which was of poetry,
and every word of which enriched my mind.

But soon, in mid-road, there appeared a tree
laden with fragrant and delicious fruit,
and at that sight the talk stopped instantly.

As fir trees taper up from limb to limb,
so this tree tapered down; so shaped, I think,
that it should be impossible to climb.

From that side where the cliff closed-off our way
a clear cascade fell from the towering rock
and broke upon the upper leaves as spray.

The poets drew nearer, reverent and mute,
and from the center of the towering tree
a voice cried: 'You shall not eat of the fruit!'

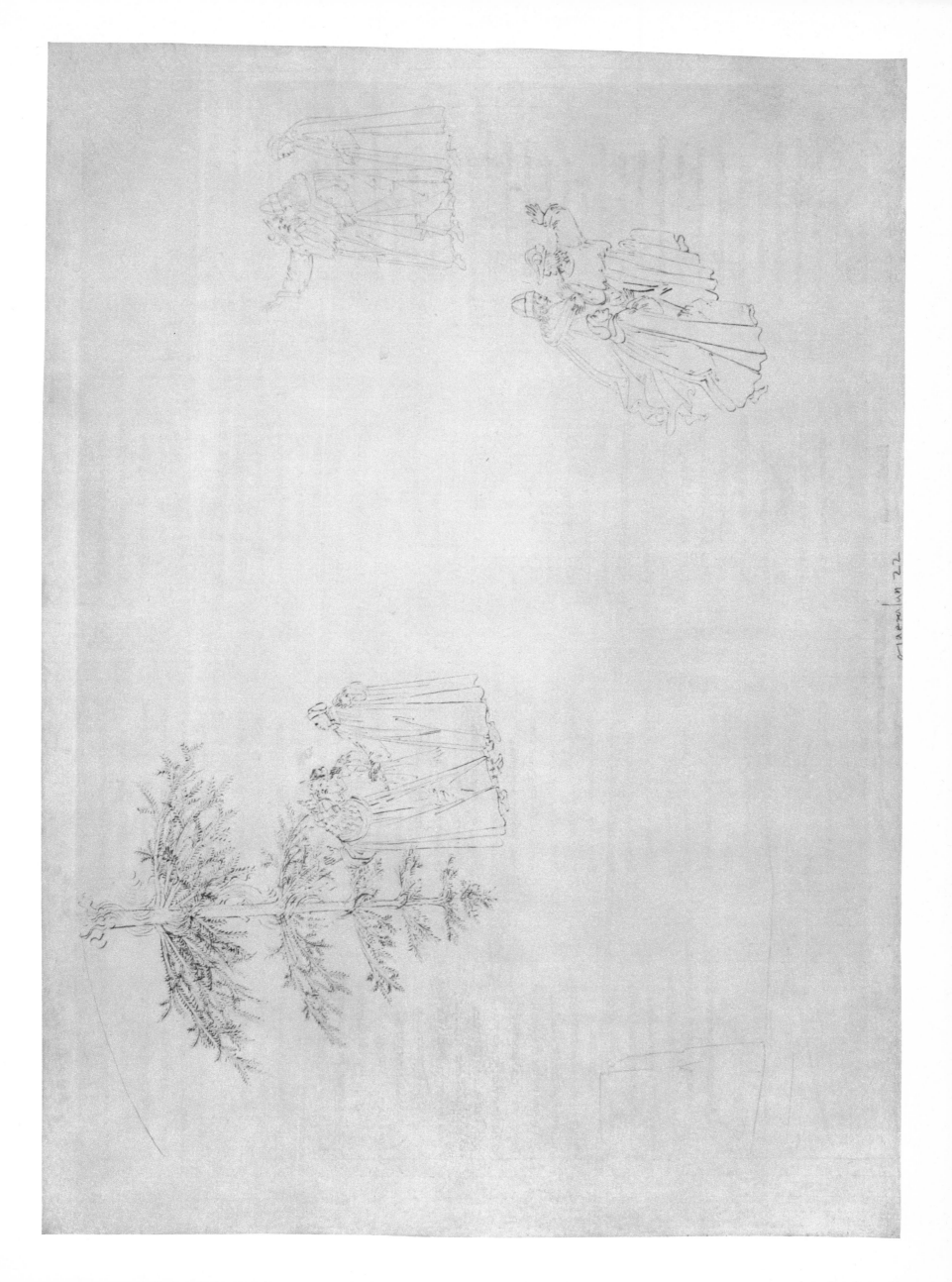

In hope of seeing who had cried those words
I drew near and peered up at the green boughs
like one who wastes his lifetime stalking birds.

At that, my more-than-father said: 'My son,
come now, for we must portion out more wisely
the time allotted us.' And he moved on.

* * *

Then suddenly at my back I heard the strain
of Labia mea, Domine, so sung
that it was both a hymn and cry of pain.

* * *

As pilgrims wrapped in holy meditation,
when they encounter strangers on the way,
look, but do not pause for conversation;

so from behind us, turning half about
to stare as they went by, a band of souls
came up and passed us, silent and devout.

The sockets of their eyes were caves agape;
their faces death-pale, and their skin so wasted
that nothing but the gnarled bones gave it shape.

* * *

Their eye pits looked like gem-rims minus gem.
Those who read OMO in the face of man
would easily have recognized the M.

* * *

I was still wondering how they could have grown
so thin and scabby (since what famished them
had not yet been made clear to me), when one

turning his eyes from deep inside his skull,
stared at me fixedly, then cried aloud:
'How have I earned a grace so bountiful?'

I never would have recognized his face,
but in his voice I found that which his features
had eaten from themselves without a trace.

That spark relit my memory and, in awe,
I understood beneath those altered features
it was Forese's very self I saw.

* * *

'Hunger and thirst that nothing can assuage
grow in us from the fragrance of the fruit
and of the spray upon the foliage.

And not once only as we round this place
do we endure renewal of our pain.
— Did I say "pain"? I should say "gift of grace"'.

The Gluttons

DANTE TARRIES, looking up into the Tree of Grace, while Statius and Virgil, like all the other figures in this drawing, proceed. At last, Virgil, in the second group of figures from the right, turns round to beckon Dante on. From behind them comes a band of souls, chanting 'Domine, labia me aperies . . . O Lord, open Thou my lips', from the fifty-first Psalm of the Vulgate, in which the penitent Gluttons pray that, at last, their mouths may be opened for praise rather than for food and drink. So emaciated are these souls, says Dante the poet, that their hollow and round eye-sockets, arched over and around by the bone of their brows, make of their faces the Italian word OMO, man. From this group, one of the souls turns round in recognition of Dante and greets him. A kinsman of Dante's wife, Forese Donati was a friend of Dante; they had engaged in a poetical correspondence and in two of his poems Dante had satirized Forese's gluttonous habits. As Statius and Virgil, in the lower left corner of the drawing, walk on, Forese explains to Dante that the Tree of Grace, which the spirits of the Gluttonous repeatedly pass in their circuit of this Sixth Terrace, is simultaneously a reproach to their sin and a spur to their longing for God's healing grace.

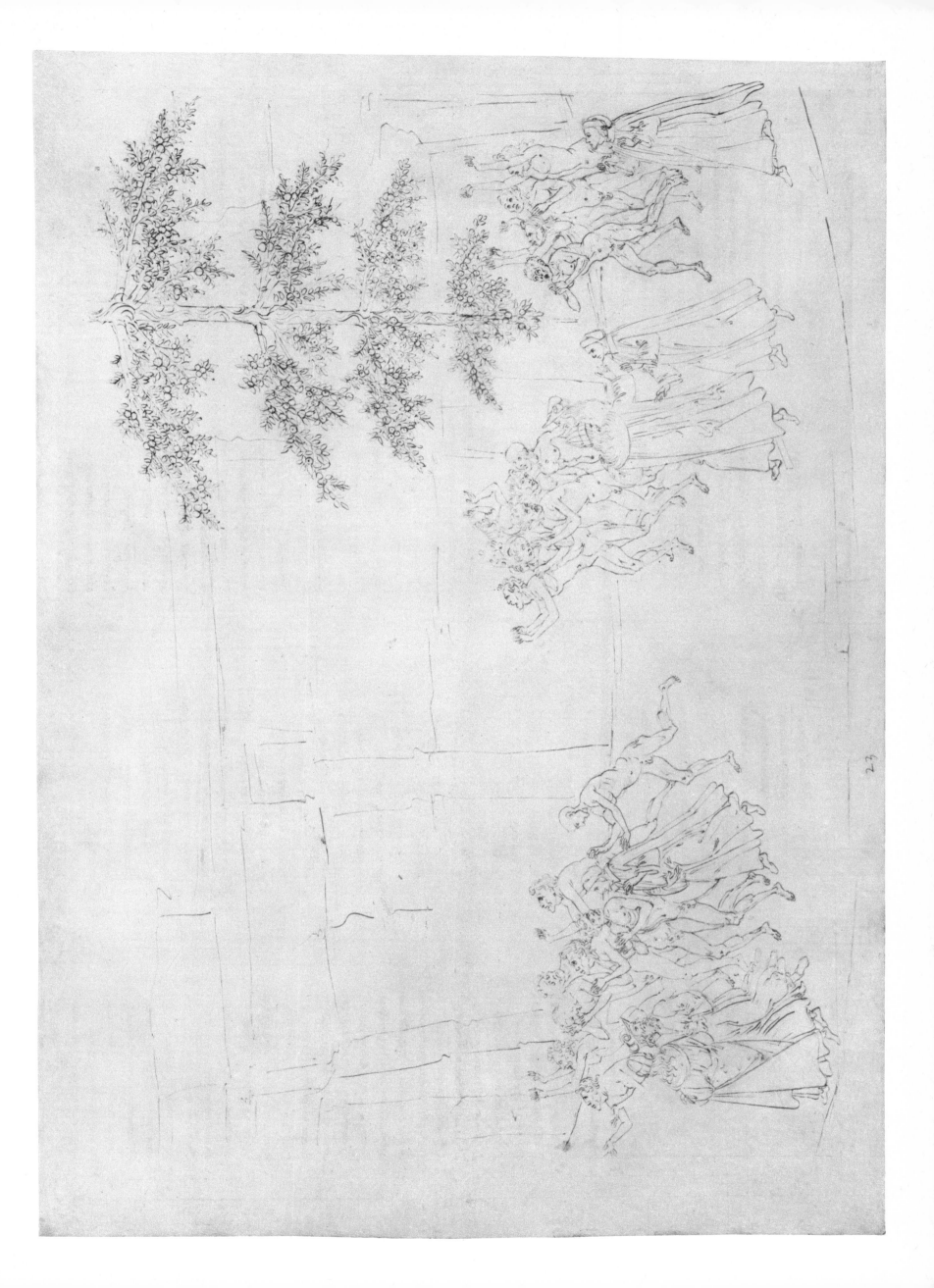

The Gluttons

DANTE AND FORESE walk briskly forward, but the distraction of their conversation nevertheless causes Dante to fall behind the hurrying Virgil and Statius. Then they see a second tree, like the first growing downwards, and with a spring of water winding down its trunk. Sprung from the same stock as the tree of Eve's sin, this Tree of Knowledge is a focus of the yearning attention of all the figures (except Statius, whom Botticelli has not drawn there) in the centre of the drawing. A voice from its branches calls out a warning to the Gluttonous that they must not snatch its fruit: knowledge of divine things comes with patience and striving, and cannot intemperately be grabbed at. Once more, three examples of the evil wreaked by a vice, in this case Gluttony, are given, now by the voice within the tree: Eve, who from the parent stock of this tree committed the primal gluttony of soul as well as body; the Centaurs, whose immoderate drinking at the wedding of Pirithoüs resulted in their carrying off the bride and, finally, their punishment by Theseus; and the troops of Gideon, some of whom were excluded from his force against the Midianites because of the lack of moderation they showed in quenching their thirst. Beyond the Tree of Knowledge, Dante (and the very faintly drawn Virgil) encounter the Angel of Abstinence, who will show them the way to the next terrace, whose flames are already visible in the upper left-hand part of the drawing; the Angel's wings brush from Dante's head the next but last of the seven P's.

Talk did not slow our steps, nor they in turn
our talk, but still conversing we moved on
like ships at sea with a brisk wind astern.

* * *

Just as the cranes that winter by the Nile
form close-bunched flights at times, then, gathering speed,
streak off across the air in single file;

so all the people there faced straight ahead,
and being lightened by both will and wasting,
quickened their paces, and away they sped.

* * *

We turned a corner and there came in sight,
not far ahead, a second tree, its boughs
laden with fruit, its foliage bursting bright.

Sometimes when greedy children beg and screech
for what they may not have, the one they cry to
holds it in plain sight but beyond their reach

to whet their appetites; so, round that tree,
with arms raised to the boughs, a pack of souls
begged and was given nothing.

* * *

'If your wish is to ascend,' I heard one say,
'this is the place where you must turn aside.
All you who search for Peace – this is the way.'

His glory blinded me. I groped and found
my Teacher's back and followed in his steps
as blind men do who guide themselves by sound.

Soft on my brow I felt a zephyr pass,
soft as those airs of May that herald dawn
with breathing fragrances of flowers and grass;

and unmistakably I felt the brush
of the soft wing releasing to my senses
ambrosial fragrances in a soft rush.

And soft I heard the Angel voice recite:
'Blessed are they whom Grace so lights within
that love of food in them does not excite

excessive appetite, but who take pleasure
in keeping every hunger within measure.'

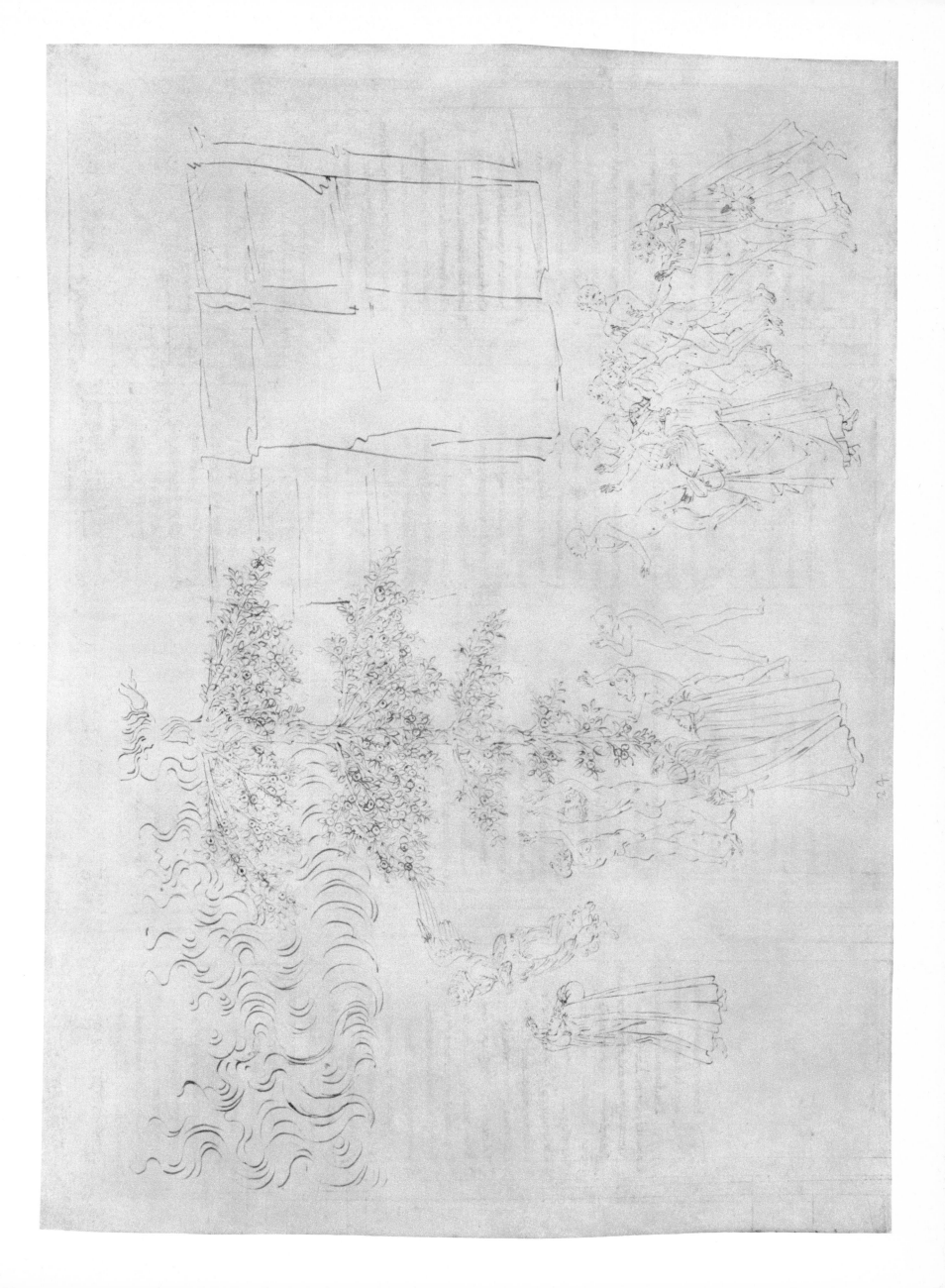

The Ascent to the Last Terrace
The Lustful

THE THREE POETS have reached the stone stairway – 'whose narrowness divides all those who climb', for no one goes accompanied along the path of penitence – to the Seventh Terrace. Statius and Virgil, both only lightly drawn here by Botticelli, lead, while Dante follows. As they reach the terrace, where the souls of the Lustful are punished by flames blasting forward from the rear wall and bent back by a current of air rising from its outer edge, Virgil, in the group at the drawing's centre, warns Dante that they must 'keep a tight rein on our eyes', not only because their path between flames and precipice is so narrow, but also because lust, whose enticements reach the soul through the eyes, is so easy a sin to fall into. The penitent souls chant the hymn 'Summae Deus clemen- tiae . . . O God of boundless mercy' as they move through the cleansing flames. When the hymn has ended, they cry out in unison examples of chastity: the first, as usual in this *cantica* of the great poem, is the Virgin Mary, whose immediate response to the angel Gabriel's announcement was that she 'knew not man' and hence did not understand how she could conceive a child; the other is Diana, the ancient goddess who was a pre-Christian model of chastity. At the left of the drawing Statius, Virgil and Dante proceed on their way. (In this drawing, Botticelli shows the wayfarers going in the direction opposite to the one Dante explicitly states in his poem. Further, the third and fourth figures from the right anticipate the episode in the next canto, which Botticelli does not illustrate in that place, when Dante sees the two penitent souls greet one another with a kiss, not a lustful embrace as in life but the 'holy kiss' recommended by Paul in his letter to the Romans.)

We had come, by then, to the last turn of the stairs
from which we bore to the right along the cornice,
and our minds were drawn already to other cares.

Here, from the inner wall, flames blast the ledge,
while from the floor an air-blast bends them back,
leaving one narrow path along the edge.

This path we were forced to take as best we might,
in single file. And there I was – the flames
to the left of me, and the abyss to the right.

My Leader said: 'In this place, it is clear,
we all must keep a tight rein on our eyes.
To take a false step would be easy here.'

'Summae Deus clementiae,' sang a choir
inside that furnace, and despite my road
I could not help but look into the fire.

* * *

Then I saw spirits moving through the flames,
and my eyes turned now to them, now to my feet,
as if divided between equal claims.

In this way, I think, they sing their prayer
and cry their praise for as long as they must stay
within the holy fire that burns them there.

Such physic and such diet has been thought fit
before the last wound of them all may knit.

136

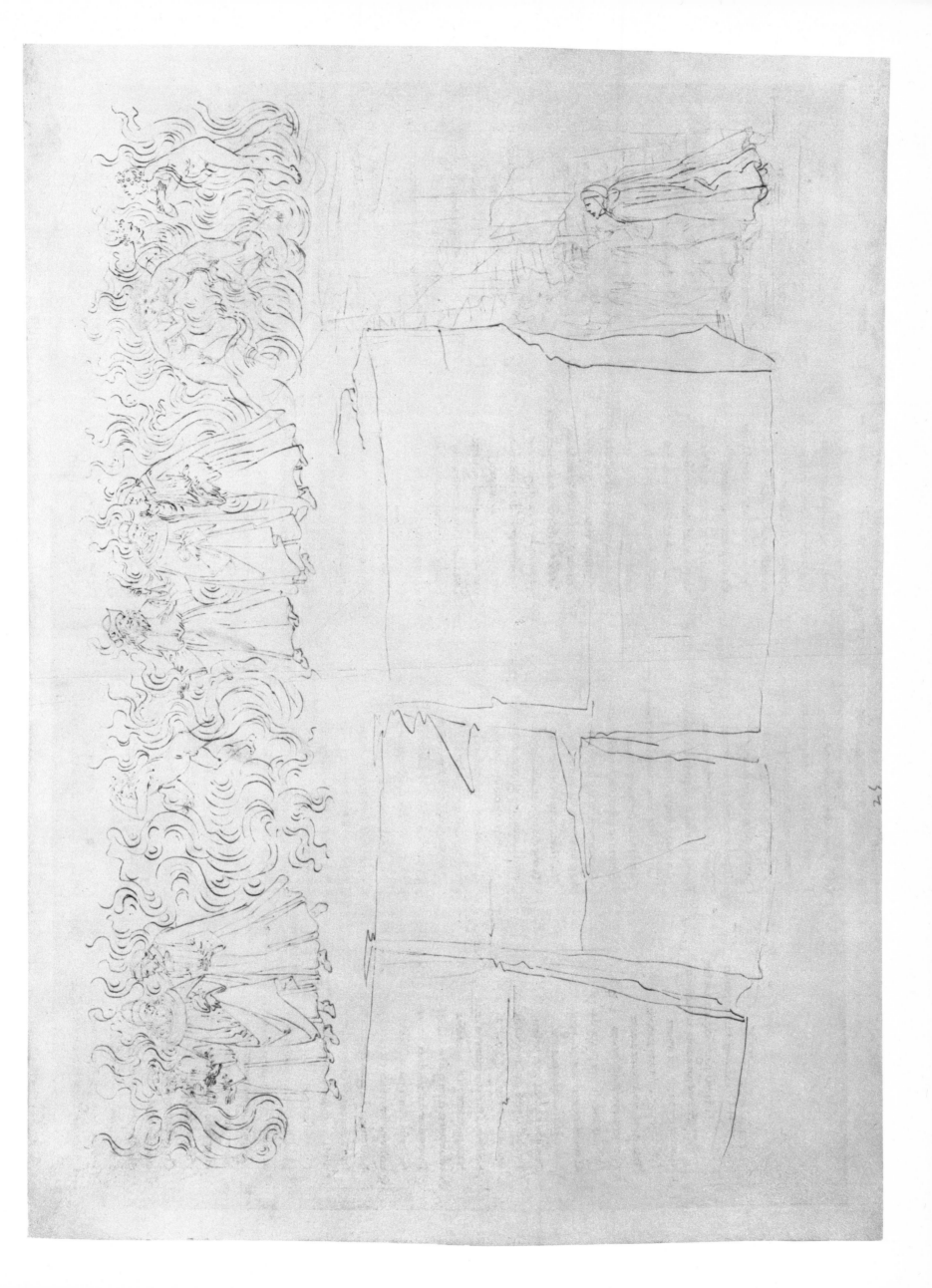

PURGATORIO XXVI

So, one before the other, we moved there
along the edge, and my Sweet Guide kept saying:
'Walk only where you see me walk. Take care.'

The Sun, already changing from blue to white
the face of the western sky, struck at my shoulder,
its rays now almost level on my right,

* *

and when they saw my shadow, these began
to speak of me, saying to one another:
'He seems to be no shade, but a living man!'

* * *

I saw them hurrying from either side,
and each shade kissed another, without pausing,
each by the briefest greeting satisfied.

* *

'And now you know our actions and our crime.
But if you wish our names, we are so many
I do not know them all, nor is there time.

Your wish to know mine shall be satisfied:
I am Guido Guinizelli, here so soon
because I repented fully before I died.'

* *

'Brother,' he said, 'that one who moves along
ahead there,' (and he pointed) 'was in life
a greater craftsman of the mother tongue.

He, in his love songs and his tales in prose,
was without peer – and if fools claim Limoges
produced a better, there are always those

who measure worth by popular acclaim,
ignoring principles of art and reason
to base their judgments on the author's name.'

The Lustful

AT THE RIGHT of the drawing (and again Botticelli reverses the direction of their progress in the poem), Virgil repeats his warning to Dante to go carefully; Statius, a little before them, waits with gracious patience. As the declining sun throws Dante's shadow on the wall of flames, the penitent souls realize that he is still a living man, and some of them approach him. The souls cry out dreadful reminders of the destructiveness of lust: Sodom and Gomorrah and Pasiphaë, who hid her body within the effigy of a cow to copulate with a bull and bore the Minotaur. One of the spirits identifies himself as Guido Guinizelli, the most illustrious Italian poet before Dante and originator of the *dolce stil nuovo*, the 'sweet new style', which Dante used to exquisite perfection. Guido points out to Dante a companion in penitence, Arnaut Daniel, a twelfth-century poet of Périgord.

138

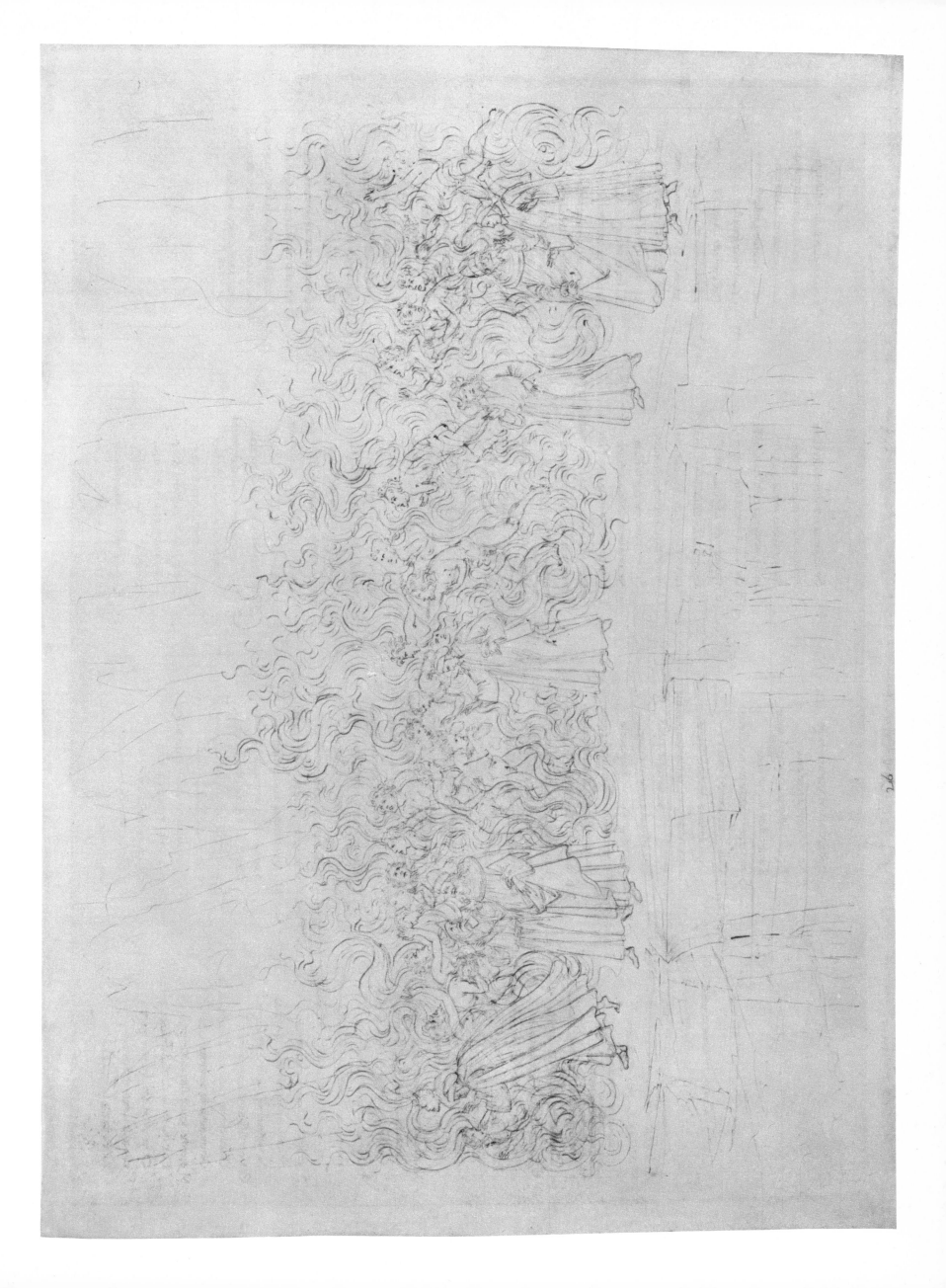

The Wall of Fire
The Two Angels

AT LAST AT THE END of their circuit of this last terrace of Purgatory, Status, Virgil and Dante come to a Wall of Fire, through which they must pass to ascend and which will achieve Dante's complete purgation. The Angel of Chastity stands here, chanting 'Beati mundo corde. . . . Blessed are the pure in heart', and urging them to pass through the fire. Dante, in the lowermost right-hand corner of the drawing, is frightened of the fire, while Virgil encourages him, reminding him that Beatrice waits beyond it. As the poets pass the Angel, the final P is removed from Dante's brow and, huddled between Virgil and Status, he goes through the flames. From the other side of this dreadful barrier, they hear a voice singing out, 'Venite benedicti patris mei . . . Come ye blessed of my father', and on the other side see another Angel, this one so bright that Dante must look away. This Angel urges them to ascend the stairs leading to the Earthly Paradise. Having climbed up, they lie down to rest. At the uppermost left-hand corner, with the trunks of the trees of the Earthly Paradise behind them, Virgil crowns Dante lord of himself. In Hell and Purgatory, only Reason is a safe and trustworthy guide and restraint to sinful man. Now that Dante has made his pilgrimage through those places and has had purged from him all impulse to sin, Love only can lead him into and through Paradise. Thus Virgil, the pre-Christian 'good pagan' whose ultimate support in a life of perfection was Reason, prepares to leave Dante, who will soon meet Beatrice. It is she, as a figure of Divine Love, who will lead Dante into Paradise and through it to the final glorious vision.

*There I beheld a light that burned so brightly
I had to look away; and from it rang:
'Venite benedicti patris mei.'*

* * *

*When we had climbed the stairway to the rise
of the topmost step, there with a father's love
Virgil turned and fixed me with his eyes.*

*'My son,' he said, 'you now have seen the torment
of the temporal and the eternal fires;
here, now, is the limit of my discernment.*

*I have led you here by grace of mind and art;
now let your own good pleasure be your guide;
you are past the steep ways, past the narrow part.*

* * *

Lord of yourself I crown and mitre you.'

. . . We met God's glad Angel standing there

*on the rocky ledge beyond the reach of the fire,
and caroling 'Beati mundo corde'
in a voice to which no mortal could aspire.*

* *

*I lean forward over my clasped hands and stare
into the fire, thinking of human bodies
I once saw burned, and once more see them there.*

*My kindly escorts heard me catch my breath
and turned, and Virgil said: 'Within that flame
there may be torment, but there is no death.*

*Think well, my son, what dark ways we have trod . . .
I guided you unharmed on Geryon:
shall I do less now we are nearer God?'*

* * *

*And seeing me still stubborn, rooted fast,
he said, a little troubled: 'Think, my son,
you shall see Beatrice when this wall is past.'*

* * *

*He turned then and went first into the fire,
requesting Status, who for some time now
had walked between us, to bring up the rear.*

*Once in the flame, I gladly would have cast
my body into boiling glass to cool it
against the measureless fury of the blast.*

* * *

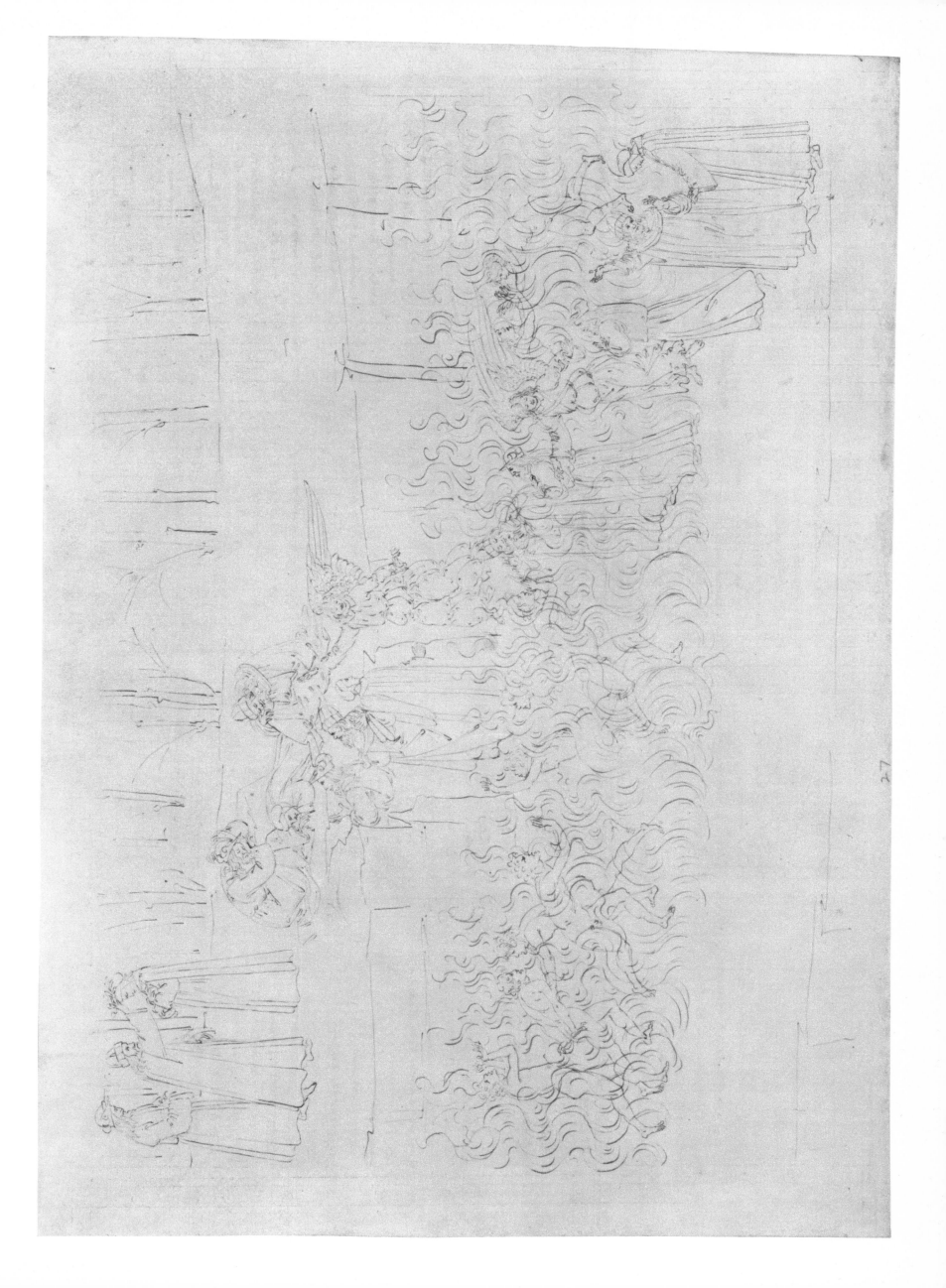

The Earthly Paradise
The Sacred Wood

FROM THE LEFT-HAND MARGIN of the drawing, Virgil, Statius and Dante walk into the Sacred Wood of the Earthly Paradise. Though his pilgrimage began when he had lost his way in the Dark Wood of the Comedy's first canto, Dante now, strengthened and purged by suffering and knowledge, hesitates not at all to enter this wood; indeed, as in Botticelli's drawing, it is the first time in the poem that he takes the lead. Through the wood, and lightly drawn in on this drawing, run two streams, Lethe and Eunoë. Across the stream nearer him, Dante sees and hears a woman walking through the wood picking flowers and singing. Dante calls to her, who answers him and offers to answer the questions that he, as a newcomer to this place, may have. This is Matilda, who in the allegory of the great poem is the soul's Active Life, the in-termediary between Reason, as personified by Virgil, and the many manifestations of Divine Love which Beatrice will later symbolize; the streams, she explains, have their source in God's love. In the centre of the drawing, Matilda stands talking to Dante, explaining that Lethe, which courses between them, removes from the soul all memory of sin; Eunoë, running behind her and therefore higher in the drawing, strengthens the soul's memory of the good it has done. Having explained these things to Dante, Matilda falls silent.

Eager now to explore in and about
the luxuriant holy forest evergreen
that softened the new light, I started out,

without delaying longer, from the stair
and took my lingering way into the plain
on ground that breathed a fragrance to the air.

* * *

I came upon a stream that blocked my way.
To my left it flowed, its wavelets bending back
the grasses on its banks as if in play.

* * *

And suddenly – as rare sights sometimes do,
the wonder of them driving from the mind
all other thoughts – I saw come into view

a lady, all alone, who wandered there
singing, and picking flowers from the profusion
with which her path was painted everywhere.

'Fair lady who – if outward looks and ways
bear, as they ought, true witness to the heart –
have surely sunned yourself in Love's own rays,

be pleased,' I said to her, 'to draw as near
the bank of this sweet river as need be
for me to understand the song I hear.'

* * *

So did she turn to me upon the red
and yellow flowerlets, virgin modesty
making her lower her eyes and bow her head.

* * *

'On this side, it removes as it flows down
all memory of sin; on that, it strengthens
the memory of every good deed done.

It is called Lethe here, Eunoë there.
And one must drink first this and then the other
To feel its power.'

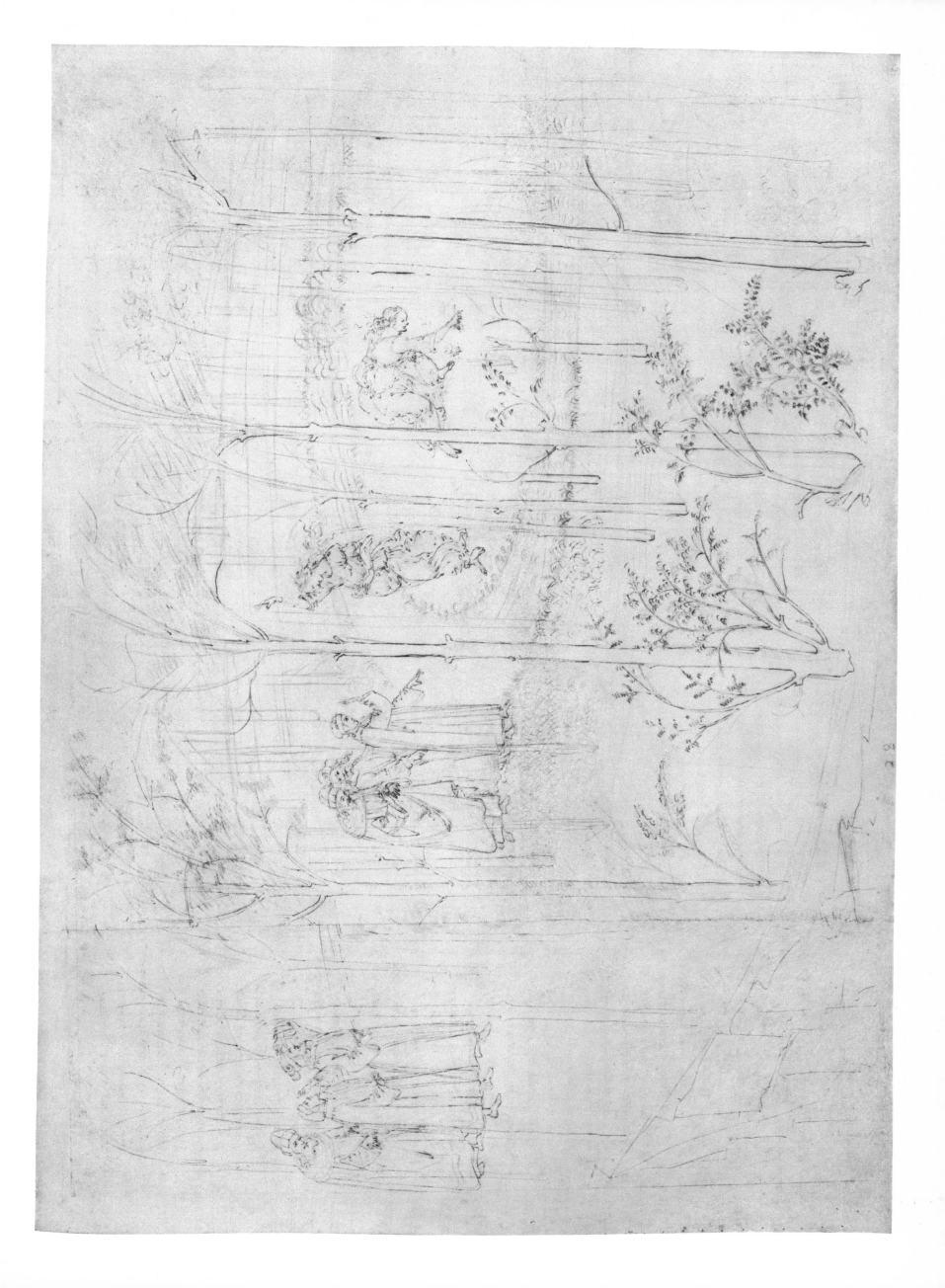

PURGATORIO XXIX

The Heavenly Pageant
Lethe

HAVING EXPLAINED TO DANTE, who stands at the lower left-hand corner of the drawing with Virgil and Statius, the functions of Lethe and Eunoë, Matilda, on the opposite bank of the stream, resumes her song: 'Beati quorum tecta sunt peccata . . . Blessed are they whose sin is covered', from Psalm 31 of the Vulgate. Matilda walks upstream along the bank, while the poet-pilgrims follow on the nearer side. Suddenly Dante sees a flash of light bright as lightning but constant and increasing, and hears a melody so sweet it makes him wonder at Eve's temerity in depriving herself, and all humankind, of its endless enjoyment. Standing with Virgil and Statius, Dante beholds the Heavenly Pageant. Seven candlesticks (in the drawing carried by angels, though in the poem they mysteriously move by themselves), so huge that Dante at first mistakes them for trees, appear; from each rises a candle whose smoke paints the air with the seven colours of the rainbow. Recalling as they do the passage in Revelations, 'And having turned, I saw seven golden lampstands; and in the midst . . . One like to a son of man', the huge candlesticks signal an advent, the arrival of a major person. Dante turns in his astonishment to Virgil, and Botticelli has doubly-drawn him on the right to convey this impulse towards sharing wonder. Behind the candlesticks, walking side by side in two columns, come twenty-four elders, to signify the twenty-four books of the Old Testament which St Jerome, in his preface to his translation of the Bible, compares to the twenty-four Elders of Revelations. Behind the Elders, whom Botticelli draws as each holding aloft a book (though he does not indicate that in the poem they are crowned with lilies), is a two-wheeled chariot, here very faint, drawn by a Gryphon, the symbol of Christ whose two natures are allegorically paralleled by the double majesty of the mythical animal: half lion and half eagle it combines supreme dominion over Earth and the heavens.

So, then, she started up the riverside
and, on my own bank, I kept pace with her,
matching her little steps with shortened stride.

* *

Some fifty paces each we moved this way,
when both banks curved as one ; and now I found
my face turned to the cradle of the day.

* * *

Nor had we gone as far again, all told,
beyond the curve, when she turned to me, saying :
'Dear brother, look and listen.' And behold ! –

* *

through all that everlasting forest burst
an instantaneous flood of radiance.
I took it for a lightning-flash at first.

* *

I saw next, far ahead, what I believed
were seven golden trees (at such a distance
and in such light the eye can be deceived).

* * *

And when I had moved close enough to be
kept at a distance by no more than water,
I halted my slow steps, better to see.

* *

And there, advancing two by two beneath
that seven-striped sky came four-and-twenty elders,
each crowned in glory with a lily-wreath.

* * *

Within the space they guarded there came on
a burnished two-wheeled chariot in triumph
and harnessed to the neck of a great Griffon

whose wings, upraised into the bands of light,
enclosed the middle one so perfectly
they cut no part of those to left or right.

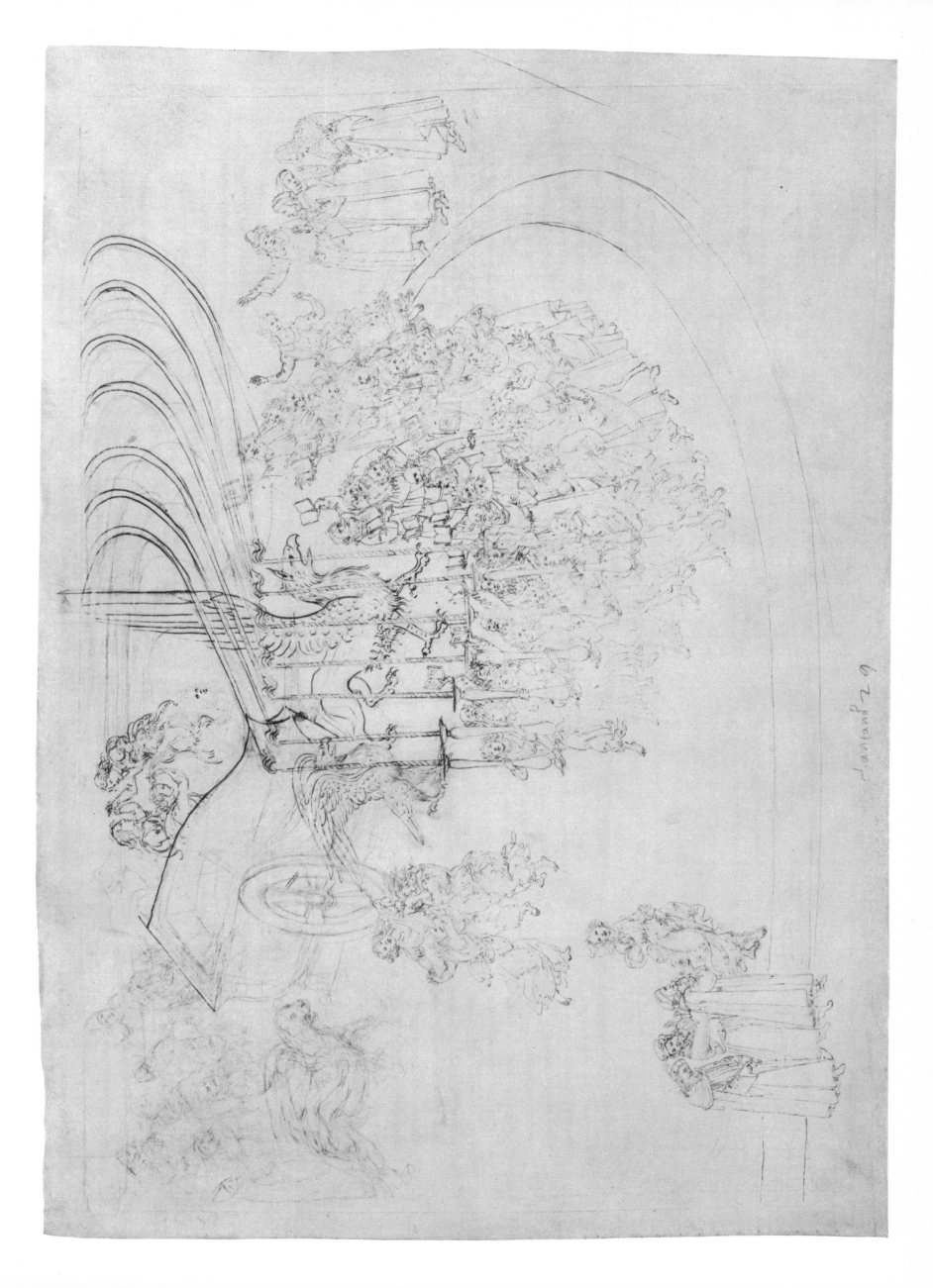

Beatrice

THE PAGEANT STOPS, and the two-wheeled chariot (here clearly visible but only barely so in the illustration to the previous canto) stops opposite Dante. Within it, cloaked in green and wearing a white veil, and crowned with an olive wreath, rides Beatrice. At each of the corners of the chariot walks one of Ezechiel's 'four living creatures', used as Christian symbols of the Evangelists: angel, Matthew; eagle, John; lion, Mark; bull, Luke; Dante describes them as winged, though Botticelli does not so draw them. To the right of the chariot, dancing in a ring, are the four Cardinal Virtues, Prudence, Justice, Fortitude, Temperance, a group balanced on the other side by the three Theological Virtues, Faith, Hope and Charity. Immediately following come, on the left, St Peter (though in the poem this is St Luke), holding his keys, and St Paul with an upraised sword, the instrument of his martyrdom. Behind Peter and Paul are four figures, in ecclesiastical dress in Botticelli's drawing, who may be four Doctors of the Church or, because Dante the poet describes them as of 'humble mien', the four authors of the 'minor' epistles, James, Peter, John and Jude. Finally, the old man bringing up the rear, 'who moved in a trance, as if asleep', is John the Divine, who in the Middle Ages was believed not actually to have died at Ephesus but to be merely sleeping there till Judgment Day. Surrounding the chariot, a symbol of the Church of Christ the Gryphon who draws it, are a host of heavenly spirits scattering flowers and crying, 'Veni, sponsa, de Libano . . . Come, my spouse, from Lebanon', a verse from the Song of Solomon here addressed to Beatrice as a figure of Divine Love; 'Benedictus qui venis . . . Blessed art thou who comest', a reminder of the welcome given to Jesus at His entry into Jerusalem before His death; and 'Manibus date o lilia plenis . . . Give me lilies with full hands!' This last verse, from the Aeneid, is simultaneously apt to the scene and a touching tribute to Virgil who, as Dante turns to share his joy at finally seeing Beatrice, has vanished. Dante bursts into tears, lowering his head in sadness, and is reprimanded by Beatrice for this last trace of human weakness he shows by bewailing loss in the presence of such bounty. He must, she says, exhaust his tears before crossing Lethe.

Time and again at daybreak I have seen
the eastern sky aglow with a wash of rose
while all the rest hung limpid and serene,

and the Sun's face rise tempered from its rest
so veiled by vapors that the naked eye
could look at it for minutes undistressed.

Exactly so, within a cloud of flowers
that rose like fountains from the angels' hands
and fell about the chariot in showers,

a lady came in view: an olive crown
wreathed her immaculate veil, her cloak was green,
the colors of live flame played on her gown.

My soul — such years had passed since last it saw
that lady and stood trembling in her presence,
stupefied by the power of holy awe —

now, by some power that shone from her above
the reach and witness of my mortal eyes,
felt the full mastery of enduring love.

The instant I was smitten by the force,
which had already once transfixed my soul
before my boyhood years had run their course,

I turned left with the same assured belief
that makes a child run to its mother's arms
when it is frightened or has come to grief,

to say to Virgil: 'There is not within me
one drop of blood unstirred. I recognize
the tokens of the ancient flame.' But he,

he had taken his light from us. He had gone.
Virgil had gone. Virgil, the gentle Father
to whom I gave my soul for its salvation!

Not all that sight of Eden lost to view
by our First Mother could hold back the tears
that stained my cheeks so lately washed with dew.

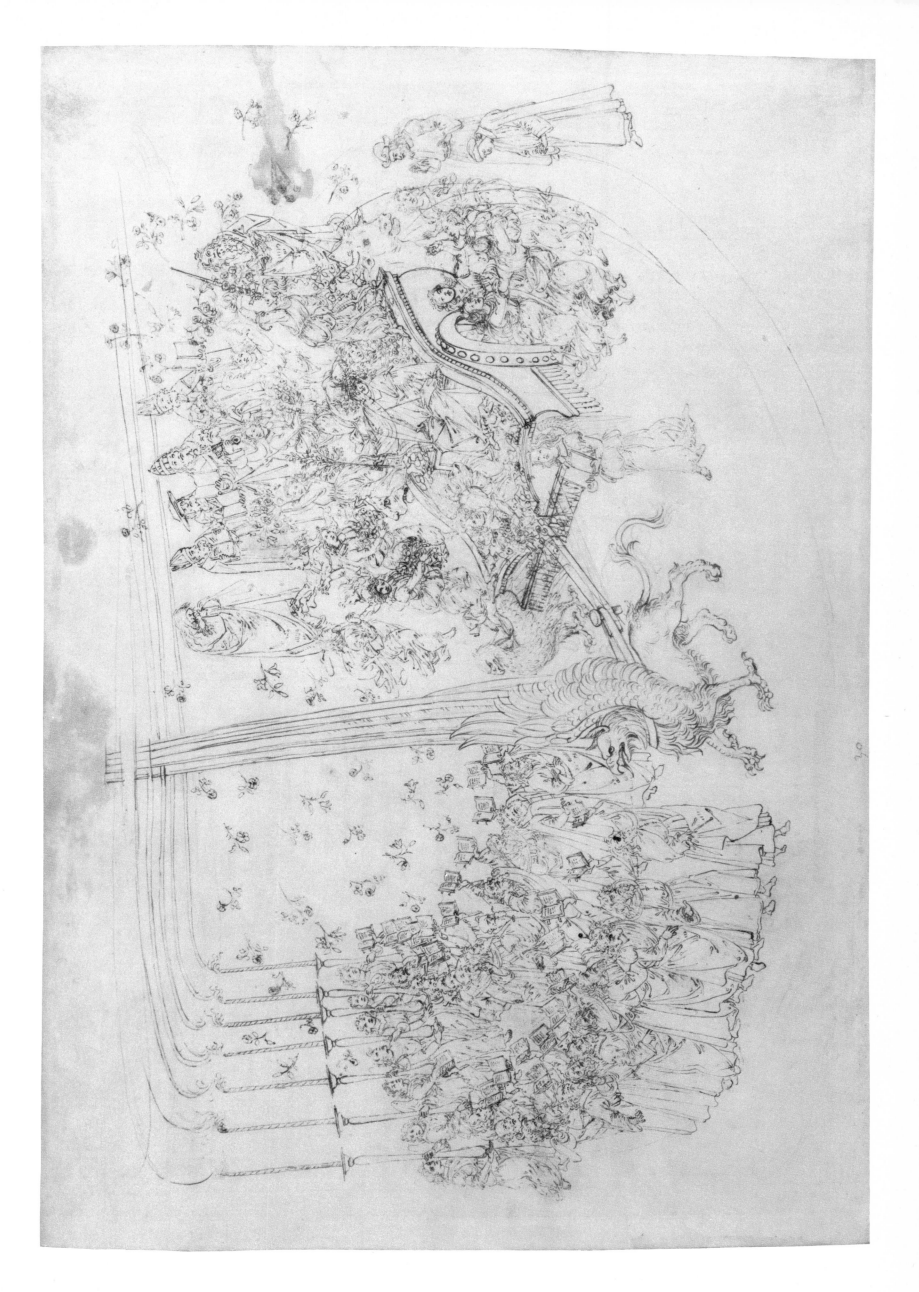

Beatrice

Lethe

BEATRICE CONTINUES to reprimand Dante, who stands with Status at the lower right-hand corner of the drawing, until he swoons with pain and remorse. When he returns to himself, he is in the stream Lethe, being pulled across it by Matilda, who walks across the surface of the water with Status. Once at the opposite shore, Matilda plunges Dante into the stream, forcing him to drink the waters that will make him forget his past sins; as she does so, she recites a verse from the Vulgate Psalm 50 'Asperges me . . . Cleanse me', the verse recited by a priest sprinkling with holy water a repentant sinner. On the opposite bank, the four maidens personifying the Cardinal Virtues dance and sing round the kneeling Dante, before, at the left, leading him to stand before the Gryphon. From this place, standing before the Gryphon-Christ, Dante looks deep into Beatrice's eyes, whose gaze she holds on the Gryphon. Thus, at this point of the great poem's allegory, Beatrice is Revelation, surrounded by the figure-symbols of the Old and New Testaments, and the Church, the mirror in which Dante has a vision of Christ's two natures, paralleled by the Gryphon's double nature. To Dante's direct awareness, the Gryphon remains unchangingly itself, while in Beatrice's eyes 'the twofold creature shone . . . now in the one, now in the other nature'; Dante does not yet see, as he will in Paradise, the two natures in the single person. The other three maidens, the Theological Virtues, now dance round Dante (Botticelli does not illustrate this episode) and urge Beatrice to unveil her face completely, so that Dante may have a further vision, this one of the beauty of Divine Love. Meanwhile, along the left of the drawing, the last of the twenty-four Elders are seen in a departing procession.

Then raising me in my new purity
she led me to the dance of the Four Maidens;
each raised an arm and so joined hands above me.

'Turn Beatrice, oh turn the eyes of grace,'
was their refrain, 'upon your faithful one
who comes so far to look upon your face.'

And she : 'Had you been silent, or denied
what you confess, your guilt would still be known
to Him from Whom no guilt may hope to hide.'

As a scolded child, tongue tied for shame, will stand
and recognize his fault, and weep for it,
bowing his head to a just reprimand,

so did I stand.

Such guilty recognition gnawed my heart
I swooned for pain ; and what I then became
she best knows who most gave me cause to smart.

When I returned to consciousness at last
I found the lady who had walked alone
bent over me. 'Hold fast!' she said, 'Hold fast!'

She had drawn me into the stream up to my throat,
and pulling me behind her, she sped on
over the water, light as any boat.

Nearing the sacred bank, I heard her say
in tones so sweet I cannot call them back,
much less describe them here : 'Asperges me.'

Then the sweet lady took my head between
her open arms, and embracing me, she dipped me
and made me drink the waters that make clean.

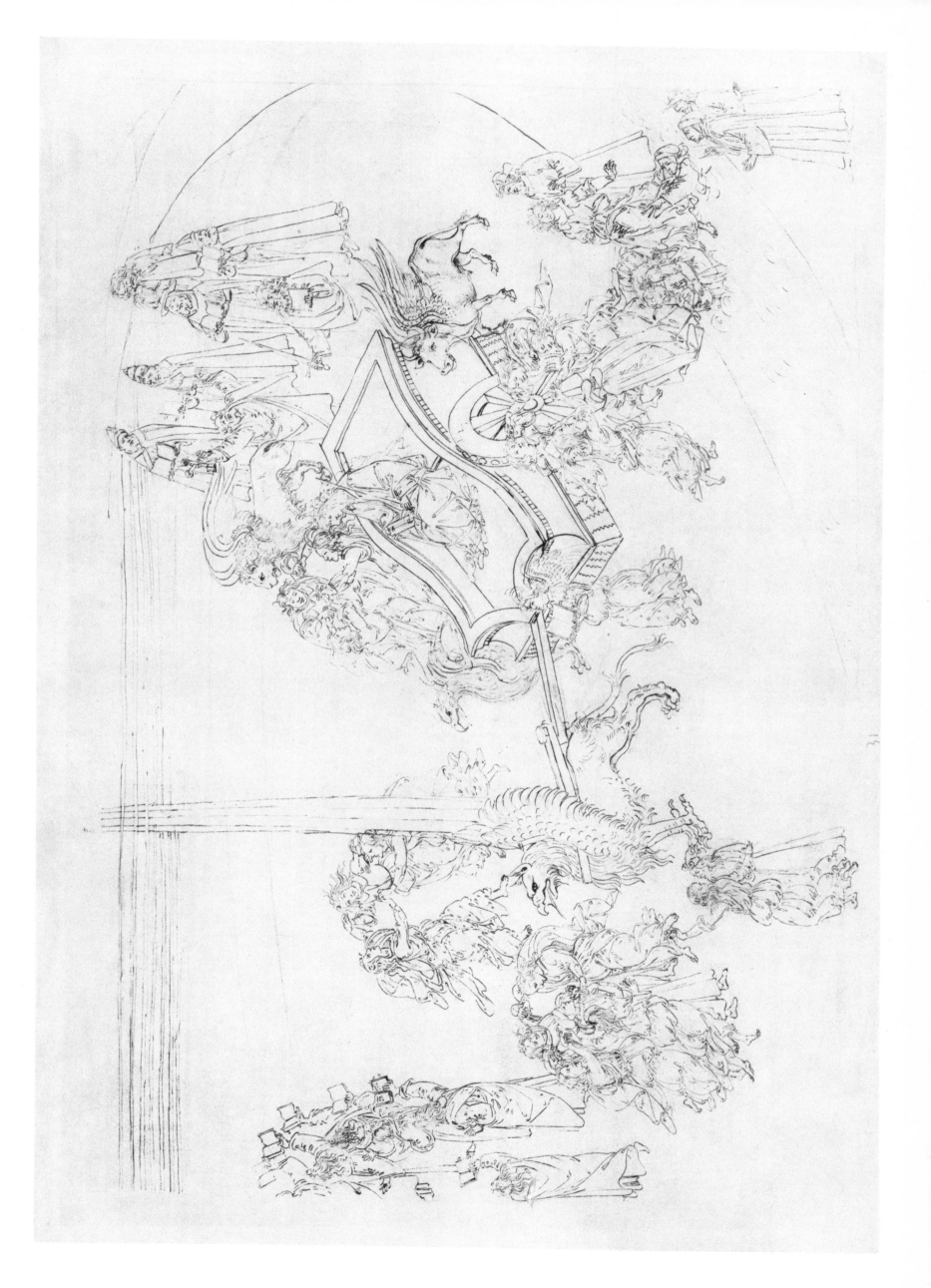

I saw the legion of those souls in grace
had turned right-wheel-about, and marched back now
with the sun and the seven torches in its face.

As forward troops when they are giving ground
turn under their shields, and their standards face about
before the rest of the column has turned round –

just so the vanguard of that heavenly force
had all gone by before the chariot
had swung its pole around to the new course.

* * *

Then to their wheels the ladies turned together,
and the Griffon once more pulled the sacred car,
not ruffling so much as a single feather.

Statius and I followed across that park
with the lady who had led me through the ford,
behind the wheel that turned the lesser arc.

* * *

She sat on the bare earth alone, left there
to guard the chariot that the Biformed Beast
had fastened to the tree with such great care.

A living cloister ringing her about,
the Seven Nymphs stood, holding in their hands
those candles no wind ever shall blow out.

* * *

 'Hence, look well

there at the great car, and that you may be
a light to the dark world, when you return
set down exactly all that you shall see.'

Beatrice
The Allegory of the Church's Vicissitudes

BEATRICE has completely removed the veil from her face as, while she remains in the chariot, the procession makes a half turn to proceed across the middle of the drawing from the left. Dante, Statius and Matilda are twice seen at the lower left. Beatrice descends from the chariot and, as she moves down to the lower right-hand corner of the drawing, the Gryphon draws the chariot to a barren tree which, when the beast ties the tongue of the chariot to it, suddenly bursts into leaf and blossom; the Gryphon, followed by the Elders at the top of the drawing, ascends into Heaven. At this Dante, in the lower centre, falls into a dream. Surrounded by the seven Virtues, who are now the Seven Pillars of Wisdom, as she is herself a figure now of Sapientia, Beatrice is seated on the ground at the foot of the tree as she instructs Dante, who will soon be a citizen of 'that Rome in which Christ is a Roman', to look attentively at the tree which becomes the centre of an allegory depicting the vicissitudes of the Church. The tree is now that first Tree of Paradise, of 'the Knowledge of Good and Evil', and from its branches swoops down a great eagle, like 'the bird of Jove', attacking the chariot and causing it to totter; just so the persecutions of the early Church by Rome grievously wounded it and tried its strength. Next, a fox appears, the figure of the wiliness of early heresies, to pounce on the chariot; Beatrice threatens it and it retreats. Once again the eagle, which had returned to the tree (hence Botticelli's drawing it twice), descends to the chariot and sheds its golden feathers on to it; here Dante the poet alludes to the Donation of Constantine, which endowed the Church with riches incongruent with its nature. Beneath the chariot, the earth splits and a dragon rises up to sink its tail into it; once again, as in *Inferno* XXVIII, Dante recalls Mahomet and clearly sees the founding of Islam as having been a great threat to the Church. Now the chariot begins to grow feathers and is soon covered entirely by them, an allusion to the wealth which accrued to the Church under the Carolingians, riches which changed its entire aspect, so that like the chariot it was no longer recognizable as itself. Out of the feathers grow seven horned beasts, the seven capital sins which were the fruits of the Church's degeneracy. At last, Dante sees seated in the cab of the chariot a harlot embraced by a giant who, finally, snatches her from the chariot and carries her off; this is the poem's allusion to the 'Avignon Captivity', when the Church, flirting with the kings of the earth, particularly of France, allowed herself to be abducted with the removal of the papal see from Rome to Avignon in 1305.

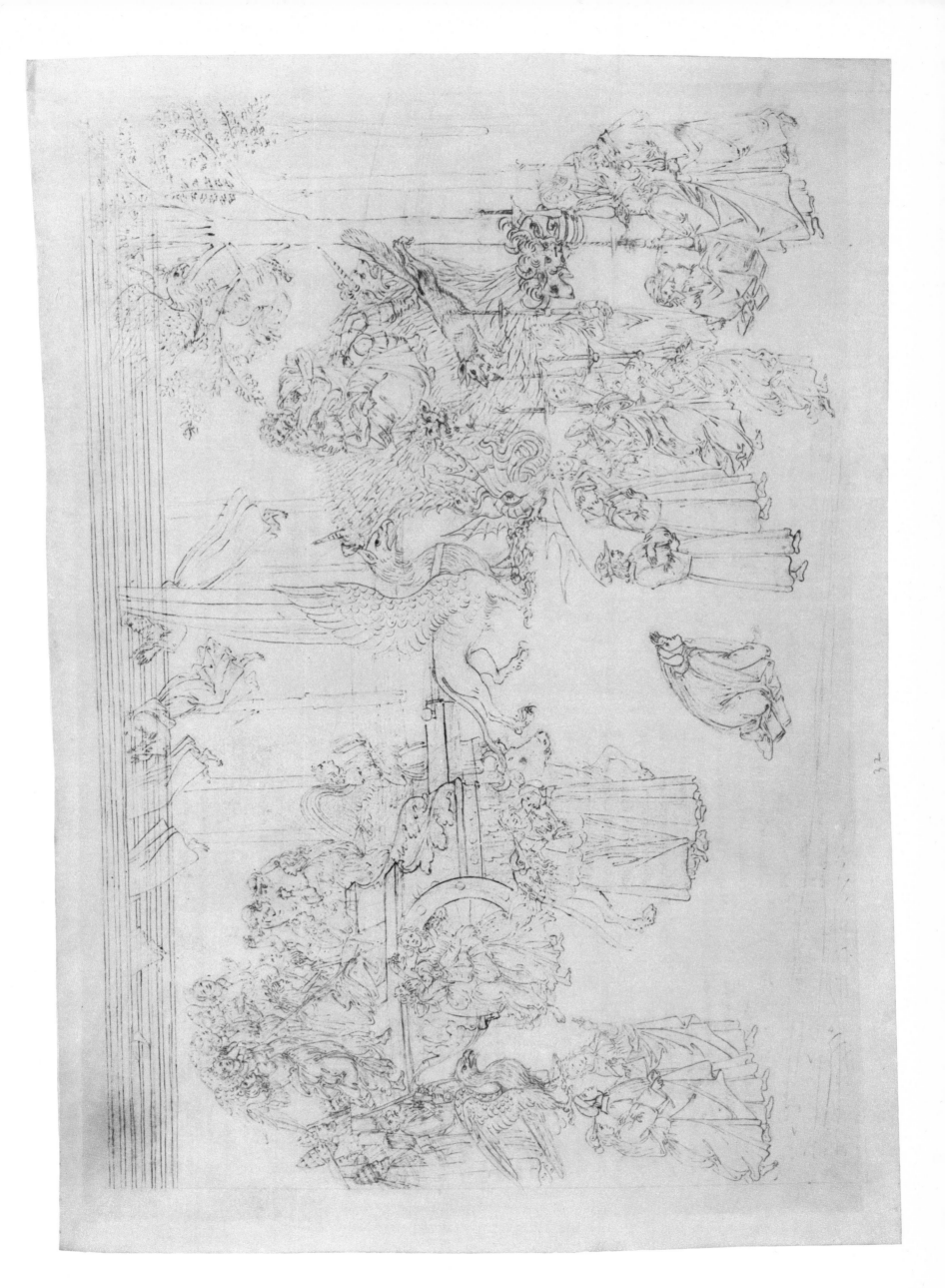

Then placing the Seven before her, she moved ahead
with a nod to me, to the Lady, and to the Sage
that had remained, to follow where she led.

So she strolled on, and she had not yet laid
her tenth step on the sward, when she turned round
and struck my eyes with her eyes as she said

with a serene tranquillity : 'Draw near,
that you may, if I wish to speak to you
as we move on, be better placed to hear.'

When I was, as I should be, at her side,
she said : 'Dear brother, why are you not moved
to question me as we move on? – Tongue-tied,

like one who knows his station is beneath
that of the presences in which he stands,
and cannot drag his voice across his teeth,

so did I, with a voice almost choked through,
manage to say : 'My Lady, all my need
and all that is my good is known to you.'

And she to me : 'My wish is that you break
the grip of fear and shame, and from now on
no longer speak like one but half awake.'

* * *

'It is my wish – because I see your mind
turned into stone, and like a stone, so darkened
that the light of what I tell you strikes it blind –

that you bear back, if not in writing, then
in outline, what I say, as pilgrims wreathe
their staffs with palm to show where they have been.'

* * *

And Beatrice : 'Perhaps a greater care,
as often happens, dims his memory
and his mind's eye. But see Eunoë there –

lead him, as is your custom, to the brim
of that sweet stream, and with its holy waters
revive the powers that faint and die in him.'

Then as a sweet soul gladly shapes its own
good will to the will of others, without protest,
as soon as any sign has made it known,

so the sweet maid, taking me by the hand
and saying in a modest voice to Statius,
'Come you with him,' obeyed the good command.

* * *

Reader, had I the space to write at will,
I should, if only briefly, sing a praise
of that sweet draught. Would I were drinking still!

But I have filled all of the pages planned
for this, my second, canticle, and Art
pulls at its iron bit with iron hand.

I came back from those holiest waters new,
remade, reborn, like a sun-wakened tree
that spreads new foliage to the Spring dew

in sweetest freshness, healed of Winter's scars ;
perfect, pure, and ready for the Stars.

Beatrice
Eunoë

THE ALLEGORICAL MASQUE has ended, and Beatrice
and the seven Virtues, at the left, remain seated at the foot
of the tree, in tears at witnessing the Church's calamities.
At last Beatrice rises and beckons Dante to follow her : in
the centre of the drawing Botticelli has drawn the still
sorrowing Virtues followed by Beatrice and Dante with
Matilda and Statius coming after them. Having bathed in
Lethe, Dante has put aside remorseful memories of sin and
the disorders of his past life. It remains now for him to
bathe in Eunoë, the other stream, whose waters will
strengthen in him every impulse to good. At Beatrice's
command, Matilda, at the upper right of the drawing, aids
Dante in plunging into Eunoë, as Statius stands looking
on. Now purged of every evil trace and strengthened in
goodness, Dante is ready for the final stage and ultimate
goal of his pilgrimage, Paradise.

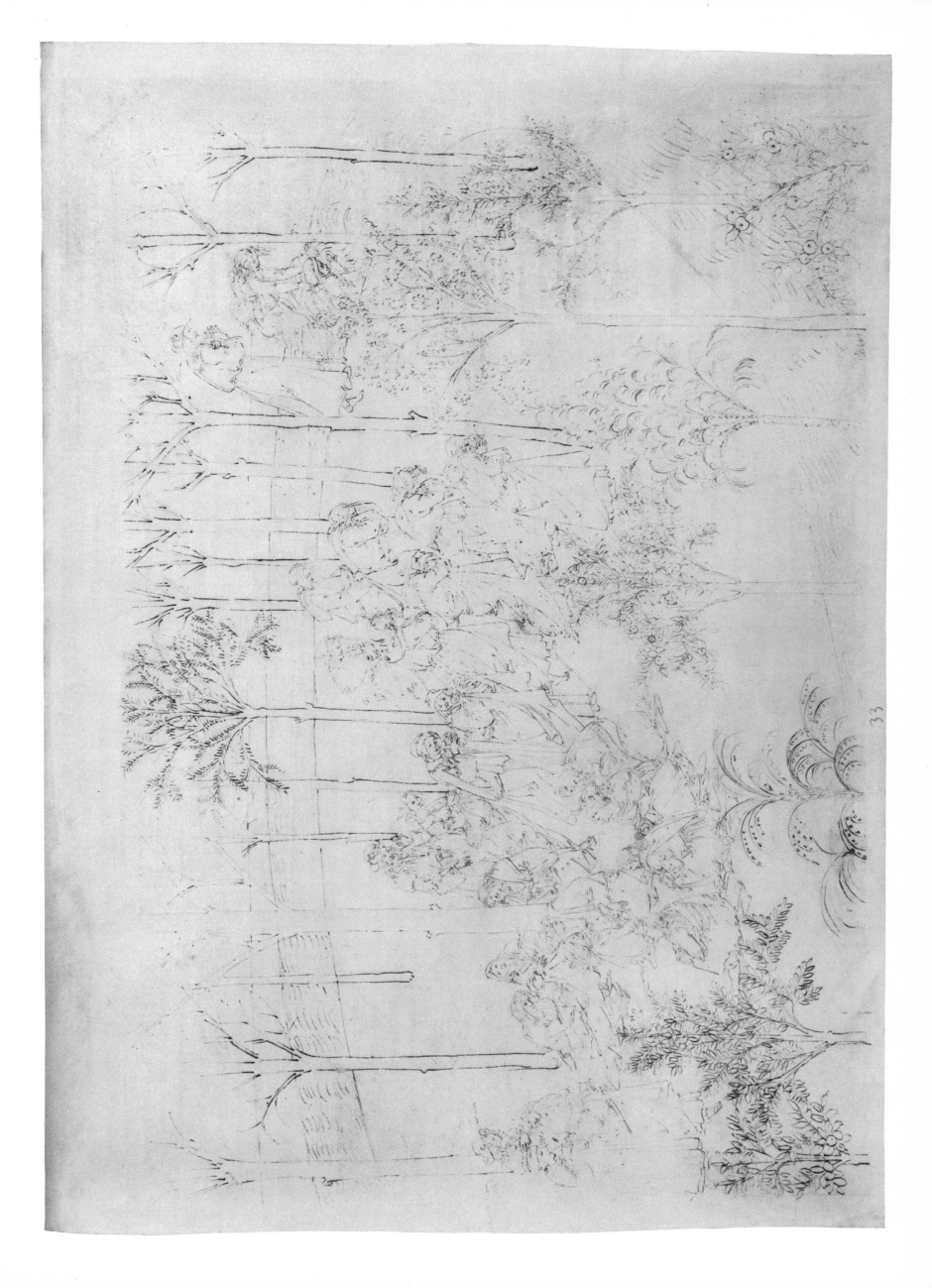

PARADISO

The Ascent to Heaven

HAVING FINISHED HIS PILGRIMAGE through Purgatory, 'perfect, pure, and ready for the stars', Dante joins Beatrice in the ascent through the planets and the various heavens to the ultimate Vision of God. As they leave behind the Sacred Wood, Dante is aware of a great magnitude of light, as though God 'had added a new sun to Heaven's glory', and hears the Music of the Spheres. Beatrice explains to him that they have left Earth behind and are rapidly rising to the purely spiritual realm of Heaven, concretized in the poem by the Moon, Sun and planets. Dante's astronomy is in accordance with the Ptolemaic system of his time, and considers Earth as the stationary centre round which the Sun, Moon and five visible planets – Mercury, Venus, Mars, Jupiter, Saturn – revolve at various speeds. Every celestial body has its own sphere or 'heaven'; beyond the farthest, Saturn, lie the Fixed Stars, and farther still is the last of the material heavens, called the Primum Mobile, infinite in its speed and from which the other bodies take their motions. Each of the nine spheres is moved and governed by one of the nine orders of Angels, and has, in the great poem, a particular spiritual significance exemplified by the blessed souls Dante and Beatrice encounter there. We are, in the *Paradiso*, to consider that the usual abode of the Blessed is the Empyrean, the sphere beyond the last of the material heavens, which is outside time and space; they descend to one or another of the minor spheres to illustrate for Dante that sphere's spiritual significance, and then return to the Empyrean. Finally, it is in the Empyrean that the Blessed eternally enjoy the vision of God's immediate presence, which Dante experiences for a time at the end of this *cantica*.

The glory of Him who moves all things rays forth
through all the universe, and is reflected
from each thing in proportion to its worth.

I have been in that Heaven of His most light,
and what I saw, those who descend from there
lack both the knowledge and the power to write.

For as our intellect draws near its goal
it opens to such depths of understanding
as memory cannot plumb within the soul.

Nevertheless, whatever portion time
still leaves me of the treasure of that kingdom
shall now become the subject of my rhyme.

* * *

That glad conjunction had made it evening here
and morning there; the south was all alight,
while darkness rode the northern hemisphere;

when I saw Beatrice had turned left to raise
her eyes up to the sun; no eagle ever
stared at its shining with so fixed a gaze.

And as a ray descending from the sky
gives rise to another, which climbs back again,
as a pilgrim yearns for home; so through my eye

her action, like a ray into my mind,
gave rise to mine: I stared into the sun
so hard that here it would have left me blind;

but much is granted to our senses there,
in that garden made to be man's proper place,
that is not granted us when we are here.

* * *

When the Great Wheel that spins eternally
in longing for Thee, captured my attention
by that harmony attuned and heard by Thee,

I saw ablaze with sun from side to side
a reach of Heaven: not all the rains and rivers
of all of time could make a sea so wide.

That radiance and that new-heard melody
fired me with such a yearning for their Cause
as I had never felt before.

* * *

Beatrice stared at the eternal spheres
entranced, unmoving; and I looked away
from the sun's height to fix my eyes on hers.

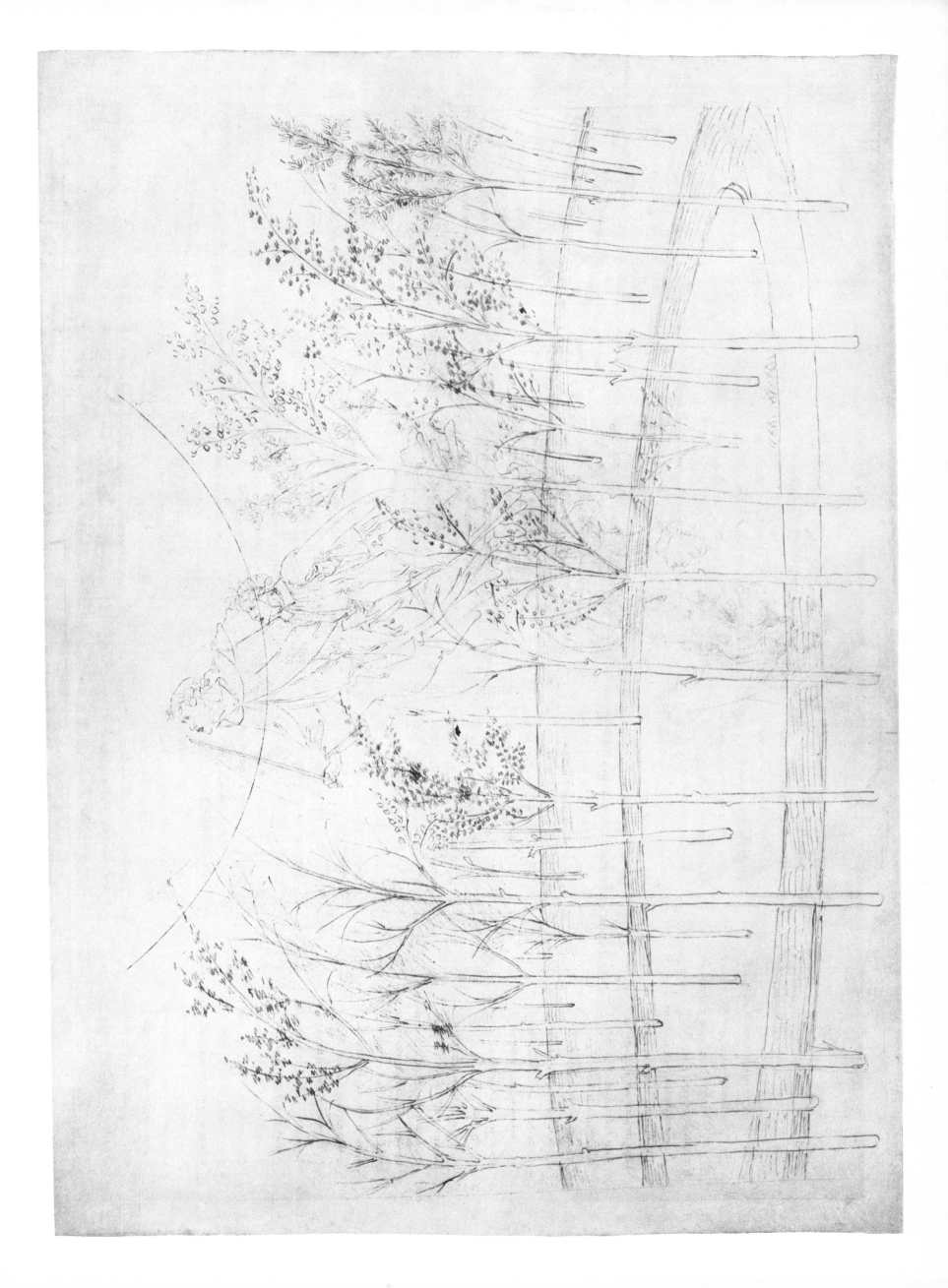

The Moon

DANTE AND BEATRICE stand within the Sphere of the Moon, the great circle enclosing them. Beatrice has turned to face a figure of the heavens, at the left of the drawing, as Dante raises his head and hands in wonder at the new knowledge he is gaining. At the heart of Botticelli's plan of the poem's heavens is Earth, TERA, which is ringed first by a circle of air, ARIA, and then by one of fire, FUOCHO. Next is the Sphere of the Moon, with its crescent symbol, and the two of Mercury and Venus, each marked by a star. Then follow the Sun's sphere, and the three of Mars, Jupiter and Saturn. Finally, are the Sphere of the Fixed Stars and, outermost and with the figures of six of its governing Angels drawn in, the Primum Mobile. The two heavenly pilgrims are to be understood (as Botticelli clearly has) as actually being within the substance of the Moon, in the way, the poet says, that 'water takes light to itself'.

Beatrice was looking upward and I at her
when – in the time it takes a bolt to strike,
fly, and be resting in the bowstring's blur –

I found myself in a place where a wondrous thing
drew my entire attention ; whereat she
from whom I could not hide my mind's least yearning

turned and said, as much in joy as beauty :
'To God, who has raised us now to the first star
direct your thoughts in glad and grateful duty.'

It seemed to me a cloud as luminous
and dense and smoothly polished as a diamond
struck by a ray of sun, enveloped us.

We were received into the elements
of the eternal pearl as water takes
light to itself, with no change in its substance.

If I was a body (nor need we in this case
conceive how one dimension can bear another,
which must be if two bodies fill one space)

the more should my desire burn like the sun
to see that Essence in which one may see
how human nature and God blend into one.

There we shall witness what we hold in faith,
not told by reason but self-evident ;
as men perceive an axiom here on earth.

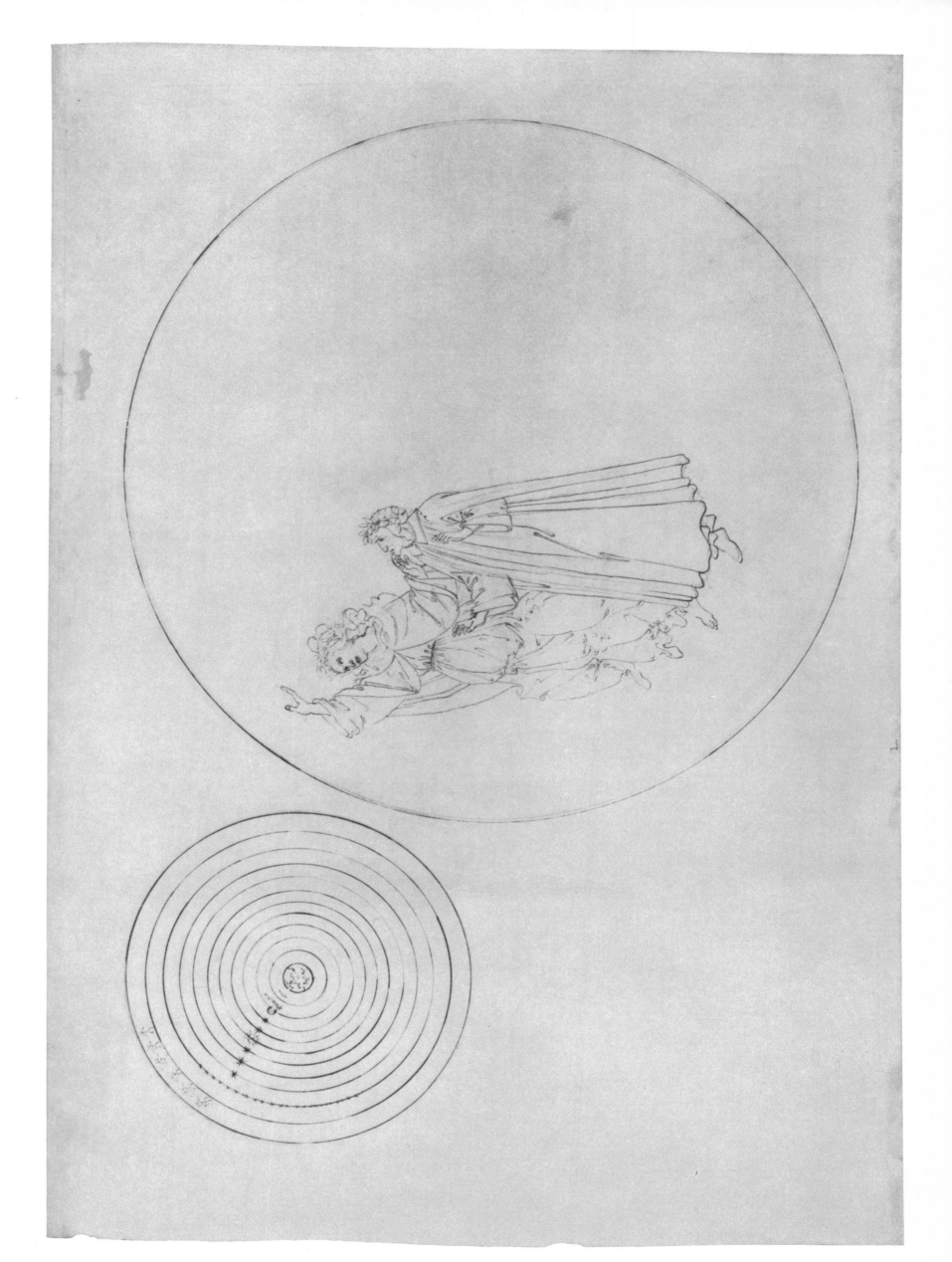

The Moon

STILL WITHIN THE SPHERE of the Moon, whose circular outline is only barely visible in this drawing, Dante is on the point of addressing Beatrice when he sees before him a multitude of faces, all of whom appear eager to address him. So faint and scarcely discernible are they, that he at first takes what he sees to be reflections and, as Botticelli indicates in his drawing, turns to look behind him to see who they are whose reflections he believes he is seeing. But Beatrice assures him that he is in fact looking directly at blessed spirits, who are in the Sphere of the Moon (always legendary for its inconstancy) because they were, through no fault of their own, inconstant to their vows. Dante addresses one of the souls, who tells him she is Piccarda Donati and that in her youth she had taken the veil and vows as a Poor Clare; for political reasons, however, her family took her from her convent and forced her into marriage. Dante ingenuously asks Piccarda if she and her companion spirits in this lowest sphere desire to move to more eminent and, he believes, more blessed levels. With a smile, Piccarda explains that every soul among the Blessed experiences the totality of joy and bliss it is capable of; God's will, she says, is their ultimate happiness and peace.

to holy vows. Greet them. Heed what they say,
and so believe; for the True Light that fills them
permits no soul to wander from its ray.'

* * *

'Brother, the power of love, which is our bliss,
calms all our will. What we desire, we have.
There is in us no other thirst than this.

* * *

In His will is our peace. It is that sea
to which all moves, all that Itself creates
and Nature bears through all Eternity.'

I, raising my eyes to her eyes to announce
myself resolved of error, and well assured,
was about to speak; but before I could pronounce

my first word, there appeared to me a vision.
It seized and held me so that I forgot
to offer her my thanks and my confession.

As in clear glass when it is polished bright,
or in a still and limpid pool whose waters
are not so deep that the bottom is lost from sight,

a footnote of our lineaments will show,
so pallid that our pupils could as soon
make out a pearl upon a milk-white brow –

so I saw many faces eager to speak,
and fell to the error opposite the one
that kindled love for a pool in the smitten Greek.

And thinking the pale traces I saw there
were reflected images, I turned around
to face the source – but my eyes met empty air.

I turned around again like one beguiled,
and took my line of sight from my sweet guide
whose sacred eyes grew radiant as she smiled.

'Are you surprised that I smile at this childish act
of reasoning?' she said, 'since even now
you dare not trust your sense of the true fact,

but turn, as usual, back to vacancy?
These are true substances you see before you.
They are assigned here for inconstancy

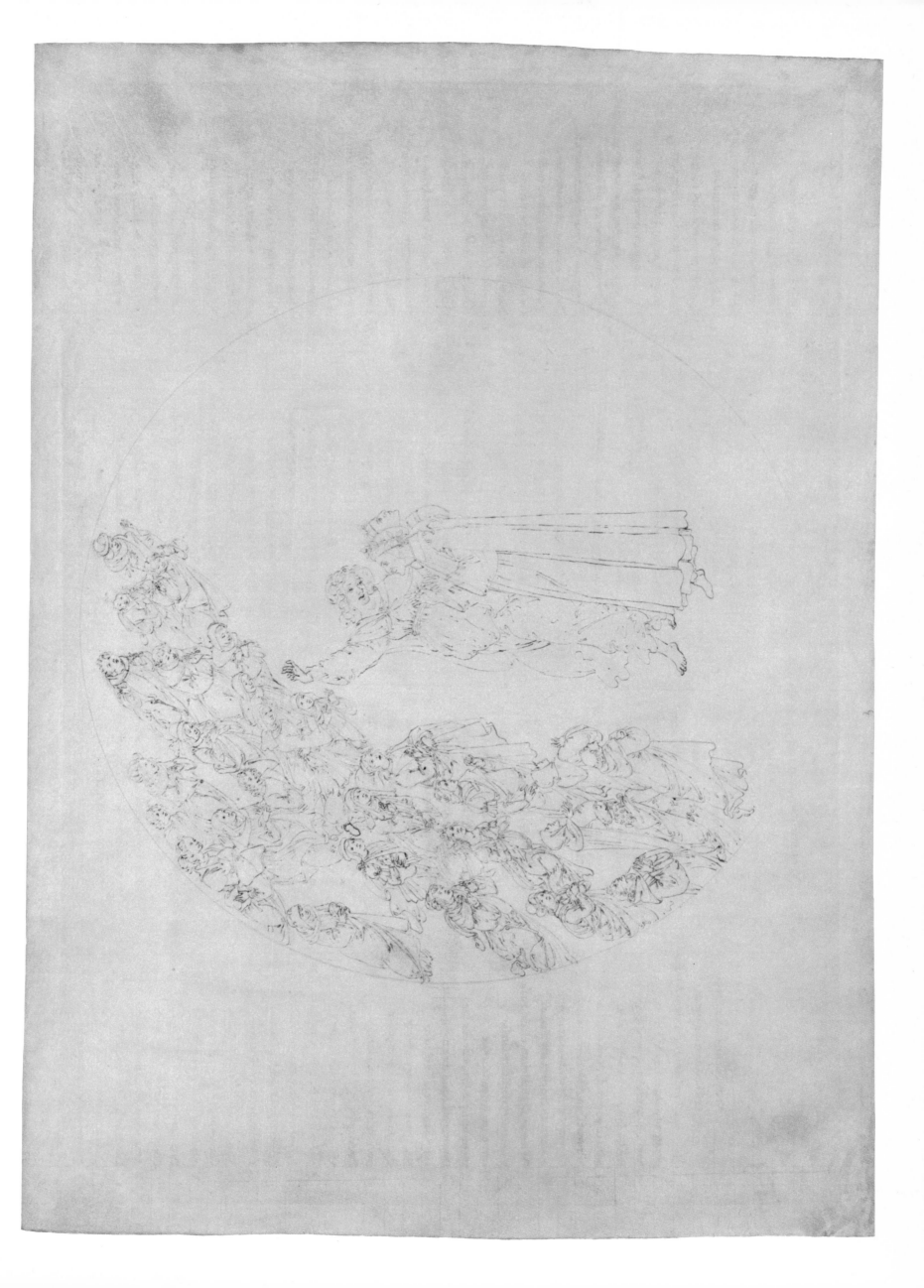

I did not speak, but on my face, at once,
were written all my questions and my yearnings,
far more distinctly than I could pronounce.

And Beatrice did as Daniel once had done
when he raised Nebuchadnezzar from the wrath
that made him act unjustly in Babylon.

* *

'Beloved of the First Love! O holy soul!'
I said then, 'You whose words flow over me,
and with their warmth quicken and make me whole,

There is not depth enough within my love
to offer you due thanks, but may the One
who sees and can, answer for me above.

Man's mind, I know, cannot win through the mist
unless it is illumined by that Truth
beyond which truth has nowhere to exist.

In That, once it has reached it, it can rest
like a beast within its den. And reach it can;
else were all longing vain, and vain the test.'

* *

Beatrice looked at me, and her glad eyes,
afire with their divinity, shot forth
such sparks of love that my poor faculties

gave up the reins. And with my eyes cast down
I stood entranced, my senses all but flown.

The Moon

AFTER TELLING DANTE HER STORY, Piccarda disappears 'like a weight into deep water' (except that in the metaphor of *Paradiso*, of course, she is more properly to be thought of as having *risen*, back to the Empyrean). Botticelli has drawn here a few of the Blessed of this sphere, but his principal focus is, again, on Beatrice, who gestures towards those remaining spirits. Dante listens with intense devotion and attention as Beatrice explains to him how a soul can enjoy complete beatitude even though at the lowest level of Heaven: each soul has its own capacity for beatitude; if that capacity is fulfilled, the soul enjoys complete beatitude, even though another soul, by comparison, may be more blessed. In Hell much of the torment of the damned arose from unquenchable desire; in Purgatory, the souls' punishment was simultaneously mitigated and sharpened by the hope of beatitude; in Heaven, there is neither unfulfilled desire nor the need for hope because the eternal moment is in itself fulfilment.

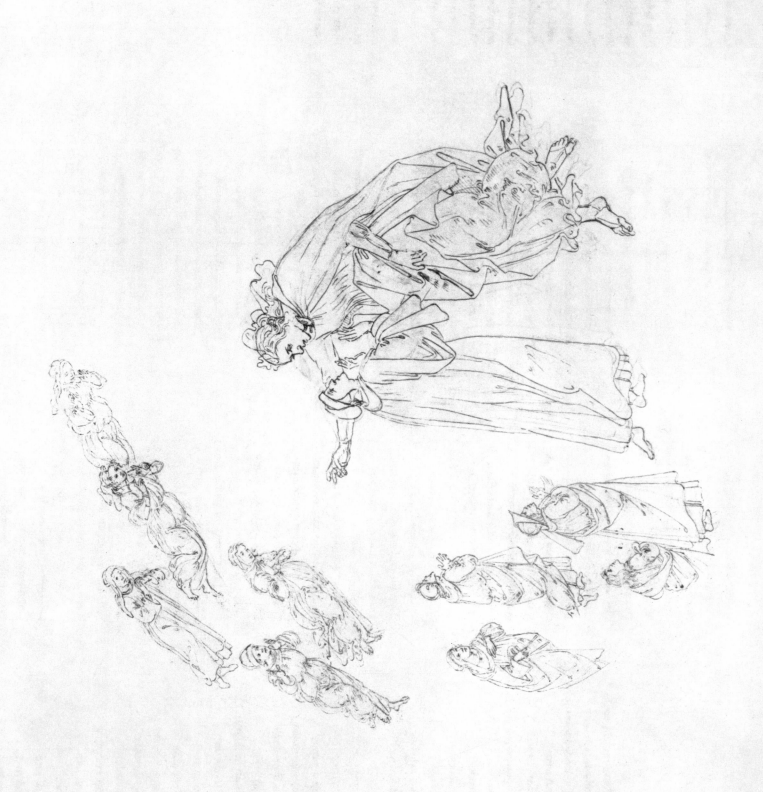

'If, in the warmth of love, I manifest
more of my radiance than the world can see,
rendering your eyes unequal to the test,

do not be amazed. These are the radiancies
of the perfected vision that sees the good
and step by step moves nearer what it sees.

Well do I see how the Eternal Ray,
which, once seen, kindles love forevermore,
already shines on you. If on your way

some other things seduce your love, my brother,
it can only be a trace, misunderstood,
of this, which you see shining through the other.'

* * *

Then she turned, full of yearning, to that part
where the world is quickened most by the True Light.

Her silence, her transfigured face ablaze
made me fall still although my eager mind
was teeming with new questions I wished to raise.

And like an arrow driven with such might
it strikes its mark before the string is still,
we soared to the second kingdom of the light.

My lady glowed with such a joyous essence
giving herself to the light of that new sky
that the planet shone more brightly with her presence.

And if the star changed then and laughed with bliss,
what did I do, who in my very nature
was made to be transformed through all that is?

As in a fish pond that is calm and clear
fish swim to what falls in from the outside,
believing it to be their food, so, here,

I saw at least a thousand splendors move
toward us, and from each one I heard the cry:
'Here is what will give increase to our love!'

And as those glories came to where we were
each shade made visible, in the radiance
that each gave off, the joy that filled it there.

* * *

Just as the sun, when its rays have broken through
a screen of heavy vapors, will itself
conceal itself in too much light – just so,

in its excess of joy that sacred soul
hid itself from my sight in its own ray,
and so concealed within its aureole,

it answered me, unfolding many things,
the manner of which the following canto sings.

The Moon
Mercury

BEATRICE continues her discourse to Dante, who in this drawing appears as though standing on solid ground. As much of this last *cantica* of the great poem consists in conversation between Beatrice and Dante in which he is initiated into the knowledge that is the essence of beatitude, many of Botticelli's drawings from here to the end of the suite show little more than these two; *Paradiso*, unlike the first two stages on Dante's pilgrimage, consists essentially not in the action of punishment or retribution, but in the contemplation of Divine Knowledge and Love. At the close of this canto, Dante and Beatrice ascend to the Sphere of Mercury.

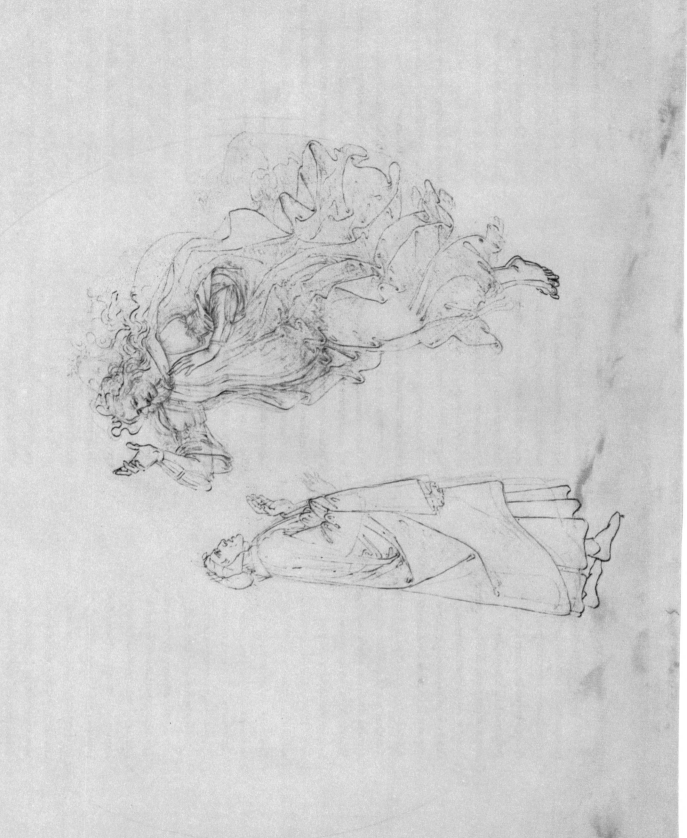

Mercury

Justinian

ASCENDED TO THE SECOND SPHERE of Heaven, Mercury, Dante and Beatrice encounter the souls of those Blessed who in life were active seekers after honour, though not in any sinful or guilty way. Botticelli illustrates them in this sphere to which they have descended from the Empyrean as flames powdered over the circle's field. Beatrice maintains her gaze on the higher heavens and, ultimately, the Vision of God, while Dante continues in contemplation of her. For the whole of this canto, the spirit of the Emperor Justinian addresses Dante, explaining that though his glory and that of his fellows in this sphere is nearly the lowest – for they all permitted their impulse to the love of God to be weakened by seeking their own glory – they exist in a joyous peace that comes from seeing a perfect balance between their reward and their desert.

'Caesar I was, Justinian I am.
By the will of the First Love, which I now feel,
I pruned the law of waste, excess, and sham.

* * *

– This little star embellishes its crown
with the light of those good spirits who were zealous
in order to win honor and renown ;

and when desire leans to such things, being bent
from the true good, the rays of the true Love
thrust upward with less force for the ascent ;

but in the balance of our reward and due
is part of our delight, because we see
no shade of difference between the two.

By this means the True Judge sweetens our will,
so moving us that in all eternity
nothing can twist our beings to any ill.

Unequal voices make sweet tones down there.
Just so, in our life, these unequal stations
make a sweet harmony from sphere to sphere.'

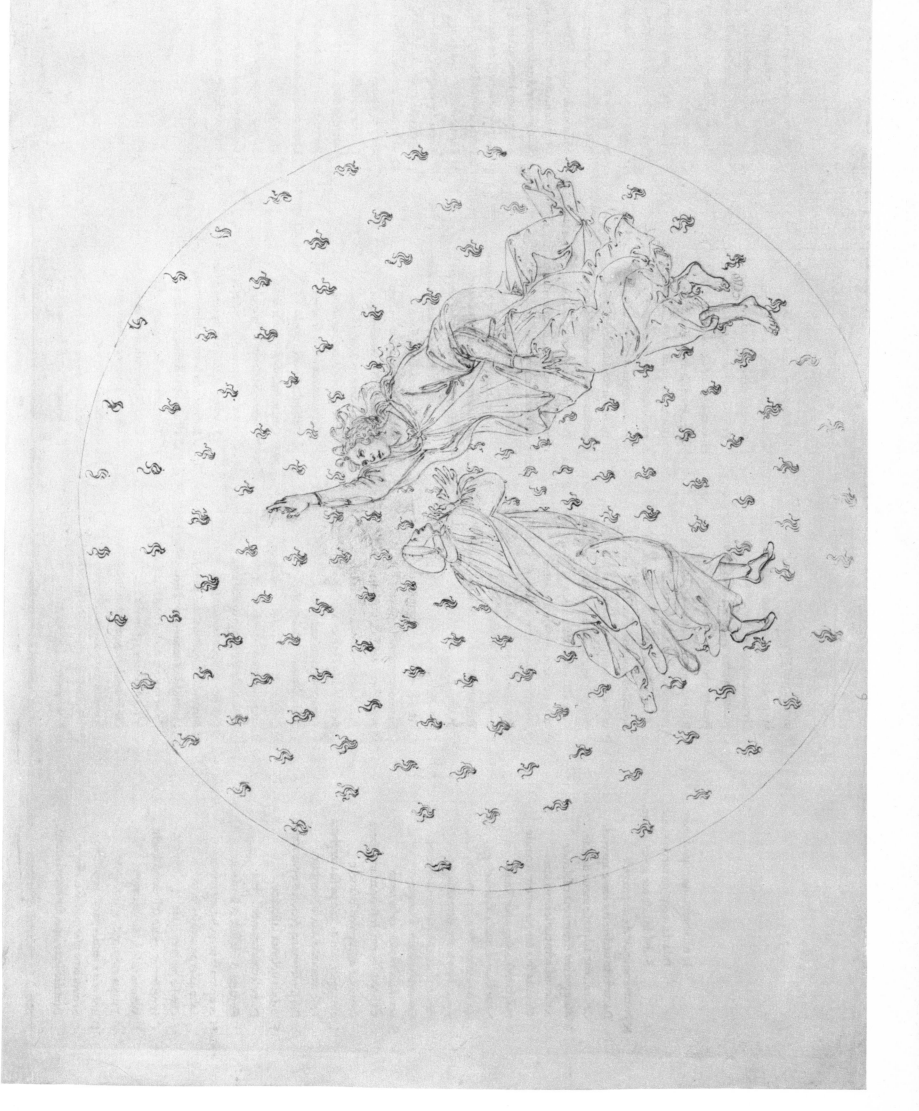

I stood, torn by my doubts. 'Speak up. Speak up,'
 I said inside myself. 'Ask the sweet lady
 who slakes your every thirst from the sweet cup.'

* *

'Whatever is poured directly from Its spring
 is wholly free; so made, it is not subject
 to the power of any secondary thing.

The Sacred Fire that rays through all creation
 burns with most joy in what is most like It;
 the more alike, the greater Its elation.

All of these attributes endow the nature
 of humankind; and if it fail in one,
 it cannot help but lose its noble stature.

Sin is the one power that can take away
 its freedom and its likeness to True Good,
 whereby it shines less brightly in Its ray.

Its innate worth, so lost, it can regain
 only by pouring back what guilt has spilled,
 repaying evil pleasure with just pain.

Your nature, when it took sin to its seed,
 sinned totally. It lost this innate worth,
 and it lost Paradise by the same deed.

* *

Thus it was up to God, to Him alone
 in His own ways – by one or both, I say –
 to give man back his whole life and perfection.

But since a deed done is more prized the more
 it manifests within itself the mark
 of the loving heart and goodness of the doer,

the Everlasting Love, whose seal is plain
 on all the wax of the world, was pleased to move
 in all His ways to raise you up again.

There was not, nor will be, from the first day
 to the last night, an act so glorious
 and so magnificent, on either way.

For God, in giving Himself that man might be
 able to raise himself, gave even more
 than if he had forgiven him in mercy.

All other means would have been short, I say,
 of perfect justice, but that God's own Son
 humbled Himself to take on mortal clay.'

Mercury

JUSTINIAN HAS RETURNED to the Empyrean, and Dante and Beatrice remain in the Sphere of Mercury, whose spirits Botticelli now draws as flames arranged in concentric circles. Once again, the figure of Beatrice is larger than that of Dante, who stands in a pose of humble inquiry. Beatrice explains, in answer to his confusion, that the Incarnation of God as Jesus Christ, and His death on the Cross, was a harmonious mixture of God's mercy and His justice: God could, in His infinite mercy, simply have forgiven mankind its guilt in the sin of Adam; His justice, on the other hand, could have demanded the (impossible to creatures, in Dante's theology) perfectly congruent retribution demanded by an offence against the Infinite God. In the event, Beatrice concludes, God's justice was satisfied by Christ's atoning death, while His birth was itself an effect of infinite mercy.

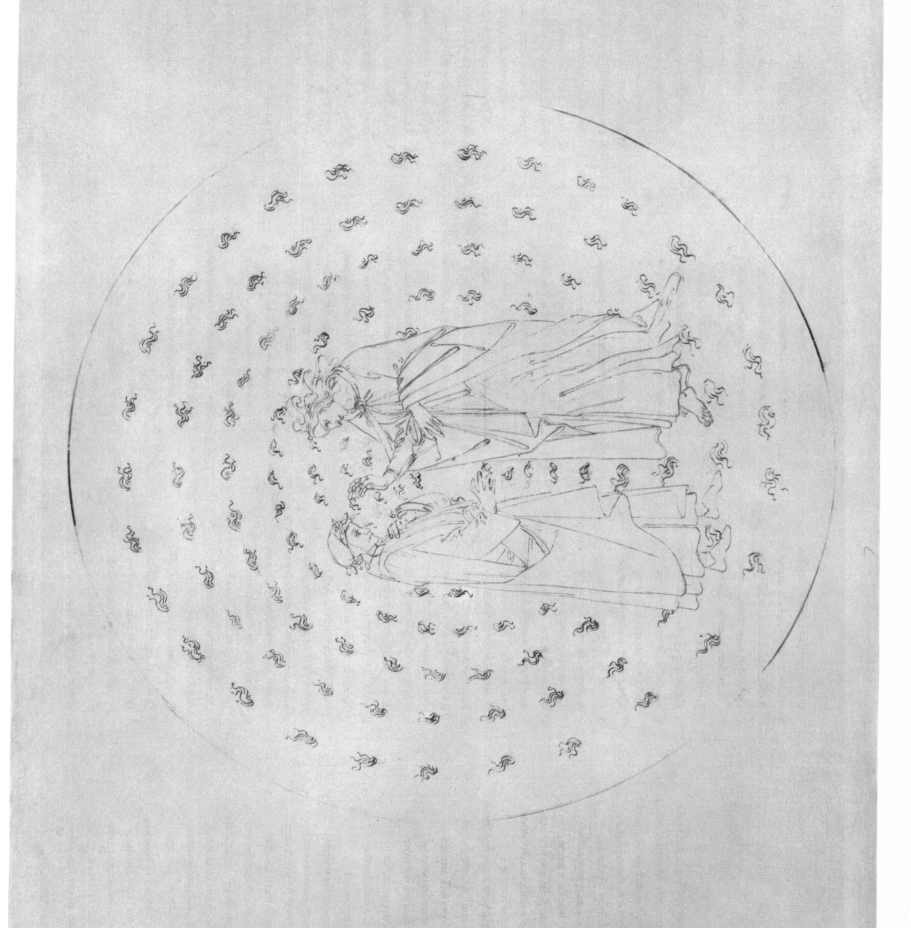

Venus

BEATRICE AND DANTE ascend to the third circle of Paradise, the Sphere of Venus. Dante sees the souls here as lights circling within the light of Venus, the Morning Star. One of the spirits, here pointed out by Beatrice, is Charles Martel of Anjou, who is in this sphere because, like his fellows here, he almost allowed his ardent human affections to divert him from salvation. Dante had known the living Charles (who died in 1295 at the age of twenty-seven) and was obviously friendly towards the young prince. The poet Dante uses the encounter with Charles as the occasion for an explanatory discourse to Dante from him on the diversity of human talents and personalities: Charles' brother, Roberto, is now King of Naples and notorious for the harshness of his character, quite different from Charles' fair-minded nobility and gentleness. Charles points out that it would be a contradictory injustice in God to allow any one man's children to inherit all their father's (in Dante's time the male was the active, influential principle in generation) virtues or shortcomings. Instead, Providence has so arranged things that the stars bearing on the hour of an individual's birth influence his development to serve God's ends and His glory.

And as a spark is visible in the fire,
and as two voices may be told apart
if one stays firm and one goes lower and higher;

so I saw lights circling within that light
at various speeds, each, I suppose, proportioned
to its eternal vision of delight.

* * *

Then one of them came forward and spoke thus:
'We are ready, all of us, and await your pleasure
that you may take from us what makes you joyous.

In one thirst and one spiraling and one sphere
we turn with those High Principalities
to whom you once cried from the world down there:

"O you whose intellects turn the third great wheel!"
So full of love are we that, for your pleasure,
it will be no less bliss to pause a while.'

I raised my eyes to the holy radiance
that was my lady, and only after she
had given them her comfort and assurance,

did I turn to the radiance that had made
such promises. 'Who are you?' were my words,
my voice filled with the love it left unsaid.

* * *

'What Nature gives a man Fortune must nourish
concordantly, or nature, like any seed
out of its proper climate, cannot flourish.

If the world below would learn to heed the plan
of nature's firm foundation, and build on that,
it then would have the best from every man.

But into holy orders you deflect
the man born to strap on a sword and shield;
and make a king of one whose intellect

is given to writing sermons. And in this way
your footprints leave the road and go astray.'

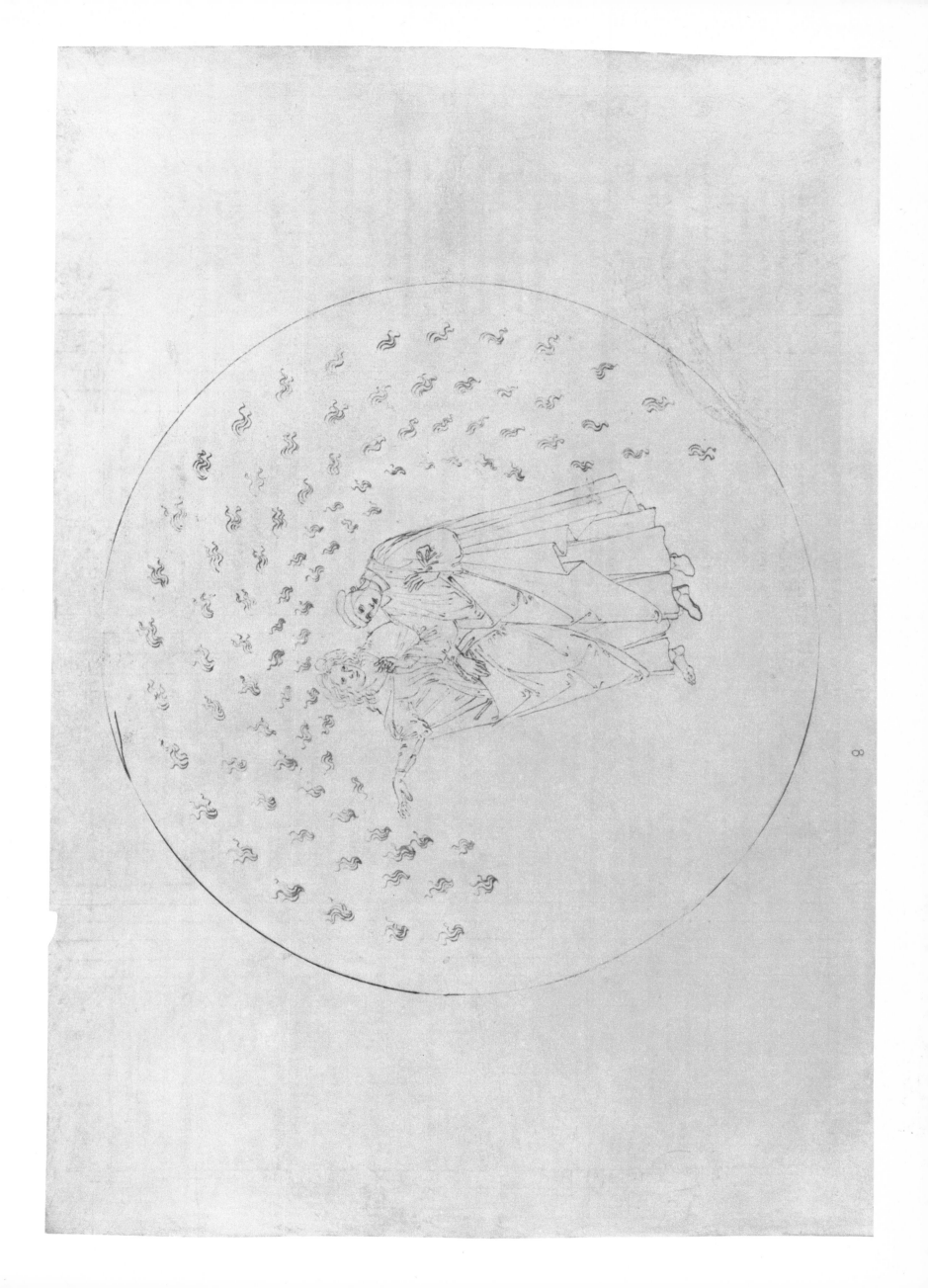

8

And lo! another of those splendors now
draws near me, and his wish to give me pleasure
shows in the brightening of his outward glow.

The eyes of Beatrice, which, as before
were fixed on me, saw all my wish and gave it
the assurance of their dear consent once more.

'O blessed spirit, be pleased to let me find
my joy at once,' I said. 'Make clear to me
that you are a true mirror of my mind!'

Thereat the unknown spirit of that light,
who had been singing in its depths, now spoke,
like one whose whole delight is to delight.

'In that part of the sinful land men know
as the Italy which lies between Rialto
and the springs from which the Brenta and Piave flow,

there stands a hill of no imposing height;
down from it years ago there came a firebrand
who laid waste all that region like a blight.

One root gave birth to both of us. My name
was Cunizza, of Romano, and I shine here
because this star conquered me with its flame.

Yet gladly I embrace the fate that so
arranged my lot, and I rejoice in it,
although it may seem hard to the crowd below.

This bright and precious jewel of our sky,
whose ray shines here beside me, left great fame
behind him on the earth; nor will it die

before this centenary is five times told.
Now ask yourself if man should seek that good
that lives in name after the flesh is cold.'

Venus

BEATRICE AND DANTE are drawn as still in the Sphere of Venus, among the Amorous. Dante has raised his head and looks attentively before him, as though at one of the spirits whose presence here Botticelli had intended to portray again in concentric rings of flames. Beatrice has turned to look fixedly at Dante. Dante seems, then, to be addressing the soul of Cunizza da Romano, who, after a youth of licentiousness followed by four marriages, died in old age a woman of piety and generosity. Cunizza repeats and reinforces for Dante the lesson that each soul in Heaven is content with its lot, which it sees and embraces as congruent with its life and disposition.

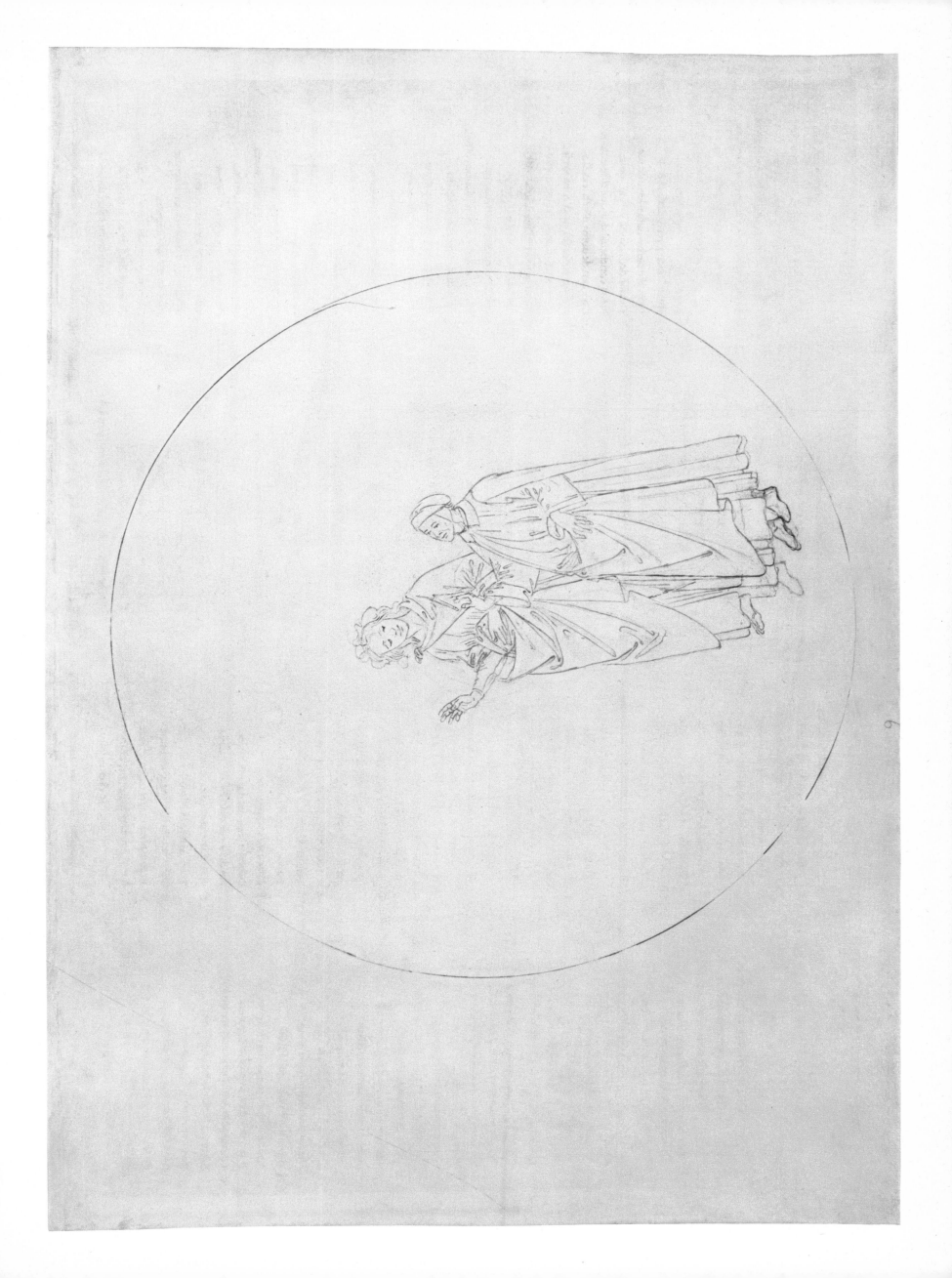

Nature's majestic minister, the Sun,
who writes the will of Heaven on the earth
and with his light measures the hours that run,

now in conjunction (as I have implied)
with Aries, rode those spirals whose course brings him
ever earlier from the eastern side.

And I was with the Sun ; but no more aware
of my ascent than a man is of a thought
that comes to mind, until he finds it there.

* *

How radiant in its essence that must be
which in the Sun (where I now was) shows forth
not by its color but its radiancy.

Though genius, art, and usage stored my mind,
I still could not make visible what I saw ;
but yet may you believe and seek to find!

And if our powers fall short of such a height,
why should that be surprising, since the sun
is as much as any eye has known of light?

Such, there, was the fourth family of splendors
of the High Father who fills their souls with bliss,
showing them how He breathes forth and engenders.

'Give thanks!' my lady said. 'With all devotion
give thanks to the Sun of Angels, by whose grace
you have been lifted to this physical one!'

* *

The Sun

IN THE SPHERE OF THE SUN, to which they have risen, Beatrice and Dante stand again within a great circle, she pointing ever upwards, the poet shielding his eyes with his right hand against the brilliance of 'Nature's majestic minister'. Barely visible within the periphery of the ring surrounding the two are faint figures probably intended by Botticelli to represent the twelve Doctors of the Church, whom Dante meets in this canto and who are described to him by St Thomas Aquinas. When Thomas has pointed out his companions in glory – Dominic, Albertus Magnus, Gratian, Peter Lombard, Solomon, Denis the Areopagite, Orosius, Isidore, Bede, Richard of St Victor and Siger of Brabant – none of whom speaks to or otherwise recognizes Dante's presence, the twelve sing in harmonies known only in the eternity of Paradise.

Then as a clock tower calls us from above
when the Bride of God rises to sing her matins
to the Sweet Spouse, that she may earn his love,

with one part pulling and another thrusting,
tin-tin, so glad a chime the faithful soul
swells with the joy of love almost to bursting –

just so, I saw that wheel of glories start
and chime from voice to voice in harmonies
so sweetly joined, so true from part to part

that none can know the like till he go free
where joy begets itself eternally.

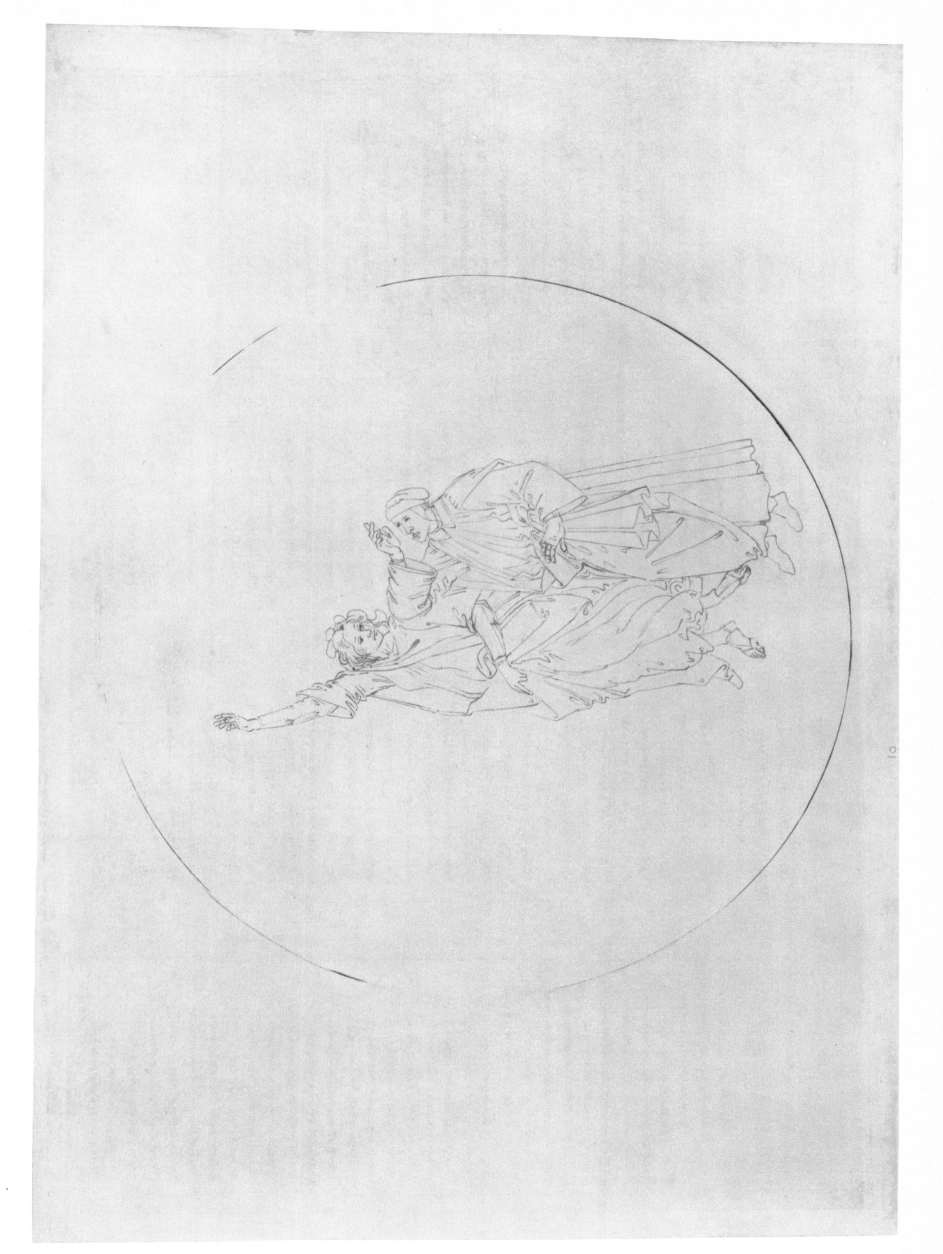

O senseless strivings of the mortal round!
how worthless is that exercise of reason
that makes you beat your wings into the ground!

One man was giving himself to law, and one
to aphorisms; one sought sinecures,
and one to rule by force or sly persuasion;

one planned his business, one his robberies;
one, tangled in the pleasure of the flesh,
wore himself out, and one lounged at his ease;

while I, of all such vanities relieved
and high in Heaven with my Beatrice,
arose to glory, gloriously received.

* * *

'He did not grieve because he had been born
the son of Bernardone; he did not care
that he went in rags, a figure of passing scorn.

He went with regal dignity to reveal
his stern intentions to Pope Innocent,
from whom his order first received the seal.

Then as more souls began to follow him
in poverty – whose wonder-working life
were better sung among the seraphim –

Honorius, moved by the Eternal Breath,
placed on the holy will of this chief shepherd
a second crown and everflowering wreath.

Then, with a martyr's passion, he went forth
and in the presence of the haughty Sultan
he preached Christ and his brotherhood on earth;

but when he found none there would take Christ's pardon,
rather than waste his labors, he turned back
to pick the fruit of the Italian garden.

On the crag between Tiber and Arno then, in tears
of love and joy, he took Christ's final seal,
the holy wounds of which he wore two years.'

The Sun

THOMAS AQUINAS, once he and the other eleven Doctors of the Church in the previous canto have finished their hymn, praises to Dante the virtues of St Dominic, founder of the Dominican order of which Thomas was a member, and St Francis of Assisi. The first, he says, in his wisdom was like one of the cherubim, while Francis' love made him 'shine like the seraphim'. Dominic traces the life of Francis, from his birth as a rich man's son to his death in 1226, two years after receiving the stigmata in a vision of Christ on Mt Alvernia, the 'crag between Tiber and Arno'. Thomas concludes with a criticism of his own, Dominican, order, thus closing an example of the generous life of Paradise which will be balanced in its graciousness by the Franciscan Bonaventure's praise of St Dominic and censure of the Franciscans in the next canto.

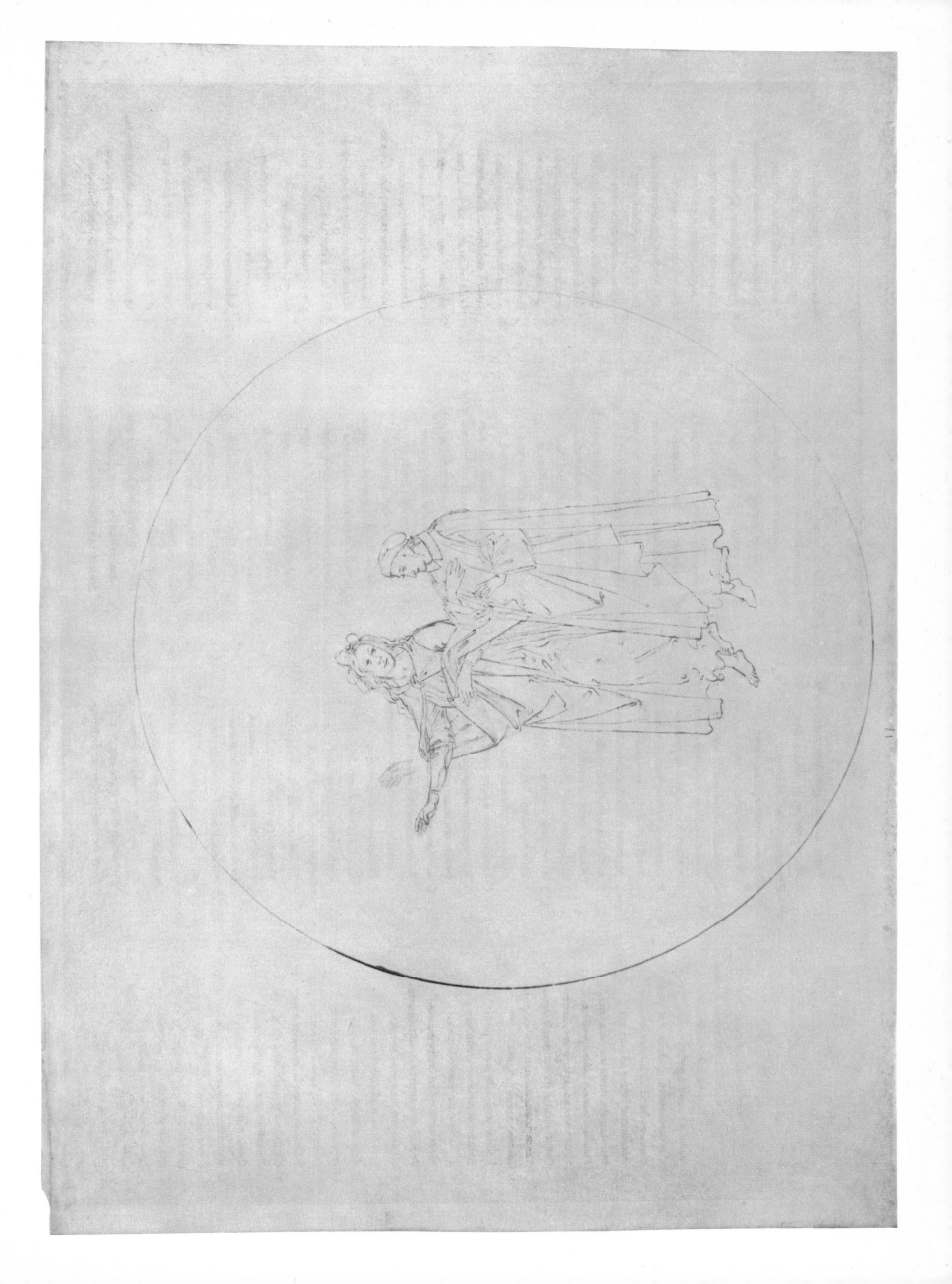

The Sun

WITHIN THE FAINTLY RULED five or six concentric circles bounded by the perimeter of the Sphere of the Sun, Dante and Beatrice stand, she gazing on him, who has his hands raised to shield his eyes from the Sun's brilliance. In this canto, once Thomas Aquinas has finished speaking the ring of spirits of which he is a member revolves and soon a second ring forms round it. From this ring, Dante hears the voice of St Bonaventure, the great Franciscan theologian, who eulogizes St Dominic and his life, from his birth in Spain, through his founding the Order of Preachers to combat the Albigensian heresy, to his death in 1221 when he was fifty years old. After denouncing his fellow Franciscans for their laxity, Bonaventure identifies for Dante, in this second wreath of twelve great souls, Illuminato and Augustino, who were early companions of Francis of Assisi, Hugh of St Victor, Petrus Comestor, Pope John xxi, the prophet Nathan, John Chrysostom, Anselm of Canterbury, Aelius Donatus, Hrabanus Maurus and Joachim of Floris.

So spoke the blessed flame and said no more;
and at its final word the holy millstone
began revolving round us as before.

* * *

And had not finished its first revolution
before a second wheel had formed around it,
matching it tone for tone, motion for motion.

* * *

And when the exalted festival and dance
of love and rapture, sweet song to sweet song,
and radiance to flashing radiance,

had in a single instant fallen still
with one accord – as our two eyes make one,
being moved to open and close by a single will –

from one of those new splendors a voice came;
and as the North Star draws a needle's point,
so was my soul drawn to that glorious flame.

Thus he began: 'The love that makes me shine
moves me to speak now of that other leader
through whom so much good has been said of mine.

When one is mentioned the other ought to be;
for they were militant in the same cause
and so should shine in one light and one glory.

* * *

Within its walls was born the ardent one,
true lover and true knight of the Christian faith;
bread to his followers, to his foes a stone.

His mind, from the instant it began to be,
swelled with such powers that in his mother's womb
he made her capable of prophecy.

* * *

Dominicus he was called. Let him be known
as the good husbandman chosen by Christ
to help Him in the garden He had sown.

A fitting squire and messenger of Christ
he was, for his first love was poverty,
and such was the first counsel given by Christ.'

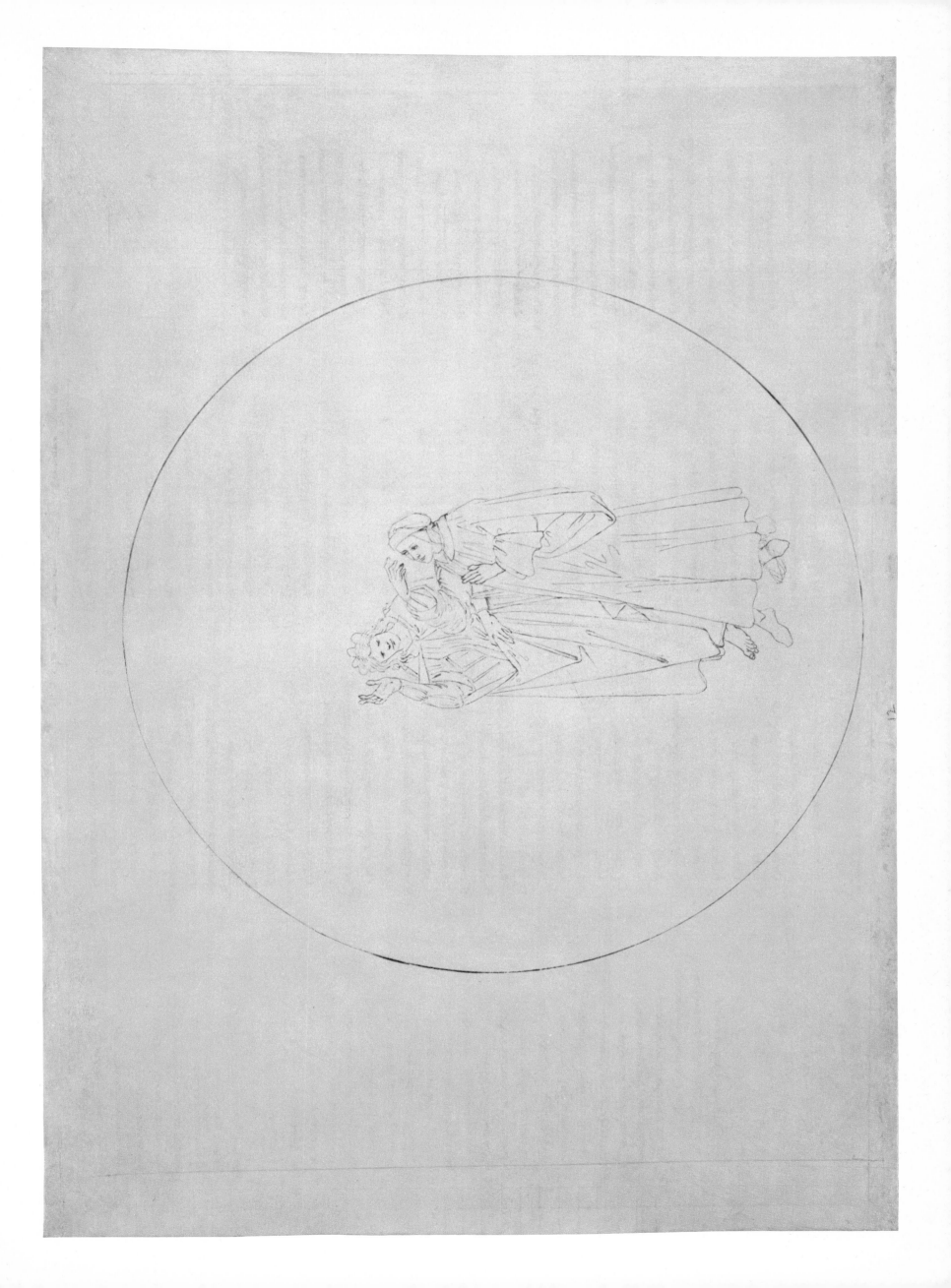

So might you dimly guess (if mankind could)
what actual stars, joined in their double dance,
circled around the point on which I stood;

though such experiences outrun our knowing
as the motion of the first and fastest heaven
outruns the low Chiana's sluggish flowing.

There they sang no Bacchic chant nor Paean,
but Three Persons in One Divine Nature
and It and human nature in One Person.

The song and circling dance ran through their measure,
and now those holy lights waited on us,
turning rejoiced from pleasure to new pleasure.

 * * *

The silence of these numina was broken
by the same lamp from which the glorious life
of God's beloved pauper had been spoken.

'Hence you may see that when I spoke before
of unmatched wisdom, it was on royal prudence
that the drawn arrow of my intention bore.

Note well that I said "rose" when I spoke of it.
Thus you will see I spoke only of kings,
of whom there are many, though so few are fit.

Such were my words, and taken in this light
they are consistent with all that you believe
of our first father and of our Best Delight.

 * * *

Opinions too soon formed often deflect
man's thinking from the truth into gross error,
in which his pride then binds his intellect.

It is worse than vain for men to leave the shore
and fish for truth unless they know the art;
for they return worse off than they were before.'

The Sun

AGAIN, BOTTICELLI'S DRAWING is unfinished, with Dante and Beatrice once more standing at the centre of the Sphere of the Sun and enclosed by a group of concentric circles. At the start of this canto Dante says that he saw the two rings of Doctors of the Church revolve in a pair of concentric circles, each going in a direction opposite to the other's. As they turn, the blessed spirits ring forth a hymn to the Trinity and to the two natures in Christ. When the hymn has ended, Thomas Aquinas once more speaks to Dante, this time explaining why no man has ever equalled Solomon's wisdom. Aquinas characteristically explains that Solomon was the wisest of *kings*, because his wisdom was, as recounted in the third book of Kings, the direct gift of God and was tempered by prudence, though not necessarily the wisest *man* ever to live. He ends with an exhortation to avoid hasty and rash judgments.

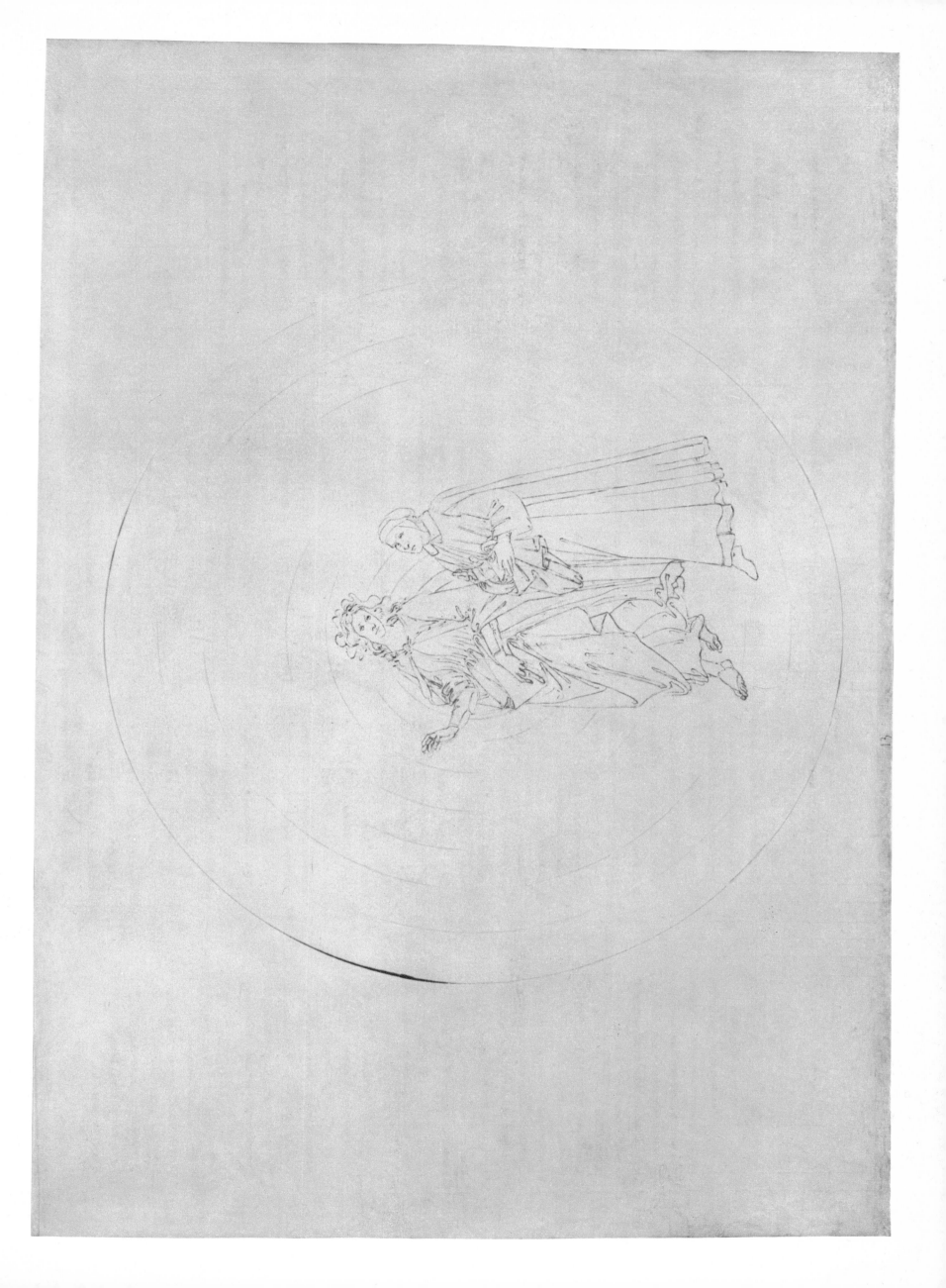

And I heard, then, from the most glorious ray
 of the inner circle, a voice as sweetly low
 as the angel's must have sounded to Mary, say:

'Long as the feast of Paradise shall be,
 so long shall our love's bliss shine forth from us
 and clothe us in these radiant robes you see.

Each robe reflects love's ardor shining forth;
 the ardor, the vision; the vision shines down to us
 as each is granted grace beyond his worth.

When our flesh, made glorious at the Judgment Seat,
 dresses us once again, then shall our persons
 become more pleasing in being more complete.

Thereby shall we have increase of the light
 Supreme Love grants, unearned, to make us fit
 to hold His glory ever in our sight.'

* * *

I was made aware that I had risen higher
 by the enkindled ardor of the red star
 that glowed, I thought, with more than usual fire.

With all my heart, and in the tongue which is
 one in all men, I offered God my soul
 as a burnt offering for this new bliss.

Nor had the flame of sacrifice in my breast
 burned out, when a good omen let me know
 my prayer had been received by the Most Blest;

for with such splendor, in such a ruby glow,
 within two rays, there shone so great a glory
 I cried, 'O Helios that arrays them so!'

Mars

AQUINAS ENDS, and Beatrice asks the double ring of theologians and philosophers to instruct Dante about the state in which the Blessed will find themselves after the Resurrection of the Body following the Last Judgment. From within the first, inner, circle, Solomon's voice is heard, explaining that the glorification of the body – which 'lies this long day through beneath the ground' – will parallel the enlightenment the souls have enjoyed in Paradise. At that, Dante realizes that he and Beatrice have risen, as Botticelli draws them here, to the next sphere, of Mars, 'the red star that glowed with more than usual fire'. The planet's unusual brilliance comes from the intersection of two rays of splendour, forming the Cross, within the sphere, the effect being that Mars encapsulates the light within itself. Inside that fiery glow stand Dante and Beatrice, both drawn here by Botticelli in an attitude of reverent wonder and worship of the Cross and of Christ, whom they see.

As, pole to pole, the arch of the Milky Way
 so glows, pricked out by greater and lesser stars,
 that sages stare, not knowing what to say –

so constellated, deep within that Sphere,
 the two rays formed into the holy sign
 a circle's quadrant lines describe. And here

memory outruns my powers. How shall I write
 that from that cross there glowed a vision of Christ?
 What metaphor is worthy of that sight?

But whoso takes his cross and follows Christ
 will pardon me what I leave here unsaid
 when he sees that great dawn that rays forth Christ.

From arm to arm, from root to crown of that tree,
 bright lamps were moving, crossing and rejoining.
 And when they met they glowed more brilliantly.

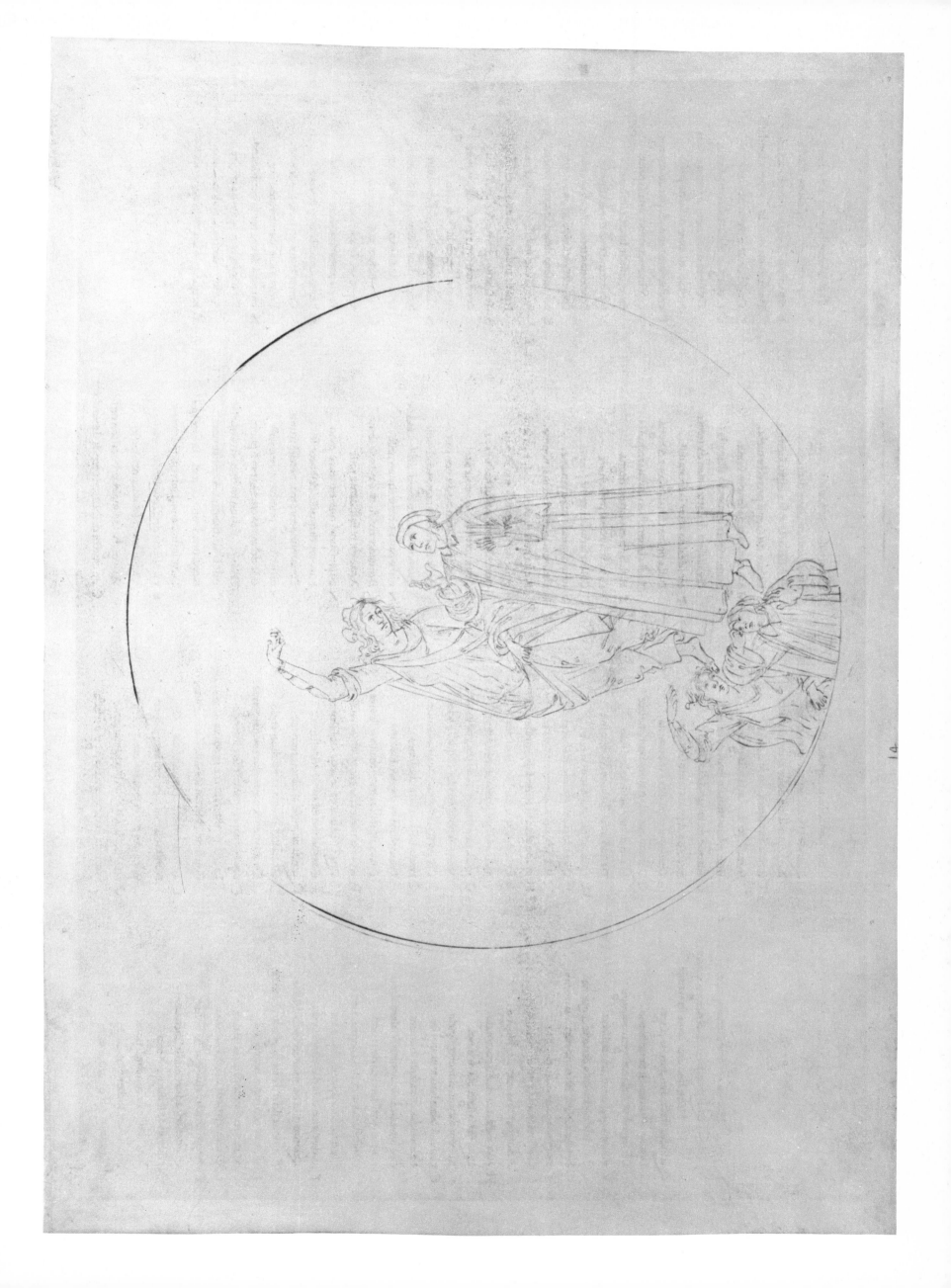

PARADISO XV

'I do indeed beseech you, holy flame,
and living topaz of this diadem,
that you assuage my hunger to know your name.'

'O leaf of mine, which even to foresee
has filled me with delight, I was your root.'
— So he began in answer to my plea.

And then : 'The first to take your present surname
(whose soul has crawled the first round of the mountain
a century and more), he who became

father of your grandfather, was my son.
You would do well, by offering up good works,
to shorten his long striving at his stone.

<center>* * *</center>

I served with Conrad in the Holy Land,
and my valor so advanced me in his favor
that I was knighted in his noble band.

With him I raised my sword against the might
of the evil creed whose followers take from you —
because your shepherds sin — what is yours by right.

There, by that shameless and iniquitous horde,
I was divested of the flesh and weight
of the deceitful world, too much adored

by many souls whose best hope it destroys ;
and came from martyrdom to my present joys.'

Mars

WITHIN THE GREAT CROSS OF SOULS that formed
itself in the last canto, one of the spirits darts across one arm
of the Cross and down to its foot, like a spark behind
alabaster, and Dante is wide-eyed with wonder. This is
Cacciaguida, Dante's great-great-grandfather, who con-
trasts the stately dignity and honesty of Florentine life in
his time with the city's corruption and viciousness as Dante
knows it. Cacciaguida — about whom nothing is known
apart from what Dante tells us in the great poem — claims
to have been on the disastrous second Crusade in the Holy
Land and knighted there by Emperor Conrad III. His
death on that Crusade, he ends by saying, gained him a
martyr's crown, because it was believed that those who
died on a crusade were martyrs and so went directly to
Heaven after their death.

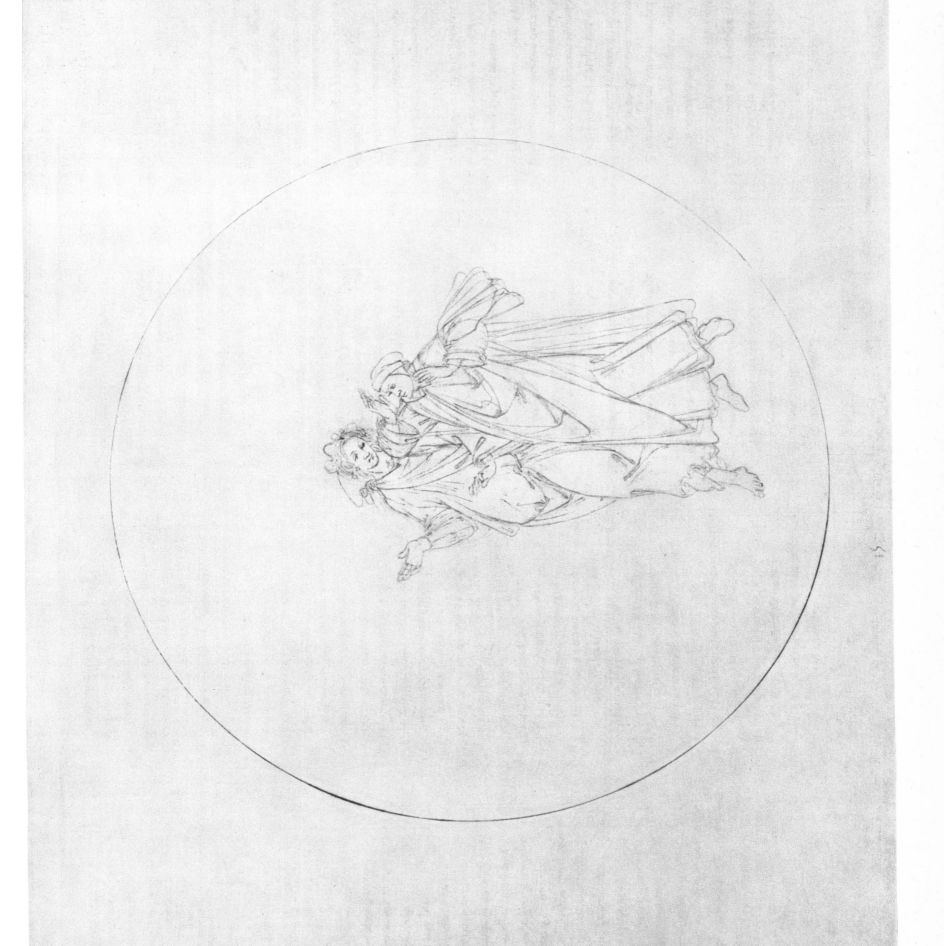

Mars

DANTE, LOOKING ATTENTIVELY at the spirit of Cacciaguida while Beatrice looks down at him, asks his ancestor for details of Florence's early history. Cacciaguida laments the gradual extinction or complete downfall of many of the city's first families, and in general decrys the widespread corruption and laxity of its citizens now, in 1300. Even the Lamberti, who had golden balls on their family shield, and whose descendant, Mosca, Dante encountered in Hell (*Inferno* XXVIII), have degenerated, he says, from the high excellence they deservedly enjoyed in his time; and in those days, when the flag of Florence showed a white lily on a red field, the Guelphs had not yet reversed those colours nor, indeed, was the city divided as the factious Guelphs and Ghibellines have made it.

I spoke again, addressing him with that 'voi'
whose usage first began among the Romans –
and which their own descendants least employ –

at which my Lady, who stood apart, though near,
and smiling, seemed to me like her who coughed
at the first recorded fault of Guinevere.

'You are my father,' I started to reply.
'You give me confidence to speak out boldly.
You so uplift me, I am more than I.

So many streams of happiness flow down
into my mind that it grows self-delighting
at being able to bear it and not drown.

Tell me, then, dear source of my own blood,
who were your own forefathers? when were you born?
and what transpired in Florence in your boyhood?'

* * *

As glowing coals fanned by a breath of air
burst into flames, so did I see that light
increase its radiance when it heard my prayer.

And as its light gave off a livelier ray,
so, in a sweeter and a softer voice –
though not in the idiom we use today –

it said: 'From the day when Ave sounded forth
in to that in which my mother, now a saint,
being heavy laden with me, gave me birth,

this flame had come back to its Leo again
to kindle itself anew beneath his paws
five hundred times plus fifty plus twenty plus ten.

* * *

How great I have seen them who are now undone
by their own pride! And even the balls of gold –
in all great deeds of Florence, how they shone!

* * *

With such as these, and others, my first life's years
saw Florence live and prosper in such peace
that she had, then, no reason to shed tears.

With such as these I saw there in my past
so valiant and so just a populace
that none had ever seized the ensign's mast

and hung the lily on it upside down.
Nor was the red dye of division known.'

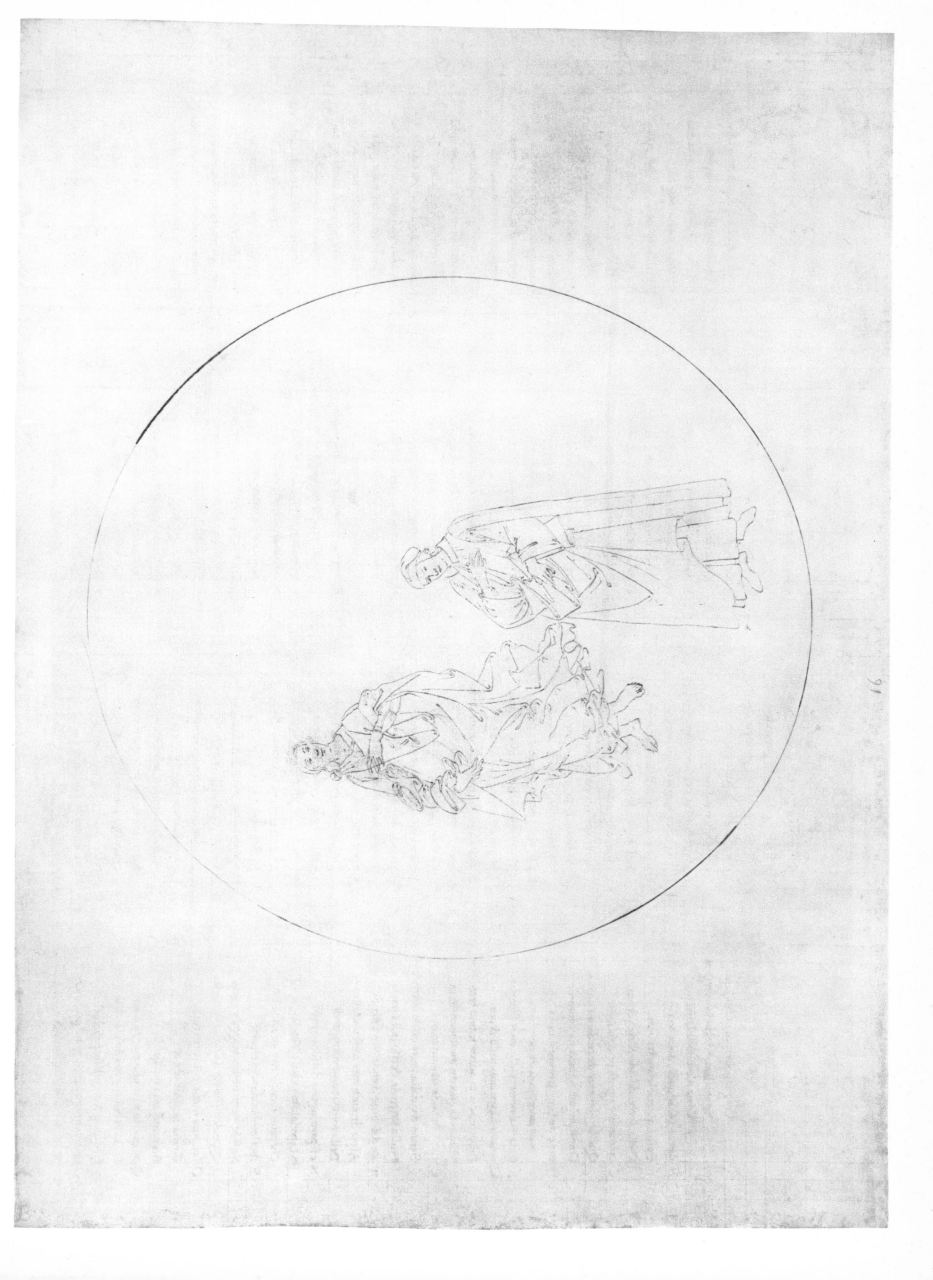

'Dear root of my existence, you who soar
so high that, as men grasp how a triangle
may contain one obtuse angle and no more,

you grasp contingent things before they find
essential being, for you can see that focus
where all time is time-present in God's mind.

While I was yet with Virgil, there below,
climbing the mountain where the soul is healed,
and sinking through the dead world of its woe,

dark words of some dark future circumstance
were said to me; whereby my soul is set
four-square against the hammering of chance:

and, therefore, my desire will be content
with knowing what misfortune is approaching;
for the arrow we see coming is half spent.'

* * *

'The public cry, as usual, will blame you
of the offended party, but the vengeance
truth will demand will yet show what is true.

All that you held most dear you will put by
and leave behind you; and this is the arrow
the longbow of your exile first lets fly.

You will come to learn how bitter as salt and stone
is the bread of others, how hard the way that goes
up and down stairs that never are your own.

And what will press down on your shoulders most
will be the foul and foolish company
you will fall into on that barren coast.

Ingrate and godless, mad in heart and head
will they become against you, but soon thereafter
it will be they, not you, whose cheeks turn red.

Their bestiality will be made known
by what they do; while your fame shines the brighter
for having become a party of your own.'

Mars

HAVING LISTENED TO CACCIAGUIDA'S reminiscence, Dante now urges him on to speak of the future. In particular, Dante recalls, while he and Virgil were passing through Hell and, especially, Purgatory (VIII and XI), some of the souls had forecast misfortune and unhappiness for him; he now asks Cacciaguida to tell him what the future will bring. Dante the poet reminds us by this passage that the great poem, though written later, is set in 1300, so that Cacciaguida's announcement of Dante's exile from Florence, in 1302, is a prediction, within the structure of the poem's drama. Botticelli has drawn the pilgrim Dante in an attitude of apprehensive grief and shame, with his head bowed and his hands folded upon his breast.

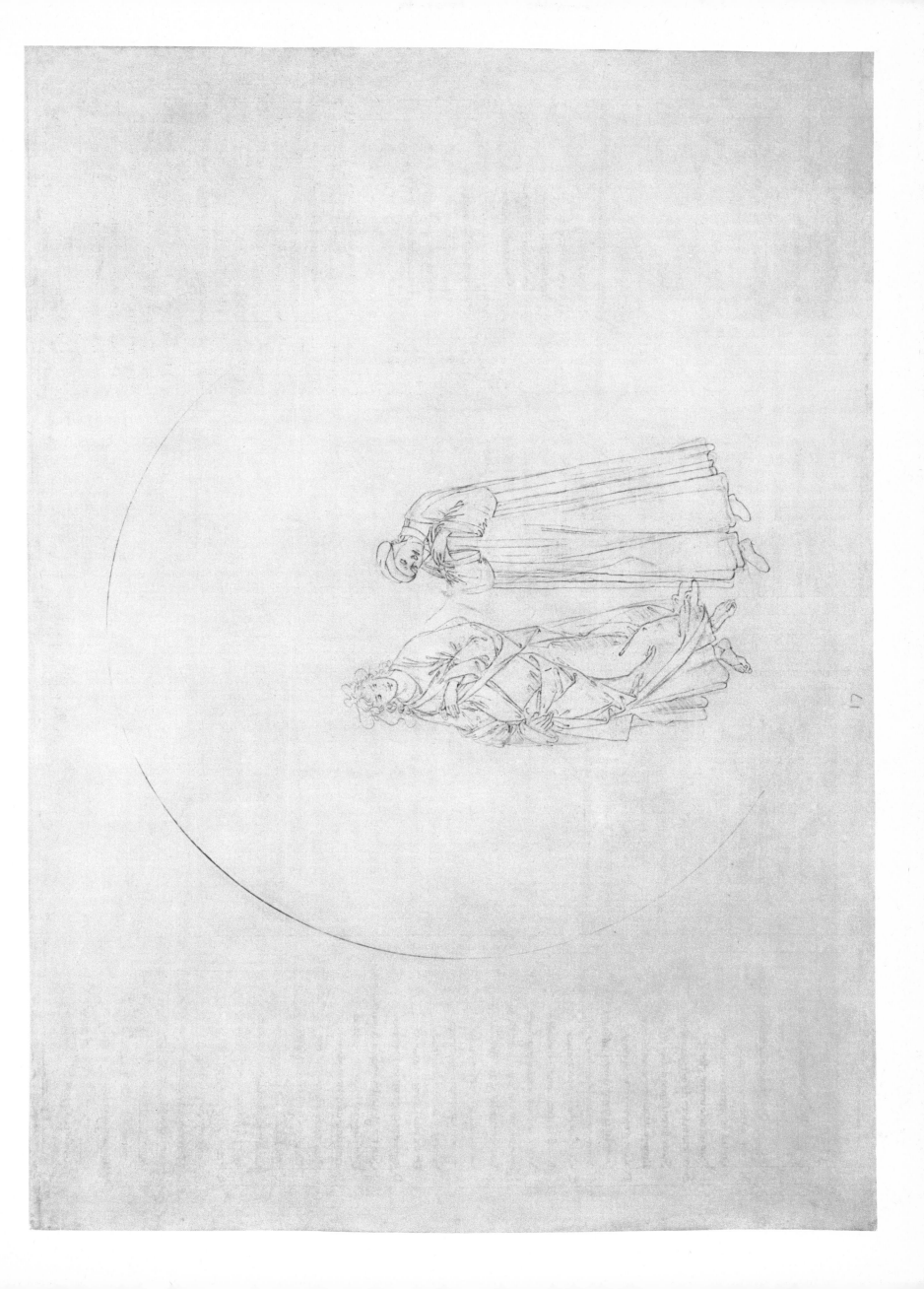

CACCIAGUIDA HAS ENDED HIS SAD FORECAST and returned to the Empyrean. Dante sees that Beatrice's beauty has increased yet again, and realizes that, as in Botticelli's drawing here, they have passed from the red glow of the Sphere of Mars into the 'pure white radiance' of Jupiter's sphere. To this sphere have descended from the Empyrean the blessed souls of Just and Temperate Rulers. These souls shine and sparkle as reflections of Divine Justice and, as Dante contemplates them in awe and wonder, form themselves into the successive letters of the words 'Diligite justitiam qui judicatis terram . . . Love justice, you who judge the earth', from the first book of Wisdom in the Vulgate. As they form the final M, Dante sees more lights – more souls – descend, and that letter is transformed into the head and shoulders of an eagle, to represent the Empire. At this, Dante prays that these souls will punish the corrupt pope, John XXII, who was pope as Dante was writing.

Mars
Jupiter

Then, moving once more through those lights, the light
that had come down to greet me, let me hear
its art among the choir of Heaven's height.

I turned to my right to learn from Beatrice,
whether by word or sign, what I should do,
and I beheld her eyes shine with such bliss,

with such serenity, that she surpassed
the vision of every other accustomed beauty
in which she had shone, including even the last.

And as a man, perceiving day by day
an increase of delight in doing good,
begins to sense his soul is gaining way –

so, seeing that Miracle surpass the mark
of former beauty, I sensed that I was turning,
together with Heaven, through a greater arc.

* * *

Within that jovial face of Paradise
I saw the sparkling of the love that dwelt there
forming our means of speech before my eyes.

As birds arisen from a marshy plain
almost as if rejoicing in their forage
form, now a cluster, now a long-drawn skein –

so, there, within their sheaths of living light,
the blest beings soared and sang and joined their rays,
and D, then I, then L formed on my sight.

First they sang and moved to their own song;
then having formed themselves into a letter,
they stopped their song and flight, though not for long.

* * *

In five times seven vowels and consonants
they showed themselves, and I grasped every part
as if those lights had given it utterance.

The first words of that message as it passed
before me were DILIGITE IUSTITIAM.
QUI IUDICATIS TERRAM were the last.

* * *

More lights descended then and took their place
on top of the M, and sang, as I believe,
a hymn to the Good that draws them to Its grace.

* * *

And as each took its place in that still choir
I saw the head and shoulders of an eagle
appear in the fixed pattern of that fire.

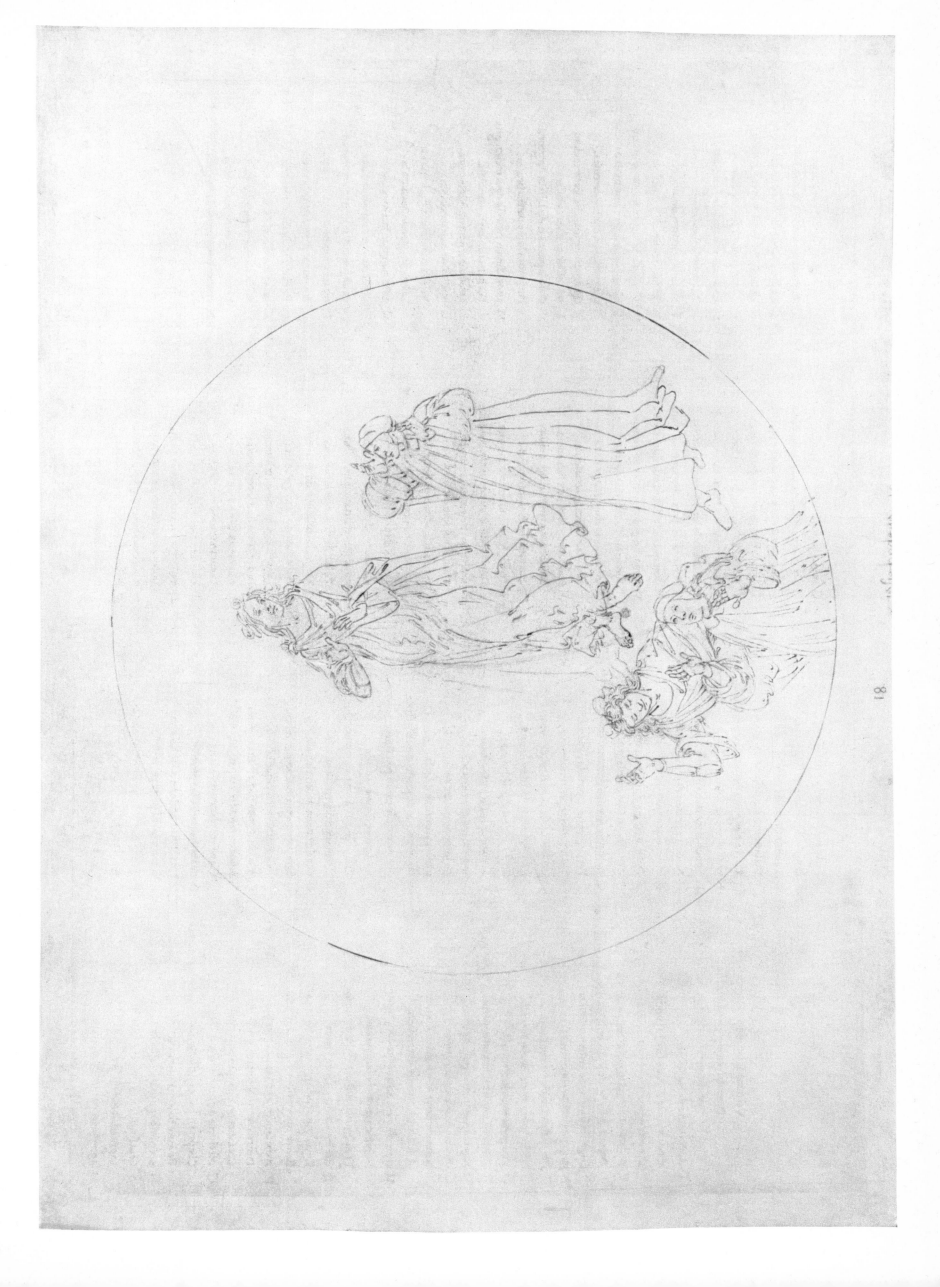

81

Before me, its great wings outspread, now shone
the image of the eagle those bright souls
had given form to in glad unison.

Each seemed a little ruby in the sky
and the sun's ray struck each in such a way
the light reflected straight into my eye.

* * *

I saw and heard the beak move and declare
in its own voice the pronouns 'I' and 'mine'
when 'we' and 'ours' were what conceived it there.

'For being just and pious in my time,'
it said, 'I am exalted here in glory
to which, by wish alone, no one may climb;

and leave behind me, there upon the earth,
a memory honored even by evildoers,
though they shun the good example it sets forth.'

* * *

At which I cried: 'O everlasting blooms
of the eternal bliss, who make one seeming
upon my sense of all your many perfumes –

my soul has hungered long: breathe forth at last
the words that will appease it. There on earth
there is no food with which to break its fast.

* * *

You know how eagerly I wait to hear;
you know the what and wherefore of the doubt
I have hungered to resolve for many a year.'

* * *

As a stork that has fed its young flies round and round
above the nest, and as the chick it fed
raises its head to stare at it, still nest-bound –

so did that blessed image circle there,
its great wings moved in flight by many wills,
and so did I lift up my head and stare.

Circling, it sang; then said: 'As what I sing
surpasses your understanding, so God's justice
surpasses the power of mortal reasoning.'

* * *

'But see how many now cry out "Christ! Christ!"
who shall be farther from Him at the Judgment
than many who, on earth, did not know Christ.'

* * *

Jupiter

IN THIS DRAWING, largely unfinished, Dante and Beatrice have been sketched in, partially traced over with the pen, and afterwards for the most part erased. They are both listening with great attention to the Eagle, which is responding to Dante's question: How is it congruent with God's justice that souls who have never known or even heard of Christ, without whom salvation is impossible, are deprived of salvation? It is not for humans, the Eagle declares, to question or even attempt to understand the operation of God's justice. Men must rest content with and in the faith that God is perfect, good and just; the exquisite delicacy of His justice is beyond creatures' comprehension, so that many virtuous pagans will be nearer to Christ in eternity than some Christians who call out His name in vain.

Jupiter

As though to give Dante an example of the inscrutability of Divine Justice's working, the Eagle tells Dante to look at its eye and see the souls that form it: David, Trajan, Hezekiah, Constantine, William of Sicily and Ripheus. Of these, the Emperor Trajan and Ripheus, who is known only from the Aeneid, where Virgil calls him the single just man among the Trojans, were of course pagans. But, the Eagle explains, Ripheus accepted Christ in a vision 'more than a thousand years before the grace of baptism was known'; Trajan, according to a legend of Dante's time, was restored to life more than two hundred years after his death in 117 by Pope Gregory the Great, so that he might accept Christ and thus merit salvation.

When then those precious gems of purest ray
with which the lamp of the sixth heaven shone
let their last angel-harmony fade away,

I seemed to hear a great flume take its course
from stone to stone, and murmur down its mountain
as if to show the abundance of its source.

And as the sound emerging from a lute
is tempered at its neck; and as the breath
takes form around the openings of a flute –

just so, allowing no delay to follow,
the murmur of the eagle seemed to climb
inside its neck, as if the neck were hollow.

There it was given voice, and through the bill
the voice emerged as words my heart awaited.
And on my heart those words are written still.

＊ ＊

'Look closely now into that part of me
that in earth's eagles can endure the Sun,'
the emblem said, – 'the part with which I see.

Of all the fires with which I draw my form
those rays that make the eye shine in my head
are the chief souls of all this blessed swarm.

You marvel at the first and the fifth gem
here on my brow, finding this realm of angels
and gift of Christ made beautiful by them.

They did not leave their bodies, as you believe,
as pagans but as Christians, in firm faith
in the pierced feet one grieved and one would grieve.

＊ ＊ ＊

Mortals, be slow to judge! Not even we
who look on God in Heaven know, as yet,
how many He will choose for ecstasy.

And sweet it is to lack this knowledge still,
for in this good is our own good refined,
willing whatever God Himself may will.'

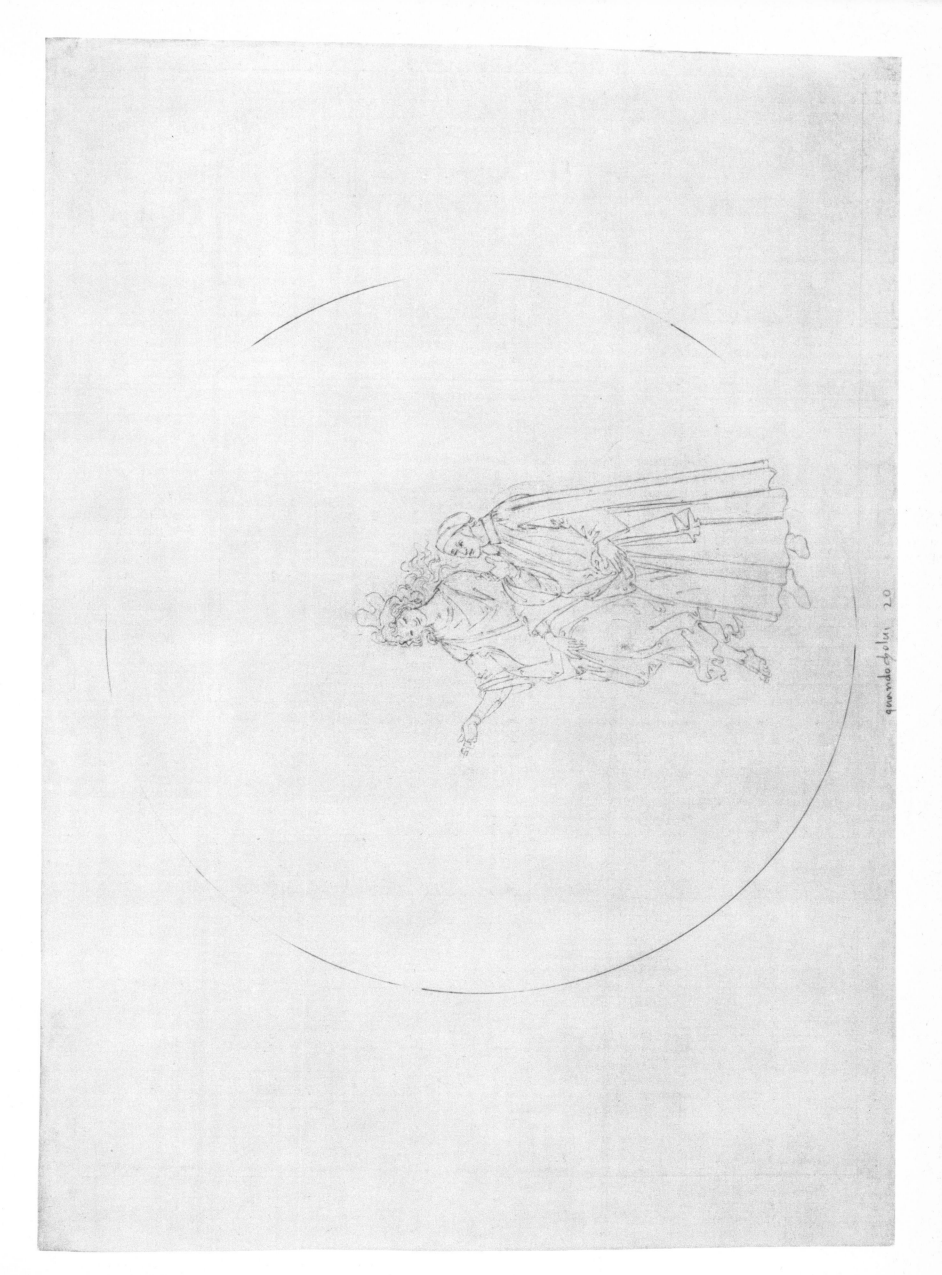

quando *dolui* 20

Saturn

DANTE AND BEATRICE have ascended to the Sphere of Saturn, the seventh heaven, to which descend from the Empyrean the souls of the Contemplative. Beatrice does not smile on Dante, explaining to him that the higher she goes towards the Empyrean the stronger grows her beauty; were she to smile, that radiance would destroy him, as Semele was destroyed when, in response to her urgent desire, Jupiter manifested himself to her in all his omnipotent radiance. From within this sphere, and as Botticelli has drawn it here, there ascends a ladder rising out of sight. The souls of the Contemplative Blessed come down the ladder to a certain rung, and then fly off into the sphere; Botticelli depicts them as small naked angels. Among the spirits is Pietro Damiano, an eleventh-century ascetic and Doctor of the Church renowned for his austere life, who explains to Dante the mystery of predestination and ends with denouncing the corruption of the papacy. At Pietro's last outburst, all the spirits descend the ladder to cluster round him and sing a hymn that makes Dante giddy and unable to understand the words they sing. Botticelli had originally drawn in Dante and Beatrice, in smaller size, ascending the ladder; this incident belongs to the next canto, however, and so he erased the figures, though they are still faintly visible. Along the top edge of this drawing, and almost illegible, is a part of the zodiac, symbolizing the eighth heaven, of the Fixed Stars, to which the ladder ascends.

My eyes were fixed once more on my lady's face;
and with my eyes, my soul, from which all thought,
except of her, had fled without a trace.

She did not smile. 'Were I to smile,' she said,
'You would be turned to ash, as Semele was
when she saw Jupiter in his full Godhead;

because my beauty, which, as it goes higher
from step to step of the eternal palace,
burns, as you know, with ever brighter fire.

* * *

We have soared to the Seventh Splendor, which is now
beneath the Lion's blazing breast, and rays
its influence, joined with his, to the world below.

Now make your eyes the mirror of the vision
this mirror will reveal to you, and fix
your mind behind your eyes in strict attention.'

* * *

Within the crystal that bears round the world
the name of its great king in that golden age
when evil's flag had not yet been unfurled,

like polished gold ablaze in full sunlight,
I saw a ladder rise so far above me
it soared beyond the reaches of my sight.

And I saw so many splendors make their way
down its bright rungs, I thought that every lamp
in all of heaven was pouring forth its ray.

* * *

One that came nearest where we stood below
then made itself so bright I said to myself:
'I well know with what love for me you glow!'

But she from whom I await the how and when
of my speech and silence, was still; and despite my yearning
I knew it was well to ask no questions then.

She saw in the vision of Him who sees all things
what silence held my eager tongue in check,
and said to me : 'Give your soul's impulse wings!'

'O blessed being hidden in the ray
of your own bliss,' I said in reverence,
'I am not worthy, but for her sake, I pray,

who gives me leave to question, let me know
why you, of all this sacred company,
have placed yourself so near me, here below ;

and tell me why, when every lower sphere
sounds the sweet symphony of Paradise
in adoration, there is no music here.'

'Your sight is mortal. Is not your hearing, too ?'
he said. 'Our song is still for the same reason
Beatrice holds back her smile – for love of you.

Only that I might make your spirit gladder
by what I say and by the light that robes me,
have I come so far down the sacred ladder.'

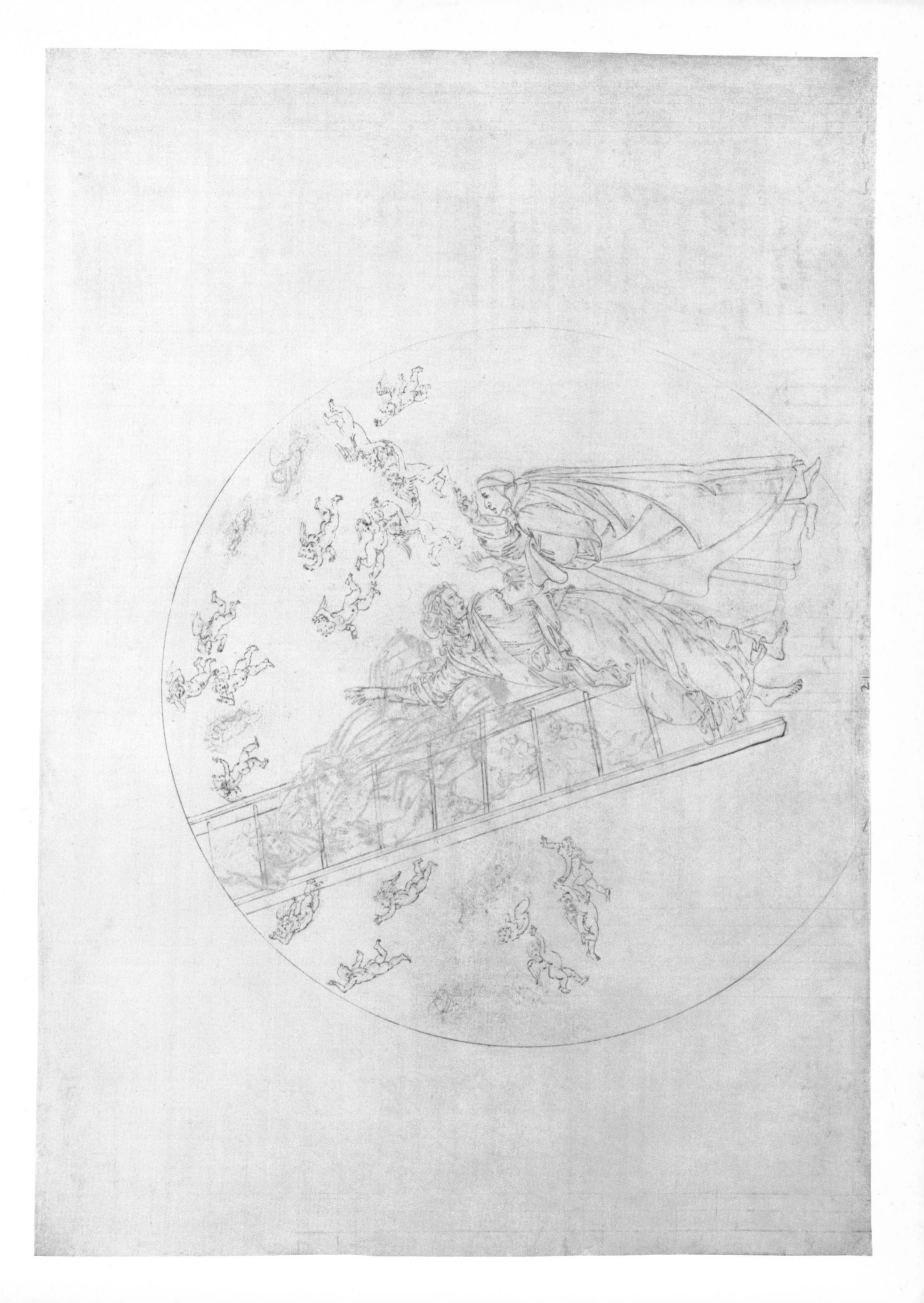

My sense reeled, and as a child in doubt
runs always to the one it trusts the most,
I turned to my guide, still shaken by that shout;

and she, like a mother, ever prompt to calm
her pale and breathless son with kindly words,
the sound of which is his accustomed balm,

said: 'Do you not know you are in the skies
of Heaven itself? that all is holy here?
that all things spring from love in Paradise?

Their one cry shakes your senses: you can now see
what would have happened to you had they sung,
or had I smiled in my new ecstasy.'

* *
*

Before my eyes
a hundred shining globes entwined their beams,
soul adding grace to soul in Paradise.

I stood there between longing and diffidence
and fought my longing back, afraid to speak
for fear my questioning might give offense.

And the largest and most glowing globe among
the wreath of pearls came forward of its own prompting
to grant the wish I had not given tongue.

These words came from within it: 'Could you see,
as I do, with what love our spirits burn
to give you joy, your tongue would have been free.

To cause you no delay on the high track
to the great goal, I shall address myself
to none but for the single question you hold back.

The summit of that mountain on whose side
Cassino lies, once served an ill-inclined
and misted people in their pagan pride.

And I am he who first bore to that slope
the holy name of Him who came on earth
to bring mankind the truth that is our hope.

Such grace shone down on me that men gave heed
through all that countryside and were won over
from the seductions of that impious creed.

These other souls were all contemplatives,
fired by that warmth of soul that summons up
the holy flowers and fruits of blessèd lives.'

Saturn

HERE BOTTICELLI has drawn the topmost part of the
Sphere of Saturn intersected by the complete circle
representing the Eighth Sphere, of the Fixed Stars. The
ladder, therefore, is to be understood as extending up-
wards from the Seventh Sphere, through the Eighth, and
beyond. Beatrice holds the swooning Dante, at the foot of
the ladder, and urges him onward. At the upper margin
Botticelli has sketched in part of the zodiac which belongs
to the Eighth Sphere: on the left is Cancer, on the right
Libra. Dante sees the spirits in this Seventh Sphere, now, as
shining globes, the largest of which, St Benedict, founder
at Monte Cassino of the monastic order that bears his
name, laments that so few contemplatives, particularly of
his own order, remain to put aside the world and begin
their own ascent of the ladder of Divine Union. When he
has finished speaking Benedict fades into the group of
brilliant globes; they all, like a whirlwind, spin away to
return to the Empyrean. Before he and she ascend to
the Eighth Sphere, Beatrice tells Dante to look back,
down through the universe they have come by.

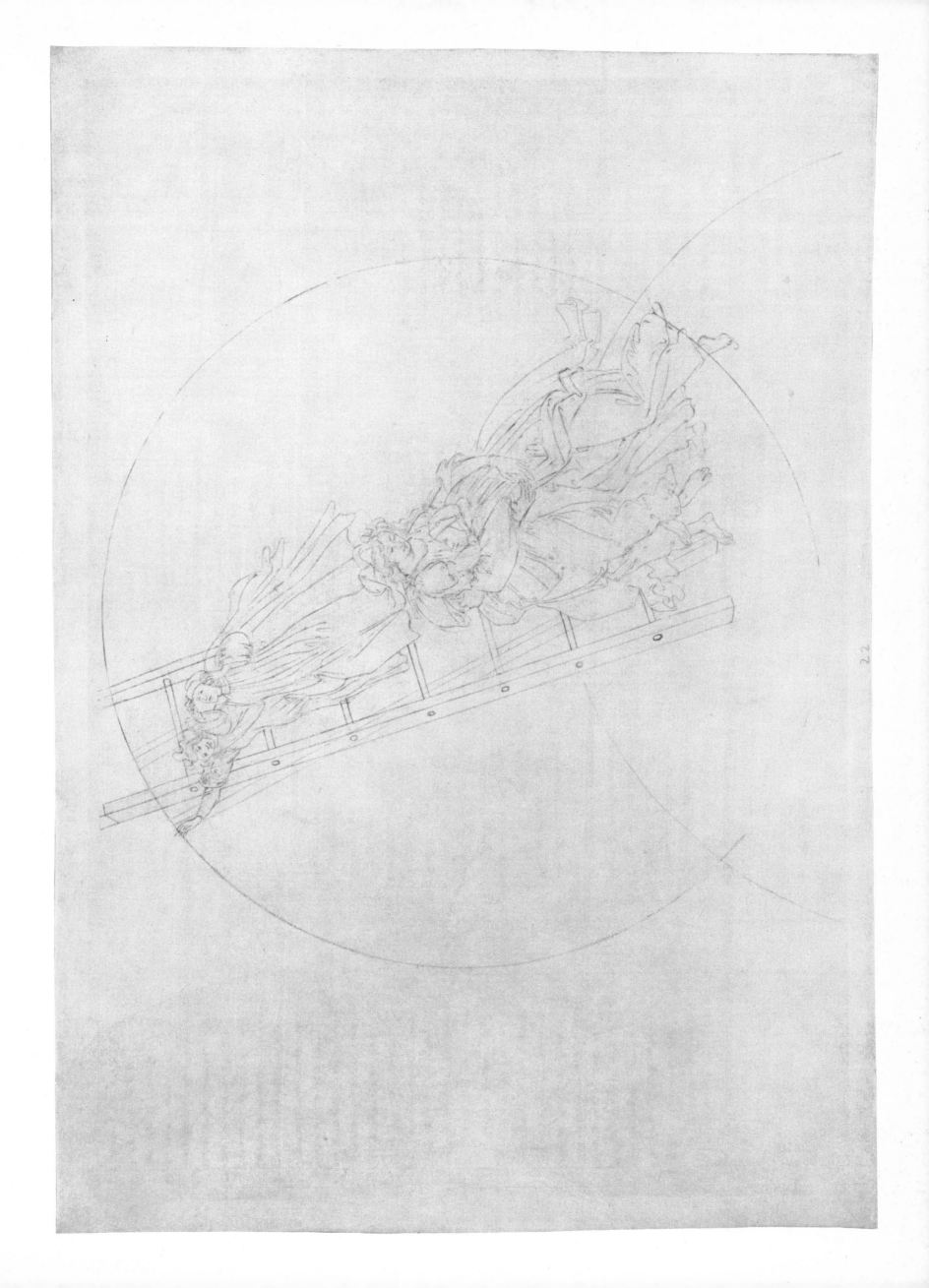

The Fixed Stars

DANTE AND BEATRICE have arrived at the eighth heaven, the Sphere of the Fixed Stars. Along the lower margin of the drawing Botticelli has lightly sketched in the signs of Taurus, Cancer, Gemini. Within the sphere, Beatrice gestures upward, directing Dante's gaze to the Sun, in which Christ's face blazes. Dante is at first overcome but then strengthened, so that Beatrice may once again show him 'the bright smile of my ecstasy'. In orbits circling the face of Christ are tongues of flame, the militia of Christ's triumph, and, in a circle above the heads of Beatrice and Dante, shines a single great flame, the Virgin Mary, surrounded by twelve smaller flames, the Apostles. As Dante contemplates the 'star' of Mary, a crown of flame descends to escort her back to the Empyrean; this is Gabriel, the Angel of the Annunciation. While the crowned Mary returns to the Empyrean, each of the flames glows more brightly and increases in size, and together they sing the hymn 'Regina Coeli . . . Queen of Heaven'.

And Beatrice said: 'Before you now appears
the militia of Christ's triumph, and all the fruit
harvested from the turning of the spheres.'

* * *

I saw her face before me, so imbued
with holy fire, her eyes so bright with bliss
that I pass on, leaving them unconstrued.

* * *

I saw, above a thousand thousand lights,
one Sun that lit them all, as our own Sun
lights all the bodies we see in Heaven's heights;

and through that living light I saw revealed
the Radiant Substance, blazing forth so bright
my vision dazzled and my senses reeled.

Oh my Beatrice, sweet and loving guide!
'What blinds you,' she said to me, ''is the very power
nothing withstands, and from which none may hide.

This is the intellect and the sceptered might
that opened the golden road from Earth to Heaven,
for which mankind had yearned in its long night.

* * *

The Rose in which the Word became incarnate
is there. There are the lilies by whose odor
men found the road that evermore runs straight.'

* * *

'I am the Angelic Love that wheels around
the lofty ecstasy breathed from the womb
in which the hostel of Our Wish was found;

so shall I wheel, Lady of Heaven, till
you follow your great Son to the highest sphere
and, by your presence, make it holier still.'

Thus the encircling melody of that flame
revealed itself; and all the other lamps
within that garden rang out Mary's name.

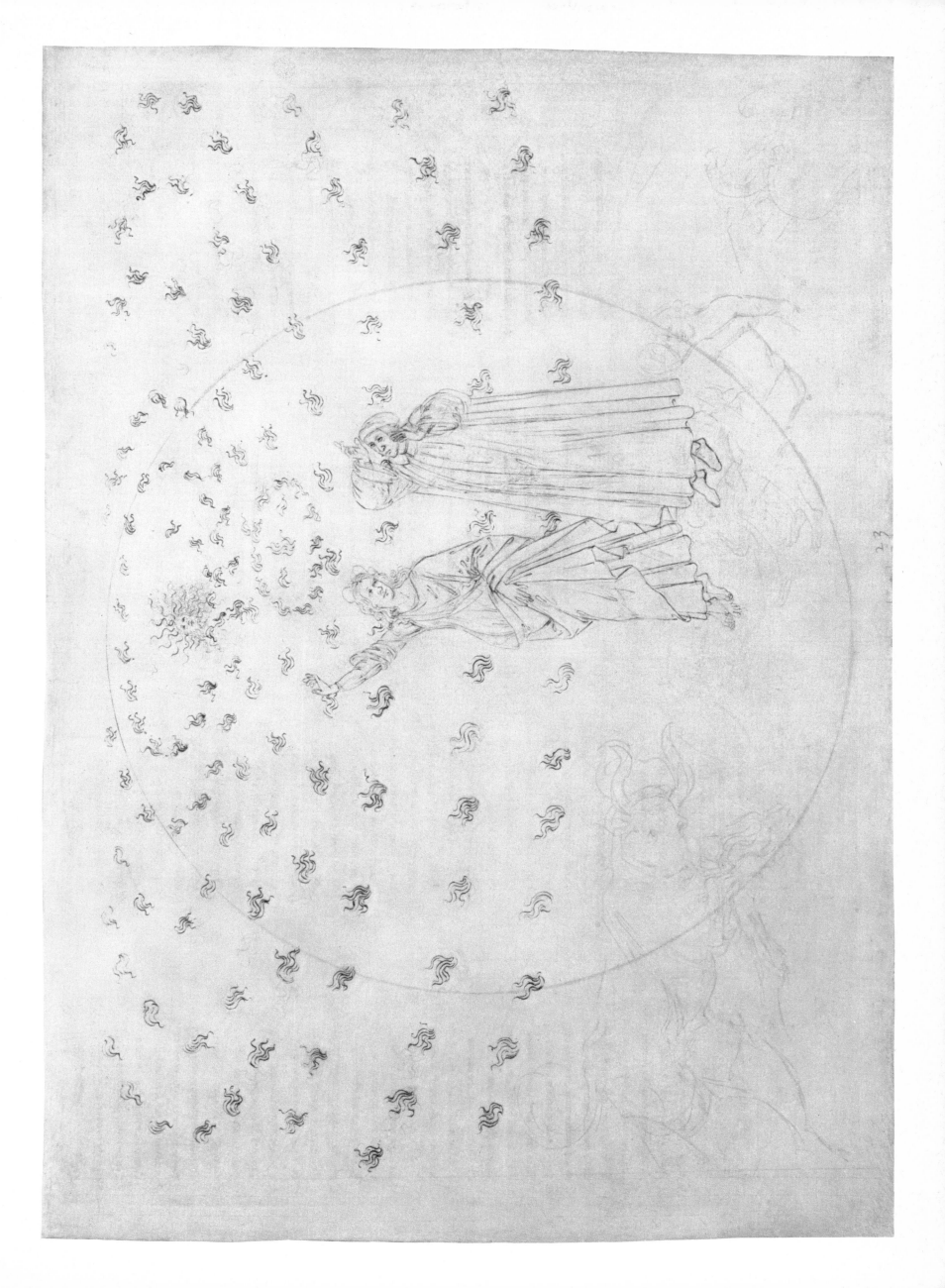

As the wheels within a clockwork synchronize
so that the innermost, when looked at closely,
seems to be standing, while the outermost flies;

just so those rings of dancers whirled to show
and let me understand their state of bliss,
all joining in the round, some fast, some slow.

* * *

'Speak, good Christian, manifest your worth:
what is faith?' – At which I raised my eyes
to the light from which these words had been breathed forth:

* * *

'Faith is the substance of what we hope to see
and the argument for what we have not seen.
This is its quiddity, as it seems to me.

* * *

And I believe in three Persons; this Trinity,
an essence Triune and Single, in whose being
is and are conjoin to eternity.

That this profound and sacred nature is real
the teachings of the evangels, in many places,
have stamped on the wax of my mind like a living seal.

This is the beginning, the spark shot free
that gnaws and widens into living flame,
and, like a star in Heaven, shines in me.'

The Fixed Stars

AS THE FLAME OF MARY RECEDED in the previous canto, Dante saw the spirit of St Peter among the attendant Blessed. Here Botticelli has drawn Dante and Beatrice standing looking up at the circles of stars circling Christ the Sun; Beatrice touches Dante's elbow as if to call his attention to the spirit of St Peter which is hovering above their heads and is marked 'piero'. At Beatrice's request, St Peter conducts an examination of Dante's faith, and the poet and the spirit exchange questions and responses in the formalistic manner of a medieval philosophers' disputation. As Dante ends with a declaration of faith in the Trinity, the flame of St Peter dances round him three times.

As a master who is pleased by what he hears
embraces his servant as soon as he has spoken,
rejoicing in the happy news he bears;

so, that glorious apostolic blaze
at whose command I had spoken heard me out,
and blessing me in a glad chant of praise,

danced three times round me there in the eighth great rim,
such pleasure had my speaking given him.

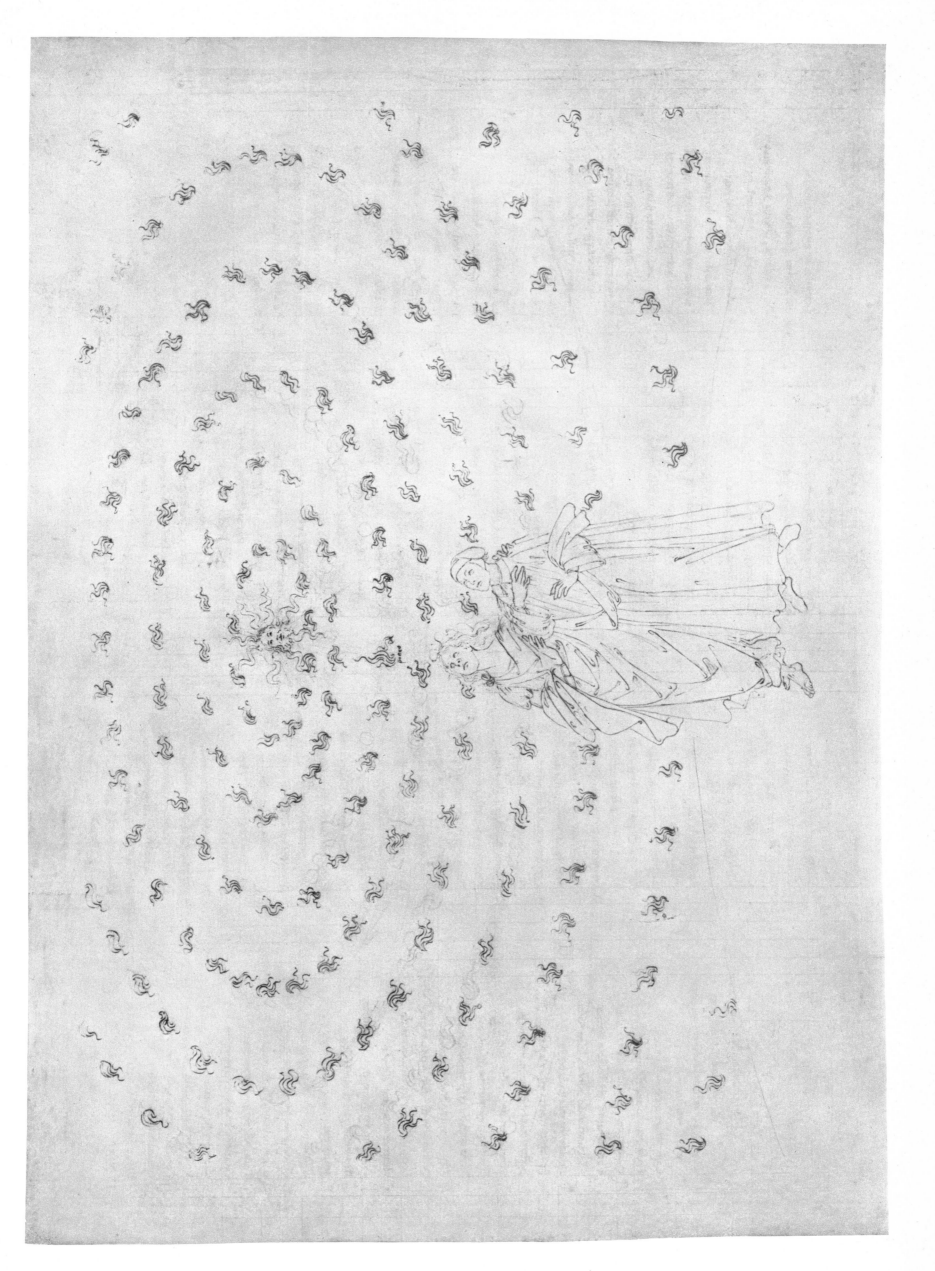

The Fixed Stars

DANTE AND BEATRICE remain in the Eighth Sphere, and the spirit of St Peter is joined by the flames of St James – which Botticelli inscribes as 'jackopo' – and St John – 'giouani'. St James – whose sanctuary at Compostela, in Galicia, was perhaps the most renowned place of pilgrimage in the Middle Ages – now examines Dante on the virtue of hope, the second of the three Theological Virtues and that most particularly apt for a pilgrim. When Dante has declared the extent and depth of his hope, the flame-spirit of St John, the 'Beloved Disciple' who was Christ's favourite and into whose care He gave Mary at the Crucifixion, flares up. Dante stares at the flame with the wish of seeing John's bodily appearance, but is blinded by the splendour so that he can no longer see Beatrice.

Thereafter another radiance came forth
from the same sphere out of whose joy had come
the first flower of Christ's vicarage on earth.

And my lady, filled with ecstasy and aglow,
cried to me: 'Look! Look there! It is the baron
for whom men throng to Galicia there below!'

At times, on earth, I have seen a mating dove
alight by another, and each turn to each,
circling and murmuring to express their love;

exactly so, within the eighth great sphere,
one glorious great lord greeted the other,
praising the diet that regales them there.

Those glories, having greeted and been greeted,
turned and stood before me, still and silent,
so bright I turned my eyes away defeated.

* *

'Hope,' I said, 'is the certain expectation
of future glory. It is the blessed fruit
of grace divine and the good a man has done.'

* *

'This is he who lies upon the breast
of Our Pelican; and this is He elected
from off the Cross to make the great behest.'

* *

As one who stares, squinting against the light,
to see the Sun enter a partial eclipse,
and in the act of looking loses his sight –

so did I stare at the last flame from that sphere
until a voice said, 'Why do you blind yourself
trying to see what has no true place here?'

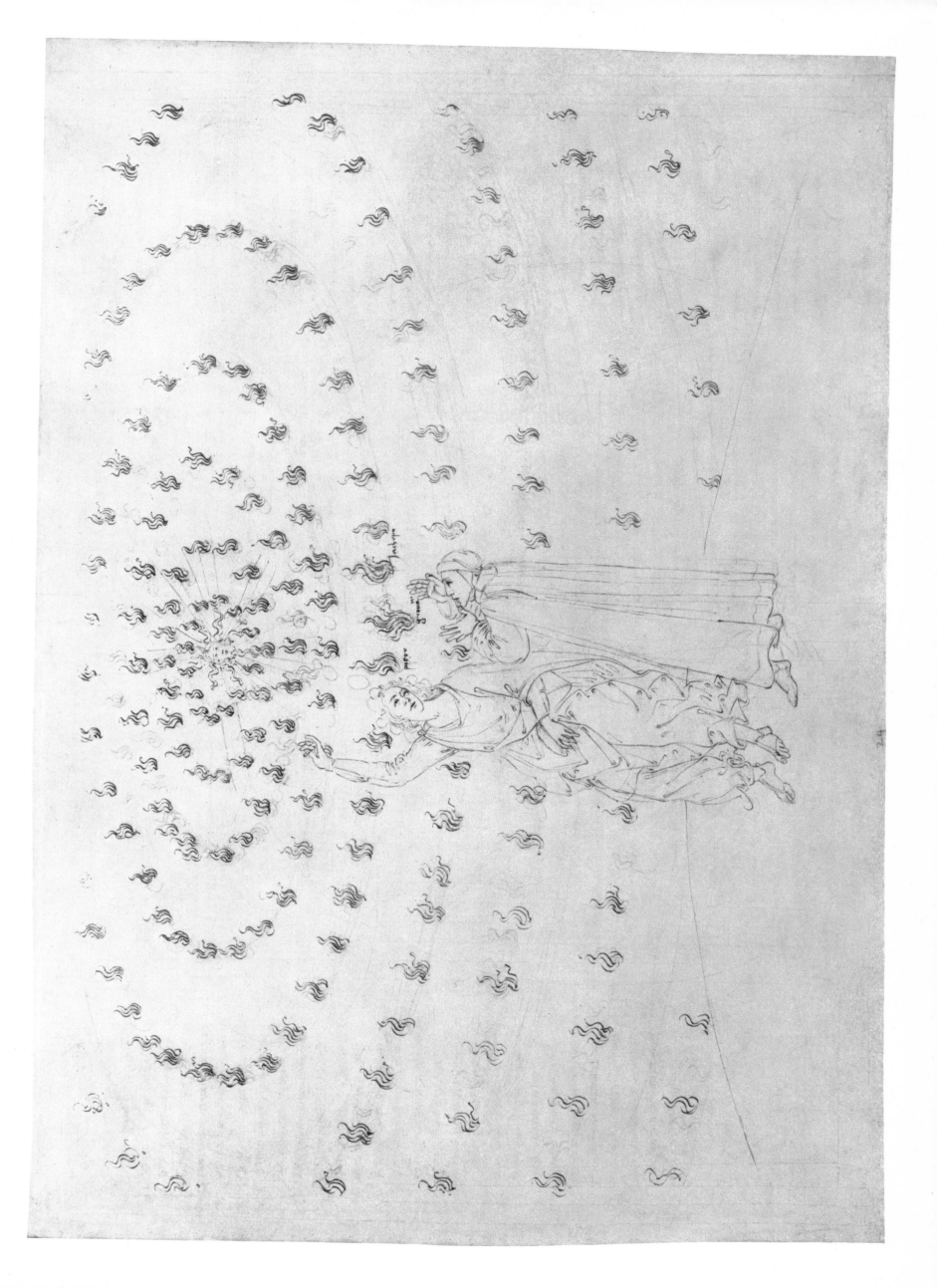

The Fixed Stars

DANTE REMAINS BLINDED by the dazzling radiance of St John's spirit and holds his hand to his eyes. John assures him that his sight will be restored by Beatrice, in the same way that St Paul's blindness was cured by Ananias (Acts 10,10), and exhorts him to make profession of his charity, or love. As Dante ends, all the spirits sing out a hymn and Dante's sight returns. At this, Beatrice points out to him the flame of the spirit of Adam, which Botticelli marks 'adamo', and Dante asks Adam questions concerning his life and language, the length of his time in Eden, and the cause of God's wrath.

While I stood thus confounded, my light shed,
out of the dazzling flame that had consumed it
I heard a breath that called to me, and said:

'Until your eyes once more regain their sense
of the light you lost in me, it will be well
for discourse to provide a recompense.

Speak, therefore, starting with the thing that most
summons your soul to it, and be assured
your sight is only dazzled and not lost;

for she who guides you through this holy land
has, in a single turning of her eyes,
the power that lay in Ananias' hand.'

* * *

I therefore: 'All those teeth with power enough
to turn the heart of any man to God
have joined in my heart, turning it to Love.

The existence of the world, and my own, too;
the death He took on Himself that I might live;
and what all believers hope for as I do –

* *

these and the living knowledge mentioned before
have saved me from the ocean of false love
and placed me by the true, safe on the shore.

The leaves that green the Eternal Garden's grove
I love to the degree that each receives
the dew and ray of His all-flowering love.'

* * *

The instant I fell still, my love professed,
all Heaven rang with 'Holy! Holy! Holy!'
my lady joining with the other blest.

As bright light shatters sleep, the man being bid
to waken by the visual spirit running
to meet the radiance piercing lid by lid,

and the man so roused does not know what he sees,
his wits confounded by the sudden waking,
till he once more regains his faculties;

so from my eyes, my lady's eyes, whose ray
was visible a thousand miles and more,
drove every last impediment away.

* * *

'In that ray's Paradise
the first soul from the hand of the First Power
turns ever to its maker its glad eyes.'

* *

'Know, my son, that eating from the tree
was not itself the cause of such long exile,
but only the violation of God's decree.

Longing to join this company, my shade
counted four thousand three hundred and two suns
where your lady summoned Virgil to your aid.

And circling all its signs, I saw it go
nine hundred and thirty times around its track
during the time I was a man below.

The tongue I spoke had vanished utterly
long before Nimrod's people turned their hands
to the work beyond their capability.'

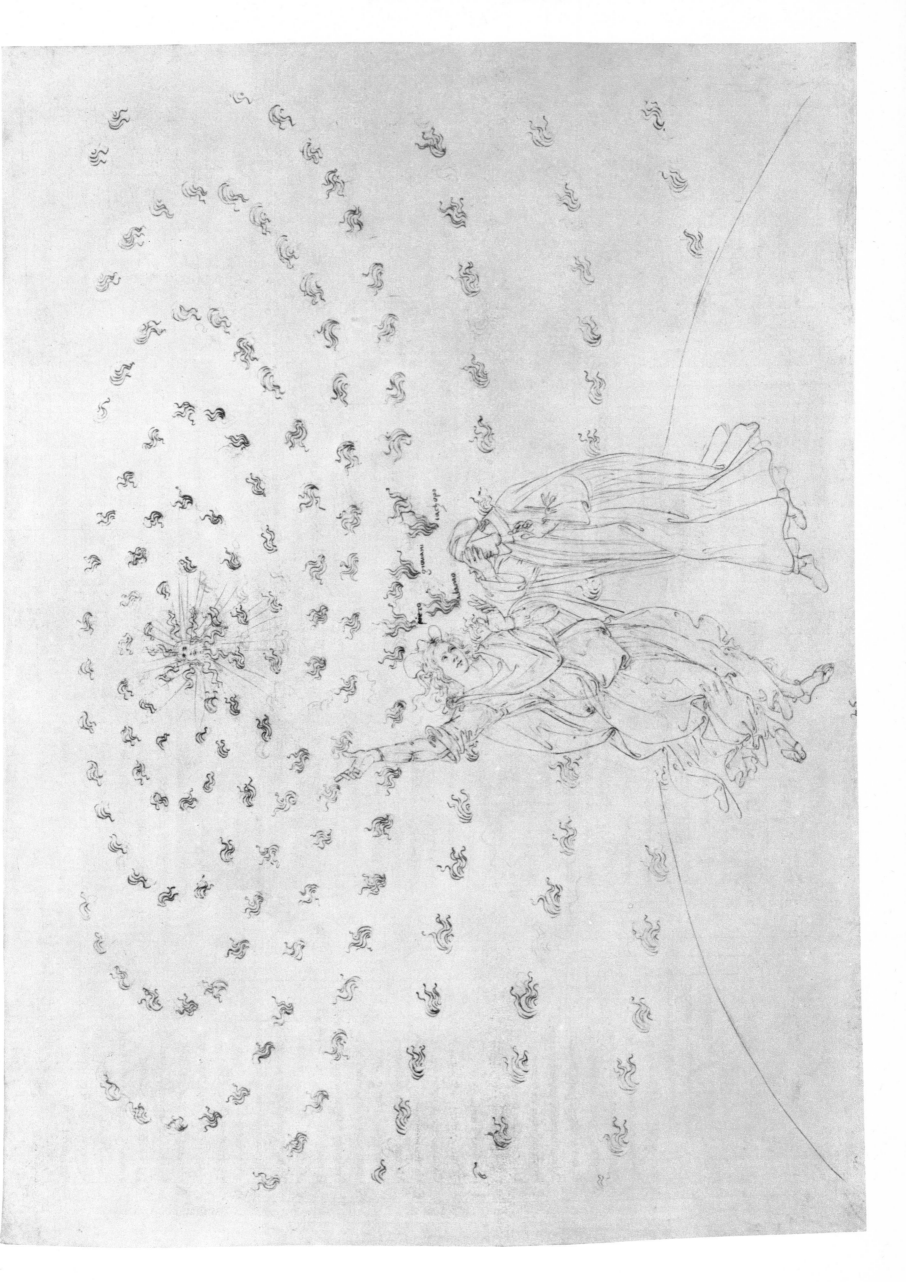

PARADISO XXVII

PARADISO XXVII

Just as the frozen vaporings sift down
out of our earthly atmosphere when the horn
of heaven's Goat is burnished by the Sun ;

Just so, up there, I saw the ether glow
with a rising snow of the triumphant vapors
who had remained a while with us below.

My eyes followed their traces toward the height,
followed until the airy medium
closed its vast distance on my upward sight ;

at which my lady, seeing me absolved
from service to the height, said : 'Now look down
and see how far the heavens have revolved.'

I looked down once again. Since the last time,
I had been borne, I saw, a length of arc
equal to half the span of the first clime ;

so that I saw past Cadiz the mad route
Ulysses took ; and almost to the shore
from which Europa rode the godly brute.

* * *

My mind, which ever found its Paradise
in thinking of my lady, now more than ever
burned with desire to look into her eyes.

If nature or art ever contrived a lure
to catch the eye and thus possess the mind,
whether in living flesh or portraiture,

all charms united could not move a pace
toward the divine delight with which I glowed
when I looked once more on her smiling face.

* * *

'The order of the universe, whose nature
holds firm the center and spins all else around it,
takes from this heaven its first point of departure.

This heaven does not exist in any place
but in God's mind, where burns the love that turns it
and the power that rains to it from all of space.

* * *

Its own motion unfactored, all things derive
their motions from this heaven as precisely
as ten is factored into two and five.

So may you understand how time's taproot
is hidden in this sphere's urn, while in the others
we see its spreading foliage and its fruit.'

The Fixed Stars
Ascent to the Primum Mobile

DANTE AND BEATRICE remain in the Sphere of the Fixed Stars after the blessed spirits have returned to the Empyrean. Botticelli has here drawn in the background the 'triumphant vapours' Dante the poet used to describe the spirits' appearance. Beatrice tells Dante, once again, to look down and see how far they have risen through the spheres of Heaven ; Dante sees that he is standing above a point exactly between Spain and Jerusalem. Beatrice explains to Dante the nature of time and, as she does so, they rise to the next sphere, of the Primum Mobile, the source of time and its corollary motion.

208

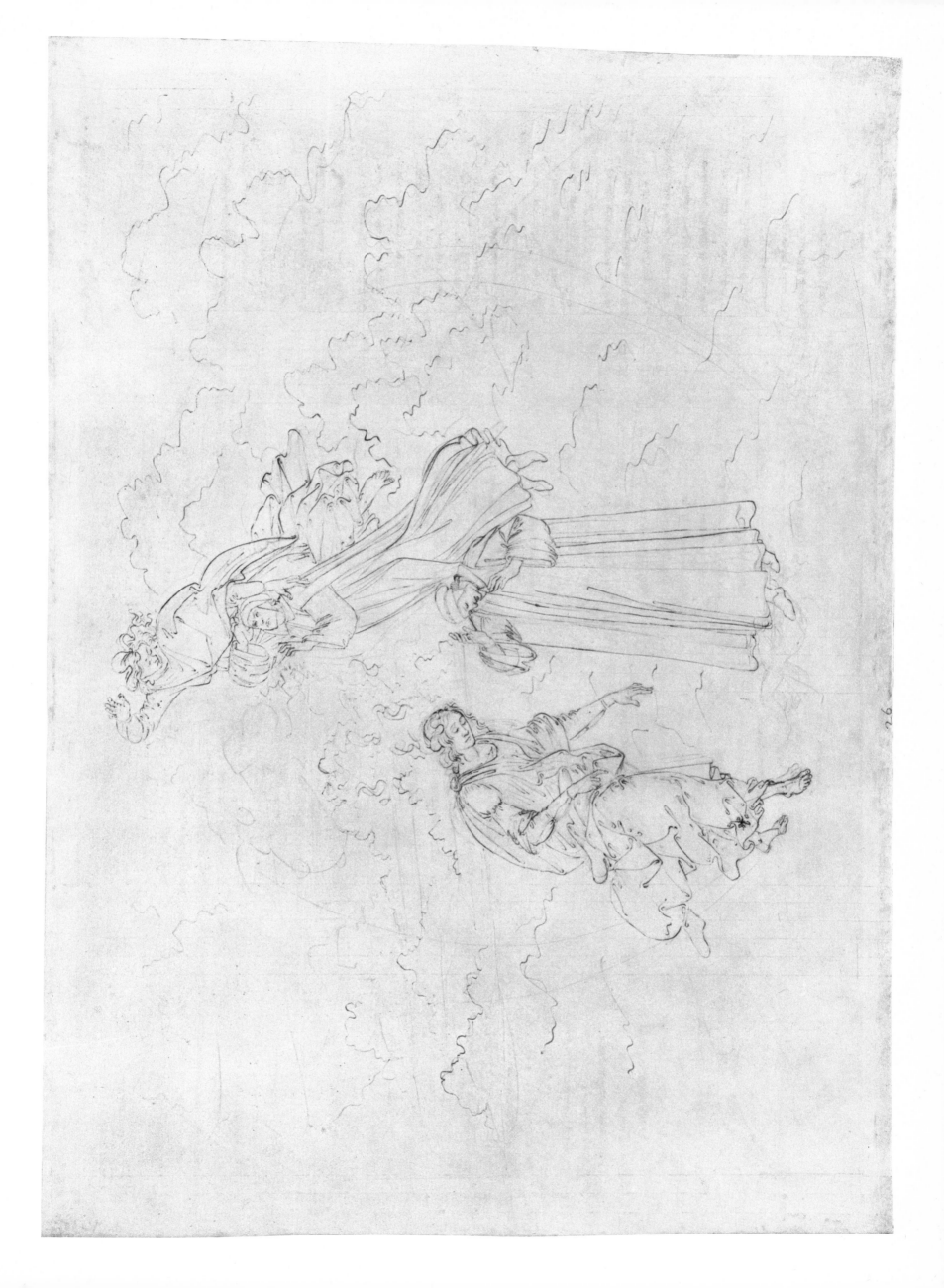

I saw a Point that radiated light
of such intensity that the eye it strikes
must close or ever after lose its sight.

The star that seems the smallest, seen from here,
would seem a moon, were it placed next to this,
as often we see star by star appear.

And at about the distance that a halo
surrounds a heavenly radiance that paints it
on the densest mist that will yet let it show,

so close around the Point, a ring of fire
spun faster than the fastest of the spheres
circles creation in its endless gyre.

Another surrounded this, and was surrounded
by a third, the third by a fourth, the fourth
by a fifth, and by a sixth the fifth in turn was bounded.

The seventh followed, already spread so wide
that were Juno's messenger to be made complete
she could not stretch her arc from side to side.

And so the eighth and the ninth, and each ring spun
with an ever slower motion as its number
placed it the further out from the first one,

which gave forth the most brilliant incandescence
because, I think, being nearest the Scintilla,
it drew the fullest share of the true essence.

* * *

As the airy hemisphere serenes and glows,
cloudless and blue into its furthest reach,
when from his gentler cheek Boreas blows,

purging and dissolving with that breeze
the turbulent vapors, so that heaven smiles
with the beauty of its every diocese;

so was it in my mind, once I was given
my lady's clear reply; and I saw the truth
shining before me like a star in heaven.

And at her last word every angel sphere
began to sparkle as iron, when it is melted
in a crucible, is seen to do down here.

And every spark spun with its spinning ring;
and they were numberless as the sum of grain
on the last square of the chessboard of the king.

From choir to choir their hymn of praise rang free
to the Fixed Point that holds them in fixed place,
as ever was, as evermore shall be.

The Primum Mobile

IN THE SPHERE OF THE PRIMUM MOBILE, Dante looks up in amazement at the Trinity, represented here by Botticelli as a small, lightly sketched circle at the centre of the drawing's upper margin, surrounded by the nine choirs, or hierarchies, of Angels. Along the right margin of the sheet, now partly cut away, Botticelli has written the names of the orders of Angels: 'an[geli]', holding small tablets (in the lower left an Angel's tablet is inscribed 'Sandro/dima/rian/o', Botticelli's name); 'arch[angeli]', bearing scrolls; 'princ[ipati]', wearing sacerdotal stoles; 'podest[adi]', carrying orbs and sceptres; 'virtut[i]', who carry shields emblazoned with a cross; 'domin[azioni]', carrying pennons with a similar blazon; 'tron[i]', who carry tabors, or tambourines; 'serafi[ni]' and 'cherub[ini]', the uppermost and very faint two circles of winged heads. Finally, at the top of his list of labels Botticelli has inscribed 'trinit[à]', to indicate the Trinity, the single focus of the Angels and of Dante and Beatrice.

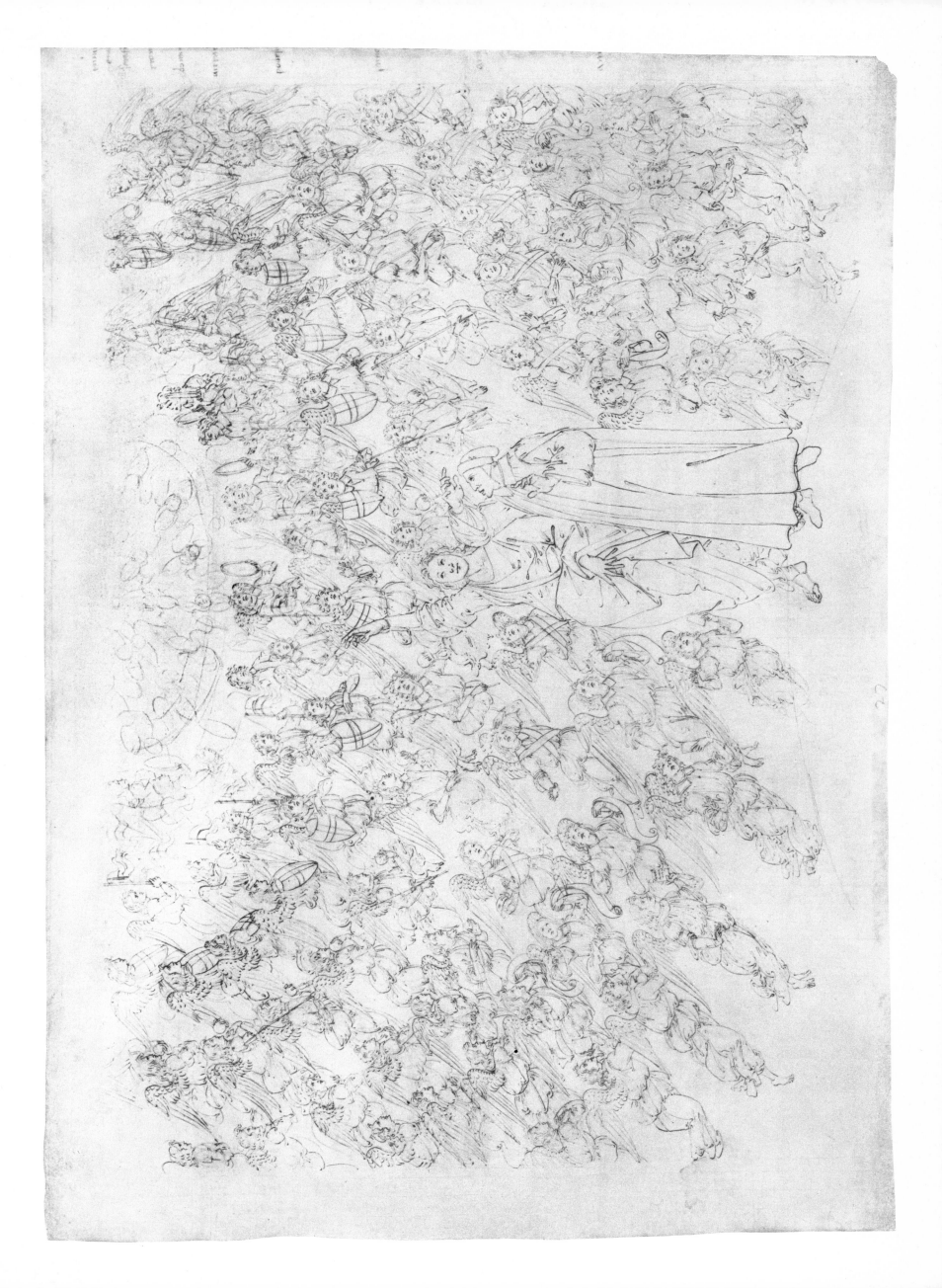

'Nor could you count to ten and ten before
some of those angels fell from Heaven to roil
the bedrock of the elemental core.

* * *

These you see here were humble, undemanding,
and prompt in their acknowledgment of the Good
that made them capable of such understanding;

whereby their vision was exalted higher
by illuminating grace and their own merit,
in which their wills are changeless and entire.

Now hear this and, beyond all doubt, believe it:
the good of grace is in exact proportion
to the ardor of love that opens to receive it.

And now, if you have heeded what I said,
you should be able to observe this college
and gather much more without further aid.

* * *

But we have strayed. Therefore before we climb
turn your attention back to the straight path
that we may fit our journey to our time.

So many beings are ranked within this nature
that the number of their hosts cannot be said
nor even imagined by a mortal creature.

Read well what Daniel saw at heaven's height.
You will soon see that when he speaks of "thousands"
every finite number is lost from sight.

To all, the Primal Light sends down Its ray.
And every splendor into which it enters
receives that radiance in its own way.'

The Primum Mobile

Here Botticelli has inked in only the three lowest orders of Angels, the others being sketched in very lightly. In a pose of great serenity and beauty, Beatrice explains to Dante various points concerning the nature of Angels, their creation and, indeed, God's purpose in creation generally. Dante listens humbly but with gracious bearing. As she ends her discourse, Beatrice recalls Dante to the purpose of their pilgrimage, and they prepare to ascend to the final sphere of Heaven, the Empyrean.

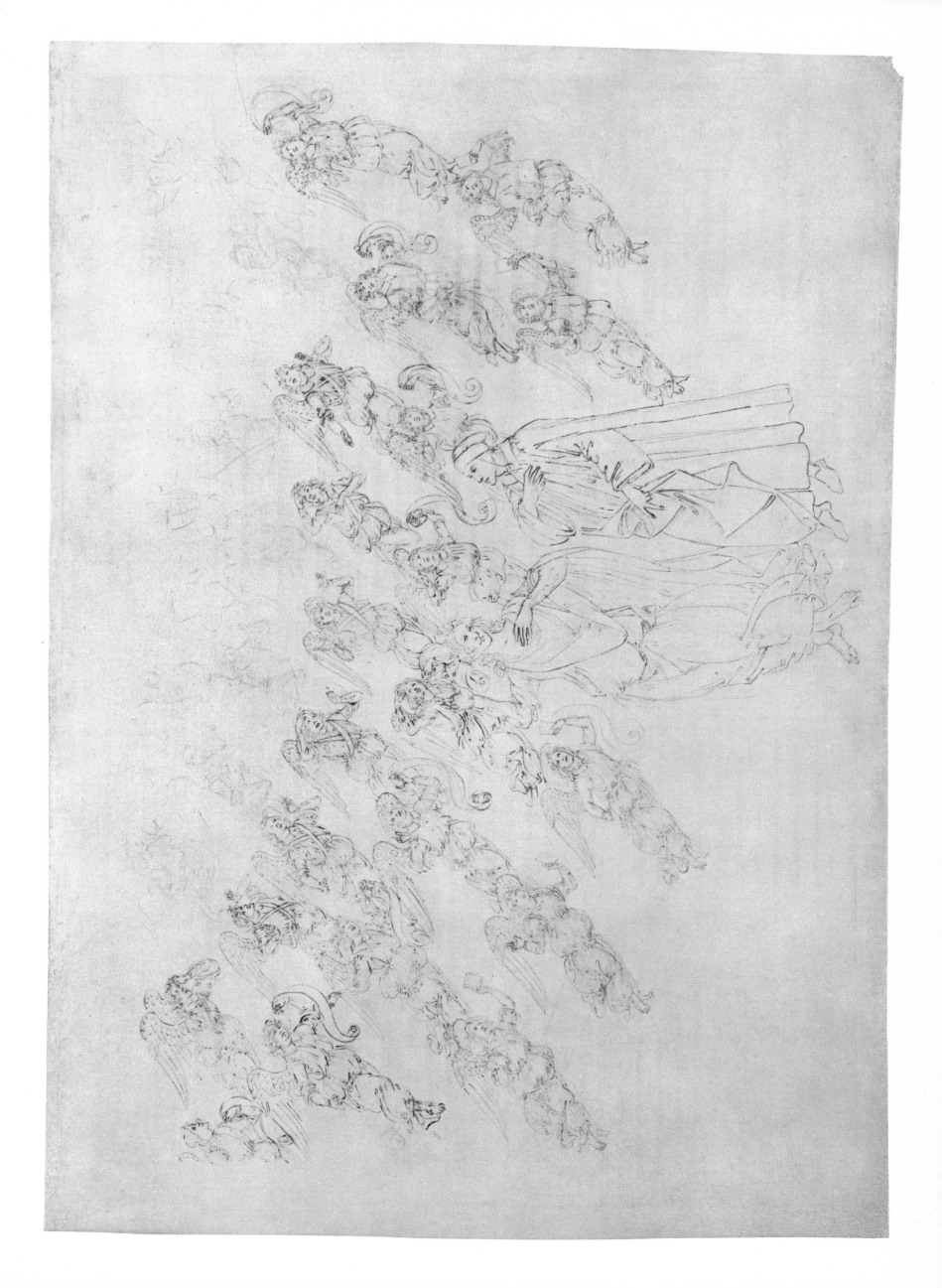

She, like a guide who has his goal in sight
began to speak again: 'We have ascended
from the greatest sphere to the heaven of pure light.

Light of the intellect, which is love unending;
love of the true good, which is wholly bliss;
bliss beyond bliss, all other joys transcending;

here shall you see both hosts of Paradise,
one of them in the aspect you shall see
when you return the day all bodies rise.'

As a flash of lightning striking on our sight
destroys our visual spirits, so that the eye
cannot make out even a brighter light;

just so, an aureole burst all about me,
swathing me so completely in its veil
that I was closed in light and could not see.

'The Love that keeps this Heaven ever the same
greets all who enter with such salutation,
and thus prepares the candle for His flame.'

* * *

I saw a light that was a river flowing
light within light between enameled banks
painted with blossoms of miraculous spring;

and from the river as it glowed and rolled
live sparks shot forth to settle on the flowers.
They seemed like rubies set in bands of gold;

and then, as if the fragrance overthrew
their senses, they dove back into the river;
and as one dove in there, out another flew.

* * *

I bent down to drink in Paradise
of the sweet stream that flows its grace to us,
so to make better mirrors of our eyes.

No sooner were my eyes' eaves sweetly drowned
in that bright stream to drink, than it appeared
to widen and change form till it was round.

* * *

O splendor of God eternal through which I saw
the supreme triumph of the one true kingdom,
grant me the power to speak forth what I saw!

Ascent to the Empyrean

As BEATRICE POINTS THE WAY UPWARD to the Empyrean, Dante's goal from the moment he first lost his way in the 'dark wood' of the *Inferno*, he is surrounded by an aureole of light. He and Beatrice pass above the River of Light, whose banks (only one of which is finished in this drawing) are lined with plants and flowers of extraordinary beauty. Sparks of light, which Botticelli draws as tiny angels, rise from the river, settle on the flowers as bees or butterflies would, and then return to the river. Beatrice, the 'sun and pole-star of my eyes', tells Dante he must drink from the River of Light and as he lowers his face into it to drink, it re-forms into a great circle, in which he sees 'the courts of Paradise'.

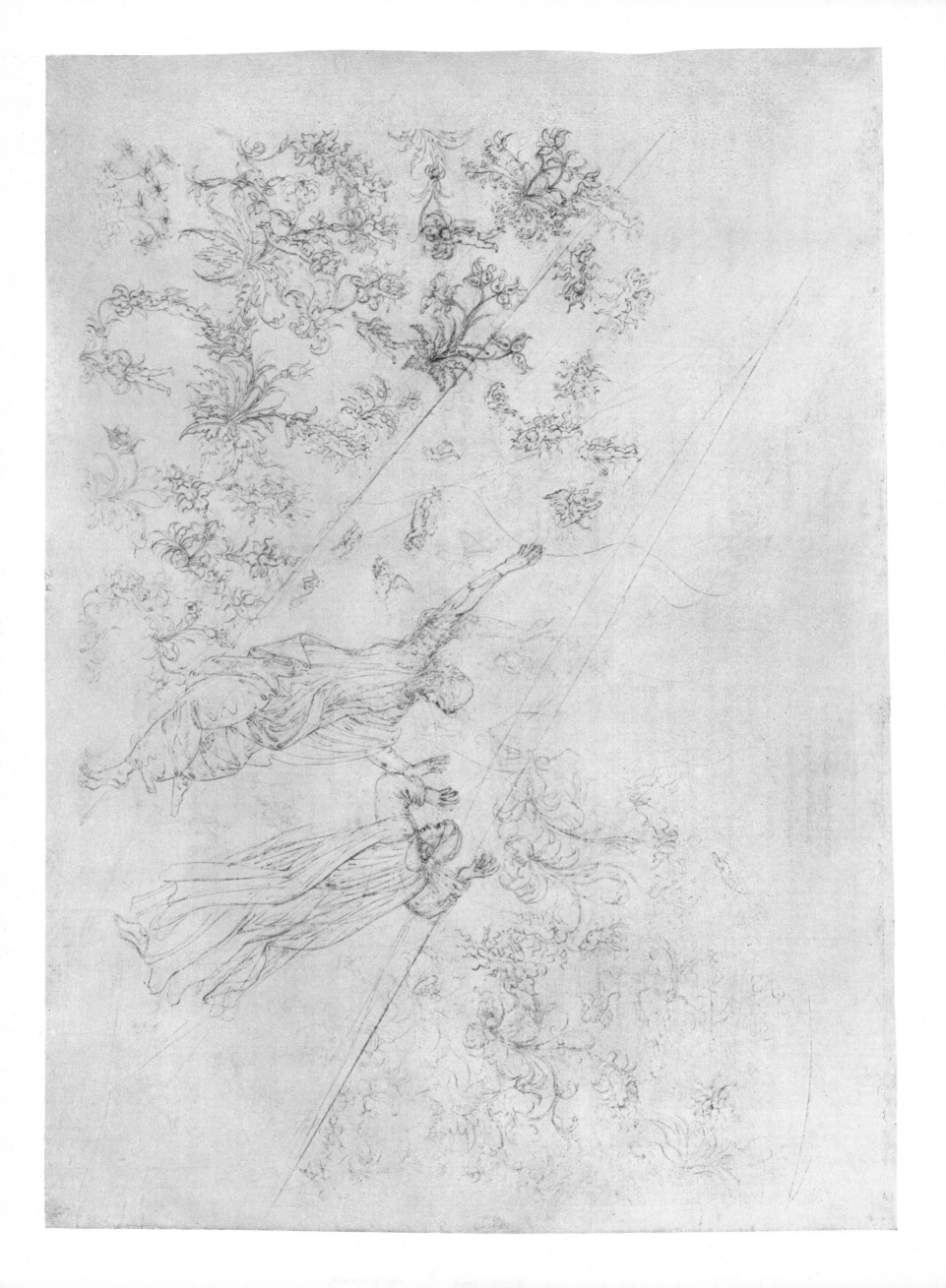

'Look now on her who most resembles Christ,
for only the great glory of her shining
can purify your eyes to look on Christ.'

I saw such joy rain down upon that face –
borne to it by those blest Intelligences
created thus to span those heights of space –

that through all else on the long road I trod
nothing had held my soul so fixed in awe,
nor shown me such resemblances to God.

The self-same Love that to her first descended
singing, 'Ave, Maria, gratia plena'
stood before her with its wings extended.

Thus rang the holy chant to Heaven's Queen
and all the blessed court joined in the song,
and singing, every face grew more serene.

* * *

The one just to the left of her blessedness
is the father whose unruly appetite
left man the taste for so much bitterness.

The Empyrean

IN THE PREVIOUS CANTO – to which there is no drawing by Botticelli – Beatrice's place has been taken by St Bernard, who will serve as Dante's guide to the ultimate Vision of God. Dante has his last sight of Beatrice, who has returned to her throne among the Blessed formed in the concentric rings of the Mystic Rose, with Christ at its heart. The drawing to this canto, largely unfinished, shows lightly sketched what would appear to be some of the circles of the Blessed. Towards the top are two seated figures and a hovering Angel. The seated figure at the left of the group is probably intended to show the Virgin Mary. At her left, gesturing with open arms and hands, is a male personage. In Dante's poem, Adam sits at the Virgin's left hand, the nearest to her in that hemisphere of those who lived in expectation of Christ's coming. In this illustration, however, Botticelli seems quite deliberately to have drawn the figure in this attitude to bring attention to its upraised hands, which seem to bear the stigmata. In that case, this figure would be Christ in His glory showing the wounds of His crucifixion, with Mary seated at His right hand and the Angel, perhaps Gabriel (in allusion to the Annunciation), hovering near the two.

ACKNOWLEDGMENTS
Permission is gratefully acknowledged to reproduce the following illustrative material in the Introduction: 10, Reproduced by courtesy of the Trustees, The National Gallery, London; 11, Photo Mansell-Anderson; 12, Musée Condé, Chantilly, Photo Giraudon; 13, 14, Musée Condé, Chantilly; 14, Reproduced by permission of the British Library Board; 15, Biblioteca Apostolica Vaticana, Archivio Fotografico; 16, Reproduced by permission of the British Library Board; 17, Photo Alinari; 19, The Royal Library, Windsor, Reproduced by gracious permission of Her Majesty Queen Elizabeth II; 22, Reproduced by permission of the British Library Board; 23, Photo Mansell-Anderson.

0

76-06943

A boca solleuo del fiero pasto .
Quel peccator forbendola acapelli .
Del capo chegli hauea didietro guasto .
P oi comincio tu uuoi chio rinouelli .
Disperato dolor chel cor mi preme .
Gia pur pensando pria chio ne fauelli .
M a selle mie parole esser dien seme .
Che fructi infamia altraditor chio rodo .
Parlare & lagrimare uedrai insieme .
I o nonso chitu se ne perche modo .
Venuto se quaggiu ma fiorentino .
Mi sembri ueramente quandio todo .
T u dei saper chio fui conte ugolino .
Et questie larciuescouo ruggieri .
Hor ti diro perchio son tal uicino .
C he per leffecto desuoi mai pensieri .
fidandomi dilui io fossi preso .
Et poscia morto dir none mestieri .
P ero quel che nõ puoi hauere inteso .
Cioe come la morte mia fu cruda .
Vdirai & saprai sel ma offeso .
B rieue pertugio dentro dallamuda .
Laqual perme ha iltitol della fame .
Et che conuien anchor chaltrui si chiuda .
M hauea mostrato perlo suo forame .
Piu lume gia quandio fei ilmal sonno .
Che del futuro mi squarcio iluelame .
Questi pareua me maestro & donno .
Cacciando illupo & lupicini almonte .
Perche pisan ueder lucca non ponno .
C on cagne magre studiose & conte .
Gualandi consismondi & con lanfranchi .
Sbauea messi dinanzi dalla fronte .
I npicciol corso mi pareano stanchi .
Lopadre & figli & collagute scane .
Mi parea lor ueder fender lifianchi .
Q uandio fui desto innanzi la dimane .

Piangersenti fral sonno imiei figliuoli .
Cheran con meco & dimandar del pane .
B en se crudel se tu gia nonti duoli .
Pensando cio chel mio cuor sanunziaua .
Et se non piangi di che pianger suoli .
G ia era desto & lora sappressaua .
Chel cibo ne soleua essere adecto .
Et per suo segno ciascun dubitaua .
E t io senti chiauar luscio di socto .
Allorribil torre ondio guardai .
Nel uiso a miei figliuoli sanza far mocto .
I o non piangeua si dentro impetrai .
Piangeuano egli & anselmuccio mio .
Dixe tu guardi si padre che hai .
P ercio non lagrimai ne rispuosio .
Tucto quel giorno ne lanocte appresso .
Infin chelaltro sol nel mondo uscio .
C ome un poco di raggio si fu messo .
Nel doloroso carcere & io scorsi .
Per quattro uisi ilmio aspecto stesso .
A mbo leman perdolor mi morsi .
Et ei pensando chil fessi per uoglia .
Dimaniear disubito leuorsi .
E t disser padre assai cifia men doglia .
Se tu mangi dinoi tu ne uestisti .
Queste misere carni & tu le spoglia .
Q uetami allhor pernon fargli piu tristi .
Quel di & laltro stemo tucti muti .
Hai dura terra perche non tapristi .
P oscia che fumo alquarto diuenuti .
Gaddo mi sigitto disteso apiedi .
Dicendo padre mio che non maiuti .
Q uiui mori & come tu miuedi .
Vidio cascar litre aduno aduno .
Tral quinto di elsecto ondio midiedi .
G ia cieco ad brancolar soura ciascuno .
Et tre di gli chiamai poche fur morti .
Poscia piu chel dolor potel digiuno .
Q uando hebbe decto cio cõ gliocchi torti .
Riprese iltescho misero coidenti .